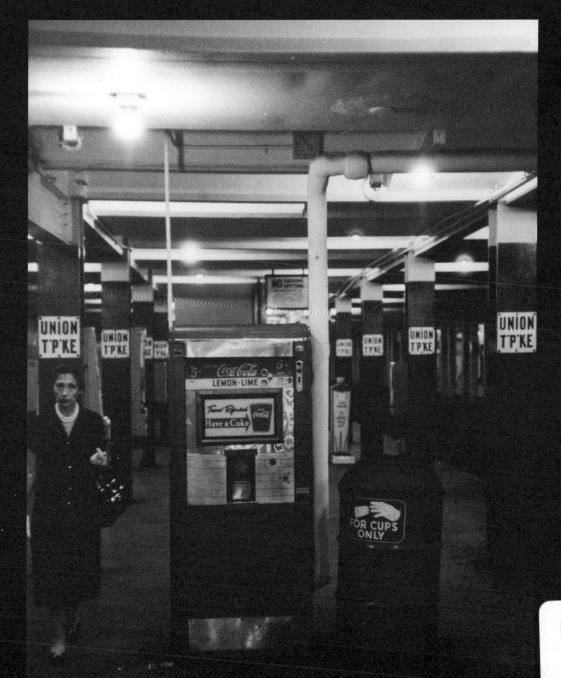

VINTAGE NEW YORK CITY SUBWAY SIGNS

1920s–1980s

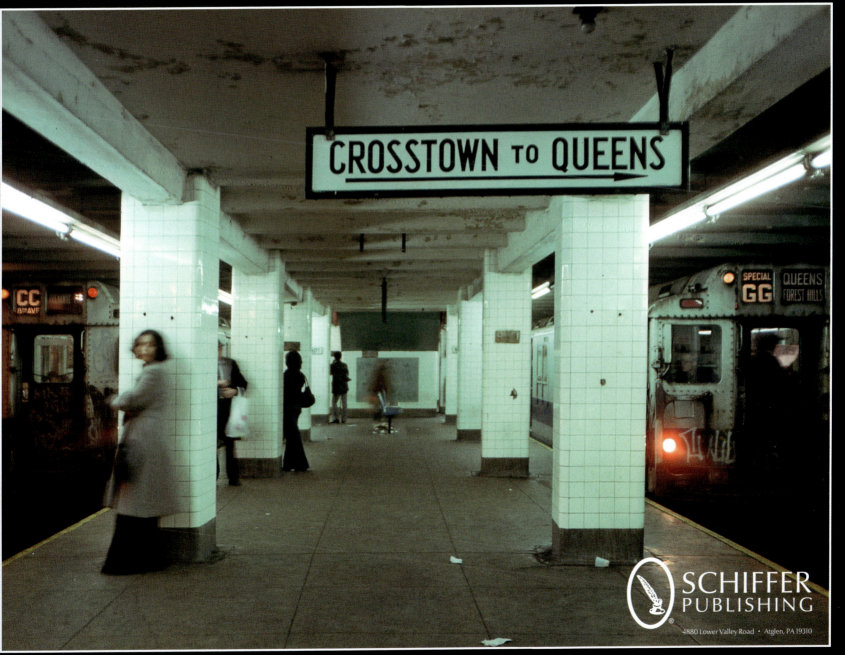

TOD LANGE

FOREWORD BY DOUGLAS GROTJAHN

SCHIFFER PUBLISHING
4880 Lower Valley Road • Atglen, PA 19310

Text Copyright © 2025 by Tod Lange
Photographs Copyright © 2025 by Tod Lange unless otherwise noted below

Photo Credits:
Cover: Douglas Grotjahn
Back Cover: Steve Zabel
William Mangahas: 3, 5 middle, 34, 35, 36, 39 right, 50, 51, 58, 102 top left, 108 bottom left, 117 top left, 126, 128, 130, 134, 135, 213 left, 214, 223, 236, 237, 261 top right
Steve Zabel: 18, 19, 59, 68, 69, 77 left, 98, 124, 217 top right, 249, 257
William J. Madden: 9, 10, 11, 12, 13, 14, 37 right, 120
Michael Piselli, collection of Douglas Grotjahn: 71, 76, 78, 100 top left, 102 bottom left, 233, 238
Aron Eisenpress: 140, 222, 224 top left
Joe Testagrose: 190
Paul Iovino: 244, 245

All other photos by Douglas Grotjahn and from the author's collection.

Special thank-you to Brian Merlis, James Greller, Gregory Gil, Tommy Holiday & Thomas Colasanto

Library of Congress Control Number: 2024941491

All rights reserved. No part of this work may be reproduced or used in any form or by any means—graphic, electronic, or mechanical, including photocopying or information storage and retrieval systems—without written permission from the publisher.

The scanning, uploading, and distribution of this book or any part thereof via the Internet or any other means without the permission of the publisher is illegal and punishable by law. Please purchase only authorized editions and do not participate in or encourage the electronic piracy of copyrighted materials.

"Schiffer," "Schiffer Publishing, Ltd.," and the pen and inkwell logo are registered trademarks of Schiffer Publishing, Ltd.

Designed by Jack Chappell
Cover design by Jack Chappell

Type set in Interstate/Avenir

ISBN: 978-0-7643-6920-9
ePub: 978-1-5073-0542-3
Printed in China

Published by Schiffer Publishing, Ltd.
4880 Lower Valley Road
Atglen, PA 19310
Phone: (610) 593-1777; Fax: (610) 593-2002
Email: info@schifferbooks.com
Web: www.schifferbooks.com

For our complete selection of fine books on this and related subjects, please visit our website at www.schifferbooks.com. You may also write for a free catalog.

Schiffer Publishing's titles are available at special discounts for bulk purchases for sales promotions or premiums. Special editions, including personalized covers, corporate imprints, and excerpts, can be created in large quantities for special needs. For more information, contact the publisher.

CONTENTS

FOREWORD BY DOUGLAS GROTJAHN	4
INTRODUCTION BY TOD LANGE	6
CHAPTER 1. EARLY SIGNAGE	8
CHAPTER 2. STATION ENTRANCES	16
CHAPTER 3. STATION SIGNS	86
CHAPTER 4. DIRECTIONAL/ROUTE SIGNS	132
CHAPTER 5. "NO SPITTING," "NO SMOKING," AND "WARNING" SIGNS	180
CHAPTER 6. KIOSKS	202
CHAPTER 7. GLOBES	212
CHAPTER 8. MOSAICS	220
CHAPTER 9. MISCELLANEOUS SIGNAGE AND ANCILLARY ITEMS	246
CHAPTER 10. SURVIVORS	266

FOREWORD

I grew up with my older brother, Thomas, and younger sister, Rosemarie, in the Midwood neighborhood of Brooklyn, New York, during the 1940s through the '60s. We lived across the street from the outdoor Avenue "H" station on the Brighton Beach subway line (today's "B" and "Q" lines), part of what was then the BMT (Brooklyn-Manhattan Transit) Division of the New York City Transit System.

My passion for subway trains goes back as far as I can remember. I developed a fondness for watching and listening to the trains that passed my hometown station. I was fascinated by the different types of cars and their sounds. My favorite place to observe all this action was at the entrance to the Avenue "H" station. I also enjoyed studying a large-size subway system map posted there, and I had memorized parts of it by the time I was ten years old. By the late 1950s, I was exploring the system by myself. I bought my first camera in 1961 and started building a photo and slide collection.

My photography was not limited to trains alone. I quickly expanded my interests to include stations and entrances, with emphasis on their signage. I admired the early mosaics and ceramics that adorn the walls and columns of stations on the IRT (Interborough Rapid Transit) and BMT (Brooklyn-Manhattan Transit) lines, as well as the newer-style mosaics and tile work from the 1930s in stations on the newer IND. (Independent) lines. I've always considered such ornamentation true works of art.

I was also intrigued with the different styles of graphics on wooden and porcelain signs of various shapes and sizes; relics from the teens through the '30s. I photographed as many of these as I could find while they were still in place.

Realizing the need for new and improved signage, the New York City Transit Authority hired a design-consultancy firm in 1966 to create a new signage system. By late 1967, newly designed information signs had begun to appear in many stations. These signs featured modern graphics upon a white background. A new color-coded system was developed for all subway lines and was represented on the new signage in the form of route numbers/letters within colored circles (route numbers for the IRT, and letters for the IND and the BMT), along with the route descriptions, directions, destinations, and hours of operation. New-style station-entrance signs featured station names, and route numbers (or letters) within colored circles upon a white background. This was an important step forward, but much more would be needed.

By the early '70s, a major program was underway to vastly upgrade all subway signage. The New York City Transit Authority wanted to replace outdated signage from all underground and elevated stations and entrances, and to eliminate what was considered as "visual clutter," which included the multiplicity of somewhat confusing and haphazardly placed signage of all sizes and descriptions, particularly at major transfer points.

New guidelines were developed to unify and simplify, while making legible the design of all new subway signage. These guidelines mandated that all new signage should strictly conform to a new standard style of graphics and that all existing old signage should be replaced with the new versions (many old wooden and porcelain signs from the late teens through the 1930s were still in use throughout the transit system). This was a huge change in an ever-evolving subway system, and more changes were forthcoming.

By the late '70s, system-wide changes were made in the design of new signage. All graphics were imprinted on a black background instead of white (the transition from *black on white* to *white on black* was made because the latter was considered to be more legible). The revised graphics included a color-coded system alteration to many subway lines, as well as the addition of diamond-shaped symbols to indicate part-time service.

Despite concerted efforts to replace all outdated signs, many managed to survive in place into the 1990s. Fortunately, many others have been preserved by the New York Transit Museum and by private collectors.

The early mosaics and ceramics originally incorporated into the station walls were largely spared and are still considered to be both decorative and functional.

Although some stations were "modernized" during the late '60s and '70s, with the new tilework covering their mosaics and ceramics, the newer tiles were removed from some of the stations during subsequent rehabilitation. By the '80s, there was a growing interest in preserving, rather than neglecting or destroying, our treasures. By the '90s, station renovation

guidelines were established to ensure that station makeovers included restoration of mosaics and ceramics, and enhancement by the addition of new ones.

When the idea of a book that focused strictly on the history of New York City subway signage was first brought to my attention, I began to think of my many friends over the years, some of whom I maintain contact with, and others who, sadly, have passed on. Almost all the rail fans and photographers I have known were and are collectors. I would visit them and be amazed by their collections of signs and other memorabilia. So, the concept of a book on the subject of these signs is very intriguing and unique. While I was working on this exciting project, choosing images was a real trip down memory lane. I'm glad that many of us had the foresight to document station signage while many early examples were intact and in place.

I'm very happy and excited to share the images that I, and several others, took over the decades. I'm also extremely grateful to my friend Tod Lange, who encouraged me to become part of this project!

Douglas Grotjahn, 2023

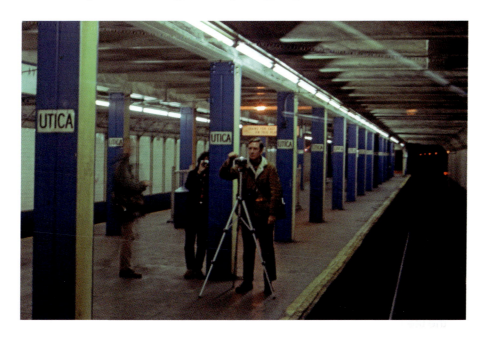

Left: Douglas Grotjahn with tripod at IRT Utica Ave. Station, Brooklyn, 1979

Below: Subway overhead advertising poster, photographed by Douglas Grotjahn 1977

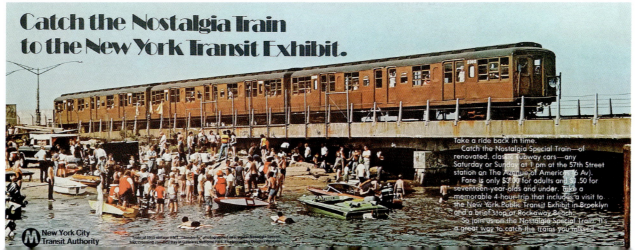

INTRODUCTION

Thousands of people move through New York City's subway system each and every day. Within the system was great art hiding in plain sight. Signs—porcelain, metal, tin, and primitive examples on wood—were used. Many of those first painted wooden signs were soon thereafter covered with porcelain or tin. I have discovered some amazing examples over the years. Although most of the best signs are today held by private collectors, some gems do surface on the market from time to time. Most commuters very rarely read the signs or need directions—they simply know the way. But, as for out-of-towners—that's a different story. It's a complex transit system to navigate, and unless you're well versed in transit dialogue, good luck! Looking back on the many decades of a changing system, we have regrettably lost some of the most amazing entrance, station platform, and directional signs. As a genre, the lettering and craftsmanship conveys an unmistakable New York City style that is easily recognized throughout the world.

This book covers the golden bygone era of signage as well as discusses other related topics and relics. Most of the signs were made of high-quality porcelain enamel baked on metal sheets. First introduced in Europe in the late 1800s, porcelain sign production began in the United States about 1900. Transit signs with more colors showcasing novel designs in a variety of sizes were being mass-produced in America by about 1920. These durable signs were made to stand the test of time. The three major transit companies in NYC were the IRT (Interborough Rapid Transit Co.), BMT (Brooklyn-Manhattan Transit), and IND (Independent Subway System). These were three independent companies (only the IND being owned and operated by the City of New York), and they all competed for revenue and ridership. Each was proud of its name and distinct logo and spelled out its brand for all to see. Many signs reproduced and discussed in this book date back to the earliest days of these respected companies. This book covers "Contract 1" signs, as well as kiosk and subway globes, some produced with glass elements. It would be difficult to pinpoint the precise dates of many signs, since manufacturers very rarely included years of manufacture on them. Some signs do not even show a maker's mark. After these companies were initially consolidated in 1940 under the Board of Transportation of the City of New York, and again in 1953 as the New York City Transit Authority, existing company signs were replaced and began to gradually disappear. A handful managed to survive into the 1980s. Serious rail fans and history buffs knew the whereabouts of such relics still within the system. There was something magical about seeing an ancient sign still in use. Decades ago, there were not many collectors for this type of signage. The rail fans always collected and traded among themselves. That has changed. Sign collectors from all over the world want to own something from the New York City subway system. Every subway entrance and station is unique, and a fixture in nearly every neighborhood.

The expression "Meet me at the station" is a phrase everyone can relate to. Let's take a look at the incredible art form of porcelain enamel signage set in its natural state.

Tod Lange

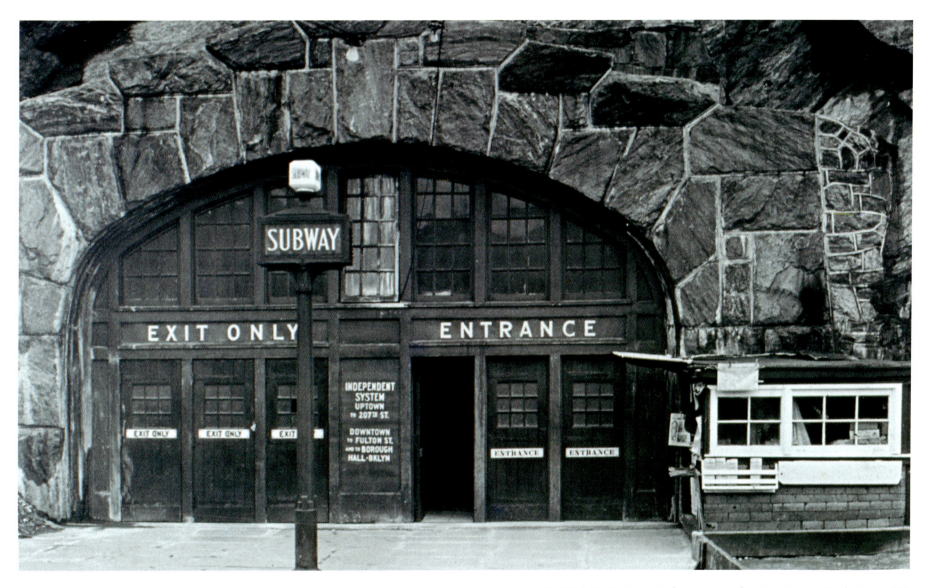
IND, 190th St. Station, Washington Heights Line, Upper Manhattan, 1933

CHAPTER 1.
EARLY SIGNAGE

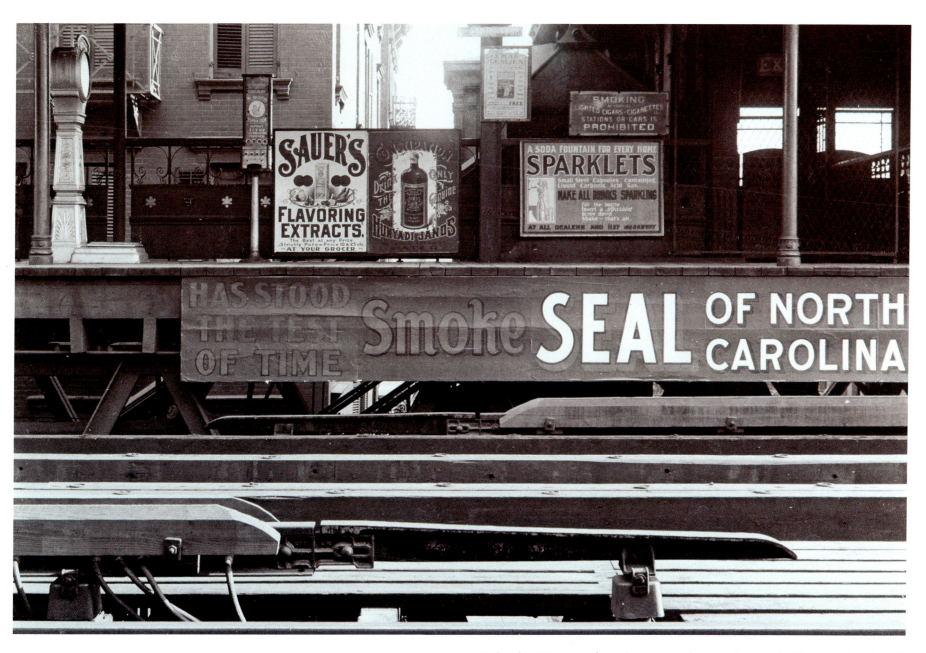

Early advertising, weight scale, gum machine, and porcelain "Smoking Prohibited" sign. Manhattan Railway Co., Second Ave. Line, Manhattan, 1900.

Chapter 1. Early Signage | 9

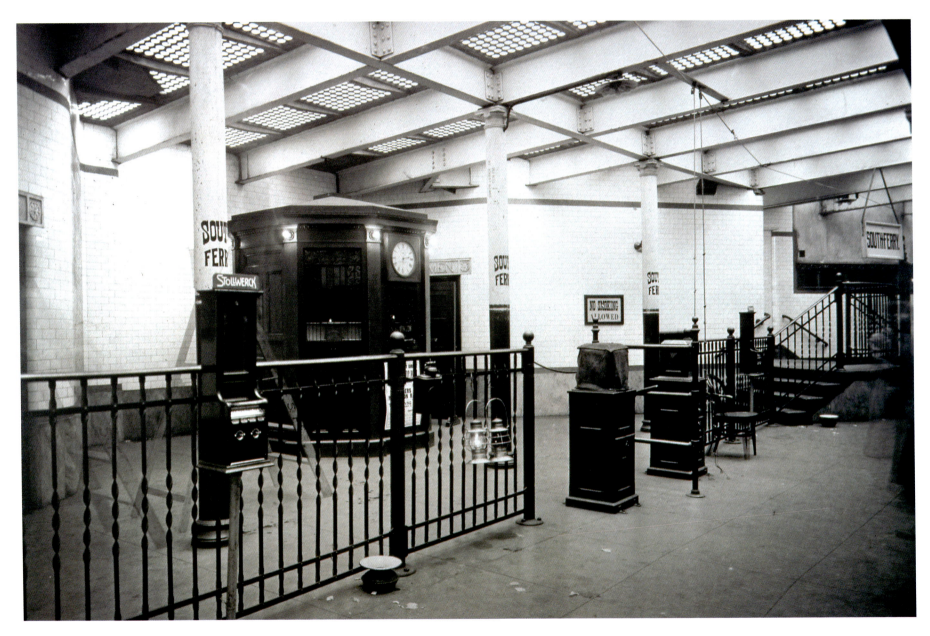

IRT, South Ferry Station, Manhattan, 1908

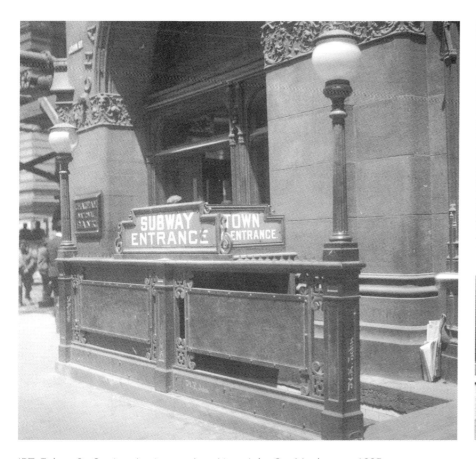

IRT, Fulton St. Station, Lexington Ave. Line, John St., Manhattan, 1905

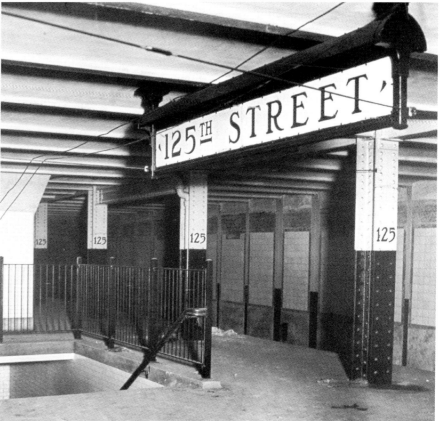

IRT, 125th St. Station, Lexington Ave. Line, Manhattan, 1918

Chapter 1. Early Signage | 11

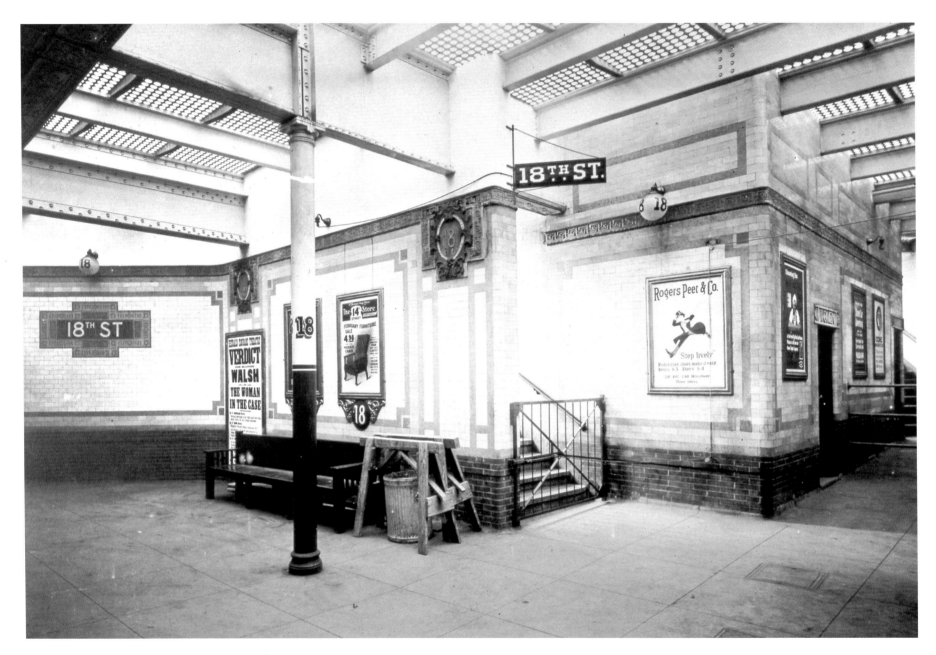

IRT, 18th St. Station, Lexington Ave. Line, Manhattan, 1905

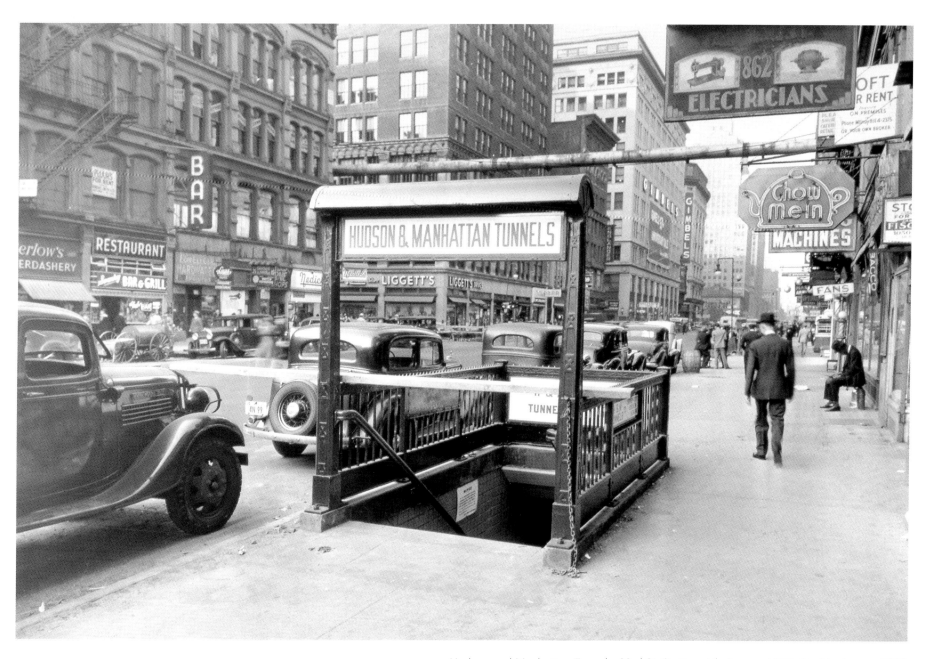

Hudson and Manhattan Tunnels, 33rd St. Station, 6th Ave. and 30th St., Manhattan, 1939

Chapter 1. Early Signage | 13

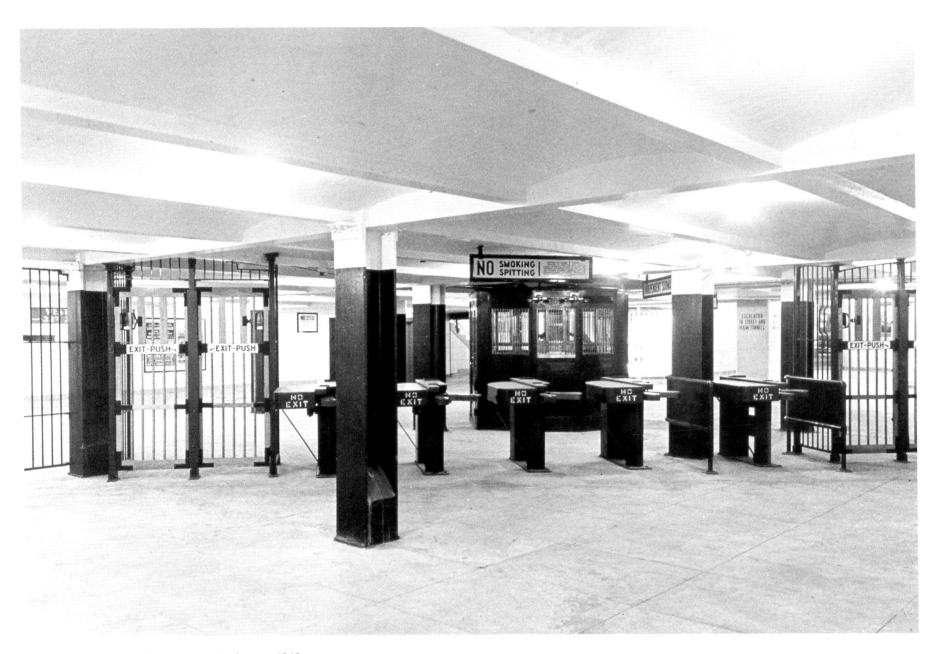

IND, 34th St. Station, 6th Ave. Line, Manhattan, 1940

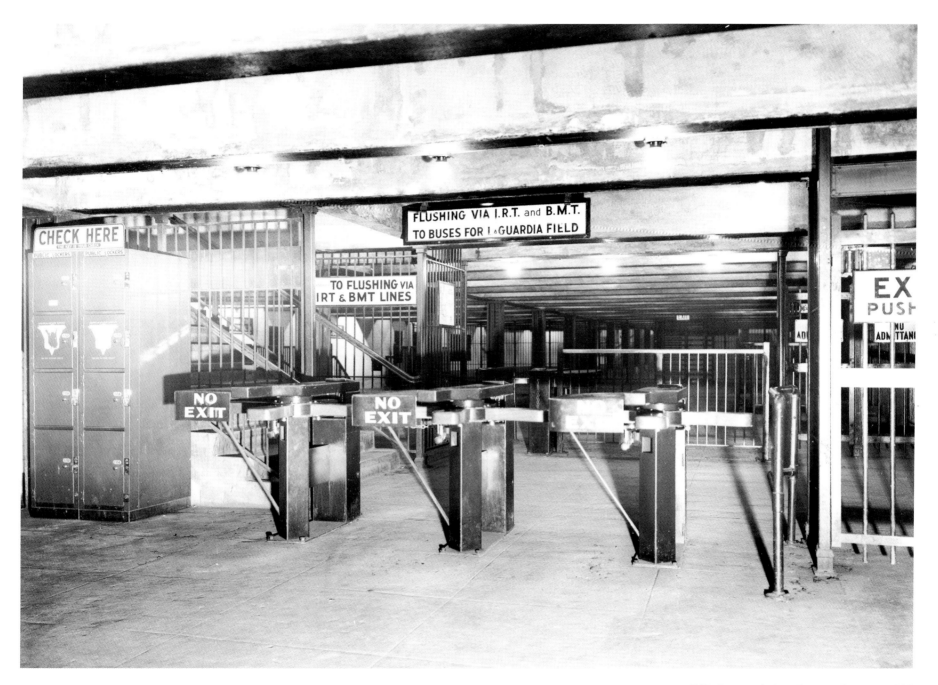

IND, Roosevelt Ave. Station, Queens, 1940

CHAPTER 2.
STATION ENTRANCES

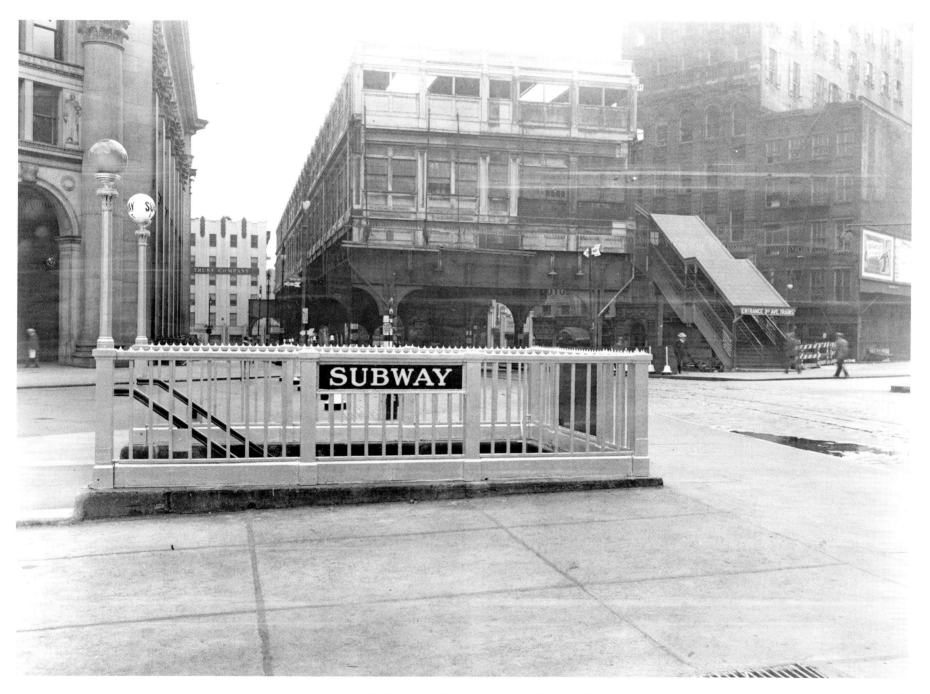

IRT, Third Ave. Elevated City Hall Station, IRT subway entrance at Tryon Row, Manhattan, August 26, 1945

Chapter 2. Station Entrances | 17

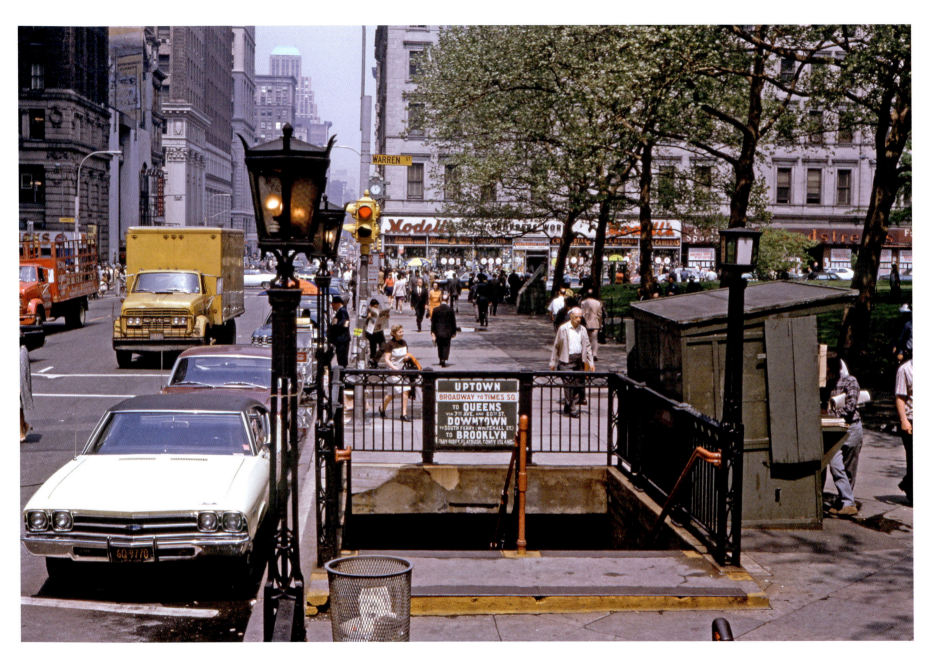

BMT, City Hall Station, Broadway Line, Manhattan, 1970

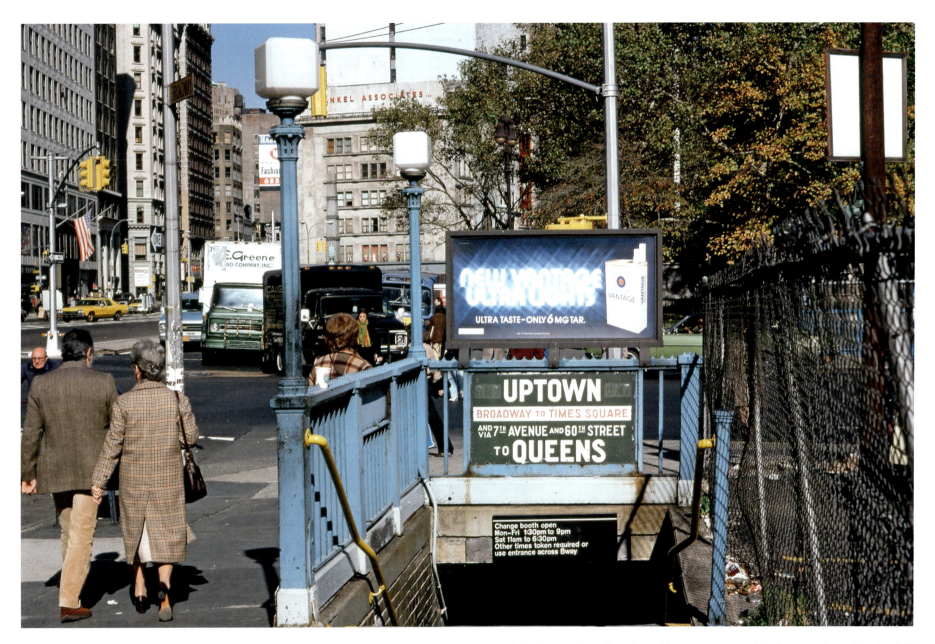

BMT, 23rd St. Station, Broadway Line, Uptown entrance, Manhattan, November 5, 1979

Chapter 2. Station Entrances | 19

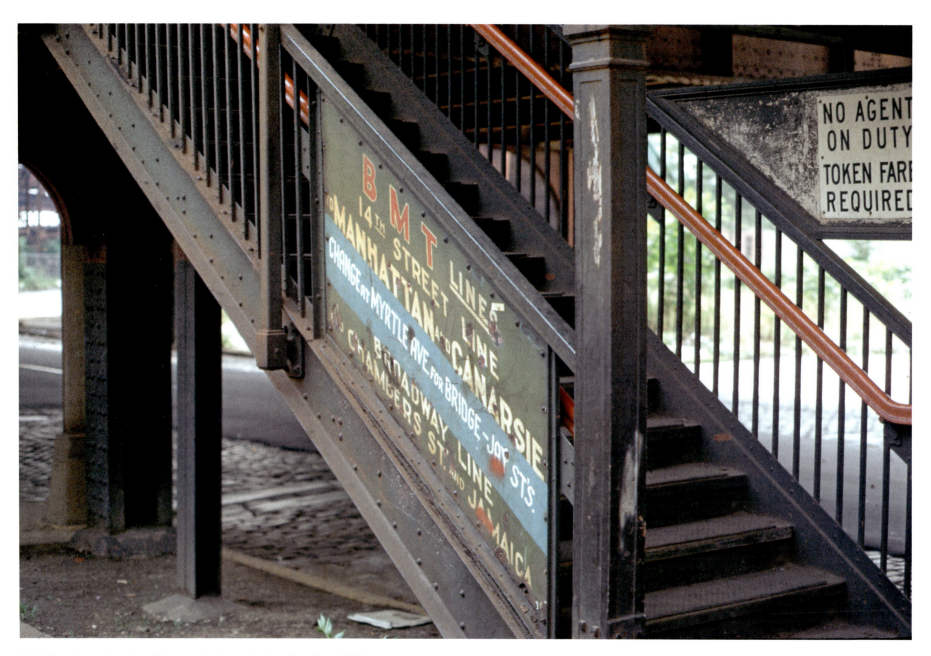

BMT, Broadway Junction / Eastern Parkway Station, Brooklyn, 1970

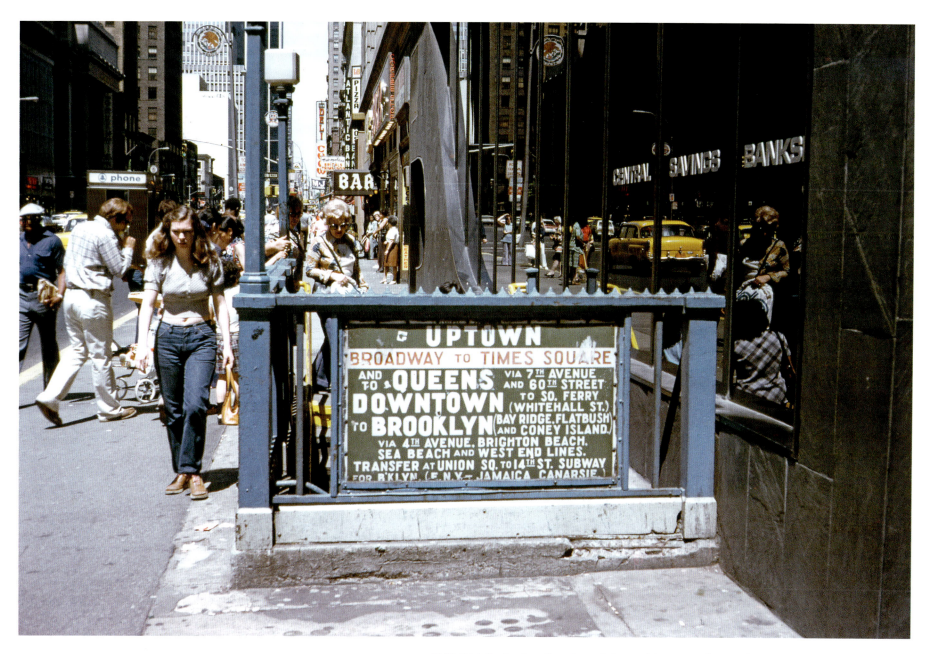

BMT, 34th St. Station, Broadway Subway, 6th Ave. and W. 34th St., Manhattan, June 21, 1975

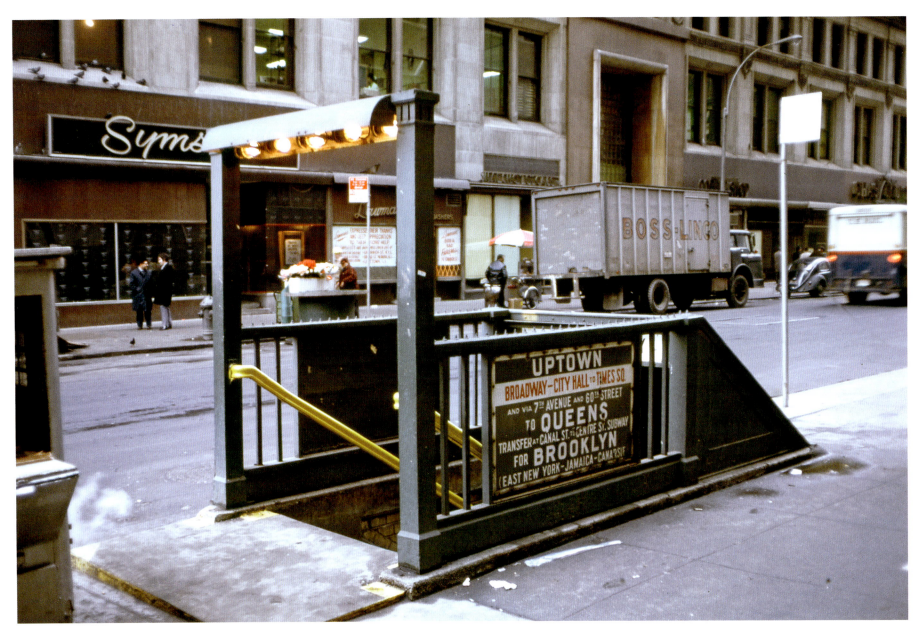

BMT, Cortlandt St. Station, Broadway Line, Manhattan, February 18, 1972

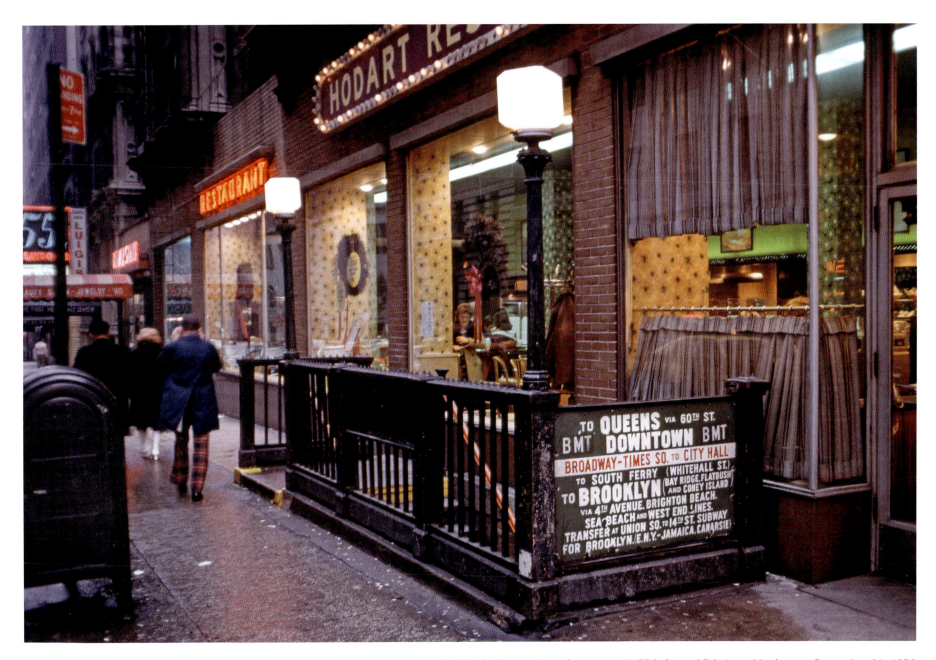

BMT, 57th St. Station, Broadway Line, W. 55th St. and 7th Ave., Manhattan, December 31, 1972

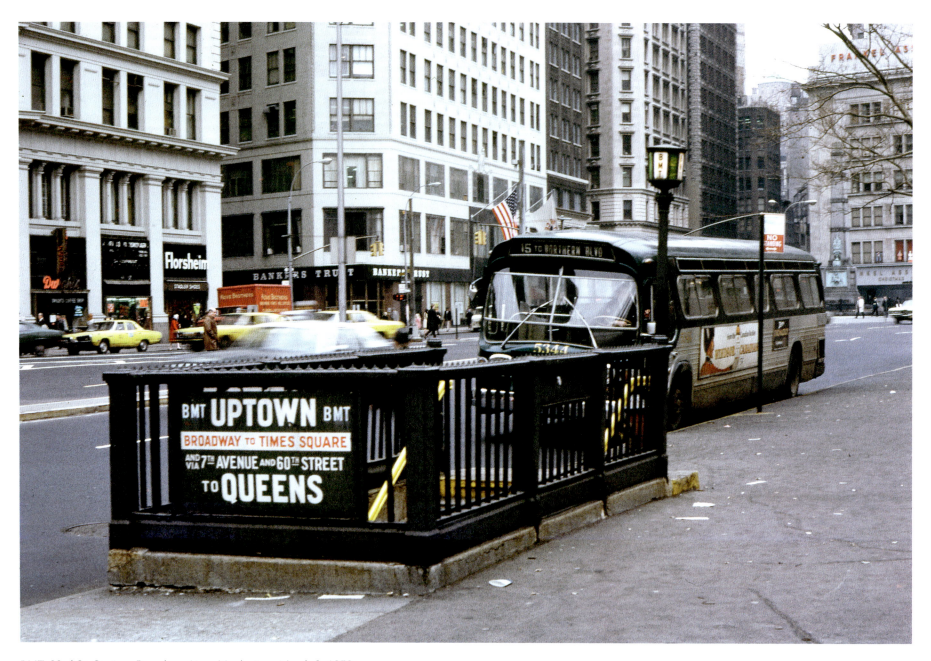

BMT, 23rd St. Station, Broadway Line, Manhattan, March 3, 1972

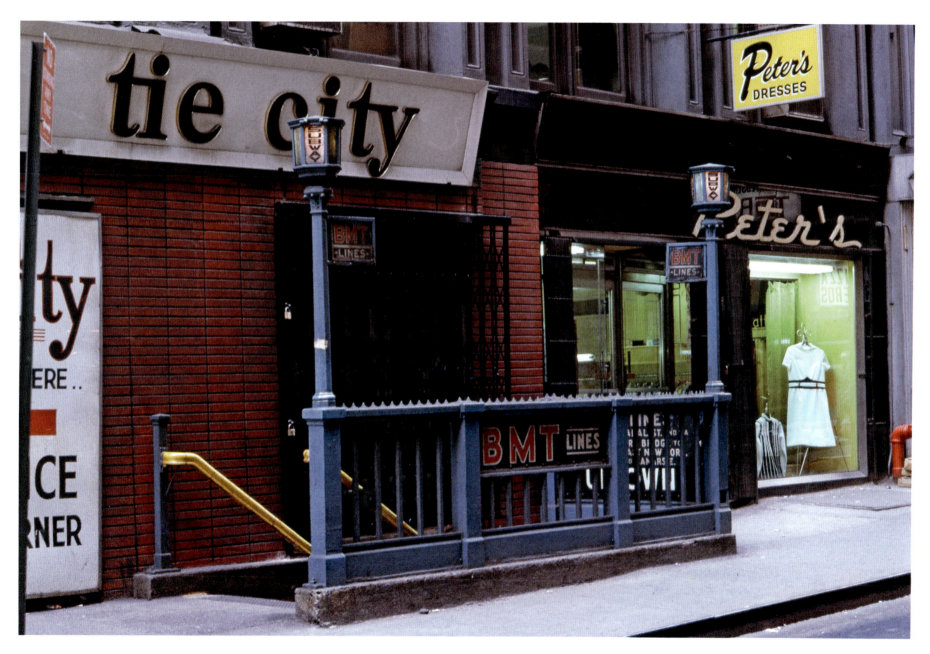

BMT, Fulton St. Station, Ann St. and Nassau St., Manhattan, April 16, 1971

Chapter 2. Station Entrances | 25

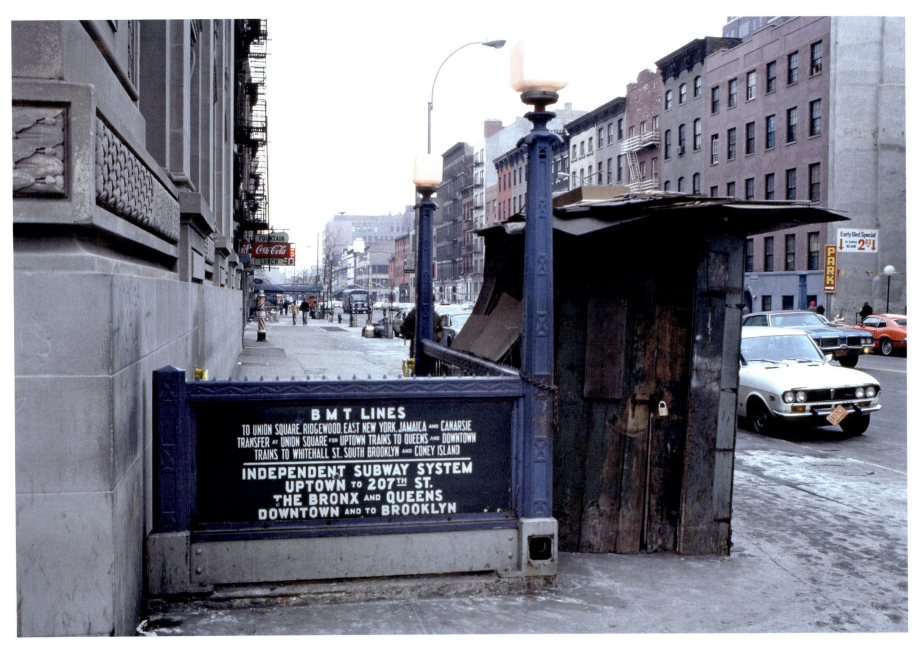

BMT/IND, 14th St. and 8th Ave., Manhattan, January 24, 1976

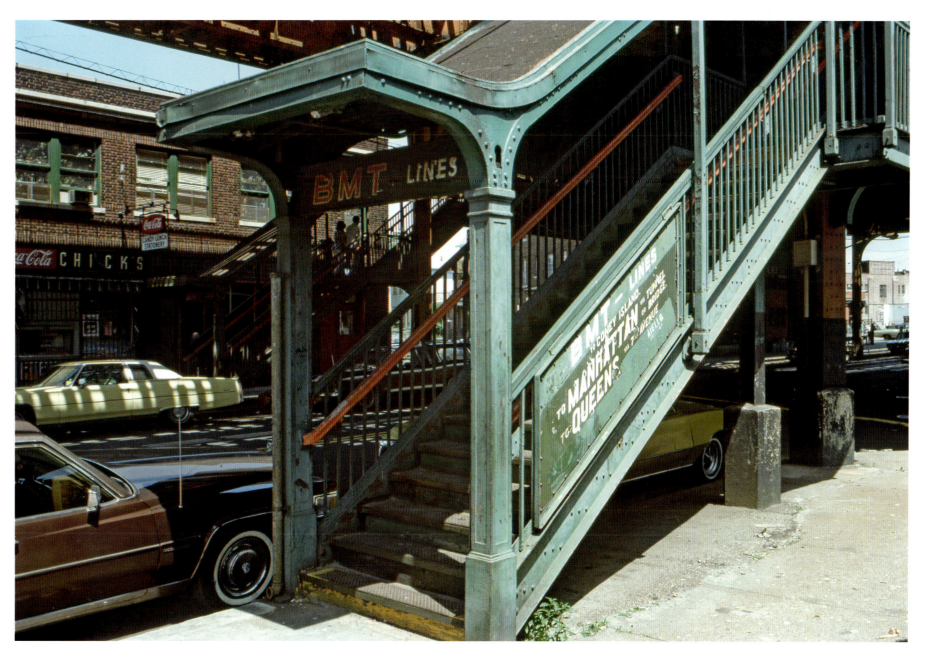

BMT, 71st St. Station entrance, West End Line, 71st St. and New Utrecht Ave., Brooklyn, June 12, 1977

Chapter 2. Station Entrances | 27

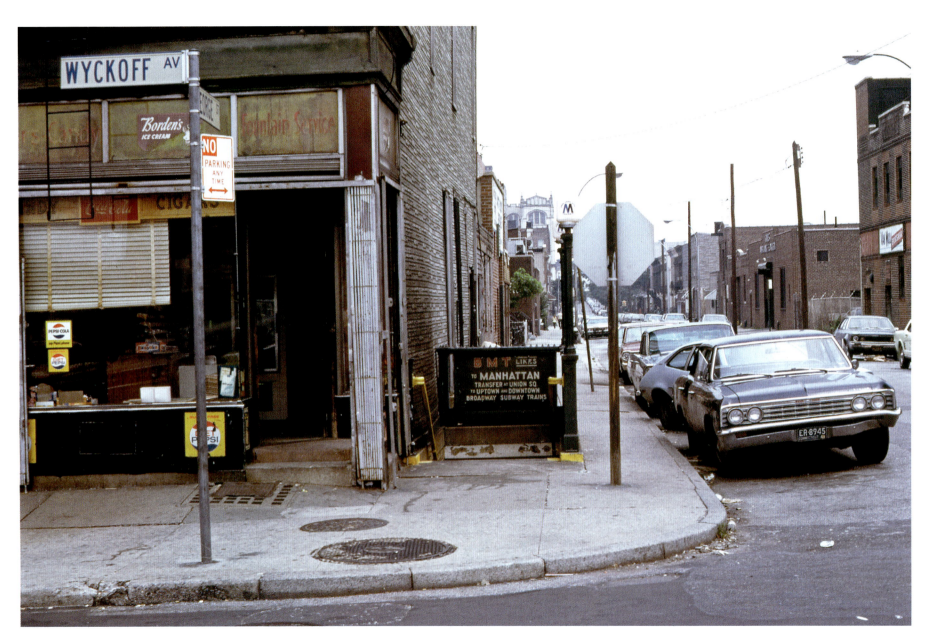

BMT, Halsey St. Station, 14th St. Canarsie Line, Brooklyn, July 16, 1972

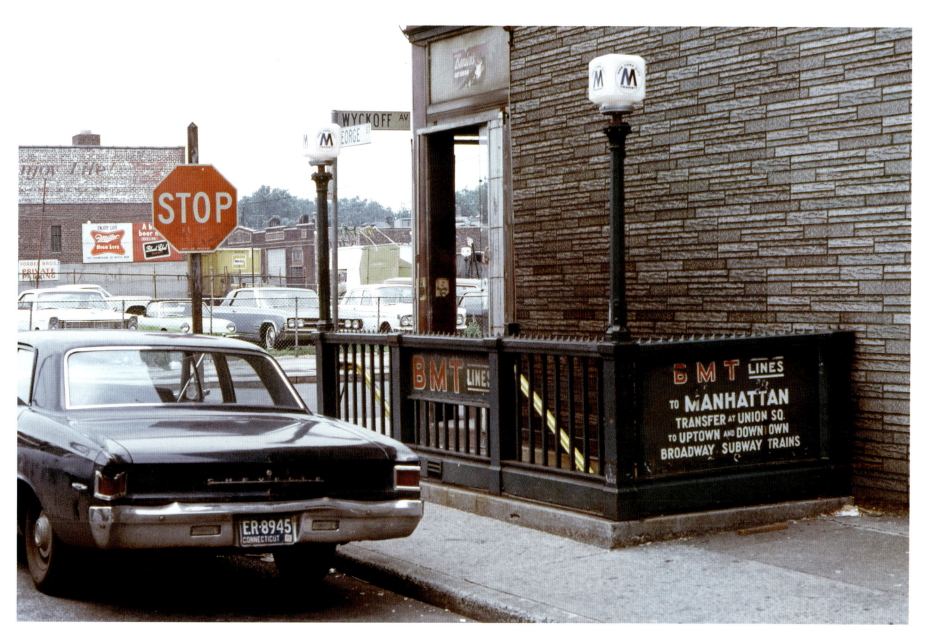

BMT, Halsey St. Station, 14th St. Canarsie Line, Brooklyn, July 16, 1972

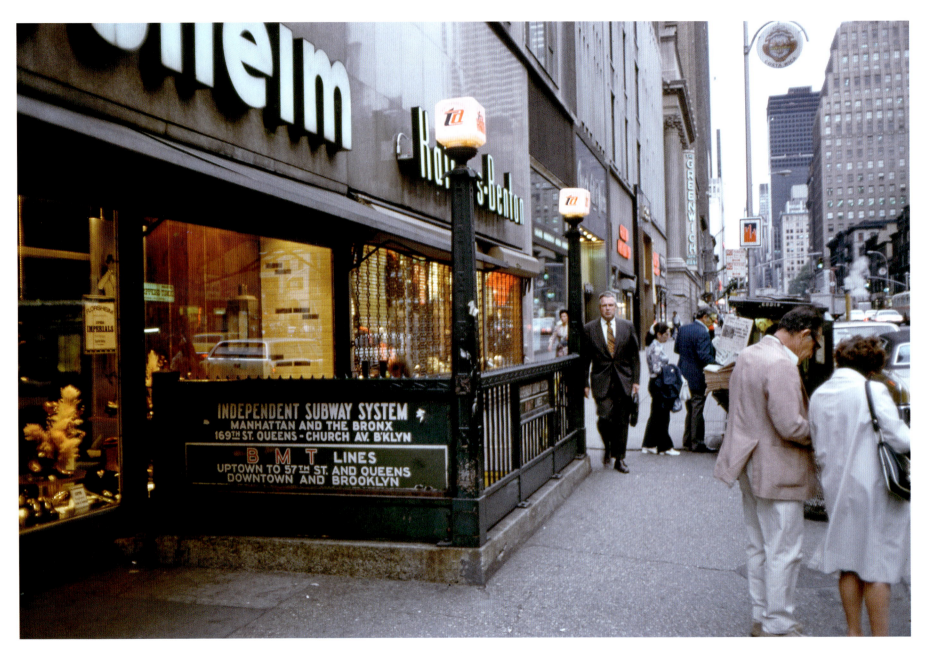

BMT/IND, 34th St. Station, Ave. of the Americas and W. 35th St., Manhattan, September 18, 1972

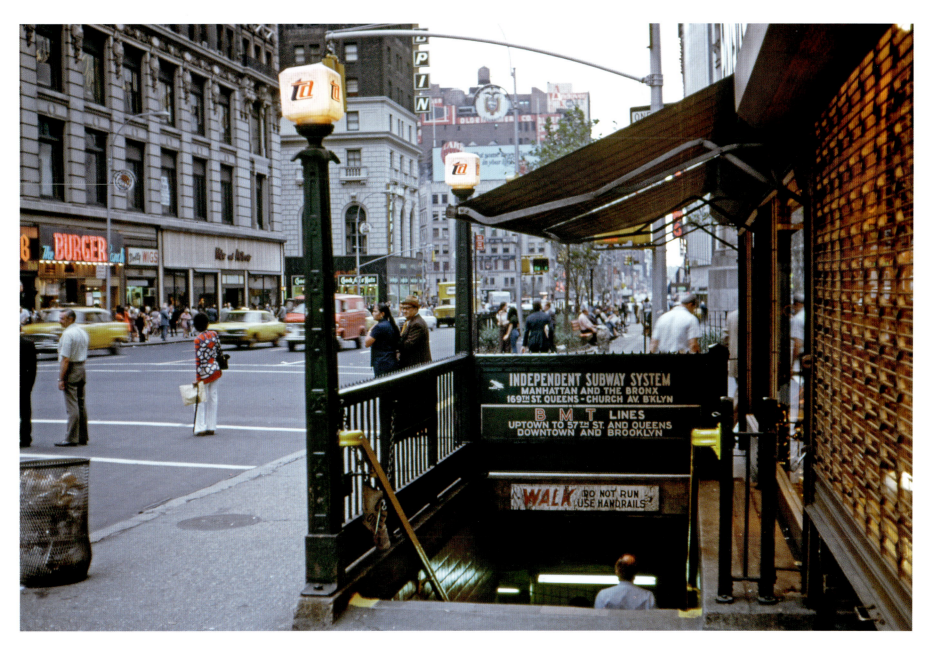

BMT/IND, 34th St. Station, Ave. of the Americas and W. 35th St., Manhattan, September 18, 1972

Chapter 2. Station Entrances | 31

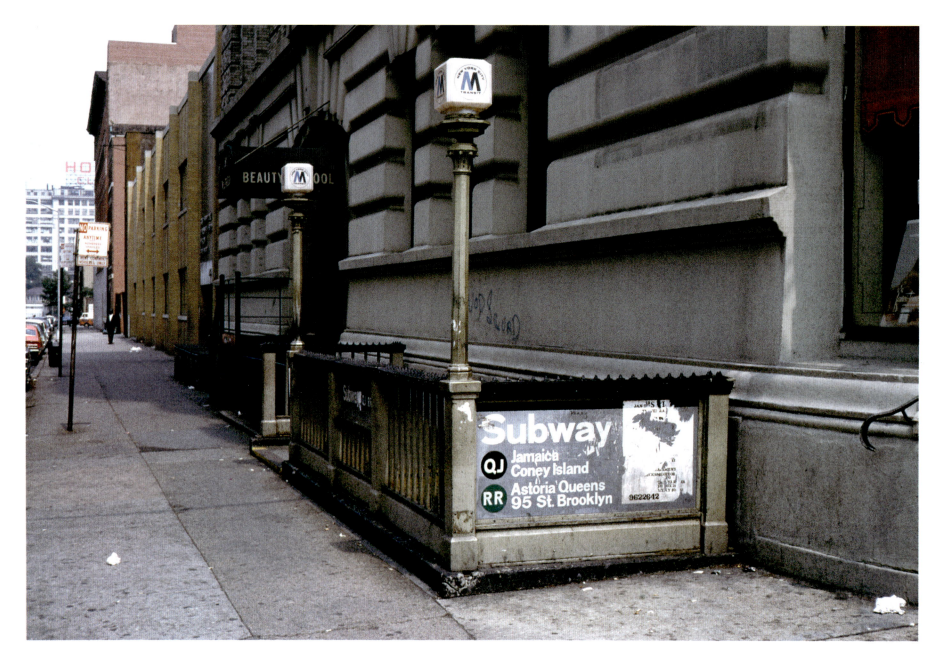

BMT, Lawrence St. Station, "QJ" and "RR" Lines, Brooklyn, August 26, 1972

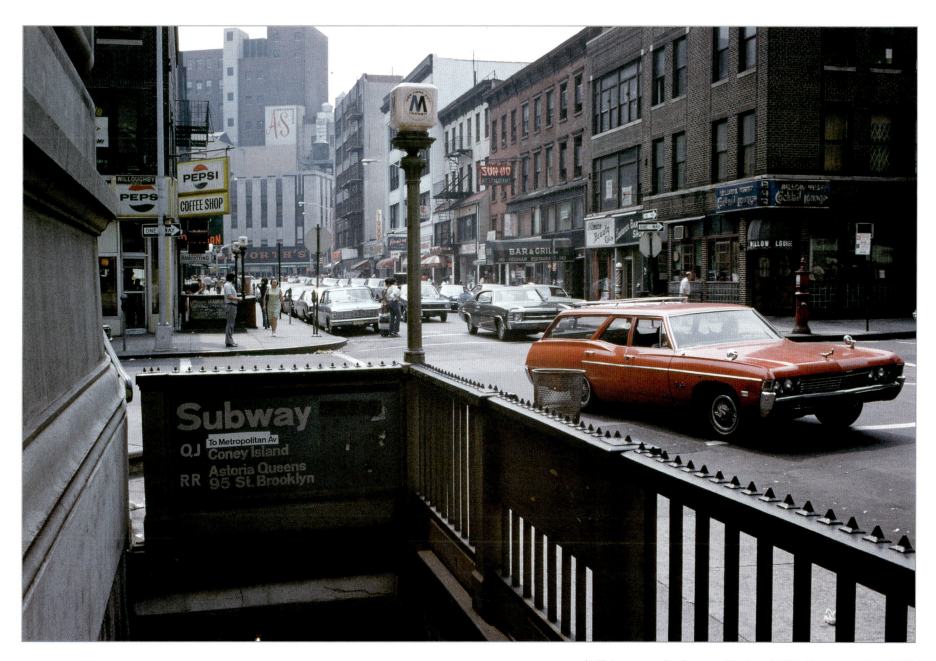

BMT, Lawrence St. Station, "QJ" and "RR" Lines, Brooklyn, 1972

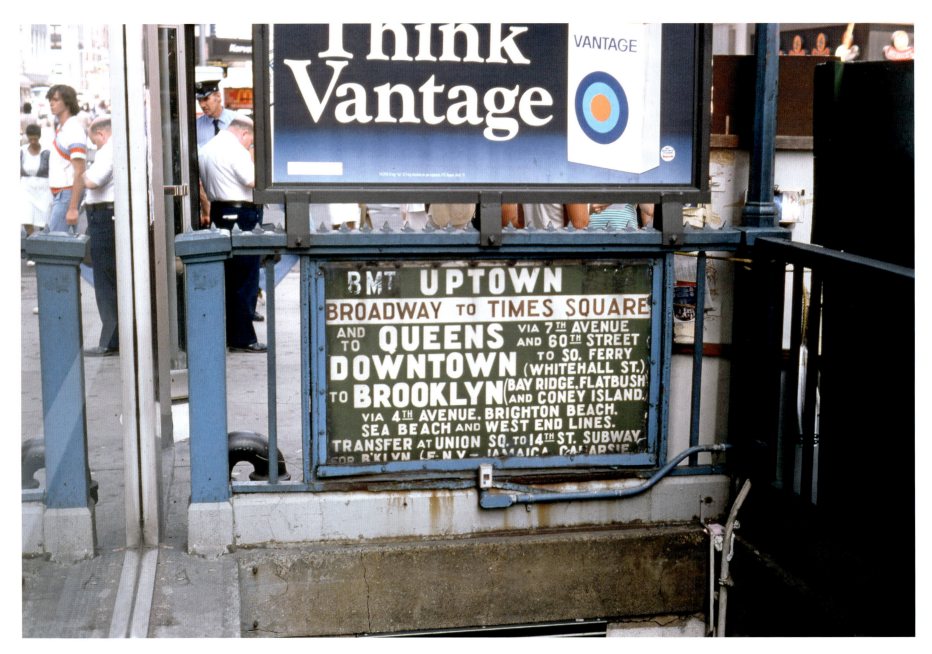

BMT, 34th St. Station, Broadway Line, Manhattan, 1978

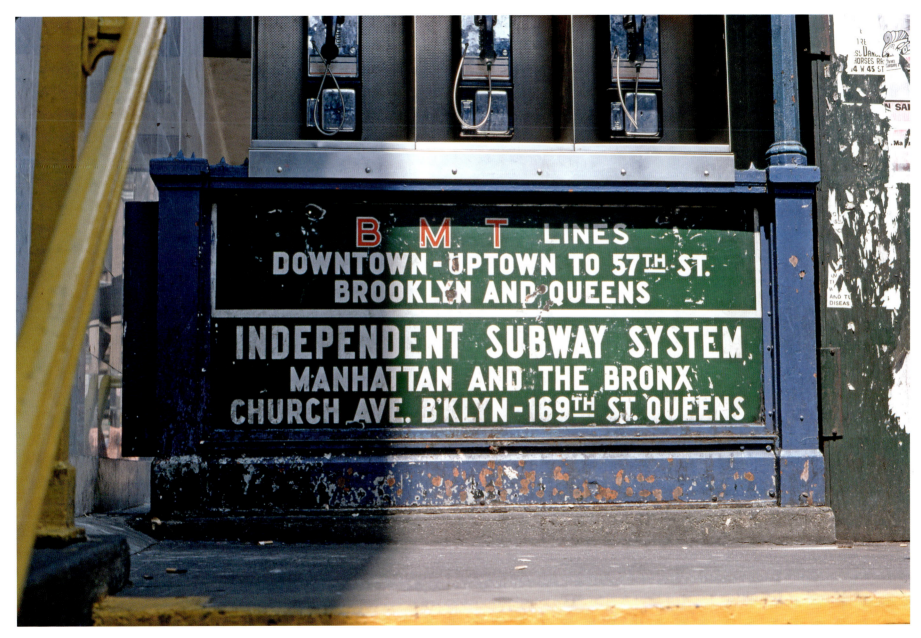

BMT/IND, 34th St. Station, Manhattan, 1978

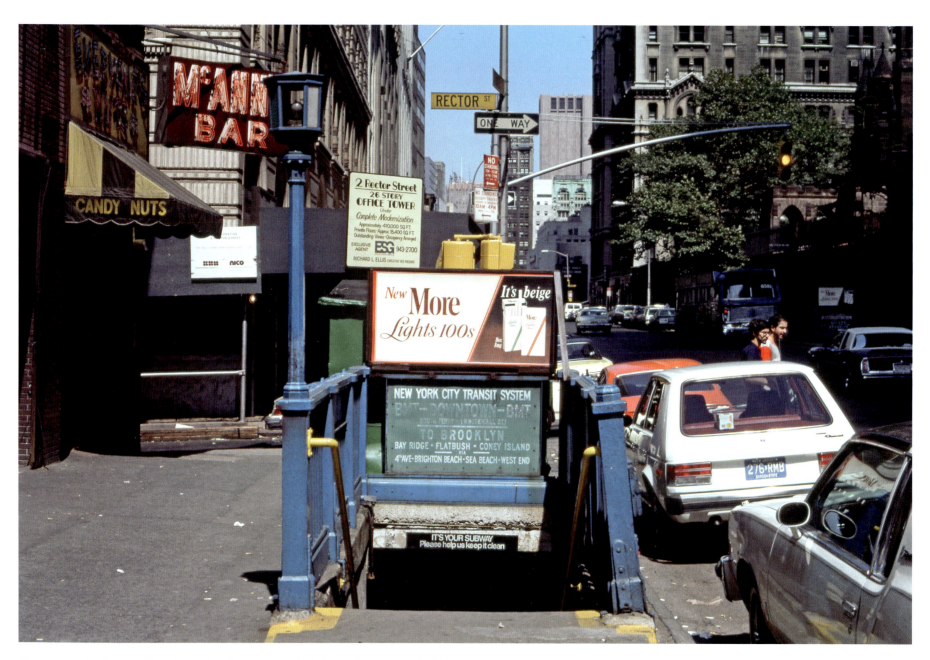

BMT, Rector St. Station, Broadway Line, Rector St. and Trinity Pl., Manhattan, 1981

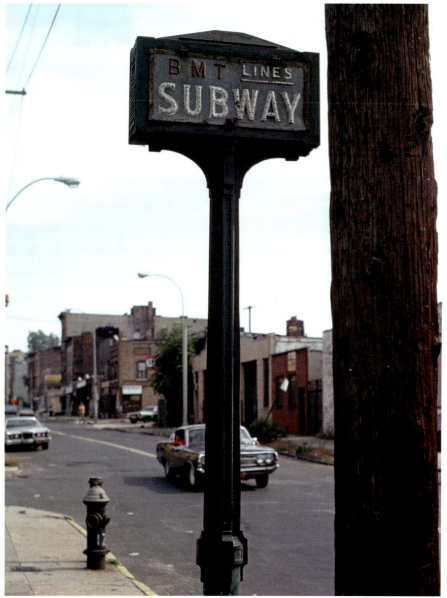

Above: BMT Seal, Stillwell Ave.–Coney Island Station, Surf Ave. entrance, Brooklyn, September 29, 1981

Right: BMT, sidewalk stanchion, Brooklyn, September 20, 1980

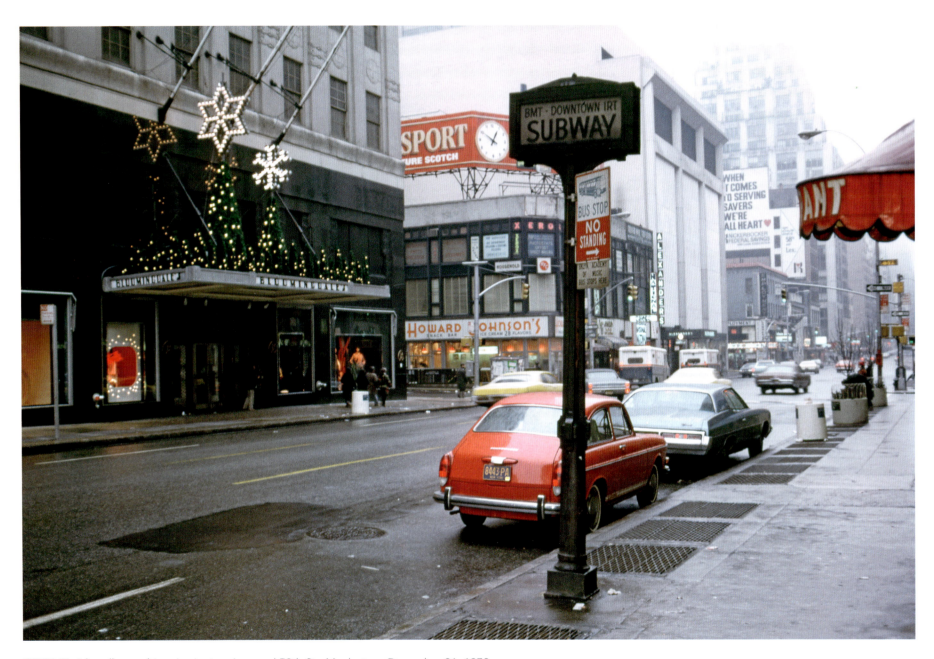

IRT/BMT, sidewalk stanchion, Lexington Ave. and 59th St., Manhattan, December 31, 1972

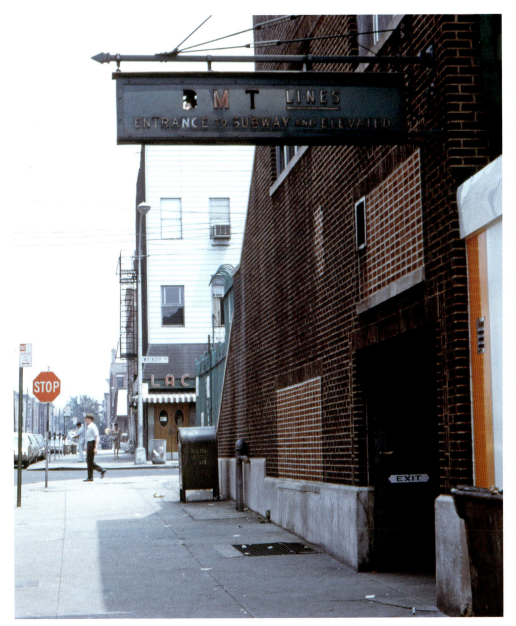
BMT, Wyckoff Ave. Station, Myrtle Ave. Elevated upstairs and Myrtle Ave. Station, 14th St. Canarsie Line downstairs, Brooklyn, July 16, 1972

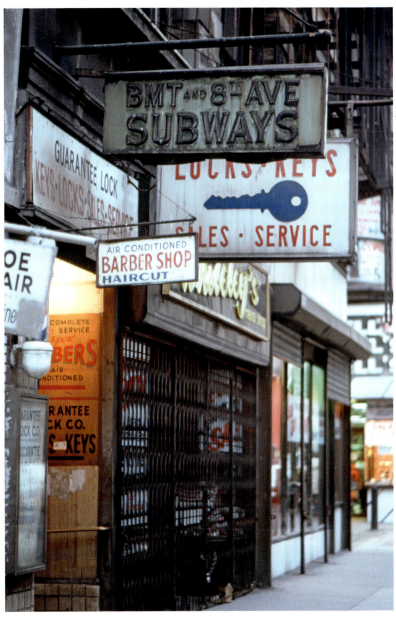
BMT, Fulton St. Station, Nassau St. Line and IND Broadway–Nassau St. Station, 8th Ave. Line, subway entrance, Nassau St., Manhattan, 1983

Chapter 2. Station Entrances | 39

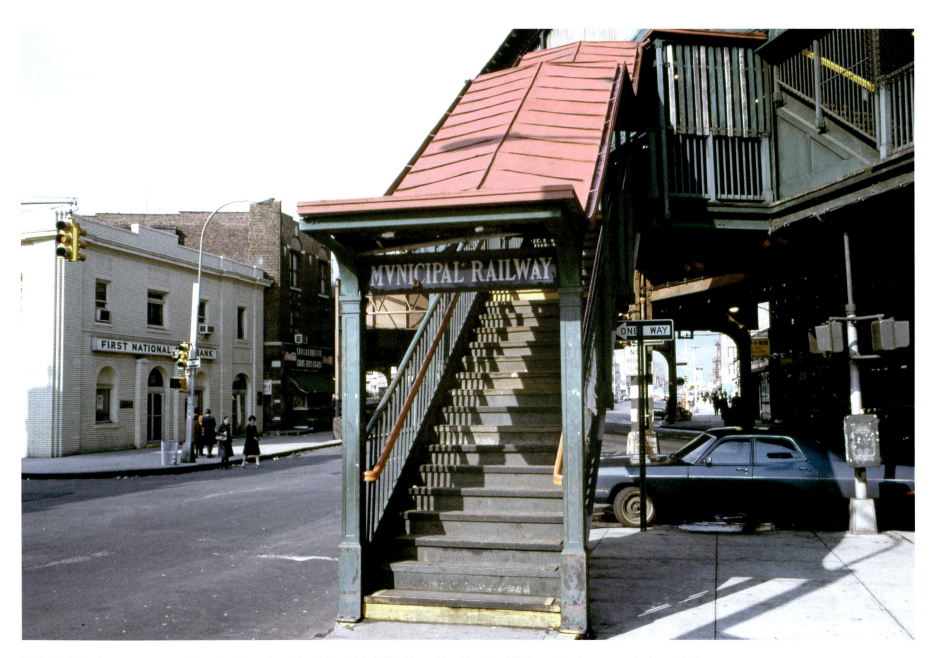

BMT, 55th St. Station entrance, West End Line, Brooklyn, March 30, 1975. Note: The Municipal Railway sign is a true relic from 1916.

BMT, Canal St. Station, Broadway Line, Broadway and Canal St., Manhattan, June 15, 1973

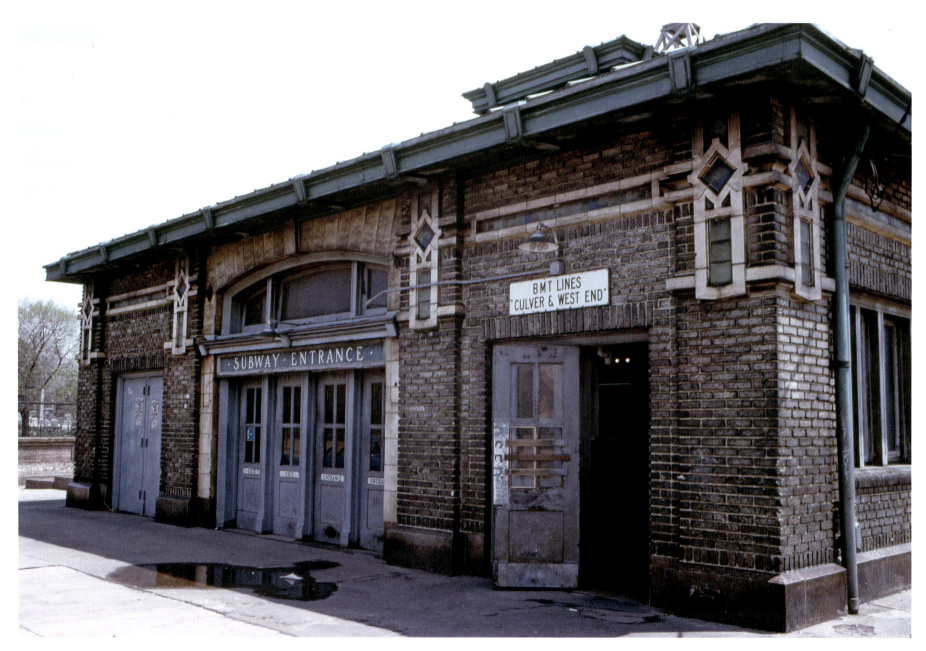

BMT, 9th Ave. Station entrance, Culver and West End Lines, Brooklyn, May 3, 1975

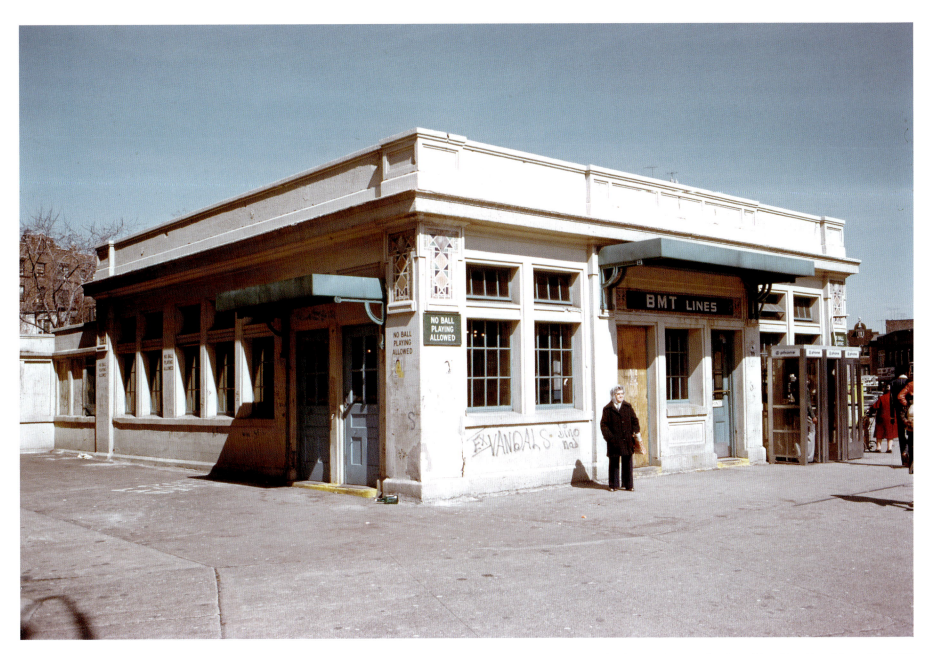

BMT, Parkside Ave. Station, Brighton Line, Brooklyn, March 23, 1975

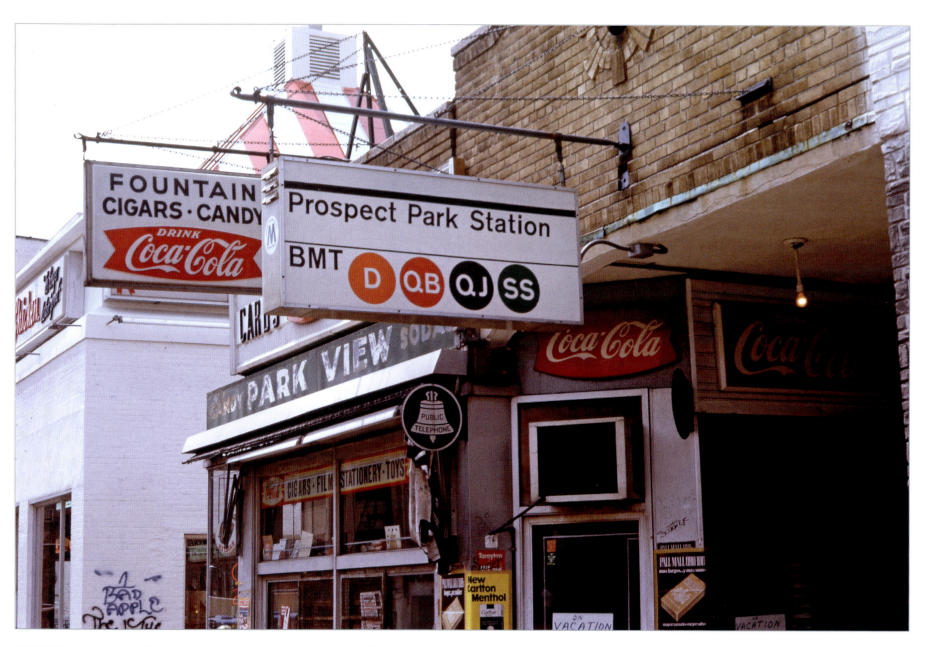

IND/BMT, Prospect Park Station, Brighton Line, Brooklyn, July 30, 1972

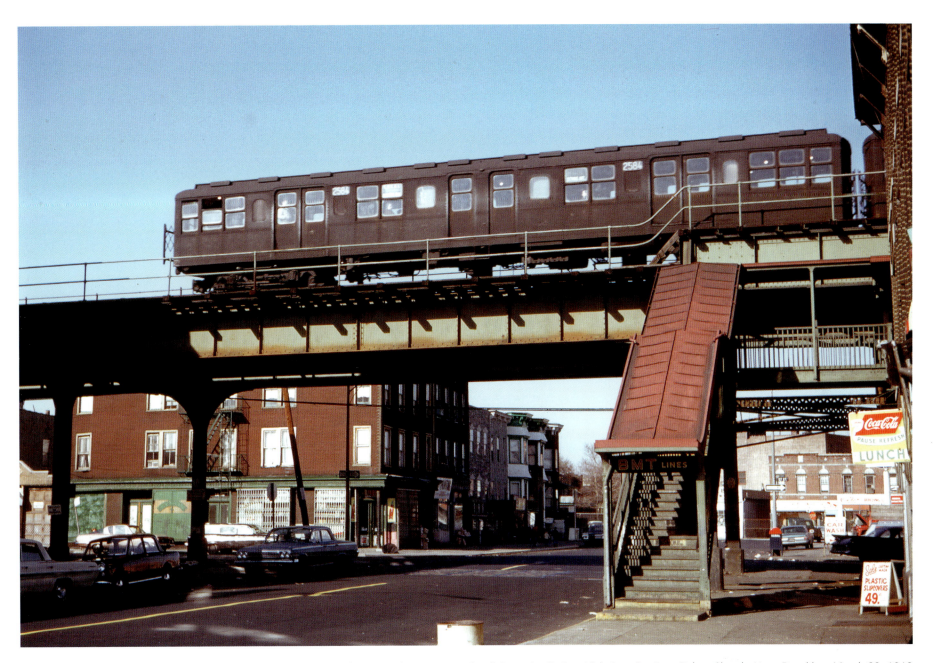

BMT, B-type subway car #2584 (built in 1919 by American Car & Foundry Co.) at 13th Ave. Station, Culver Shuttle Line, Brooklyn, March 23, 1969

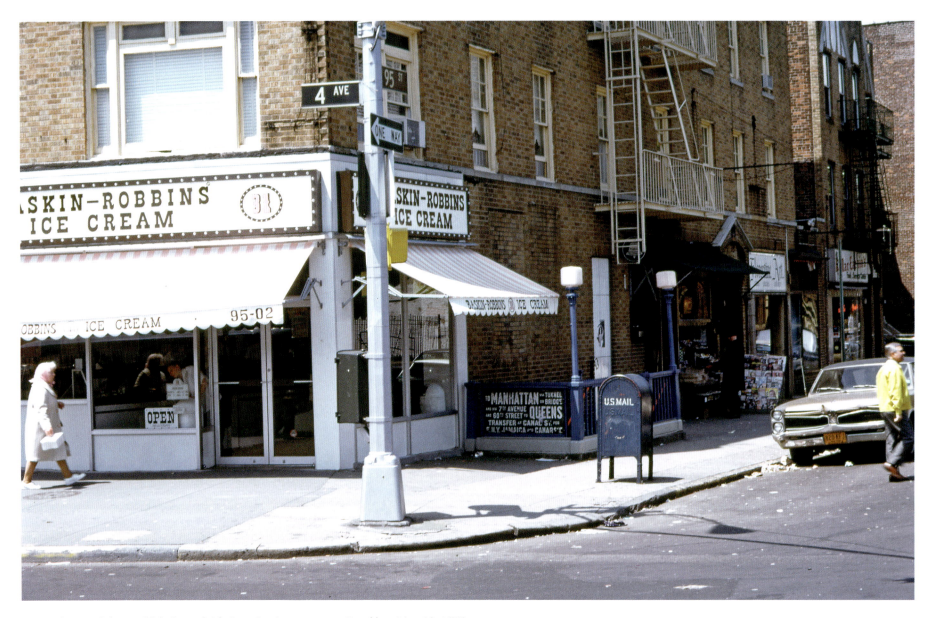

BMT, 4th Ave. Subway, 95th St. and 4th Ave. Station entrance, Brooklyn, May 12, 1972

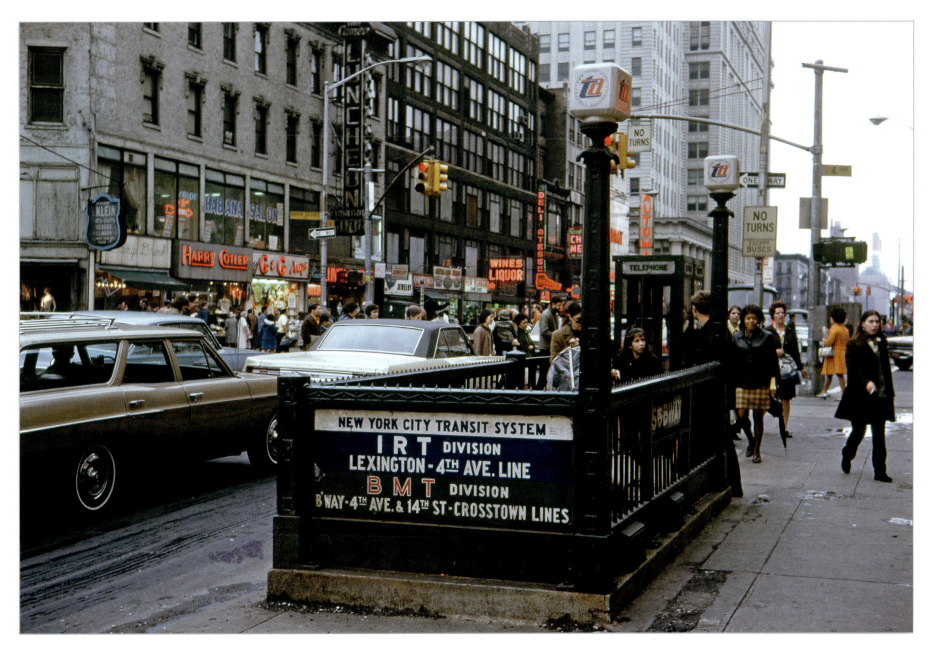

IRT/BMT, Union Square Station, 14th St. and 4th Ave., Manhattan, April 19, 1969

Chapter 2. Station Entrances | 47

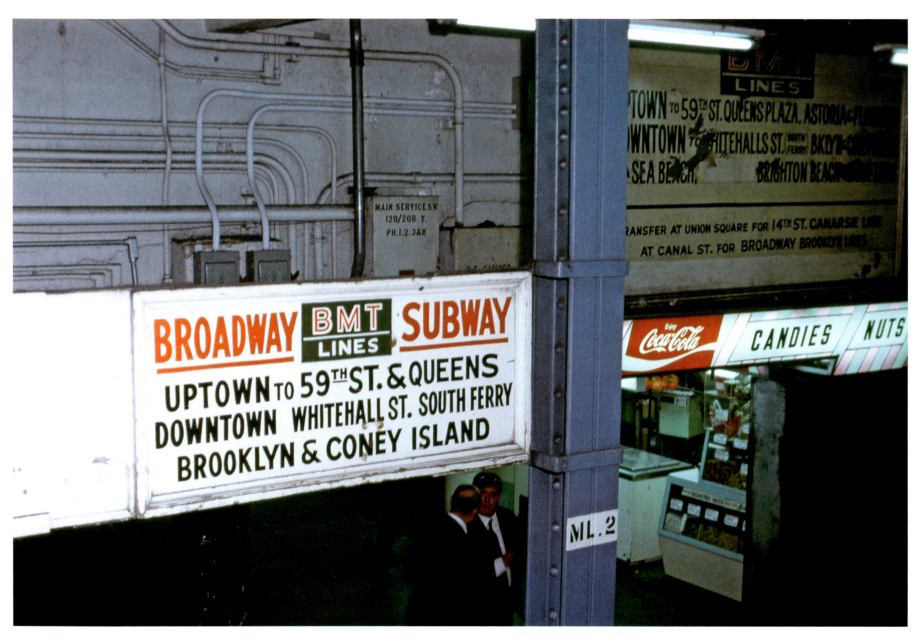

BMT, 42nd St.–Times Square Station, Manhattan, October 2, 1972

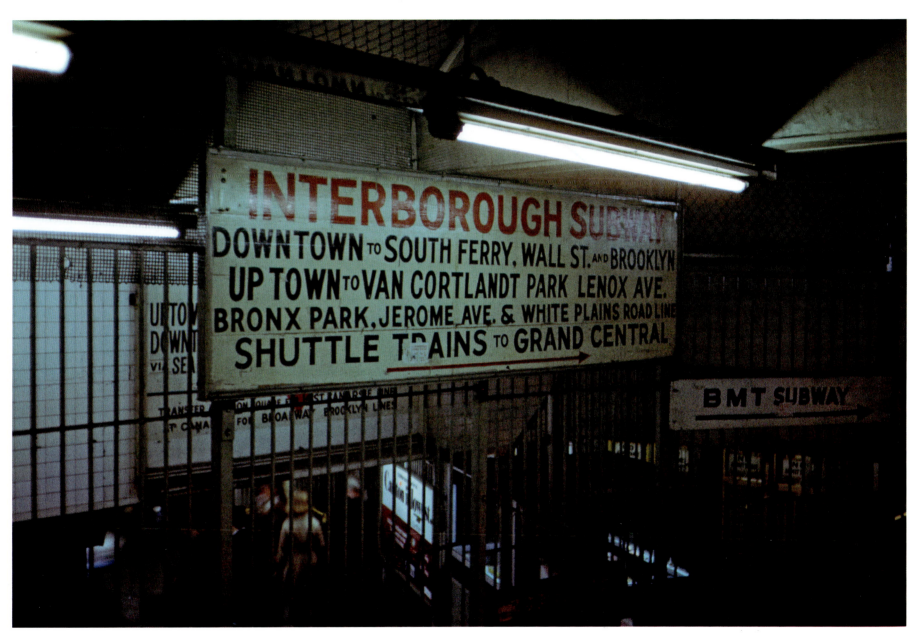

IRT/BMT, 42nd St.–Times Square Station, Manhattan, November 20, 1974

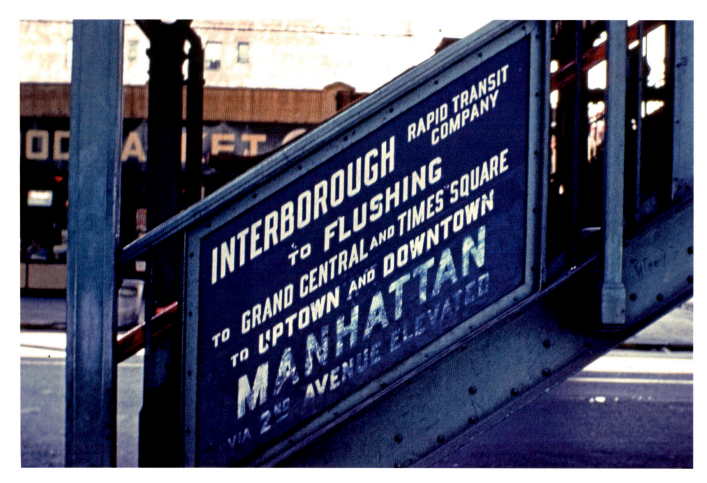

IRT, 111th St. Station, Flushing Line, Queens, 1960s

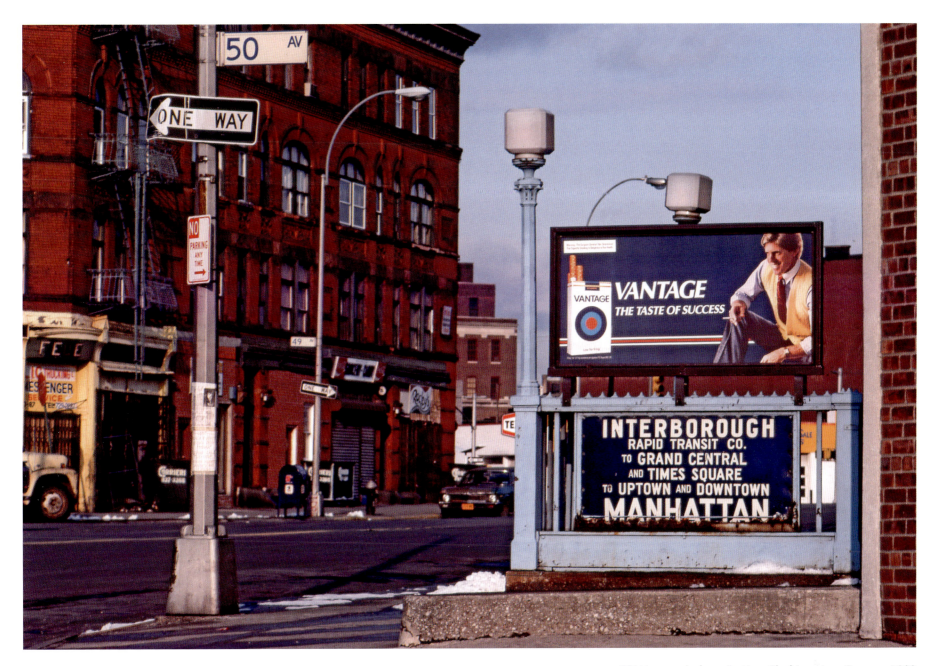

IRT, Vernon–Jackson Station, Flushing Line, Queens, 1983

Chapter 2. Station Entrances | 51

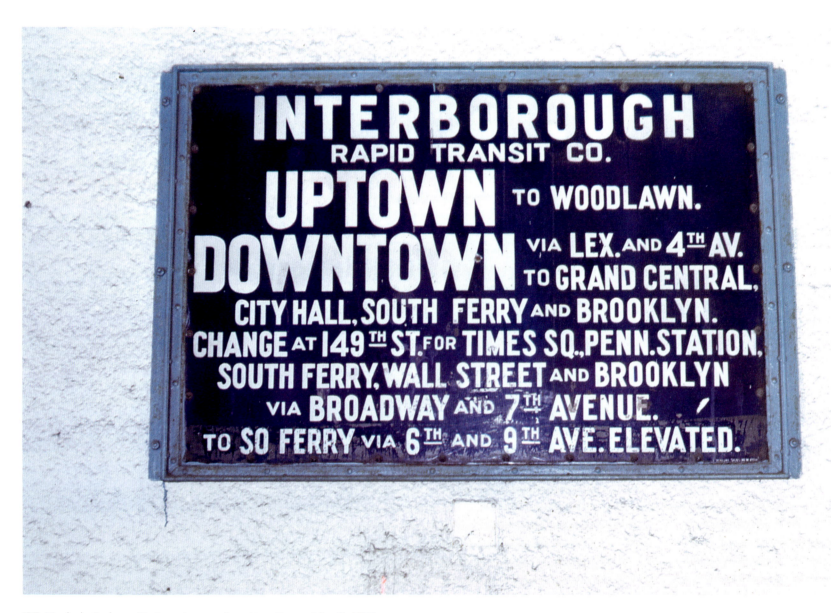

IRT, Mosholu Parkway Station, Jerome Ave. Line, Bronx, May 9, 1970

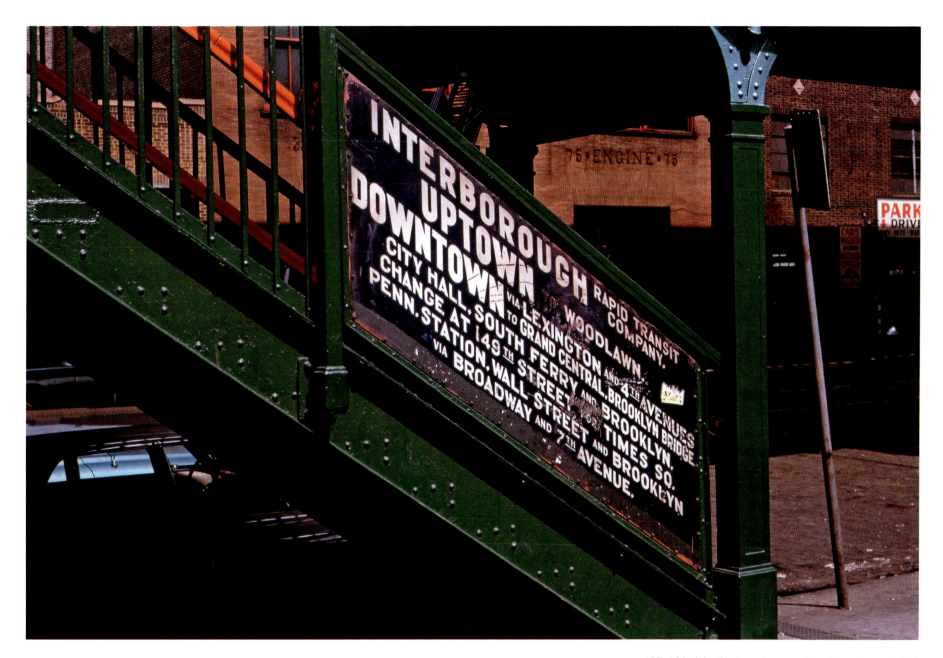

IRT, 183rd St. Station, Jerome Ave. Line, Bronx, 1963

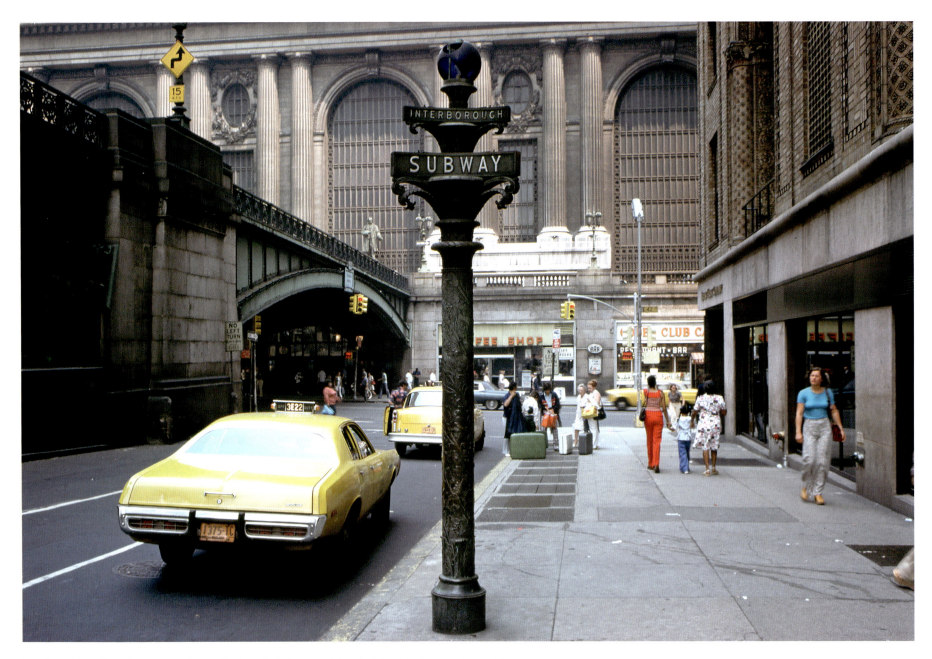

IRT Stanchion, Grand Central Subway Station, Park Ave. and E. 42nd St., Manhattan, August 23, 1974

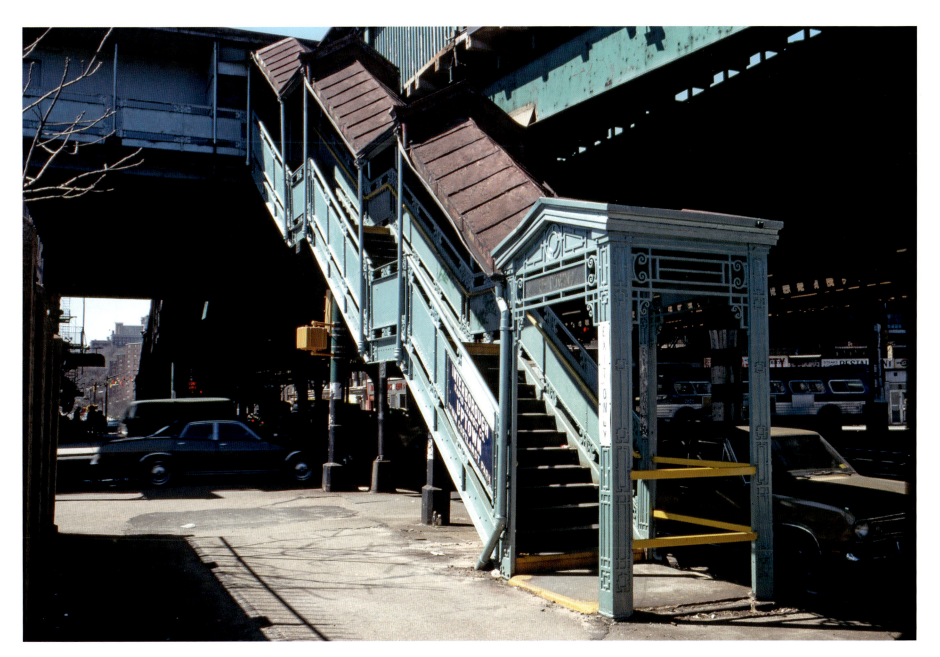

IRT, 207th St. Station, Broadway Line, Manhattan, April 10, 1976

Chapter 2. Station Entrances | 55

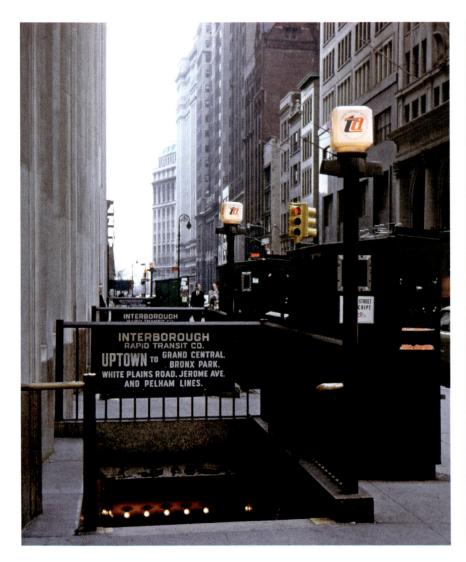

IRT, Wall St. Station, Lexington Ave. Line, Broadway and Wall St., Manhattan, April 19, 1969

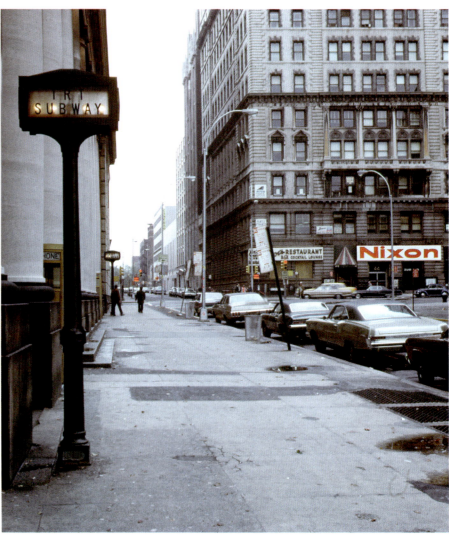

IRT Stanchion, Borough Hall Station, Lexington Ave. Line, Brooklyn, October 29, 1972

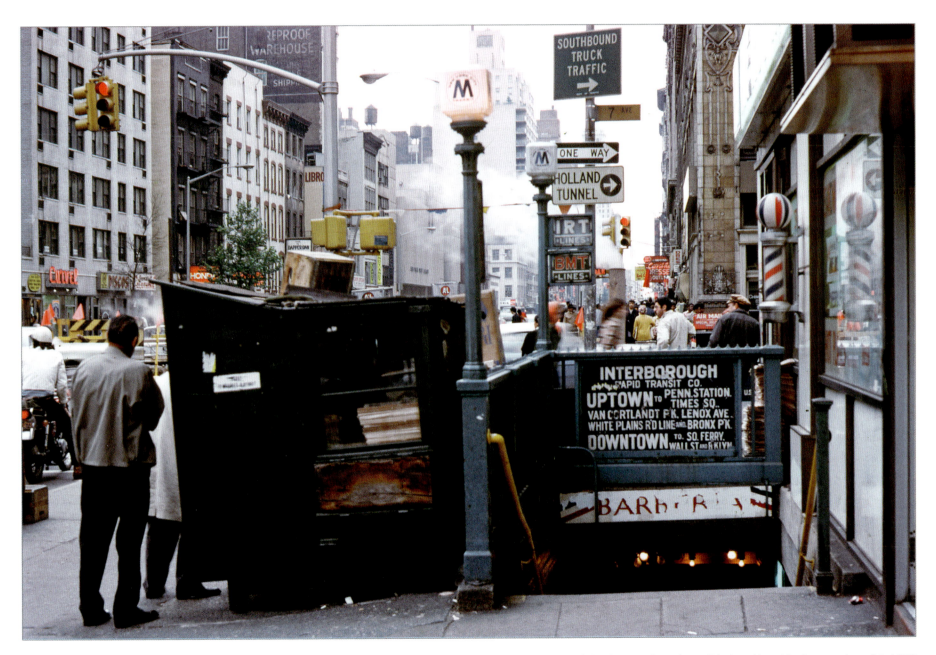

IRT, 14th St. Station, Broadway–7th Ave. Line, Manhattan, June 24, 1972

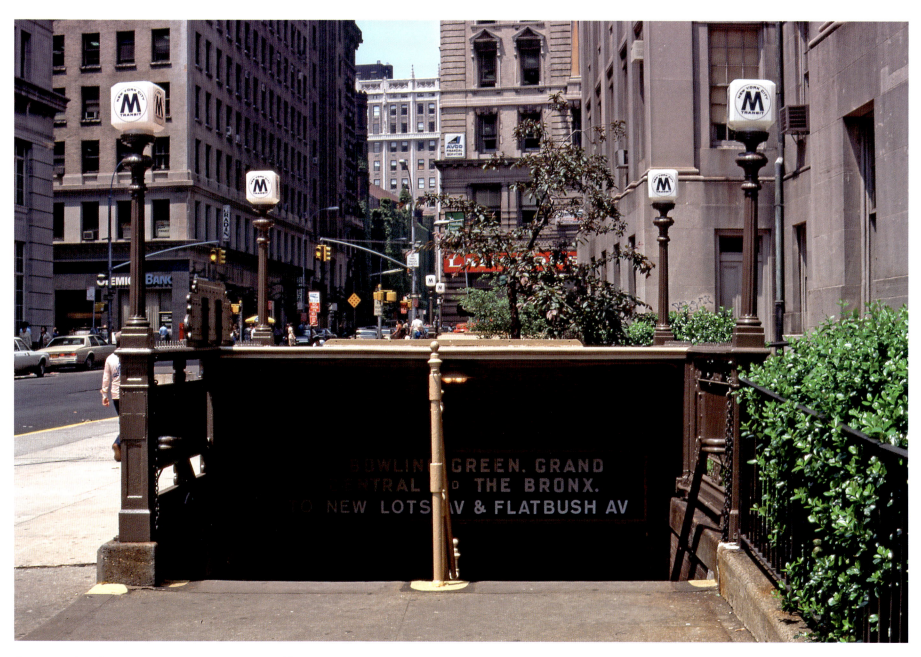

IRT, Borough Hall Station, Lexington Ave. Line, Brooklyn, 1979

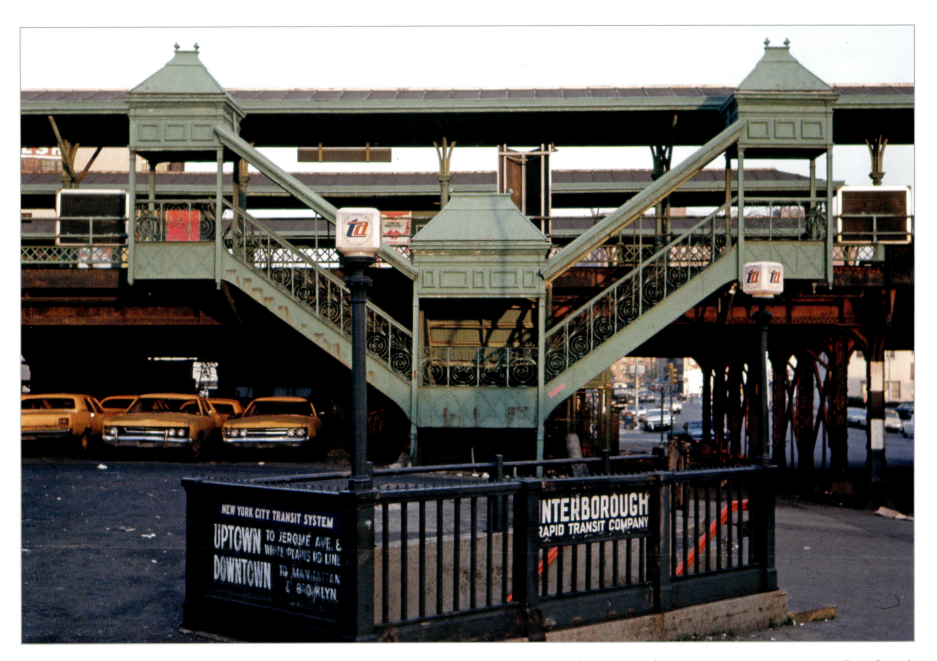

IRT, 138th St.–Grand Concourse subway entrance, Lexington Ave. Line. Penn Central, former New York Central Railroad 138th St. entrance in background, Bronx, 1970.

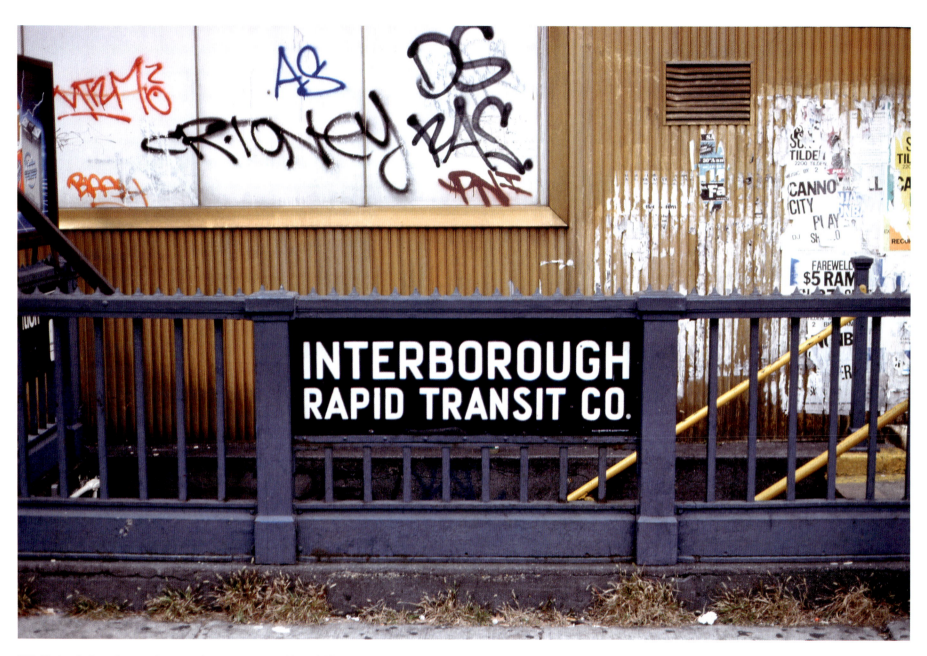

IRT, Flatbush Ave. Station, Nostrand Ave. Line, Brooklyn, 1988

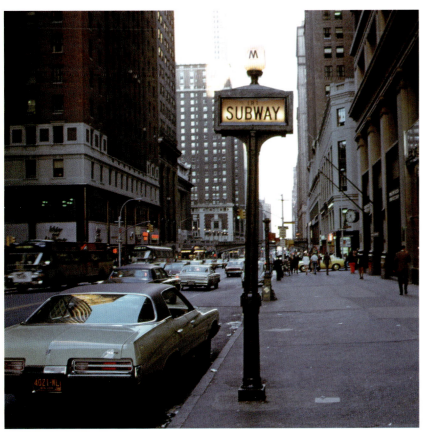

IRT stanchion, Grand Central Subway Station, Manhattan, August 9, 1972

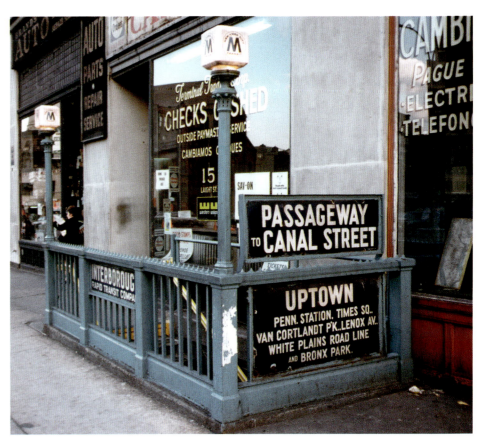

IRT, Canal St. Station, Laight and Varick Sts., Broadway–7th Ave. Line, Manhattan, April 13, 1973

Chapter 2. Station Entrances | 61

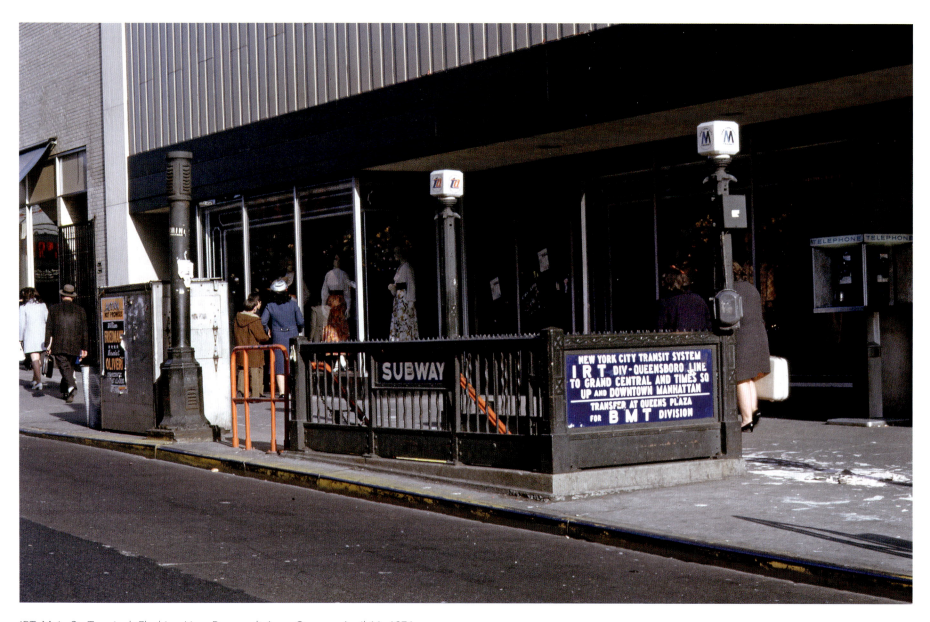

IRT, Main St. Terminal, Flushing Line, Roosevelt Ave., Queens, April 11, 1971

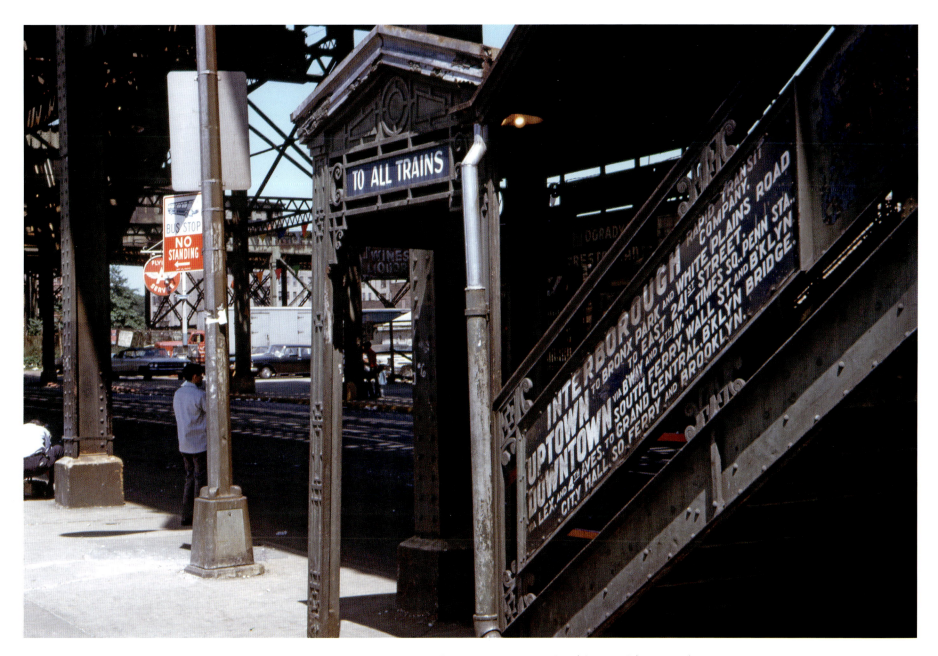

IRT, East Tremont Ave.–Boston Road Station, 7th Ave. and Lexington Ave. Lines, Bronx, June 22, 1969

Chapter 2. Station Entrances | 63

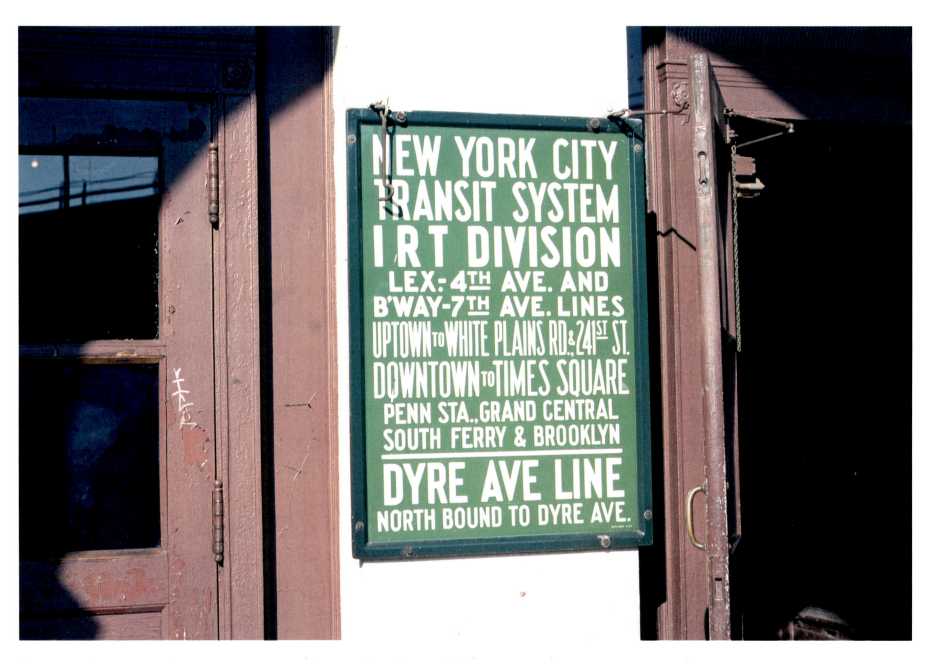

IRT, East 180th St. Station, 7th Ave., Lexington Ave. and Dyre Ave. Lines, Bronx, 1987. The green porcelain signs were unique to the Dyre Ave. Line, part of what was formerly the New York, Westchester & Boston Railway (NYW&B), discontinued on December 31, 1937.

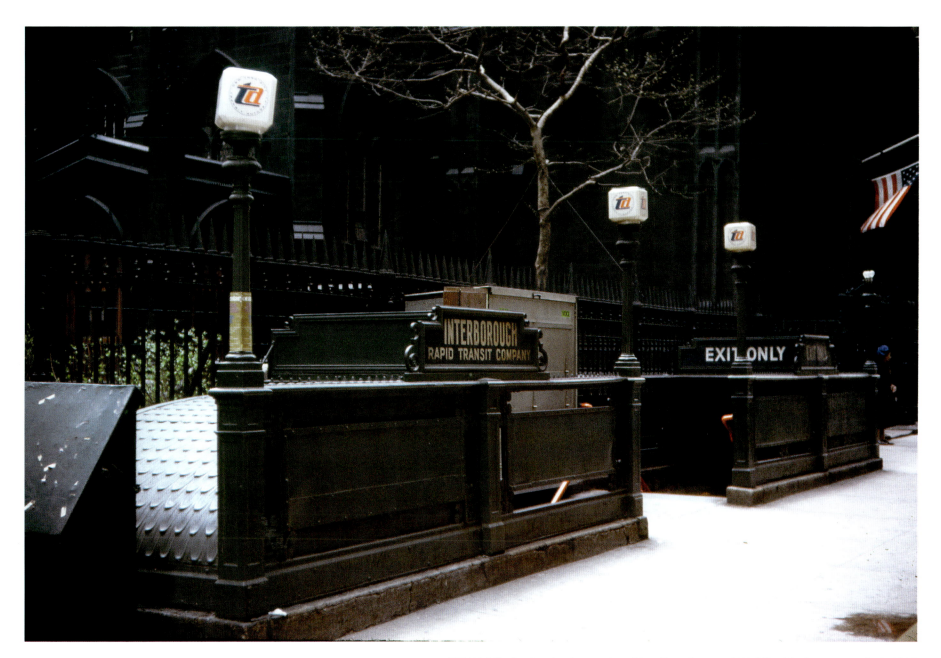

IRT, Wall St. Station, Lexington Ave. Line, Broadway and Wall St., Manhattan, April 19, 1969

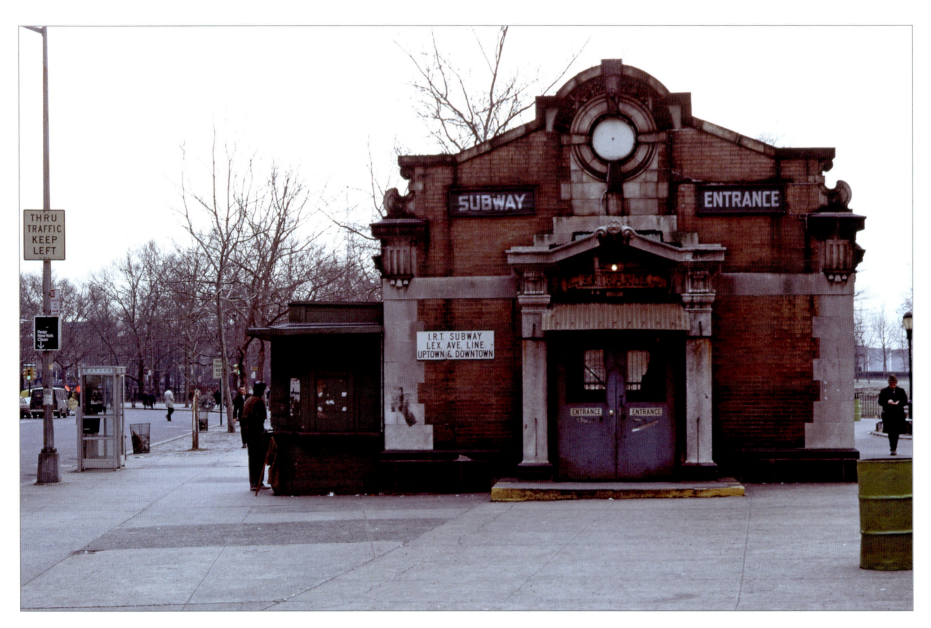

IRT, Bowling Green Station, Lexington Ave. Line, Manhattan, March 10, 1972

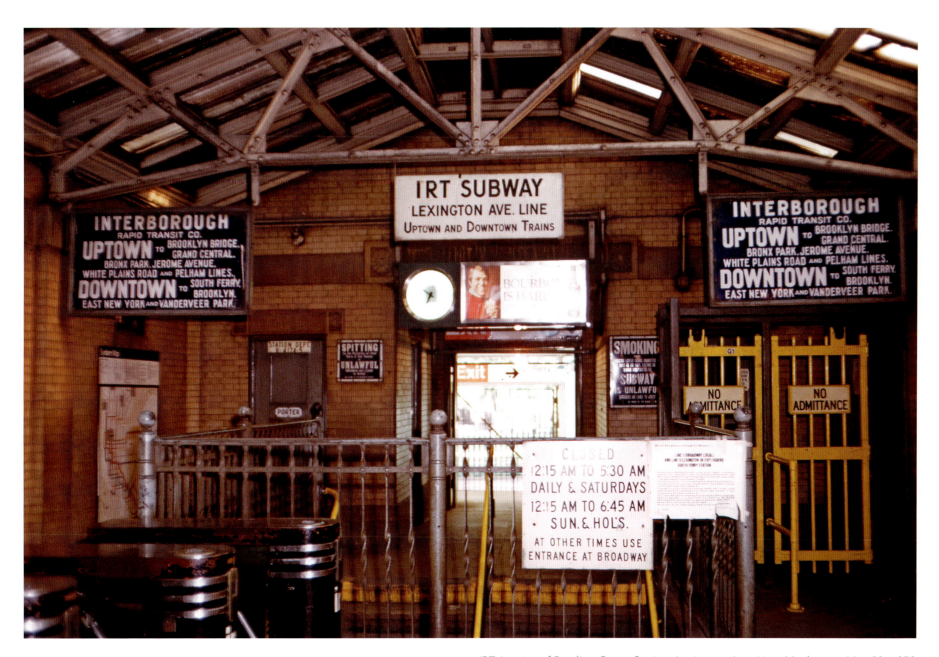

IRT, Interior of Bowling Green Station, Lexington Ave. Line, Manhattan, May 22, 1973

Chapter 2. Station Entrances | 67

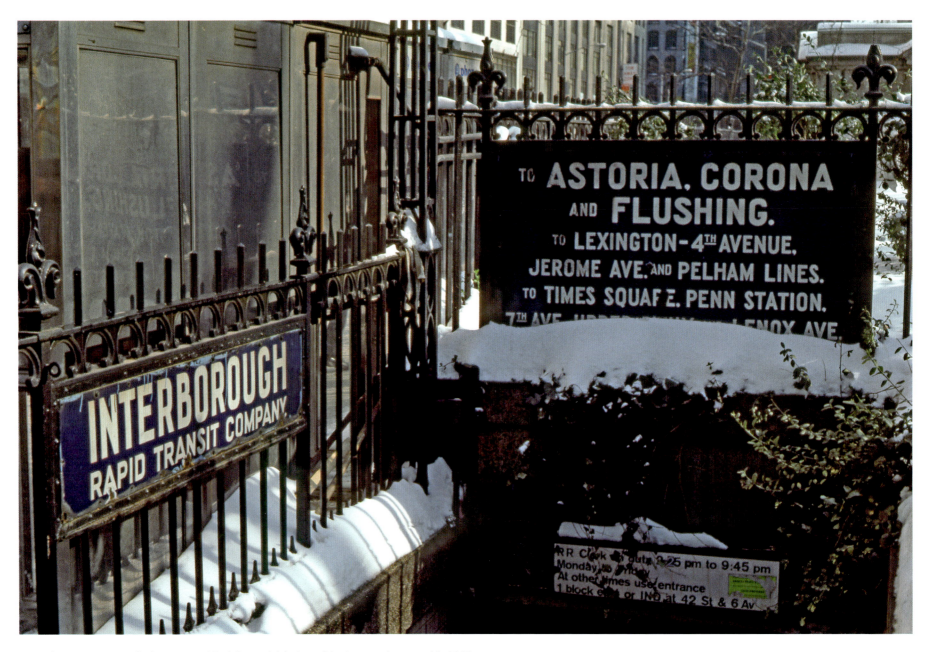

IRT, 5th Ave. Station, Flushing Line, 42nd St. and 6th Ave., Manhattan, January 15, 1982

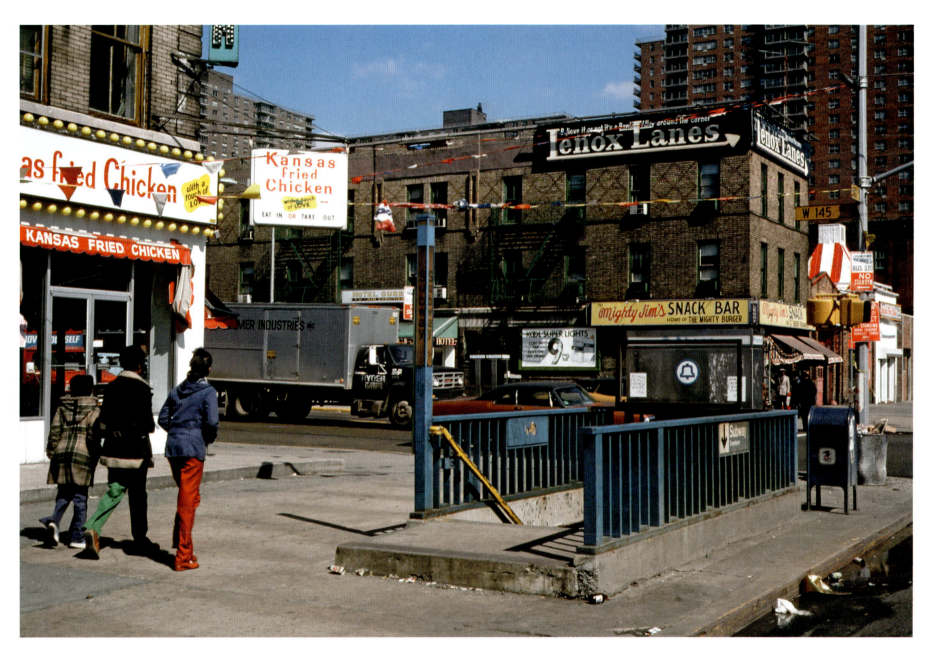

IRT, 145th St.–Lenox Ave. Station, 7th Ave. Line, Manhattan, March 30, 1978

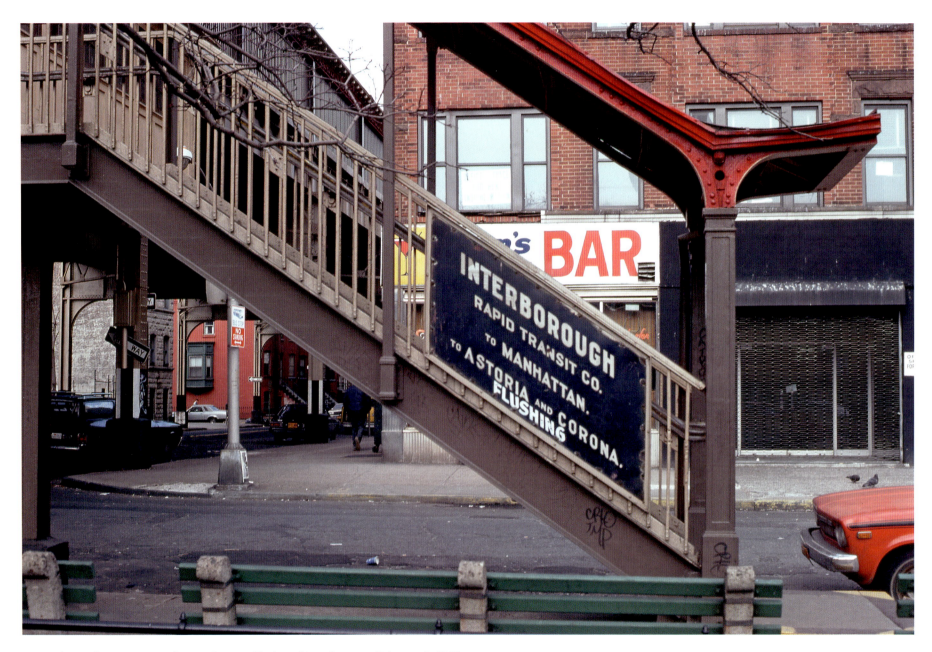

IRT, 45th Road–Court House Square Station, Flushing Line, Queens, February 8, 1982

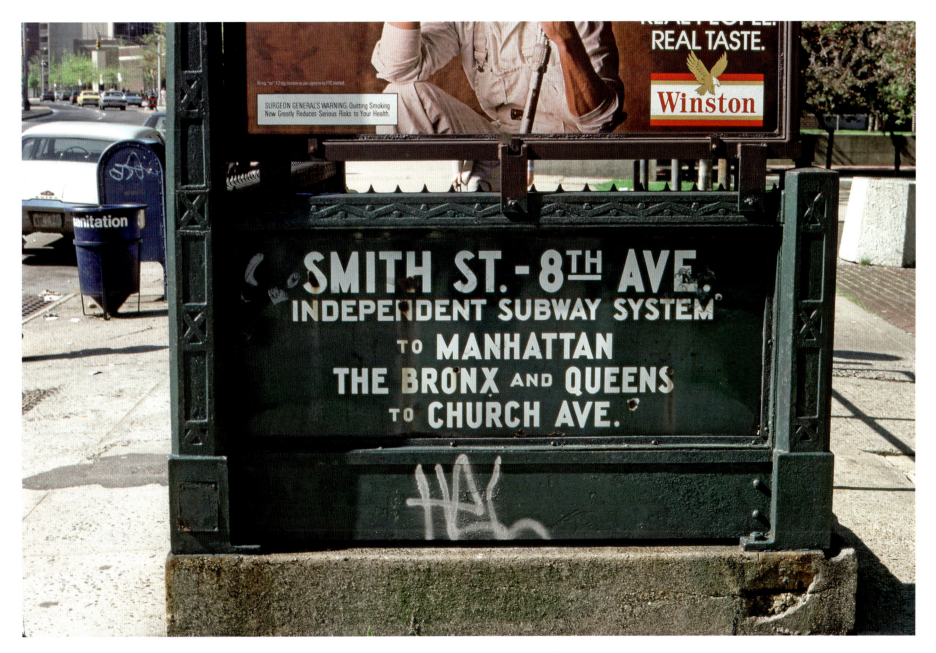

IND, High St. Station, Smith St.–8th Ave. Line, Brooklyn, May 12, 1988

IND, 47th–50th Sts.–Rockefeller Center Subway Station, 6th Ave. Line, Manhattan, September 3, 1973

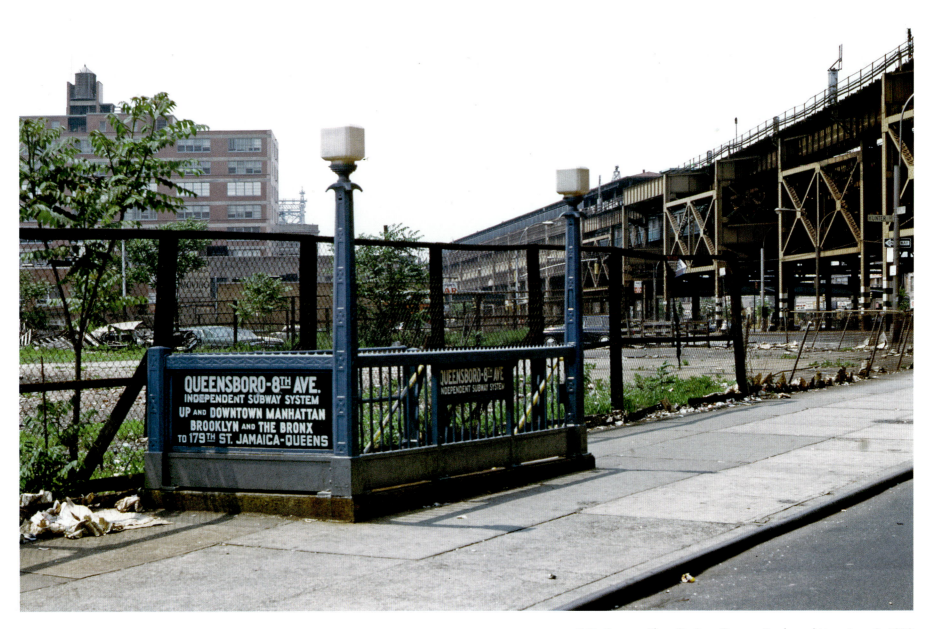

IND, Queens Plaza Station, Queens Boulevard Line, June 3, 1972

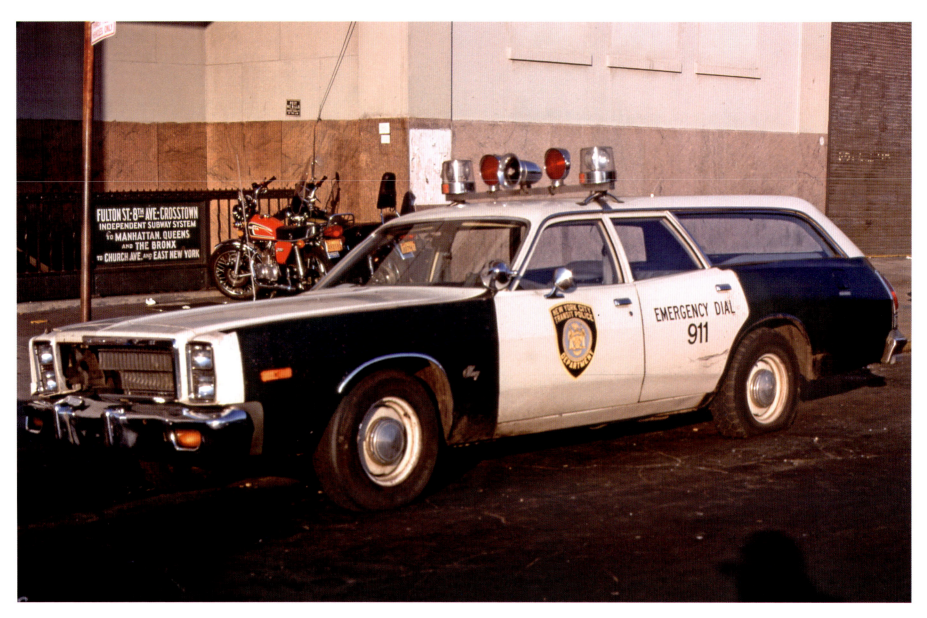

IND, Hoyt-Schermerhorn Station, Fulton St.–8th Ave.–Crosstown Lines, and New York City Transit Police Station Wagon, Brooklyn, 1979

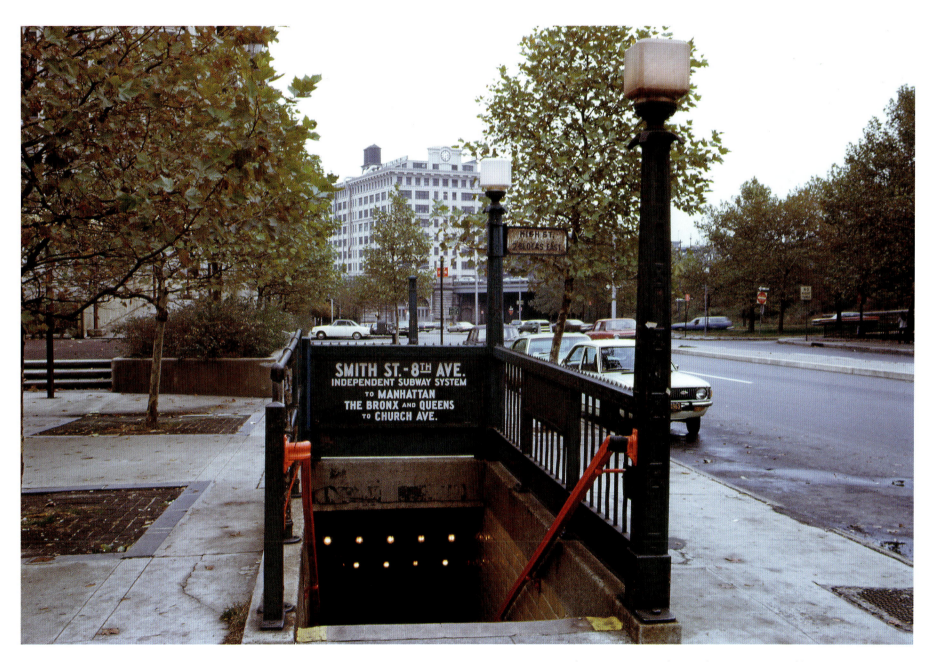

IND, High St. Station, Smith St.–8th Ave. Line, Brooklyn, October 29, 1972

Chapter 2. Station Entrances | 75

IND, High St. Station, Cadman Plaza West, Brooklyn, May 12, 1988

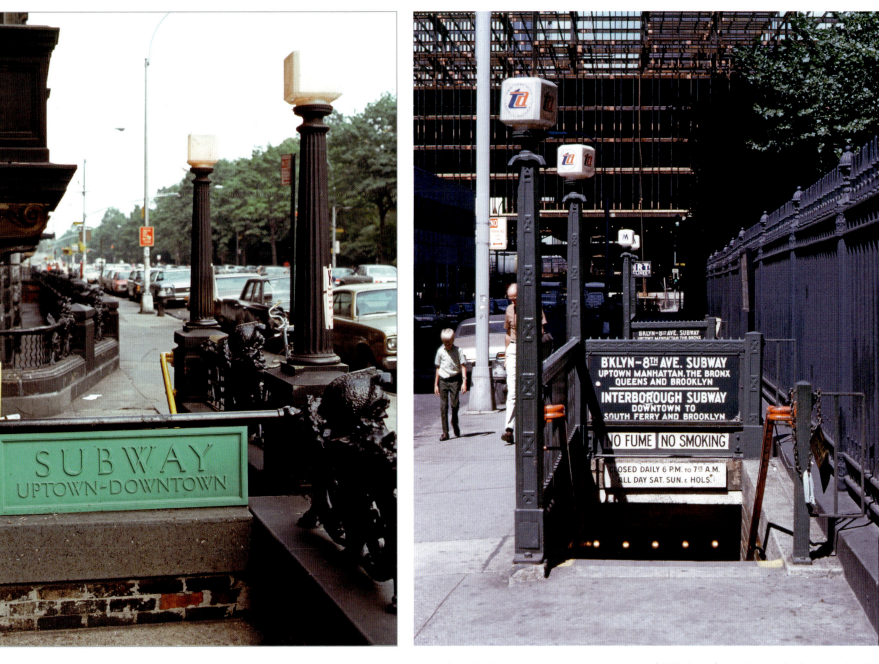

IND, 72nd St. Station, Central Park West and 72nd St., Manhattan, 1981. Note: This is also the location of the Dakota apartment building where John Lennon lived and was murdered outside the building in 1980.

IRT, Fulton St. Station, Lexington Ave. Line, and IND Broadway–Nassau St. Station, Ann St. near Broadway, Manhattan, August 29, 1970

Chapter 2. Station Entrances

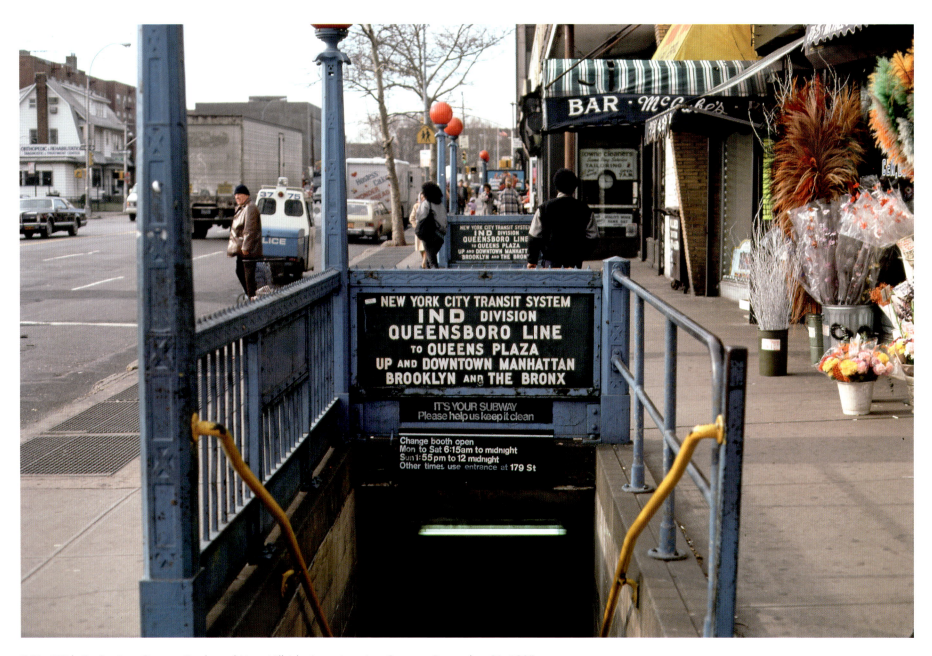

IND, 179th St. Station, Queens Boulevard Line, Hillside Ave., Jamaica, Queens, December 31, 1985

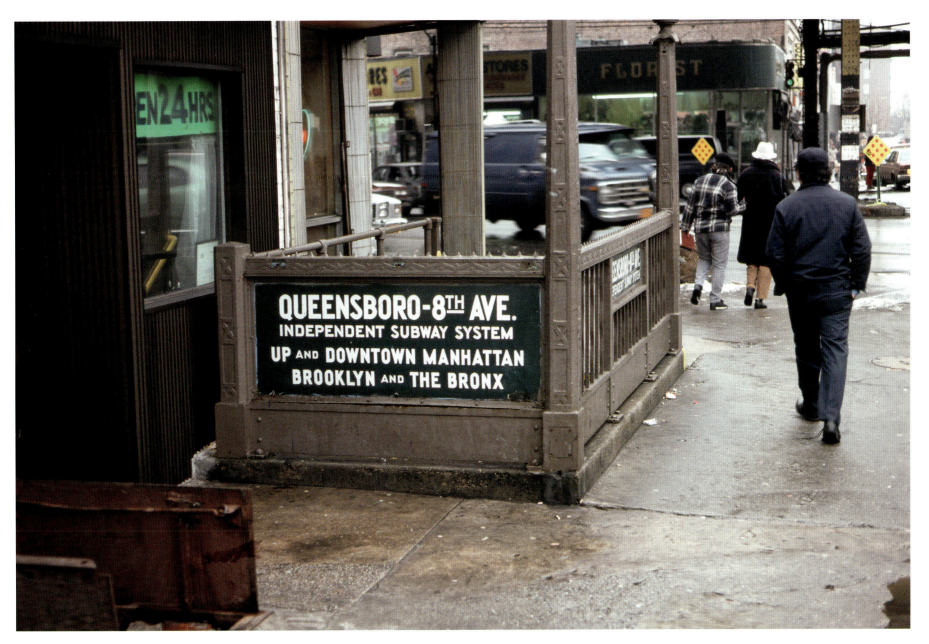

IND, Roosevelt Ave.–Jackson Heights Station, Queens Boulevard Line, February 25, 1986

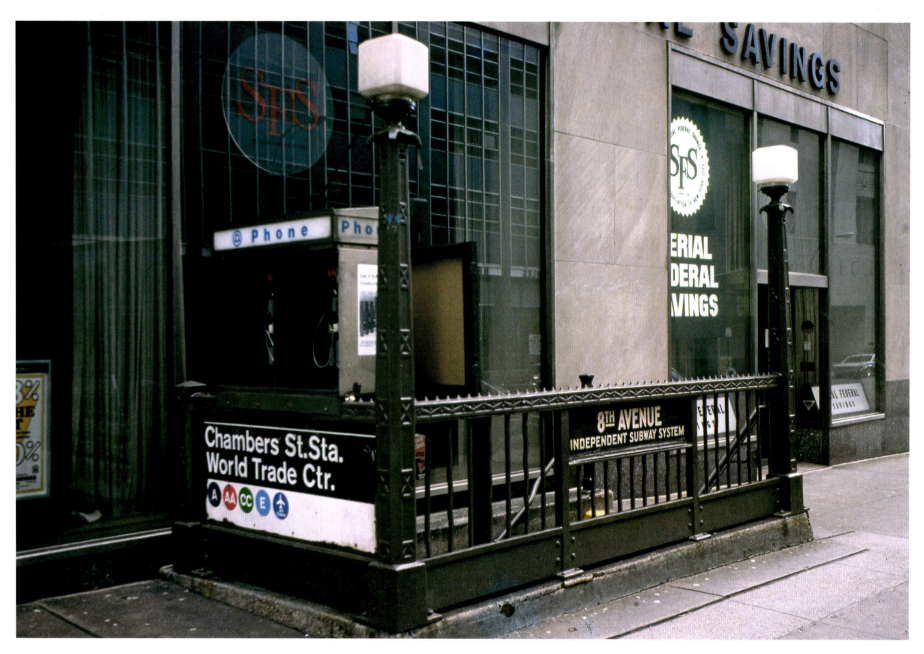

IND, Chambers St.–World Trade Center Station, Church St. and Park Place, Manhattan, January 1, 1980

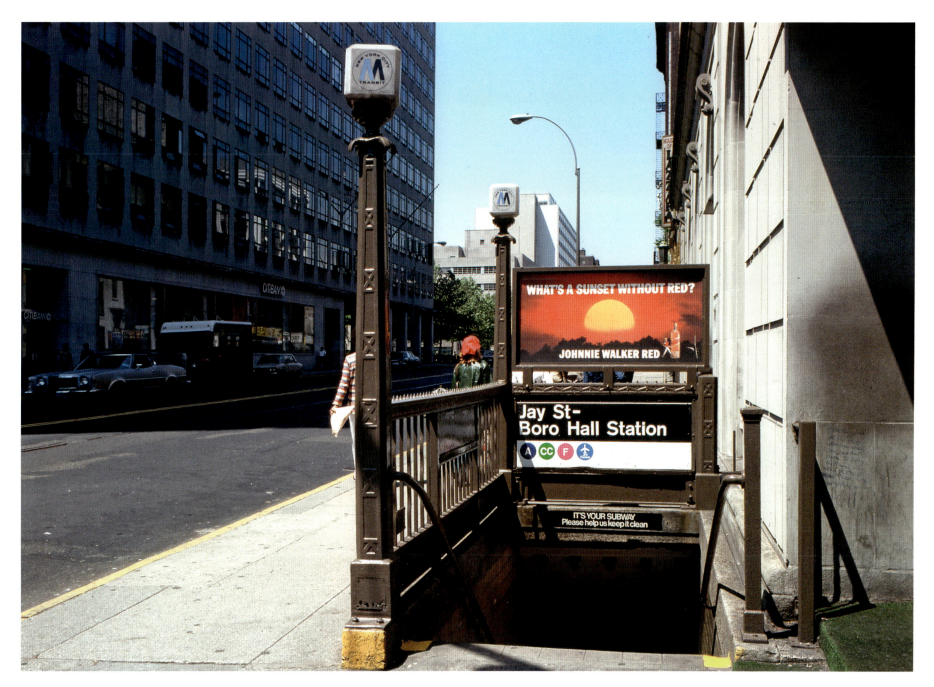

IND, Jay St.–Boro Hall Station, 6th and 8th Ave. Lines, Brooklyn, May 26, 1979

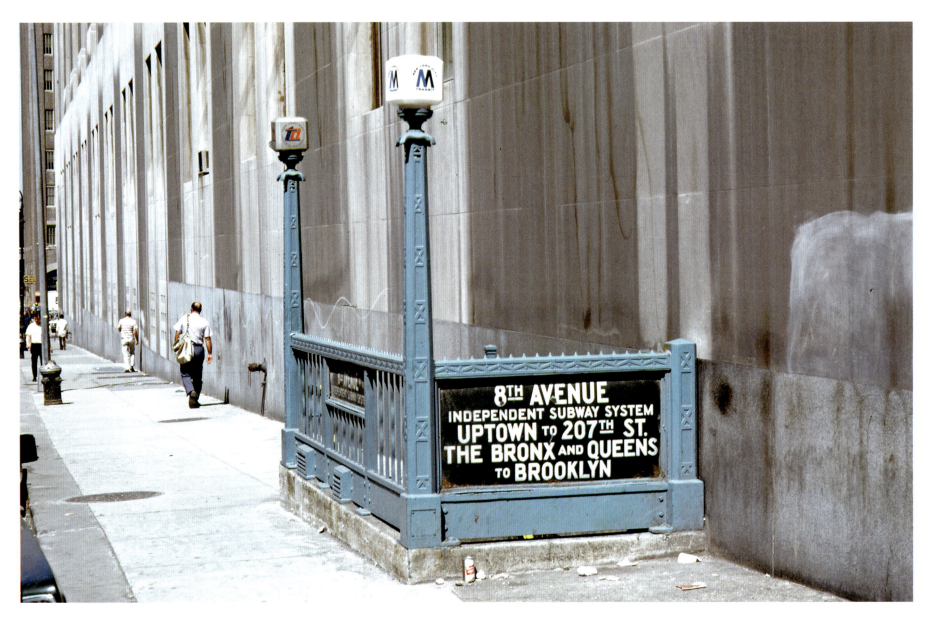

IND, Chambers St.–Hudson Terminal Station, 8th Ave. Line, Ann St., Manhattan, August 29, 1970

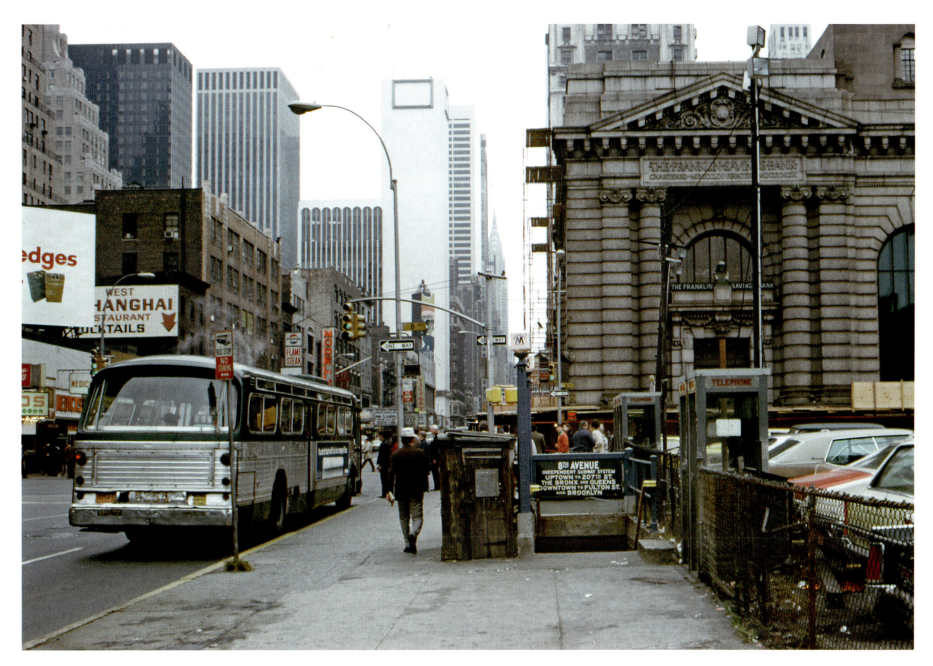

IND, 42nd St. Station, 8th Ave. Line, W. 42nd St. and 8th Ave., Manhattan, October 12, 1974

Chapter 2. Station Entrances | 83

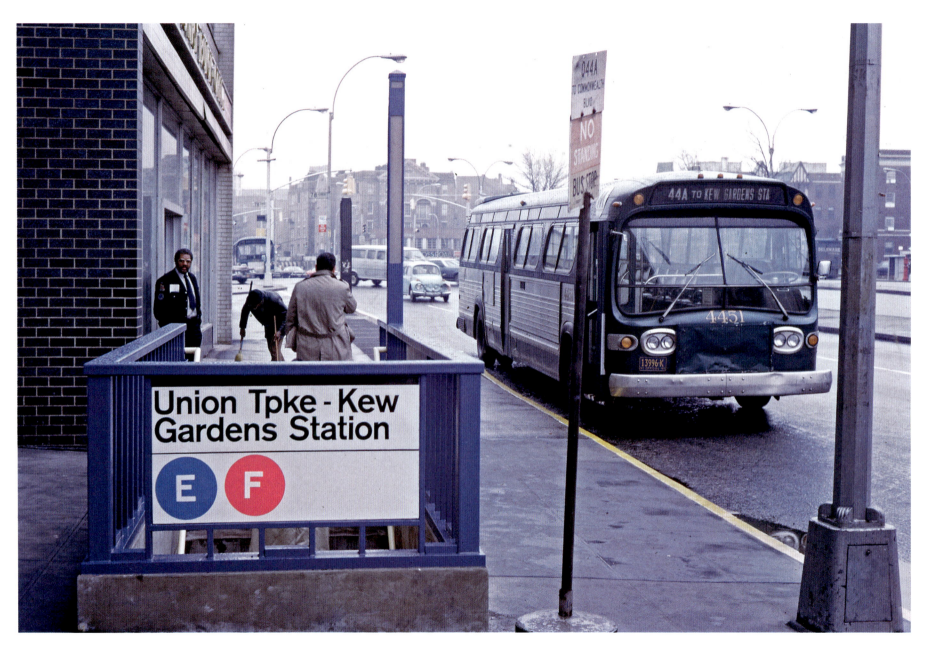

IND, Union Turnpike–Kew Gardens Station, Queens Boulevard Line, 1973

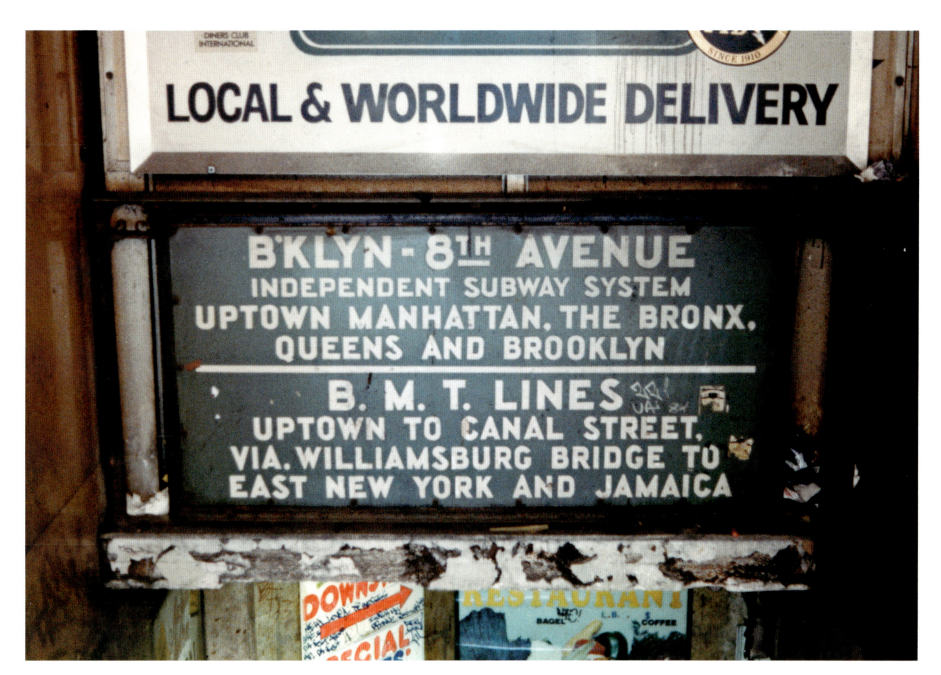

IND, Broadway–Nassau St. Station, 8th Ave. Line, and BMT Fulton St. Station, Nassau St. Line, Manhattan, 1988

Chapter 2. Station Entrances | 85

CHAPTER 3.
STATION SIGNS

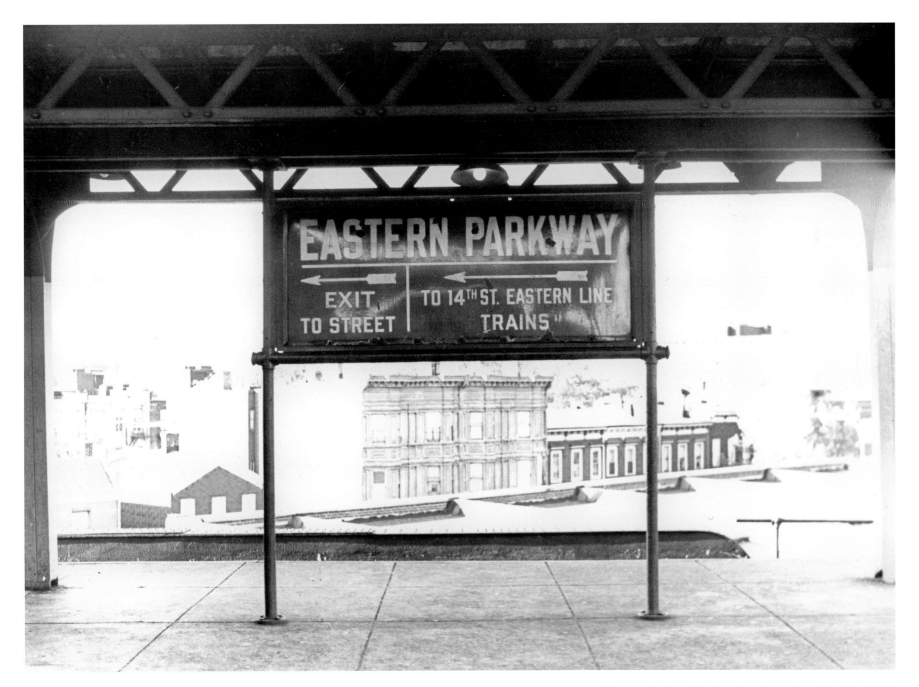

BMT, Eastern Parkway Station, Broadway–Brooklyn Line, 1970

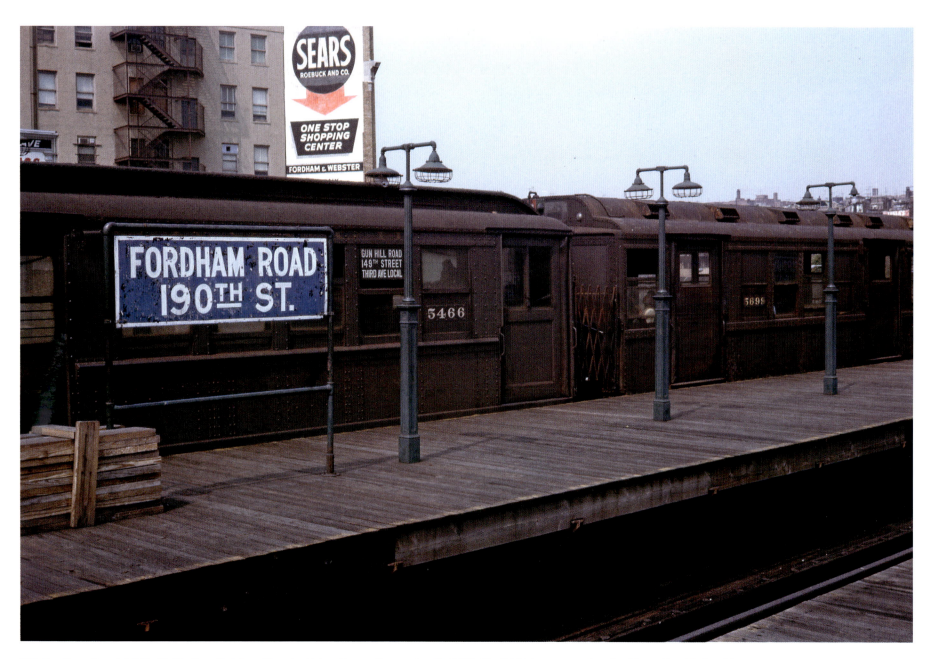

IRT, Fordham Road–190th St. Station, 3rd Ave. Elevated Line, Bronx, September 7, 1969. Car 5466 is preserved at the Shore Line Trolley Museum, Branford, Connecticut.

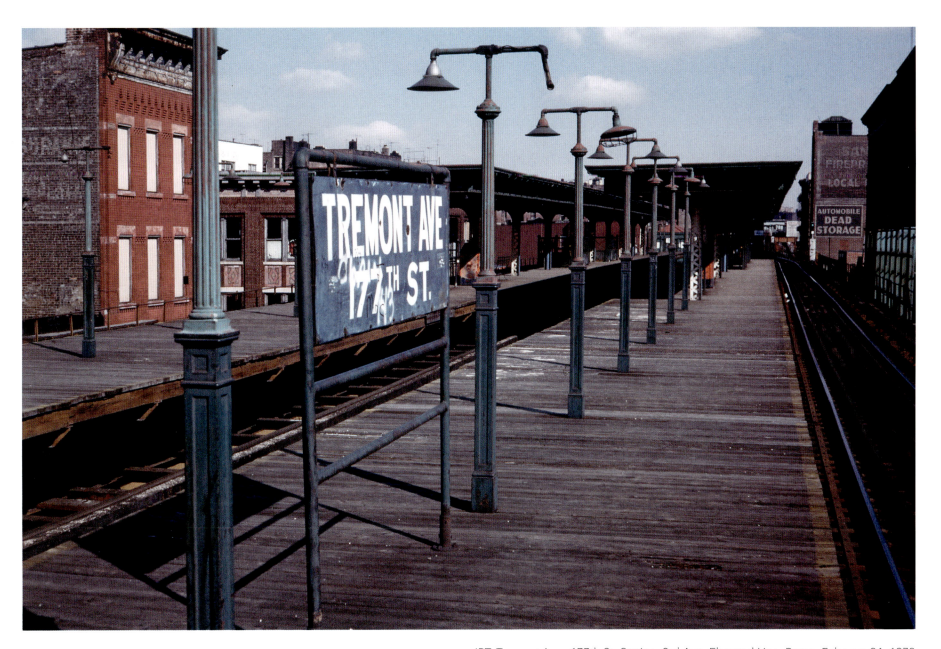

IRT, Tremont Ave.–177th St. Station, 3rd Ave. Elevated Line, Bronx, February 24, 1973

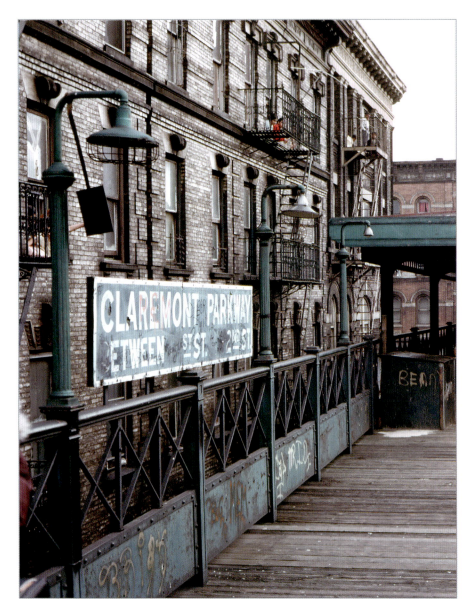

IRT, Claremont Parkway Station, 3rd Ave. Elevated Line, Bronx, April 29, 1973

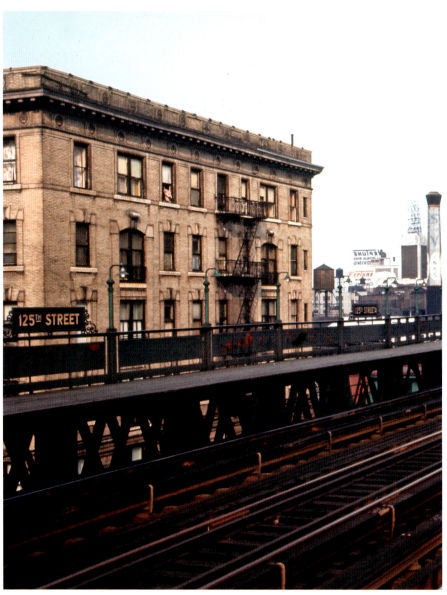

IRT, 125th St. Station, Broadway Line, Manhattan, 1968

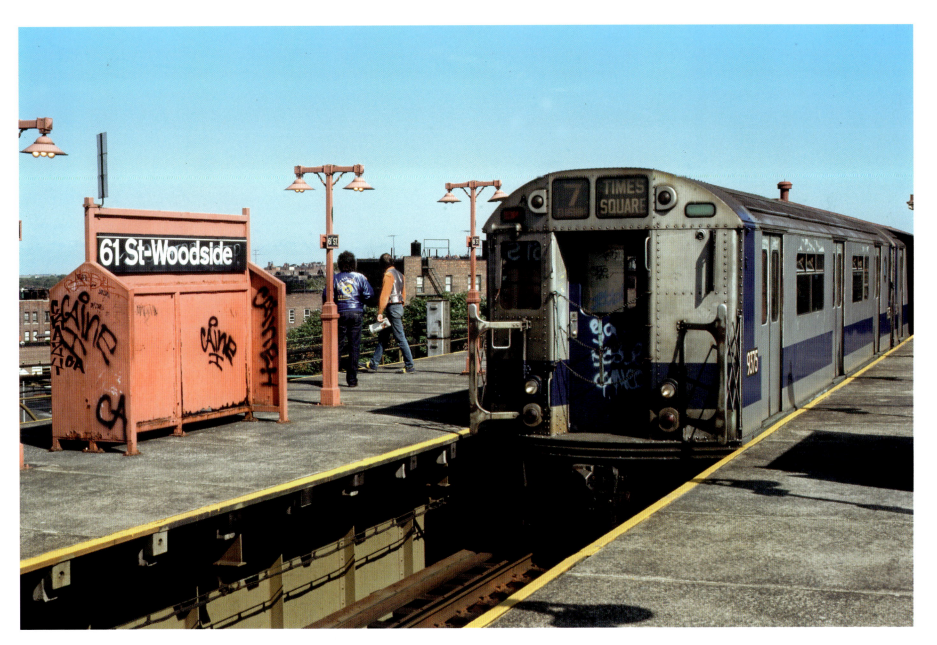

IRT, R-36 #9375 at 61st St.–Woodside Station, Flushing Line, Queens, October 4, 1981

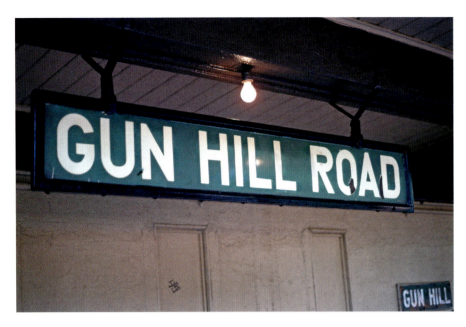

IRT, Gun Hill Road Station, Dyre Ave. Line, Bronx, August 5, 1979

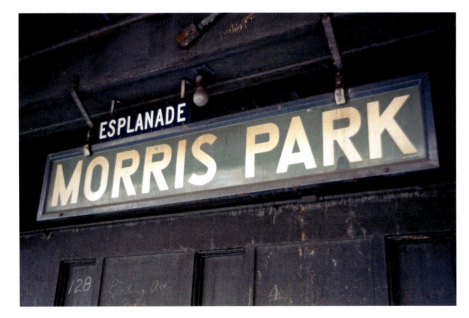

IRT, Morris Park–Esplanade Station, Dyre Ave. Line, Bronx, April 1970

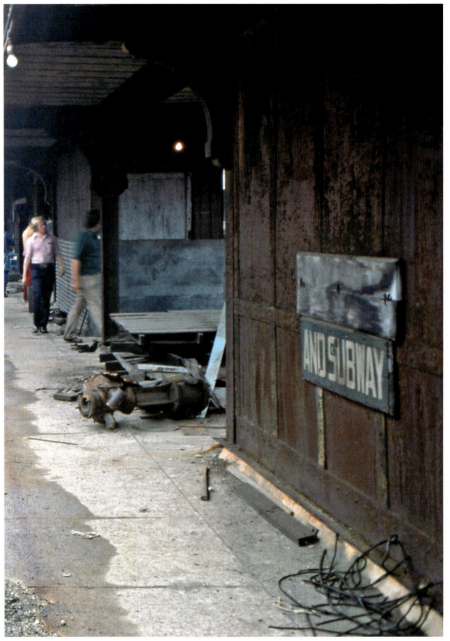

IRT, E. 180th St., former Dyre Ave. Shuttle platform, Bronx, August 24, 1975

92 | Vintage New York City Subway Signs | 1920s–1980s

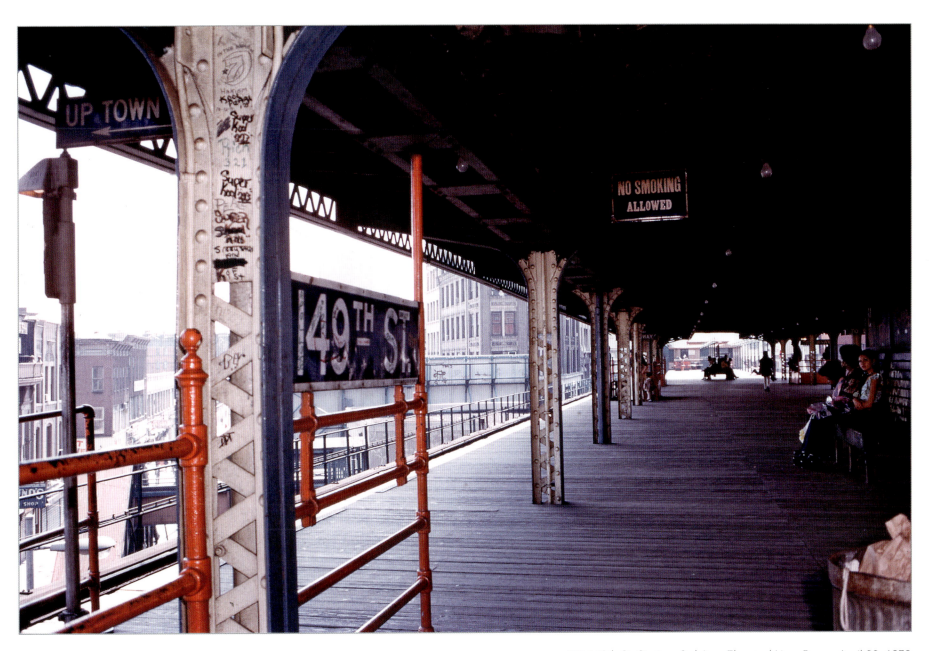

IRT, 149th St. Station, 3rd Ave. Elevated Line, Bronx, April 22, 1973

Chapter 3. Station Signs | 93

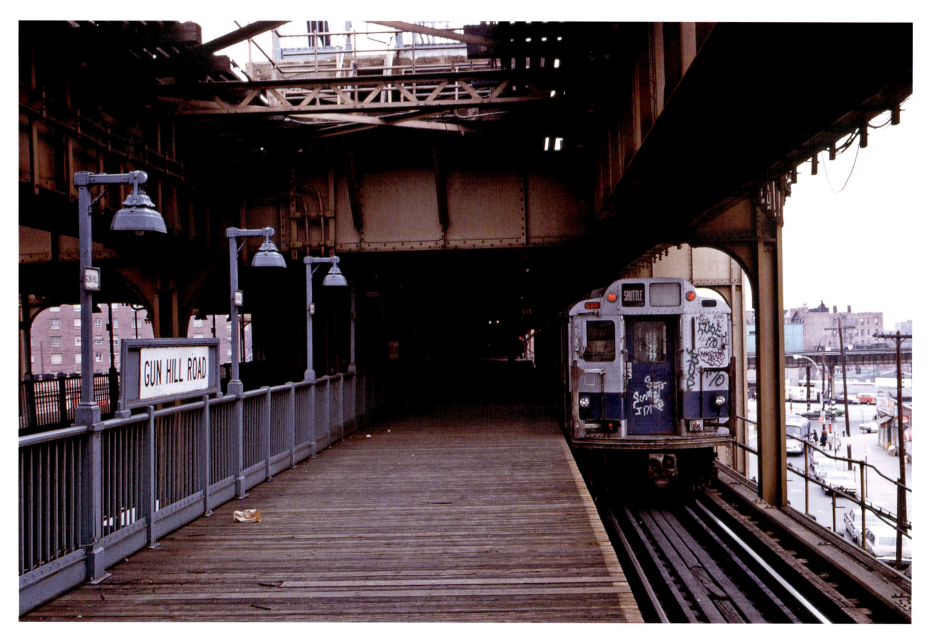

IRT, R-12-series car at Gun Hill Road Station, lower platform, 3rd Ave. Elevated Line, Bronx, March 25, 1973

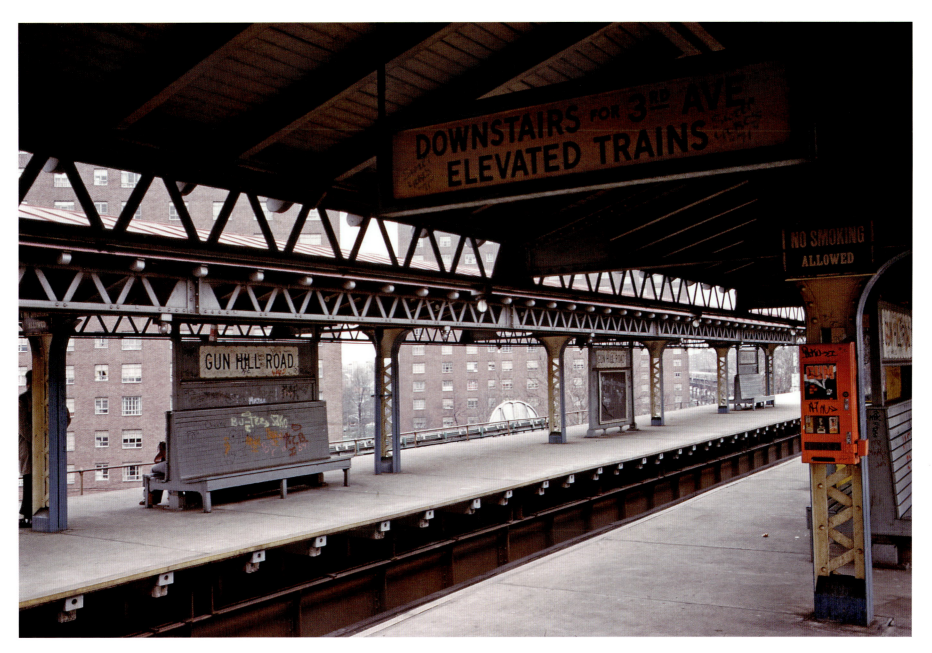

IRT, Gun Hill Road Station, upper platform, White Plains Road Line, Bronx, March 25, 1973

Chapter 3. Station Signs | 95

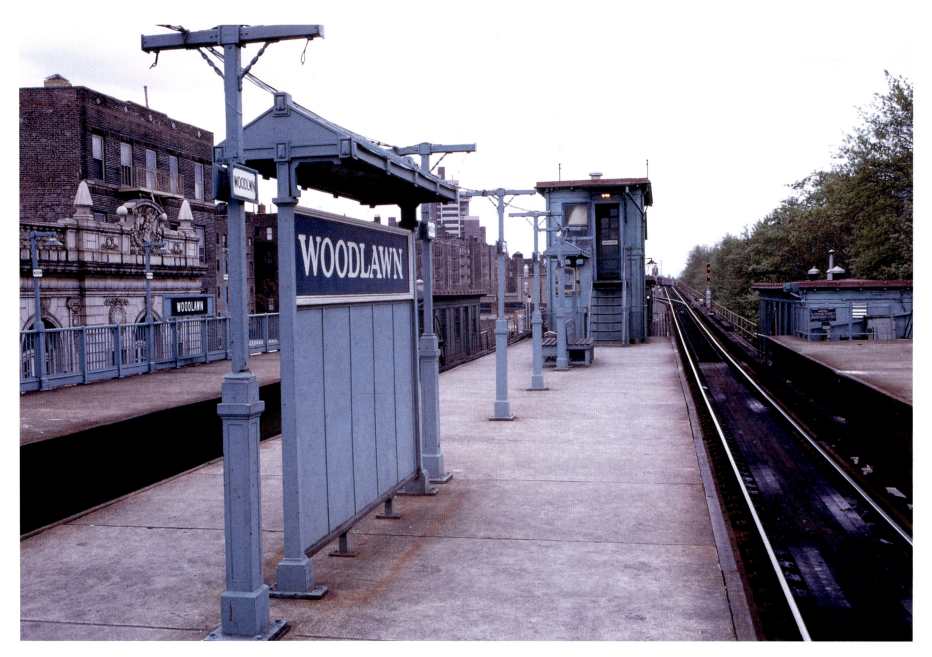

IRT, Woodlawn Station, Jerome Ave. Line, Bronx, May 5, 1973

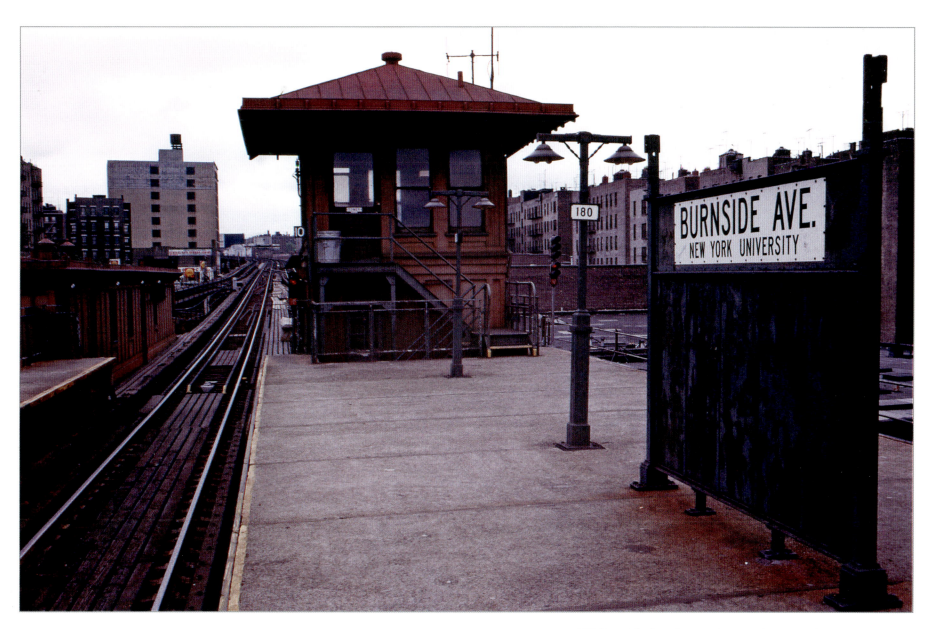

IRT, Burnside Ave. Station, Jerome Ave. Line, Bronx, May 5, 1973

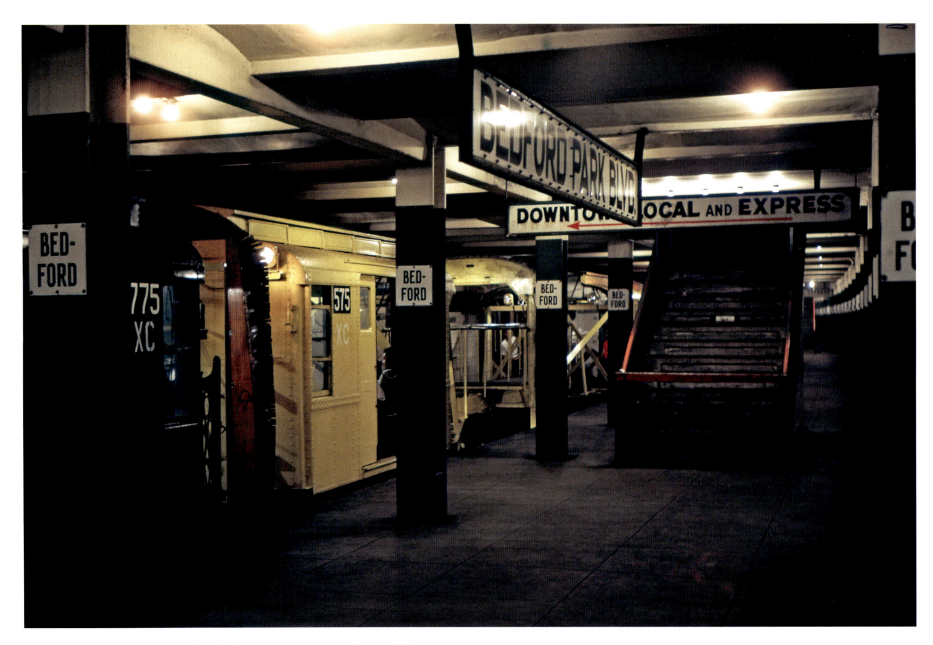

IND, Bedford Park Boulevard Station, Concourse Line, Bronx, July 16, 1969.
Note: R-1 car #575XC modified as a clearance test car for future 75-foot subway cars.

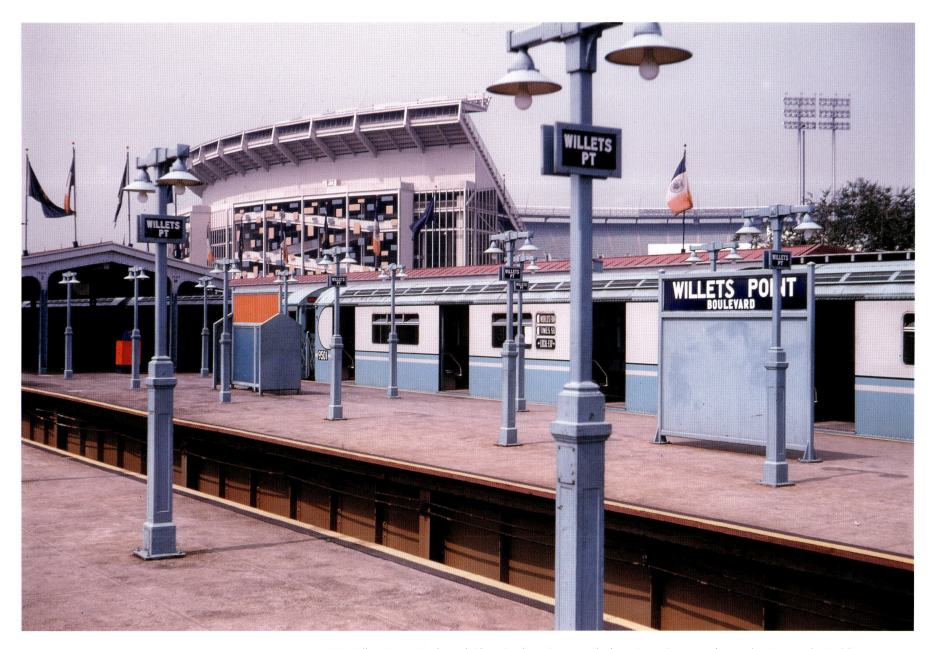

IRT, Willets Point Boulevard–Shea Stadium Station, Flushing Line, Queens, during the New York World's Fair, 1965. Note: R-36 subway car #9501.

Chapter 3. Station Signs | 99

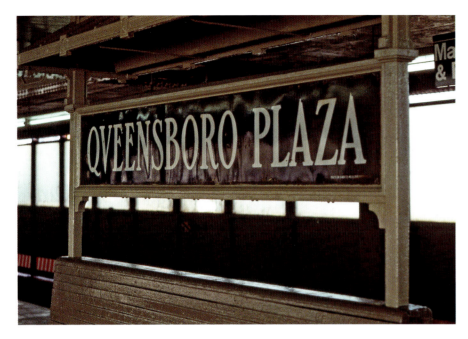

IRT/BMT, Queensboro Plaza Station, lower platform, December 8, 1988

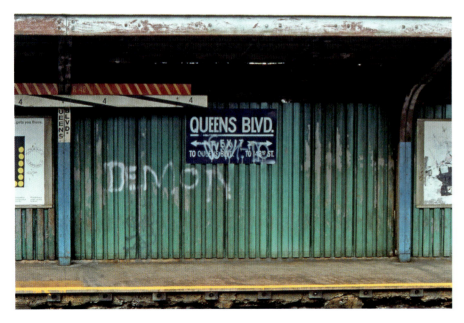

BMT, Queens Boulevard Station, Jamaica Line, November 7, 1976

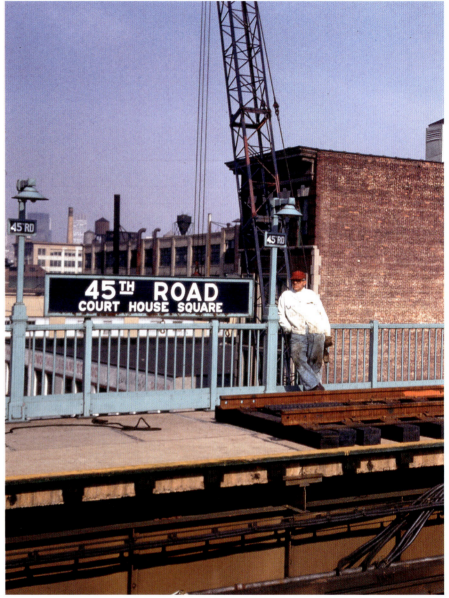

IRT, 45th Road–Court House Square Station, Flushing Line, 1967

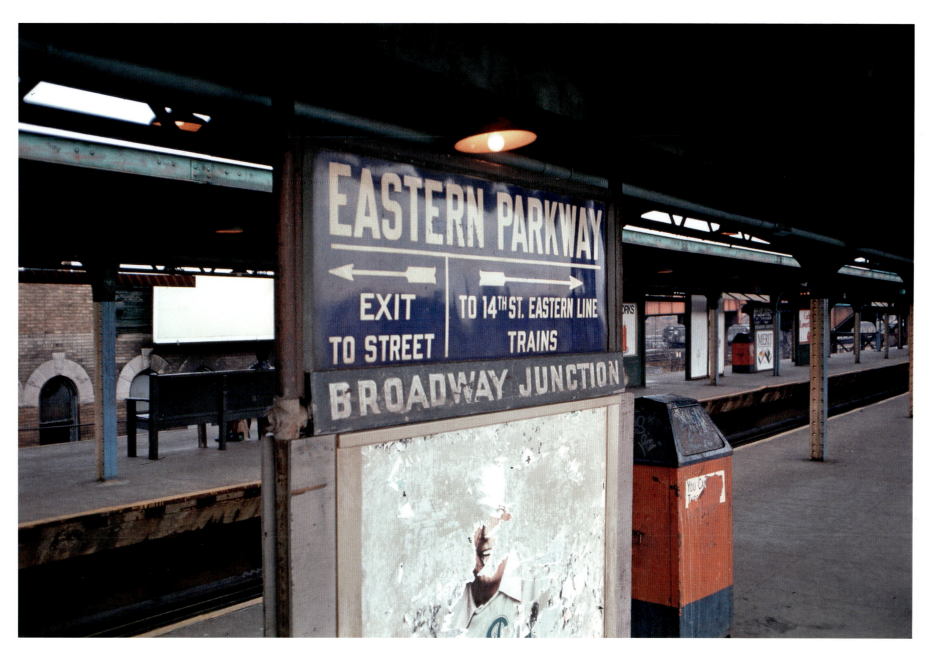

BMT, Eastern Parkway–Broadway Junction Station, Broadway–Brooklyn Line, February 16, 1976

Chapter 3. Station Signs | 101

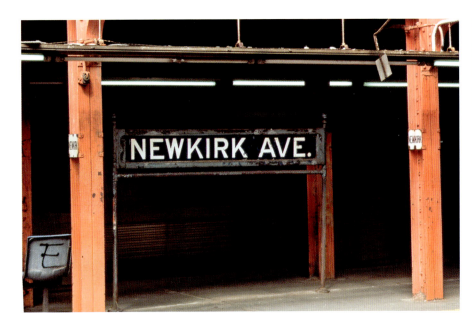

BMT, Newkirk Ave. Station, Brighton Line, Brooklyn, August 1984

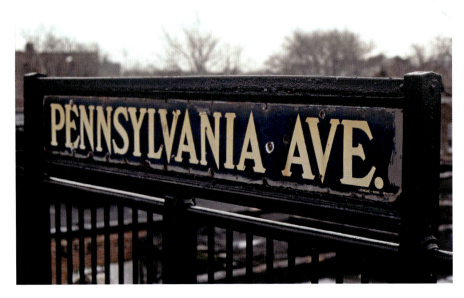

IRT, Pennsylvania Ave. Station., New Lots Line, Brooklyn, February 20, 1988

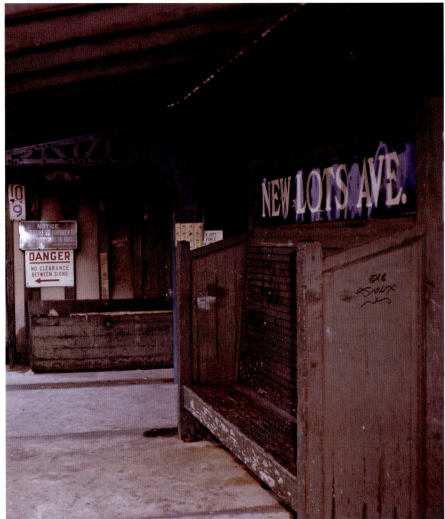

IRT, New Lots Ave. Station, Brooklyn, November 11, 1972

BMT, Prospect Park Station, Brighton Line, Brooklyn, April 15, 1973. Note: R-32A subway car #3512 on special shuttle to DeKalb Ave.

Chapter 3. Station Signs | 103

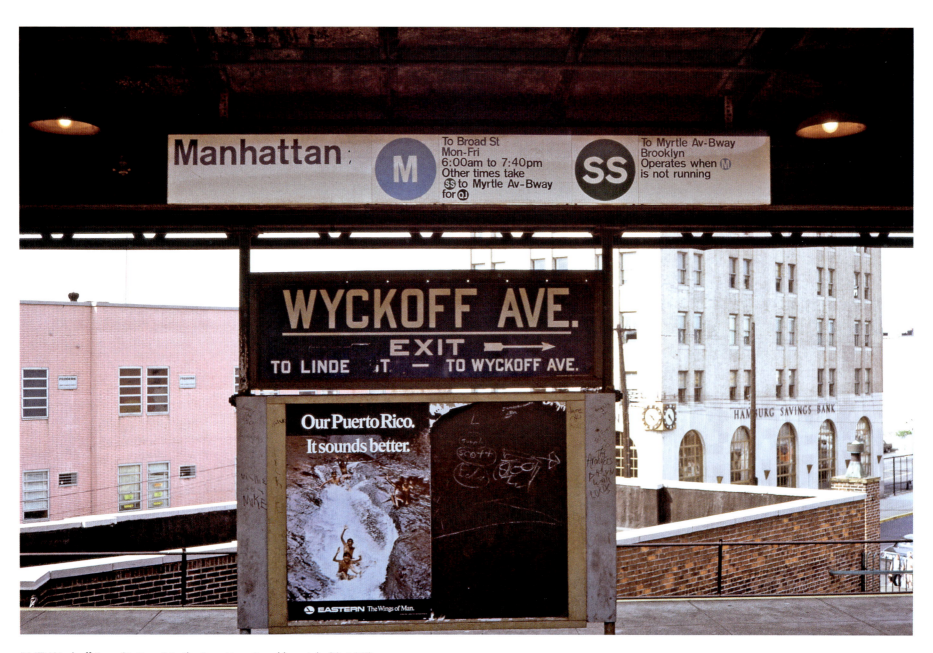

BMT, Wyckoff Ave. Station, Myrtle Ave. Line, Brooklyn, July 29, 1972

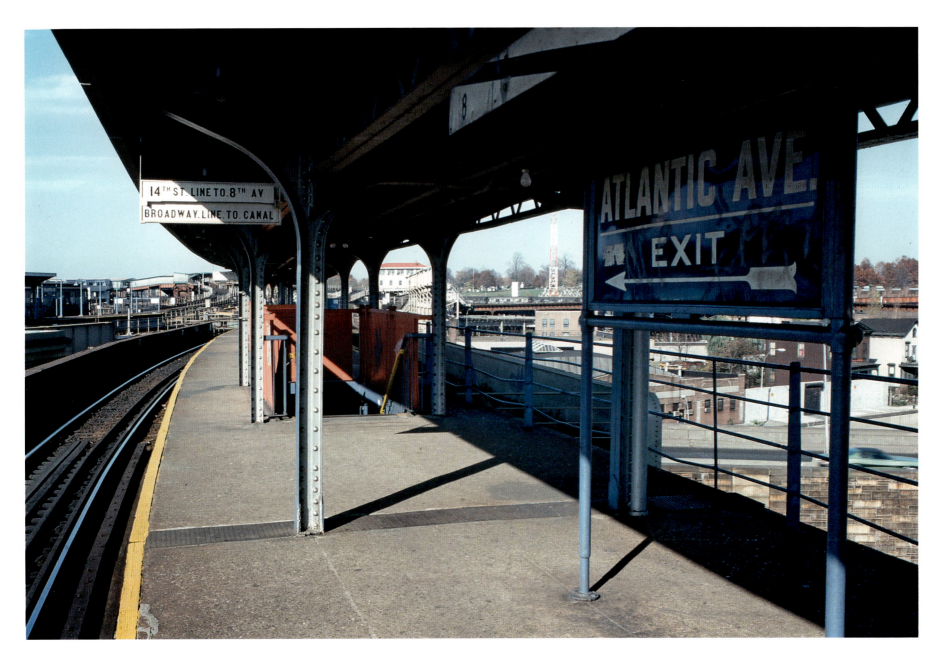

BMT, Atlantic Ave. Station, 14th St.–Canarsie Line, Brooklyn, November 6, 1976

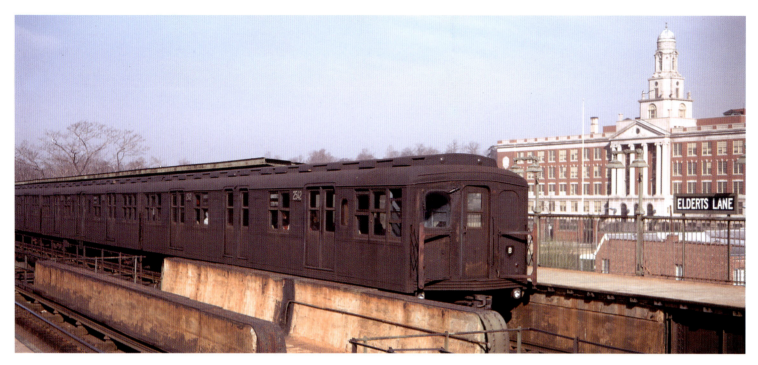

BMT, B-type subway cars #2542–2541–2540 on Manhattan-bound Broadway–Brooklyn Local at Elderts Lane Station, Jamaica Line, April 9, 1969

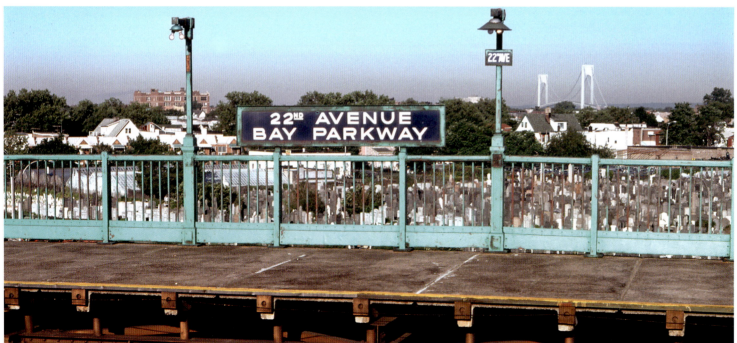

IND, 22nd Ave.–Bay Parkway Station, southbound platform, Culver Line, Brooklyn, June 26, 1979

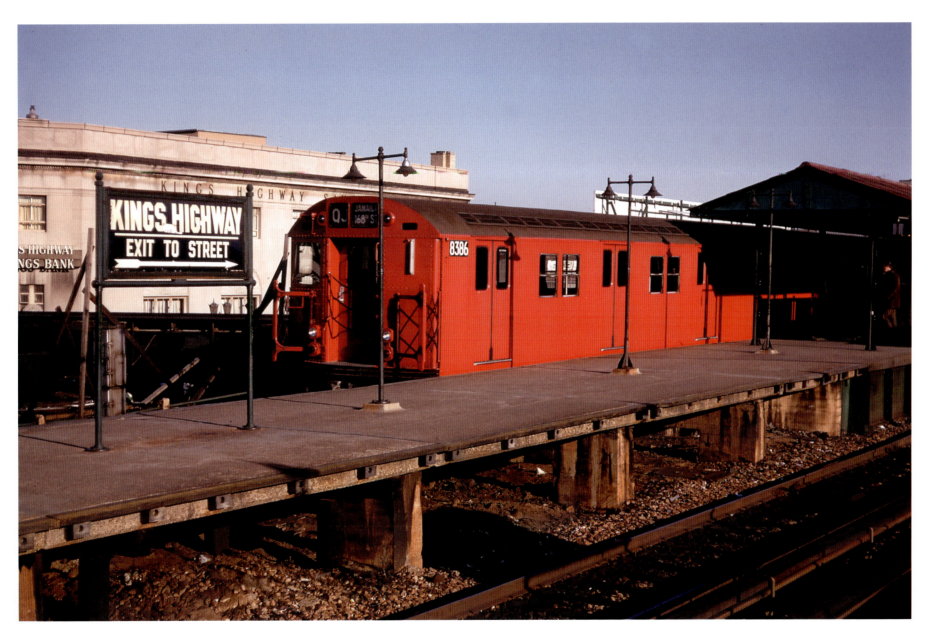
BMT, R-30A subway car #8386 on Queens-bound "QJ" Brighton–Jamaica local at Kings Highway Station, Brighton Line, Brooklyn, May 7, 1970

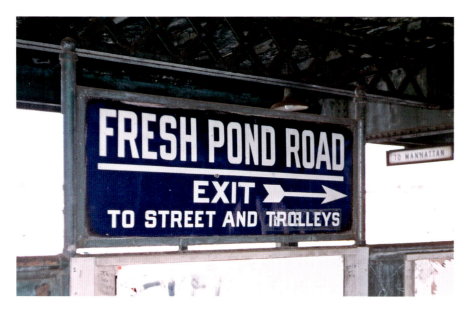

BMT, Fresh Pond Road Station, Myrtle Ave. Line, Queens, January 1, 1973

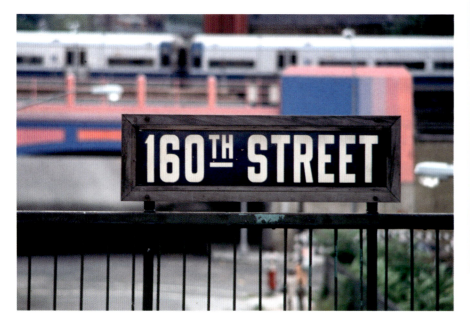

BMT, 160th St. Station, Jamaica Line, Queens, September 11, 1977

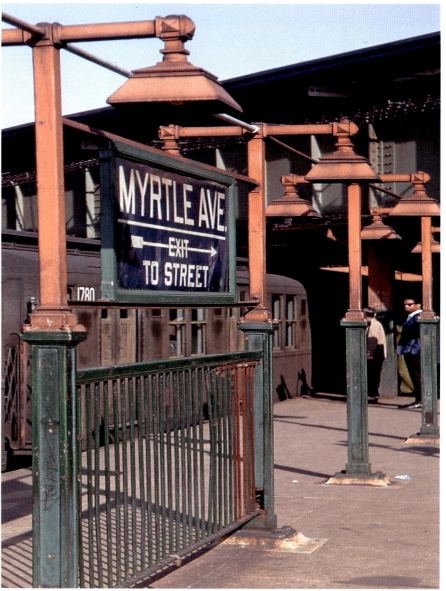

BMT, Myrtle Ave.–Broadway Station, Brooklyn, May 14, 1968

108 | Vintage New York City Subway Signs | 1920s–1980s

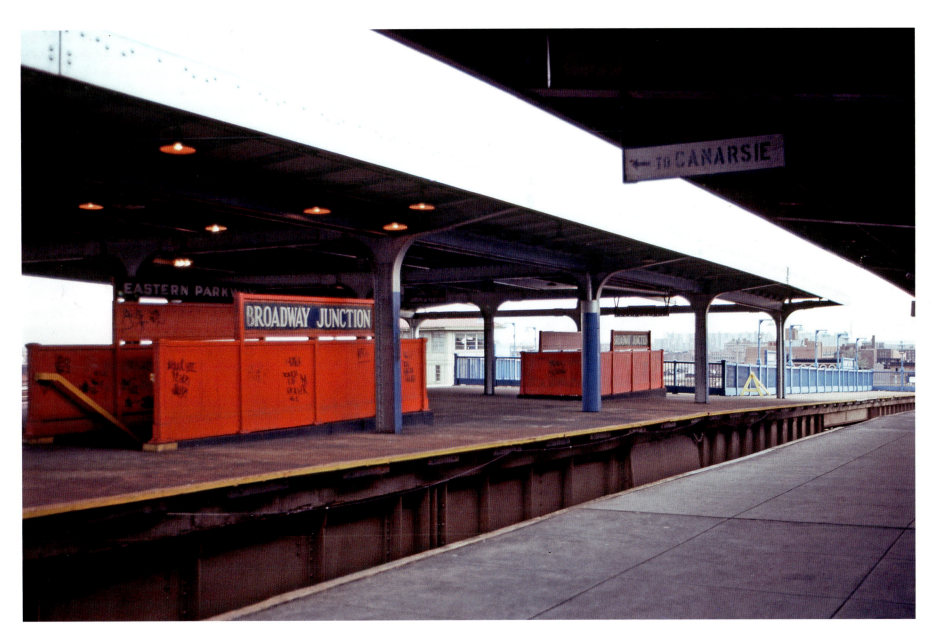

BMT, Broadway Junction–Eastern Parkway Station, 14th St.–Canarsie Line, Brooklyn, November 27, 1980

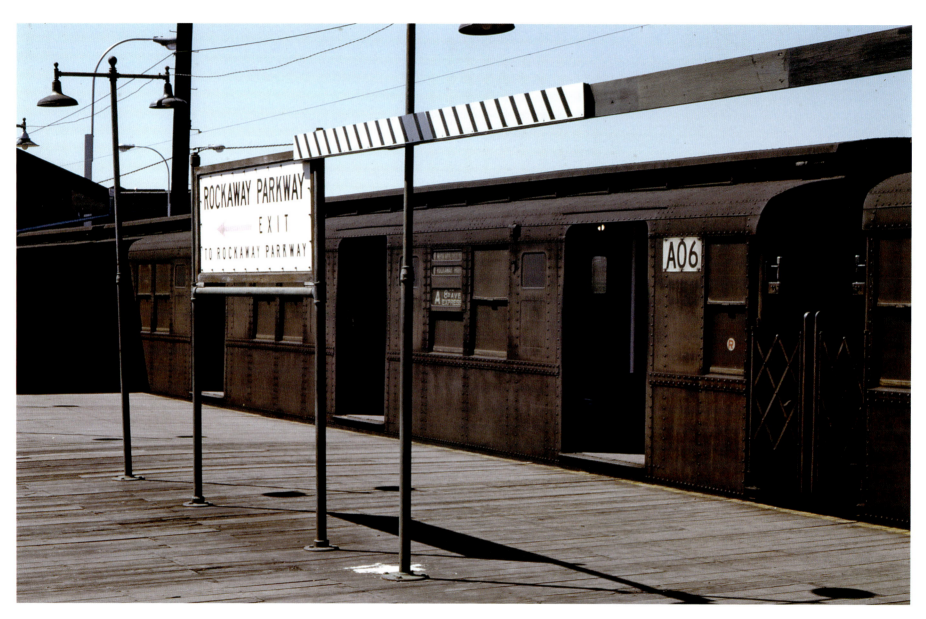

BMT, Rockaway Parkway Station, 14th St.–Canarsie Line, Brooklyn, April 12, 1969. Note: R-9 subway car #A06 (ex-#1754) in service.

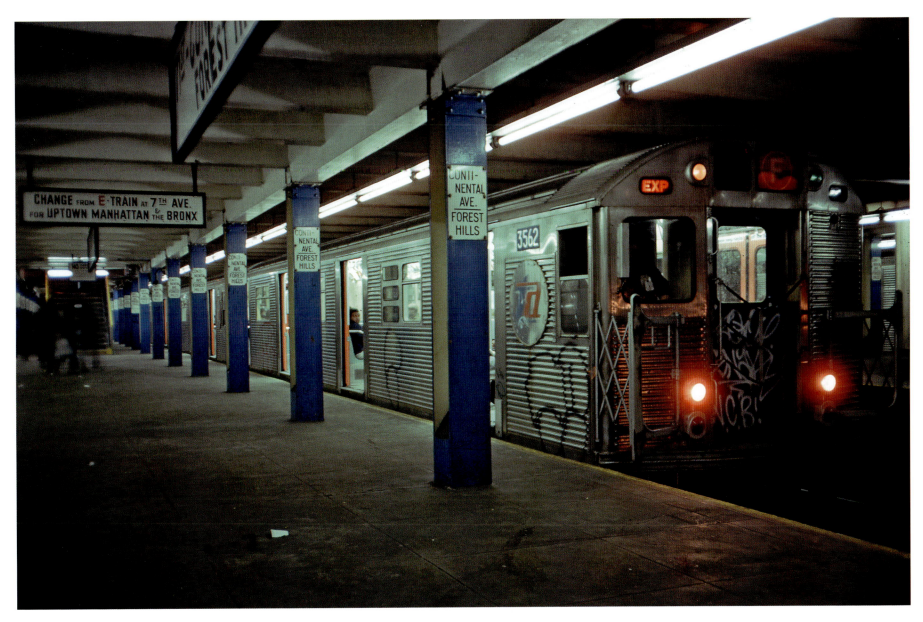

IND, Continental Ave.–Forest Hills Station, Queens Boulevard Line, February 9, 1978.
Note: R-32A subway car #3562 on Coney Island–bound "F"–Queens Boulevard Exp.–6th Ave. Local.

Chapter 3. Station Signs | 111

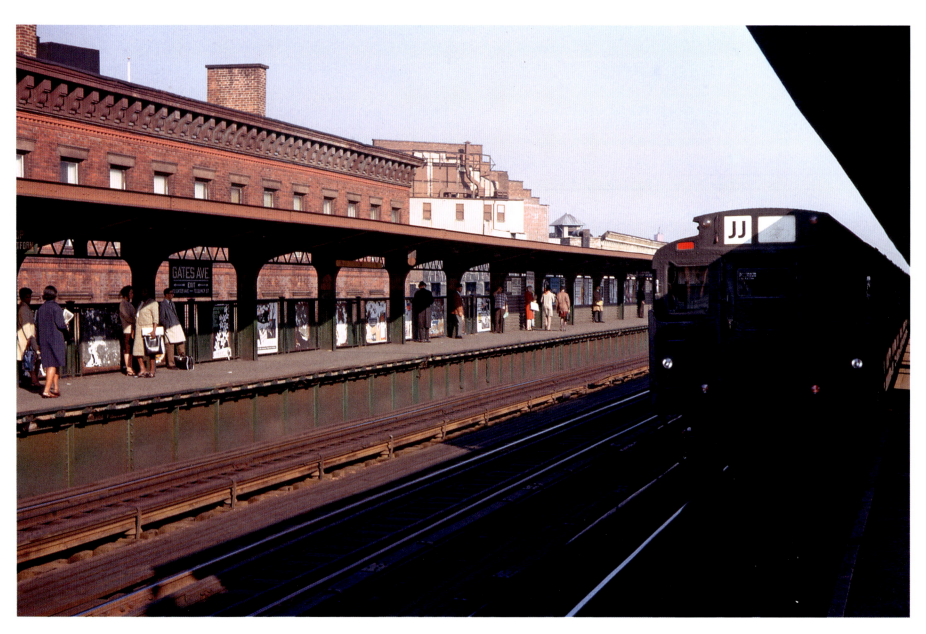

BMT, Gates Ave. Station, Broadway–Brooklyn Line, May 22, 1968. Note: R-7A subway car #1639 on Manhattan-bound "JJ"–Broadway–Brooklyn Local to Canal St.

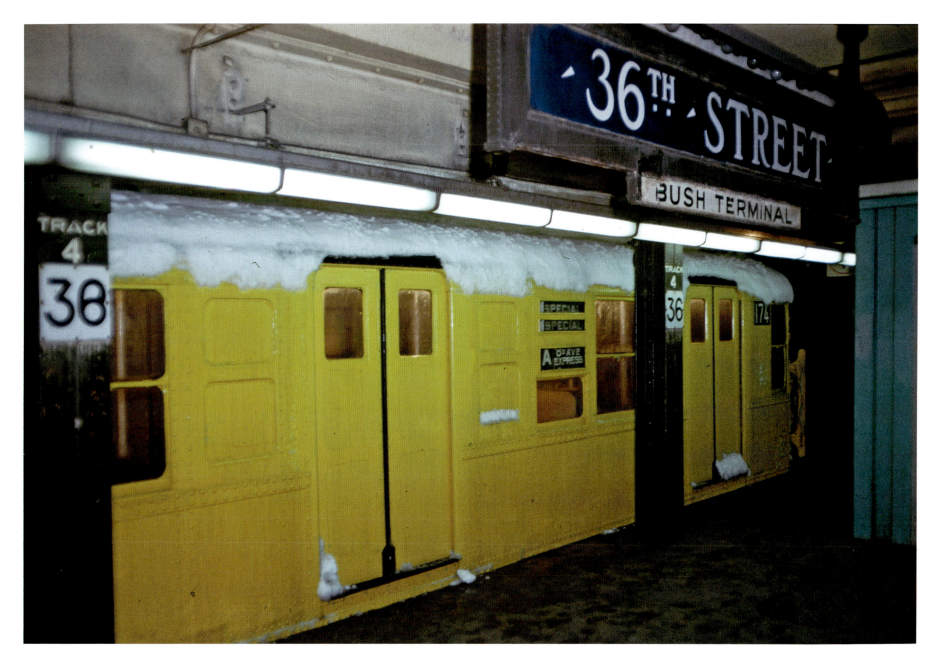

BMT, 36th St.–Bush Terminal Station, 4th Ave. Line, Brooklyn, February 9, 1969.
Note: R-1 subway car #174 used as an alcohol / snow-removal car.

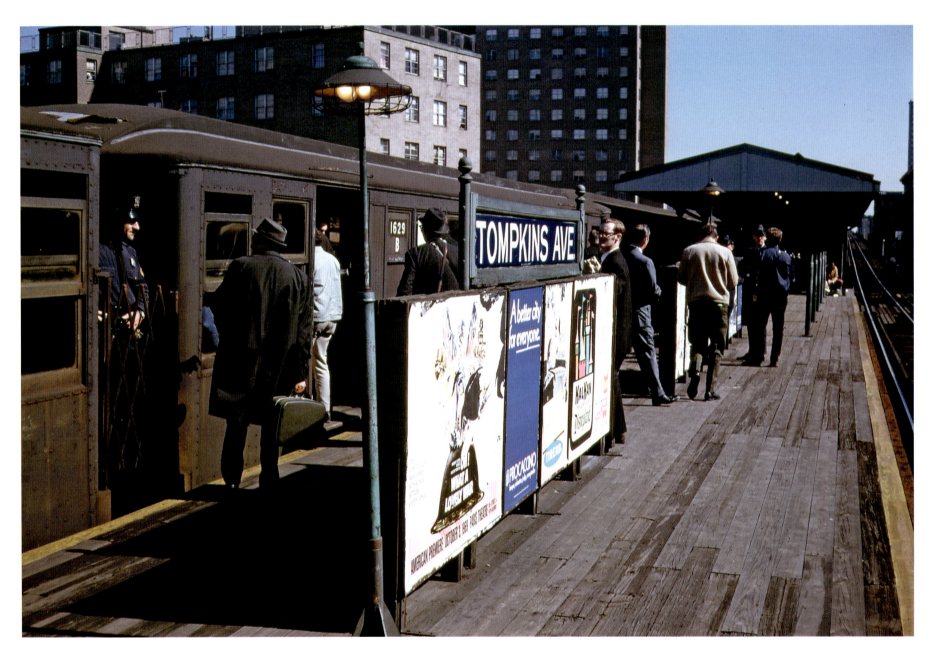
BMT, Tompkins Ave. Station, Myrtle Ave. Line, Brooklyn, October 4, 1969. Note: Q-type elevated car #1629B on a fan trip.

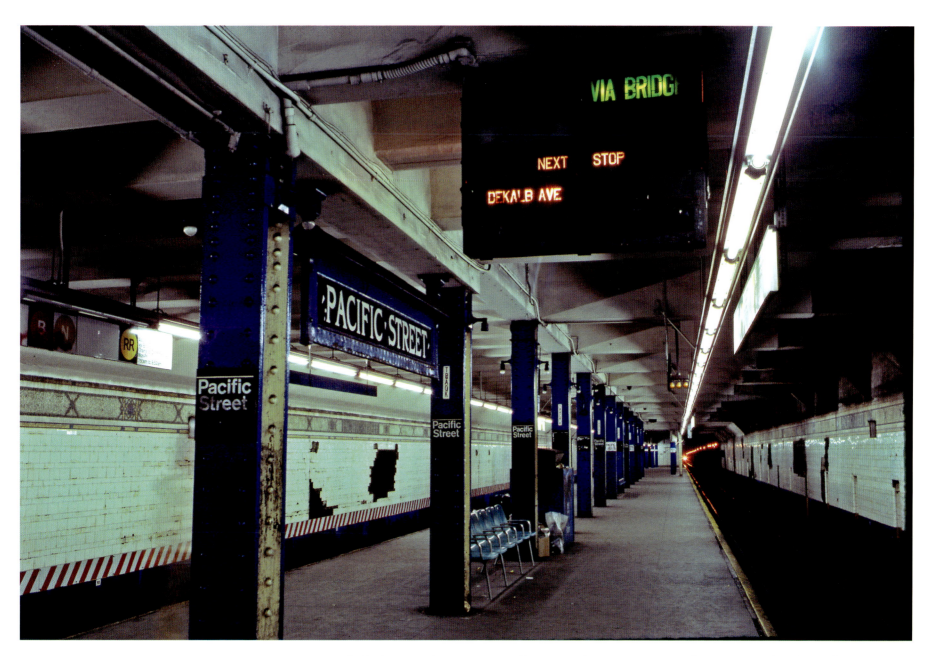

BMT, Pacific St. Station, 4th Ave. Line, Brooklyn, December 30, 1979. Note: illuminated sign box dating from the 1920s.

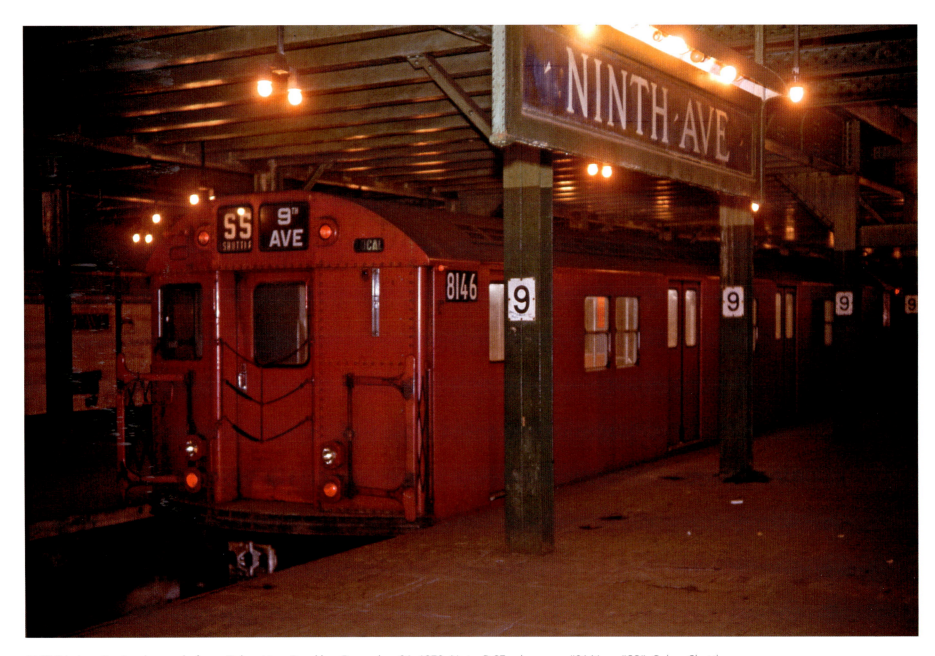

BMT, 9th Ave. Station, lower platform, Culver Line, Brooklyn, December 26, 1970. Note: R-27 subway car #8146 on "SS"–Culver Shuttle. Note also "Ninth Ave." station sign illuminated from above.

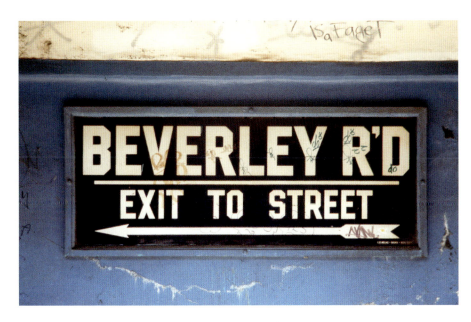

BMT, Beverley Road Station, Brighton Line, Brooklyn, May 21, 1978

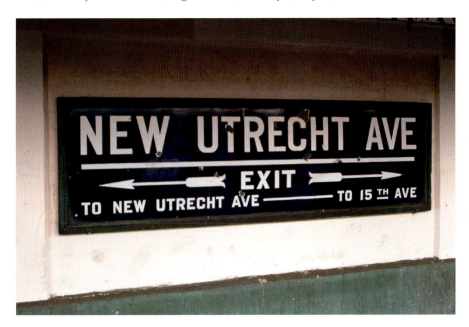

BMT, New Utrecht Ave. Station, northbound platform, Sea Beach Line, Brooklyn, November 9, 1975

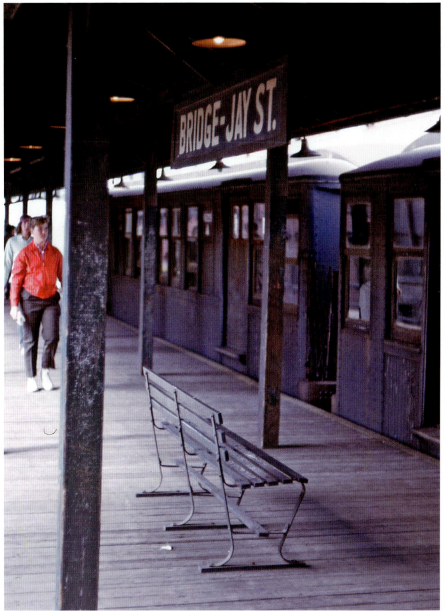

BMT, Bridge St.–Jay St. Station, Myrtle Ave. Line, Brooklyn, October 5, 1969

Chapter 3. Station Signs | 117

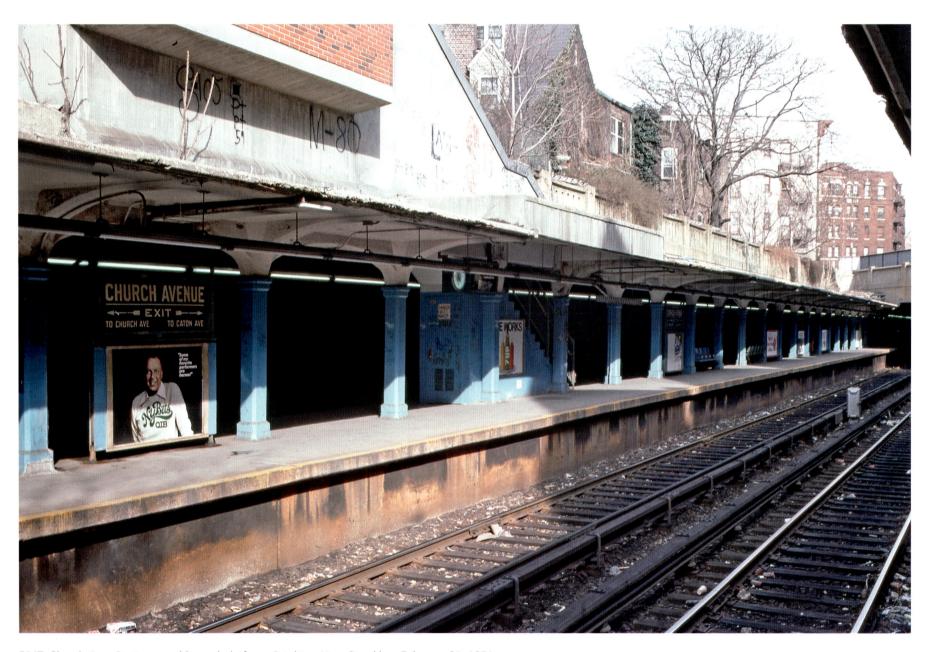

BMT, Church Ave. Station, southbound platform, Brighton Line, Brooklyn, February 21, 1976

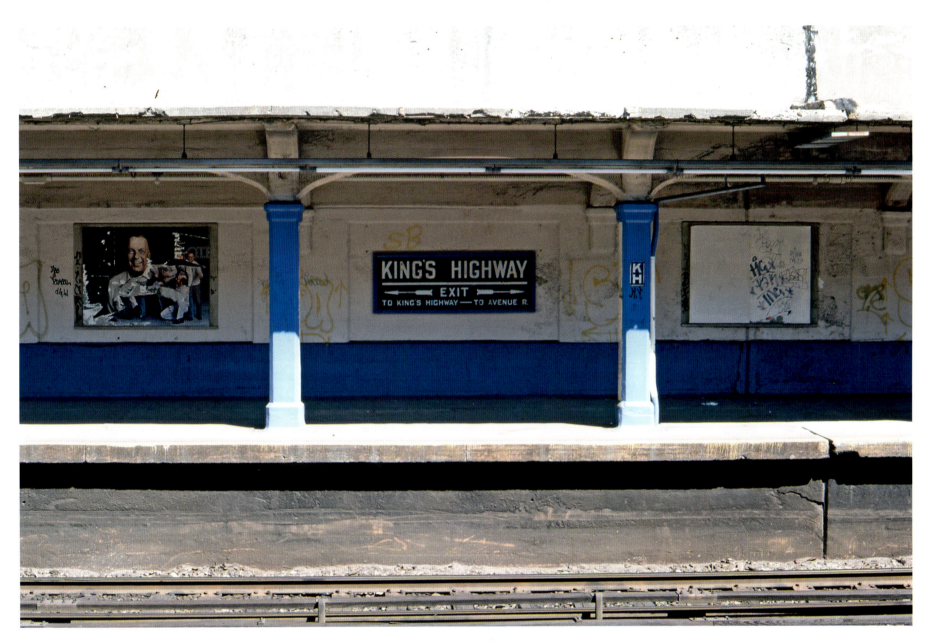

BMT, King's Highway Station, northbound platform, Sea Beach Line, Brooklyn, September 6, 1976

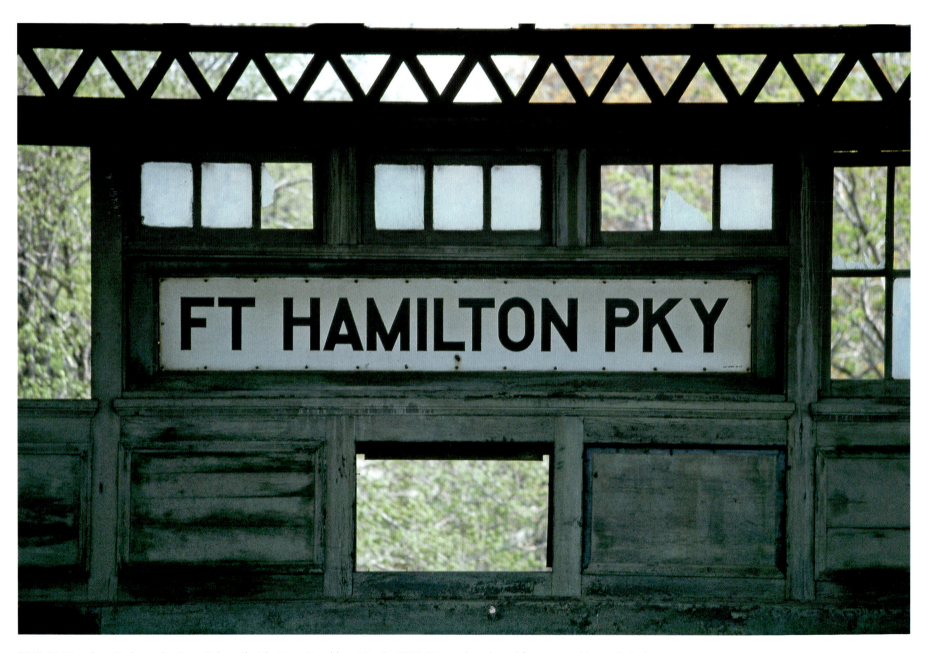

BMT, Ft. Hamilton Parkway Station, Culver Shuttle Line, Brooklyn, May 3, 1975. Note: abandoned former northbound platform.

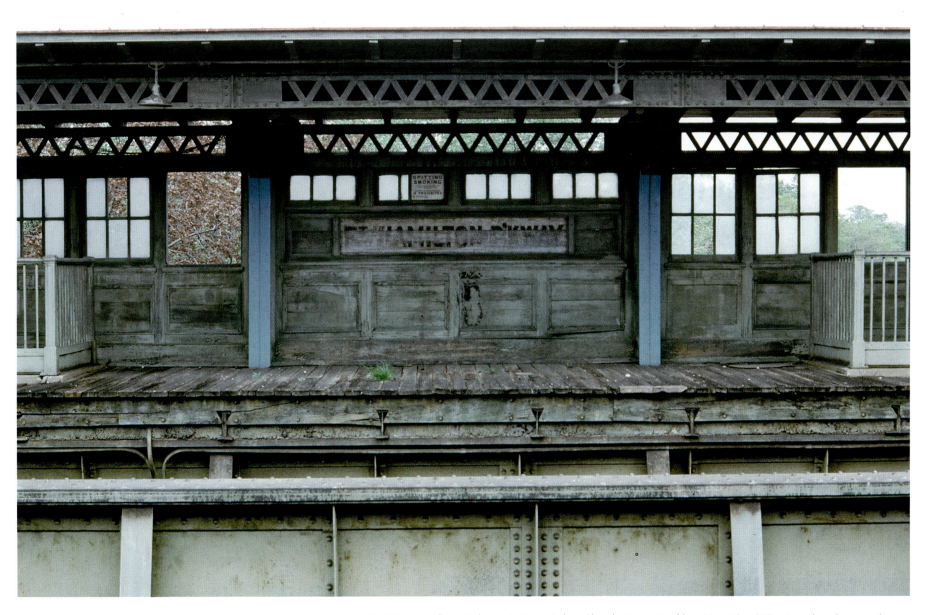

BMT, Ft. Hamilton Parkway Station, Culver Shuttle Line, Brooklyn, May 10, 1975. Note: hand-painted sign.

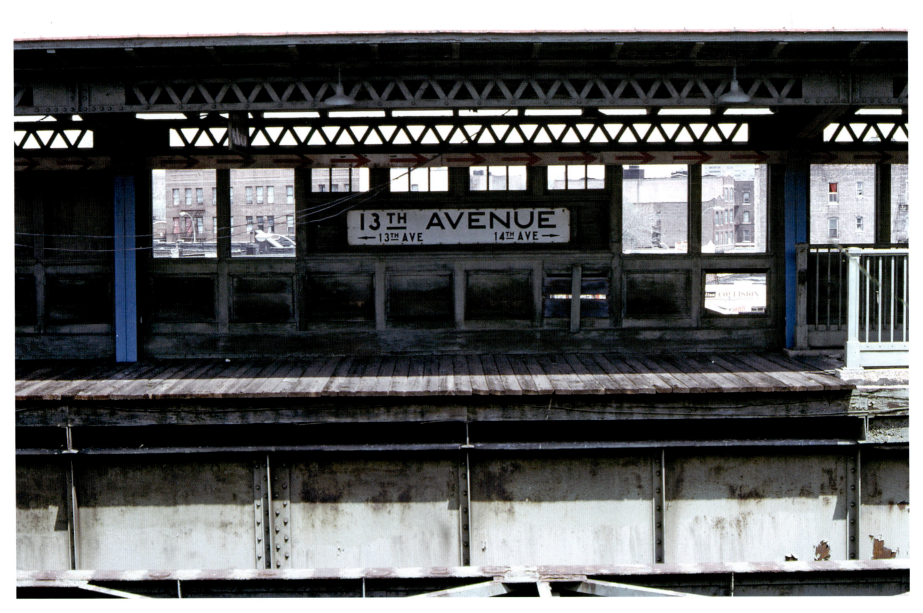
BMT, 13th Ave. Station, Culver Shuttle Line, Brooklyn, May 3, 1975 Note: abandoned former northbound platform.

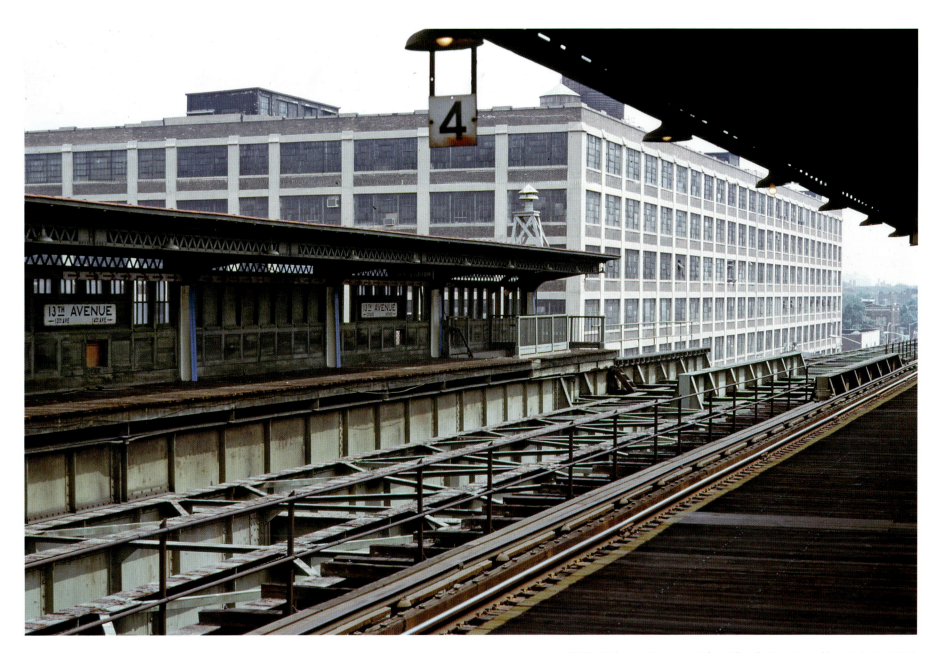

BMT, 13th Ave. Station, Culver Shuttle Line, Brooklyn, July 24, 1971

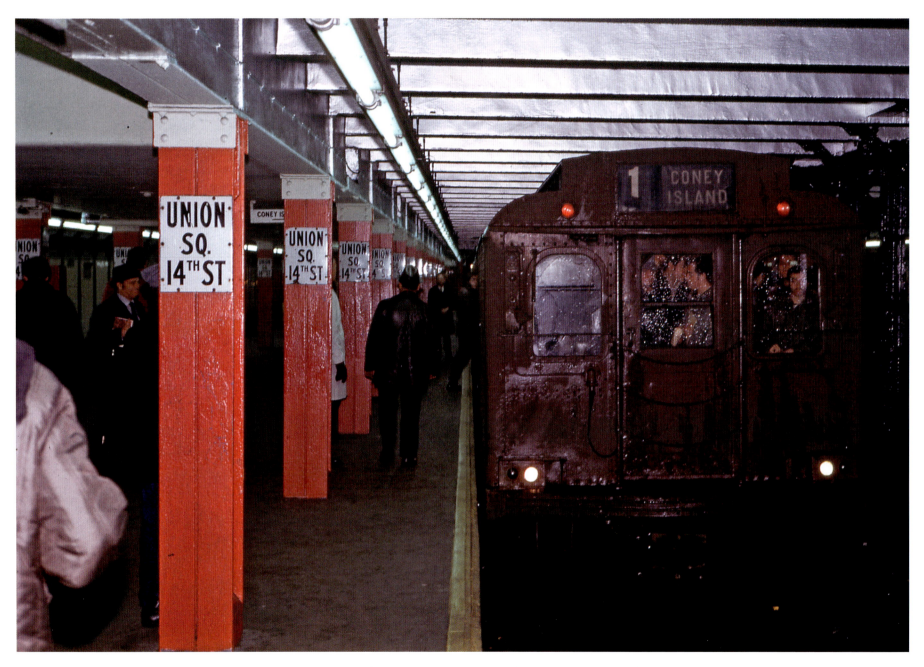
BMT, Union Sq.–14th St. Station, Broadway Line, Manhattan, December 9, 1973. Note: D-type subway car #6019C on a fan trip.

IND, Canal St.–Holland Tunnel Station, 8th Ave. Line, Manhattan, October 24, 1977. Note: R-40 subway car #4150 on southbound "A" train.

Chapter 3. Station Signs | 125

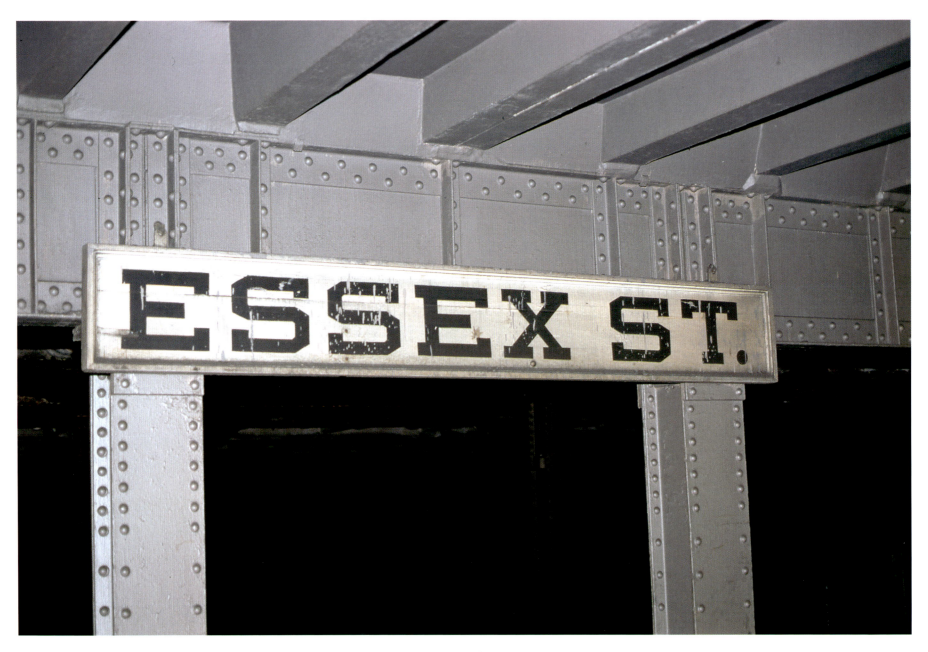

BMT, Essex St. Station, Nassau St. Line, Manhattan, June 1980. Note: hand-painted wooden sign.

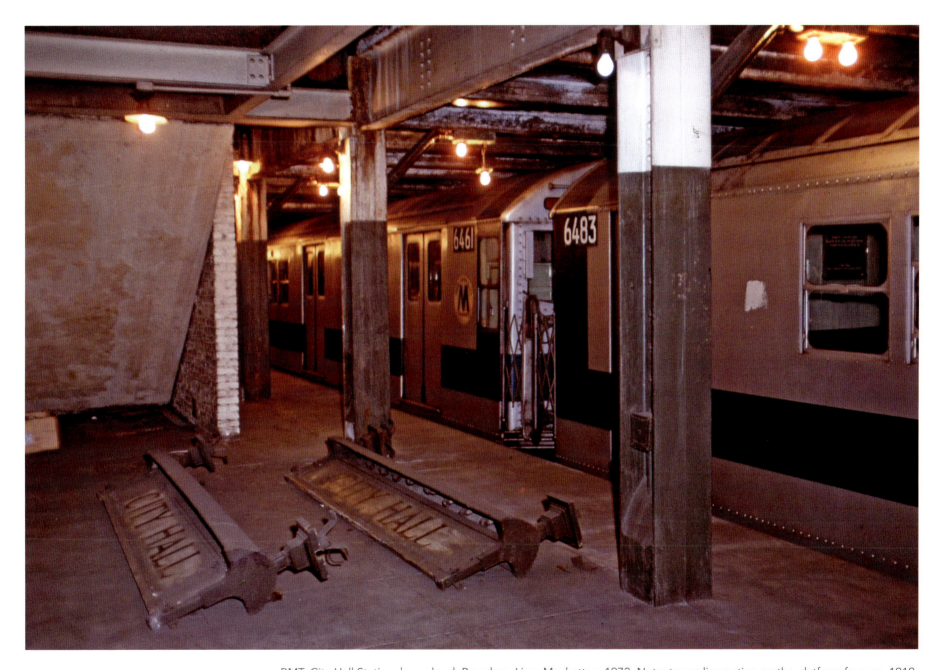

BMT, City Hall Station, lower level, Broadway Line, Manhattan, 1972. Note: true relics resting on the platform from ca. 1919.

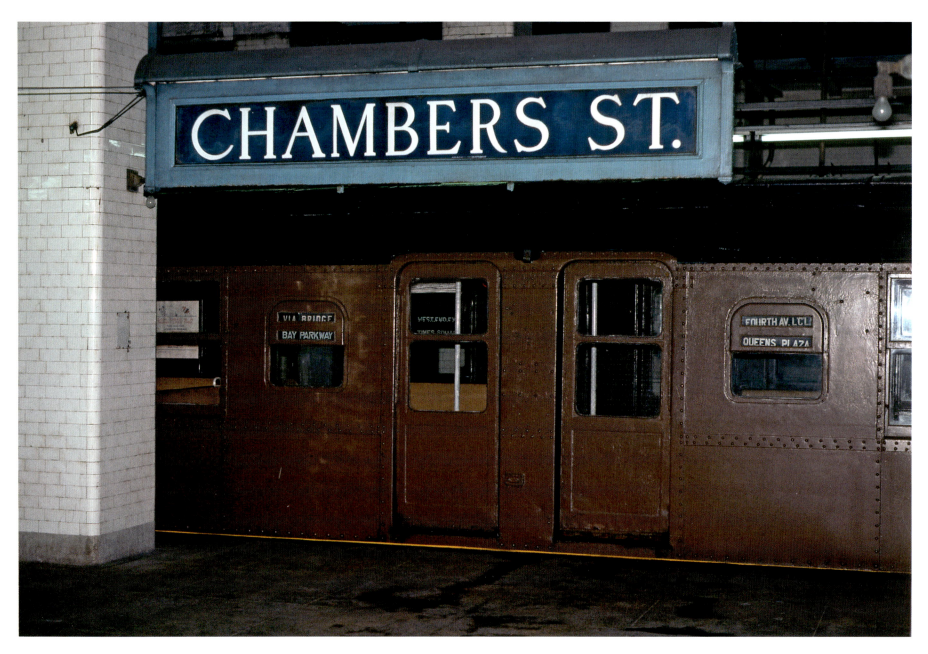

BMT, Chambers St. Station, Nassau St. Line, Manhattan, March 1979. Note: restored 1917 B-type subway car.

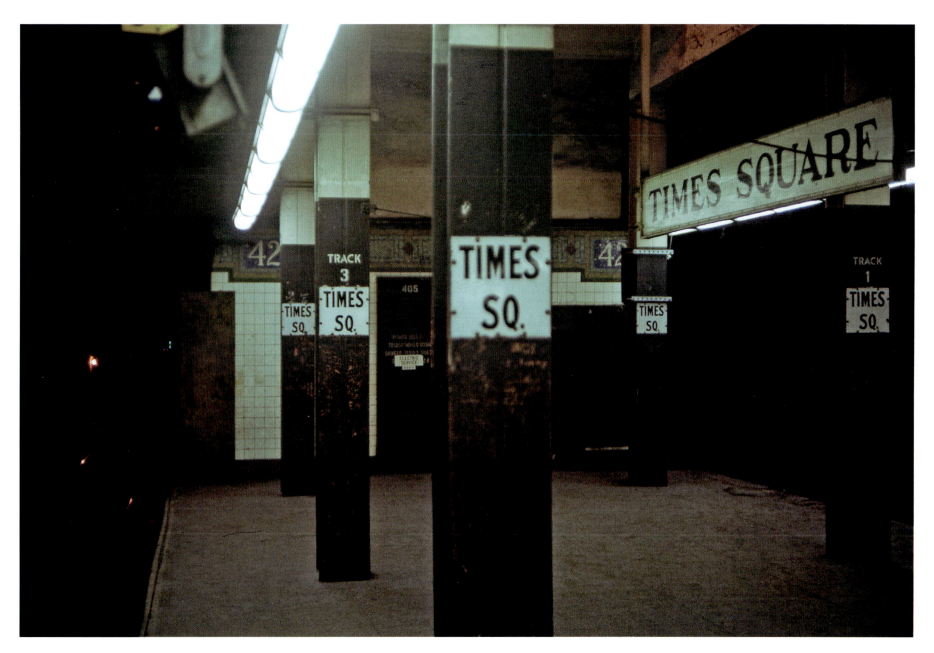

BMT, Times Square Station, south end of southbound platform, Broadway Line, Manhattan, June 22, 1969

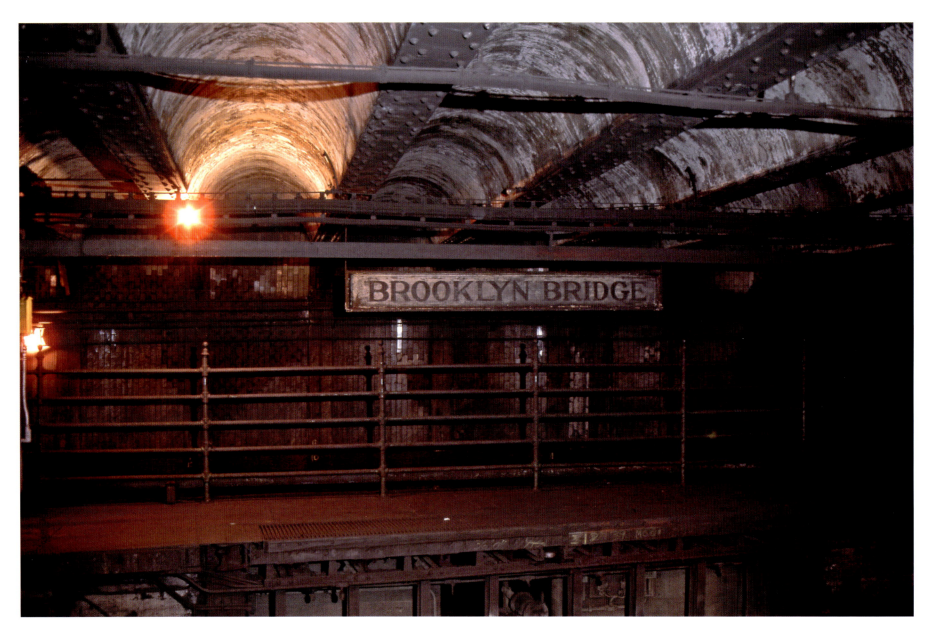

IRT, Brooklyn Bridge Station, south end, Lexington Ave. Line, Manhattan, October 27, 1985,
Note: hand-painted sign, most likely original to the station.

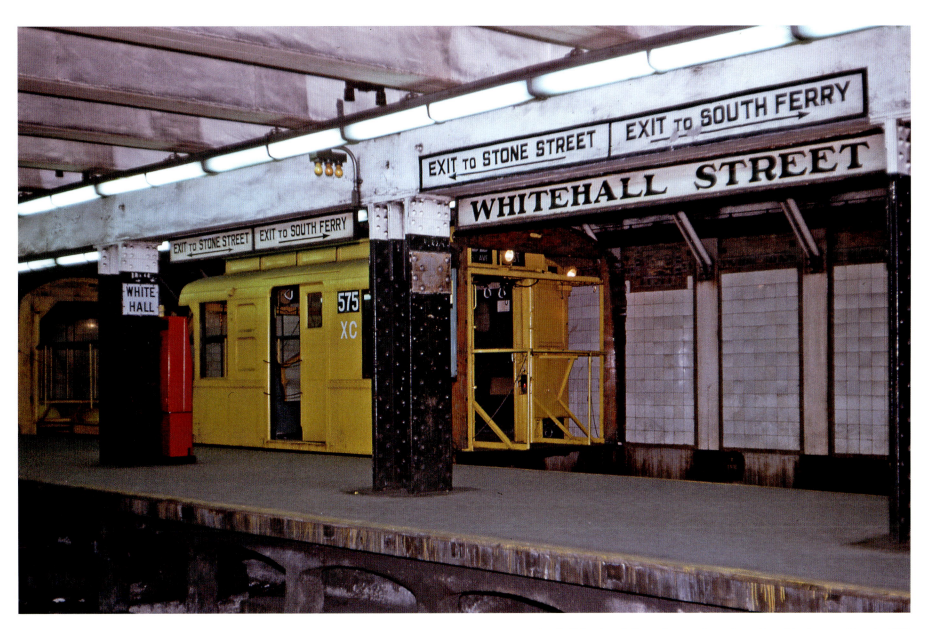

BMT, Whitehall St.–South Ferry Station, Broadway Line, Manhattan, May 6, 1970

CHAPTER 4.
DIRECTIONAL/ROUTE SIGNS

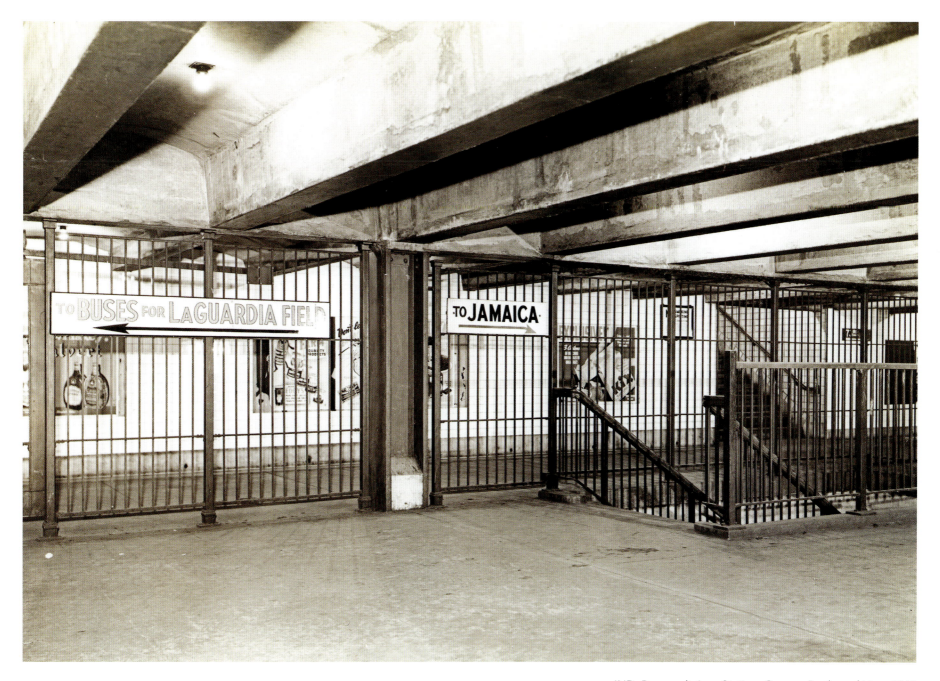

IND, Roosevelt Ave. Station, Queens Boulevard Line, 1940

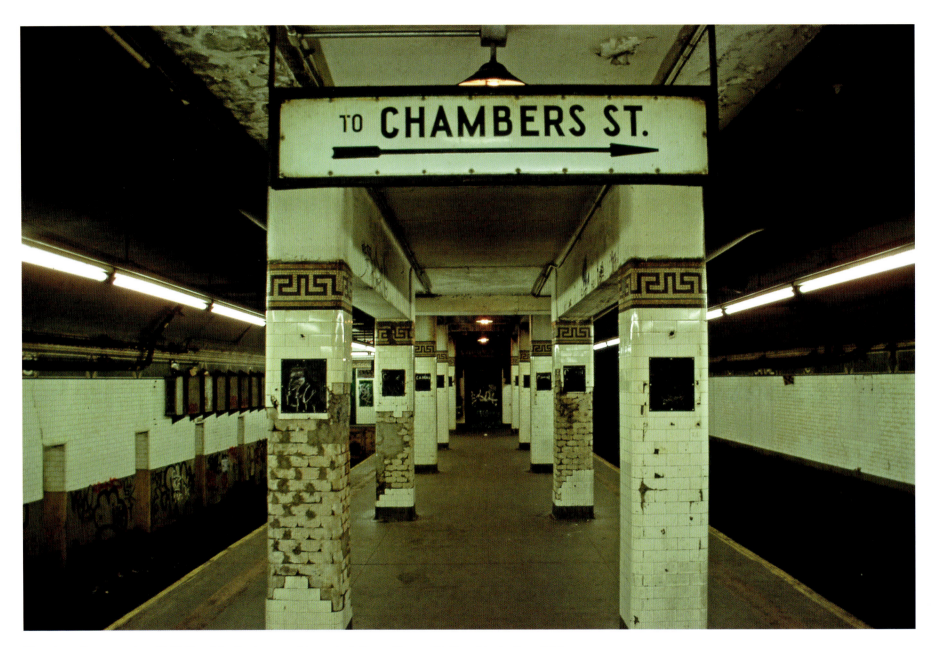
Chambers St. arrow sign, BMT, Canal St. Station, southbound platform, Nassau St. Line, Manhattan, 1988

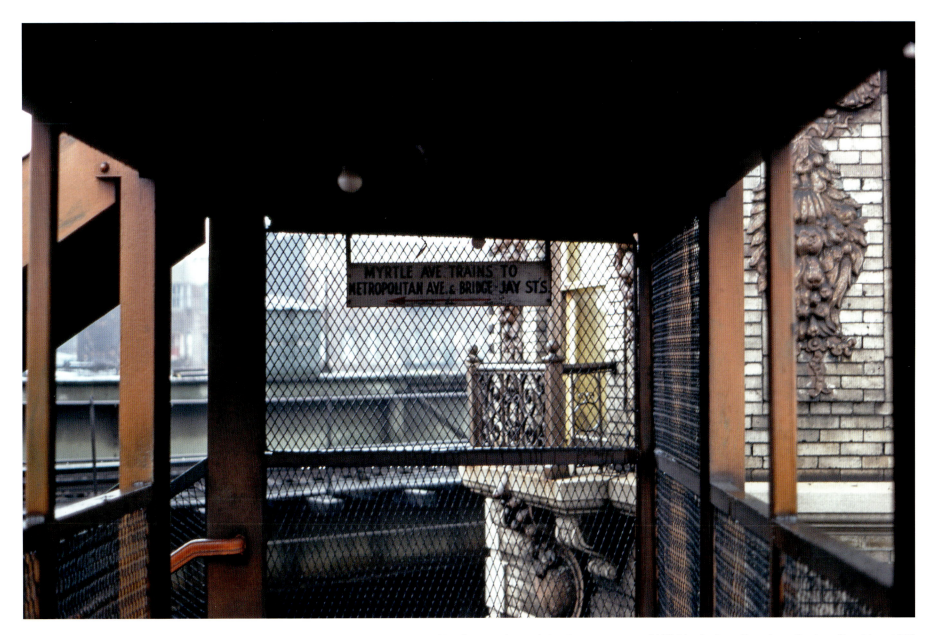

Hand-painted wood sign in passageway, BMT, Myrtle Ave.–Broadway Station, Brooklyn, 1978

Chapter 4. Directional/Route Signs | 135

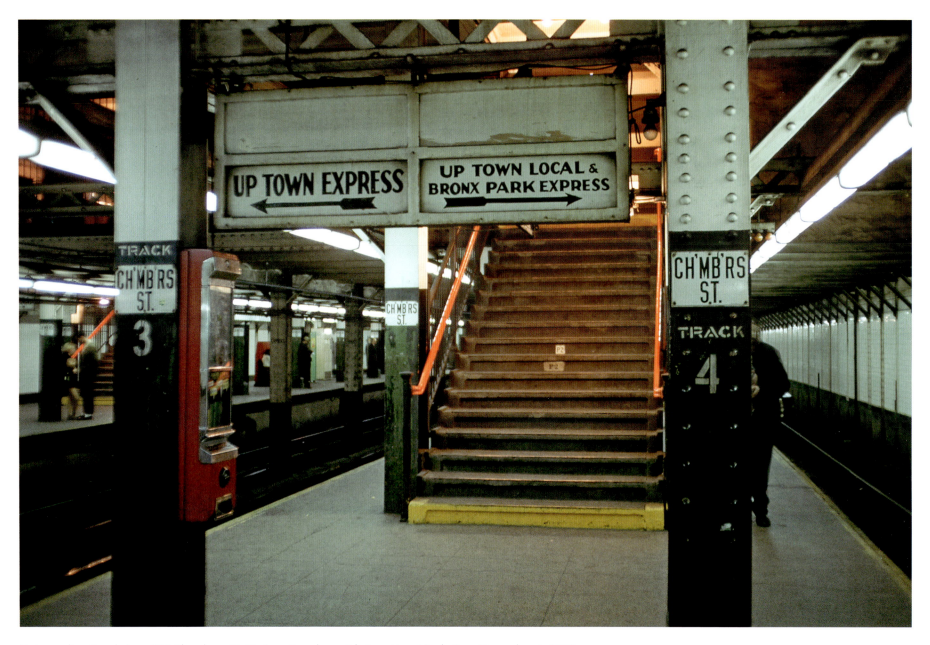

Uptown directional signs, IRT Chambers St. Station, Broadway–7th Ave. Line, Manhattan, December 1, 1968

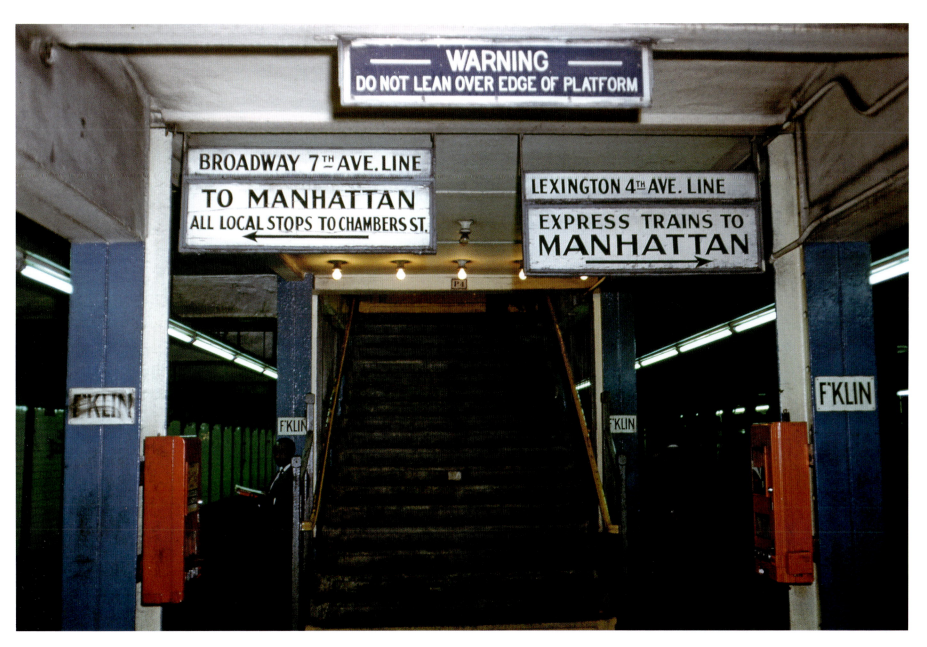

Hand-painted directional signs, IRT, Franklin Ave. Station, northbound platform, Brooklyn, October 1, 1972

Chapter 4. Directional/Route Signs | 137

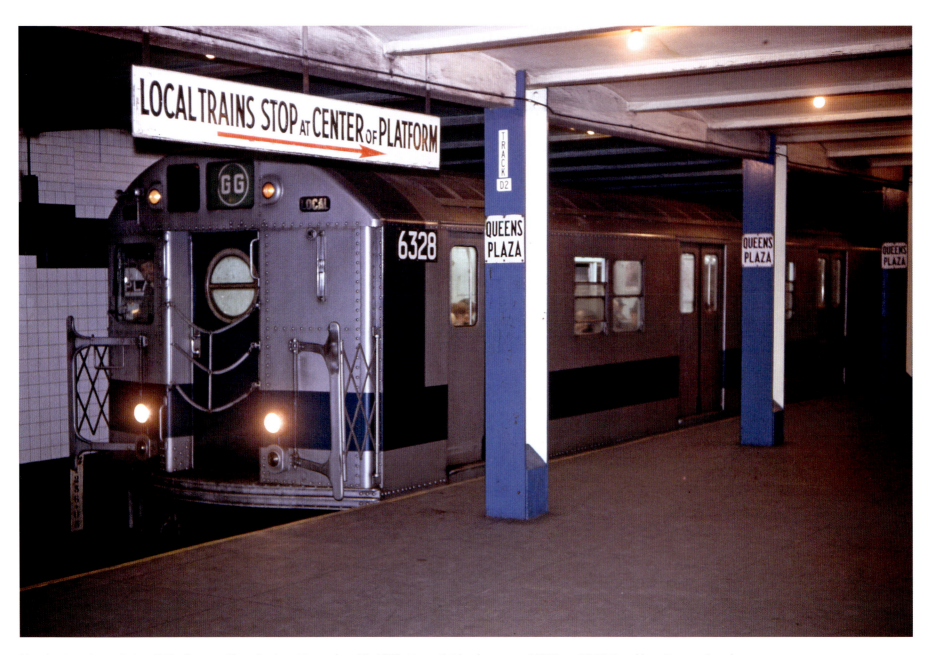

Hand-painted wood sign, IND, Queens Plaza Station, November 15, 1970. Note: R-16 subway car #6328 on "GG" Brooklyn–Queens Local.

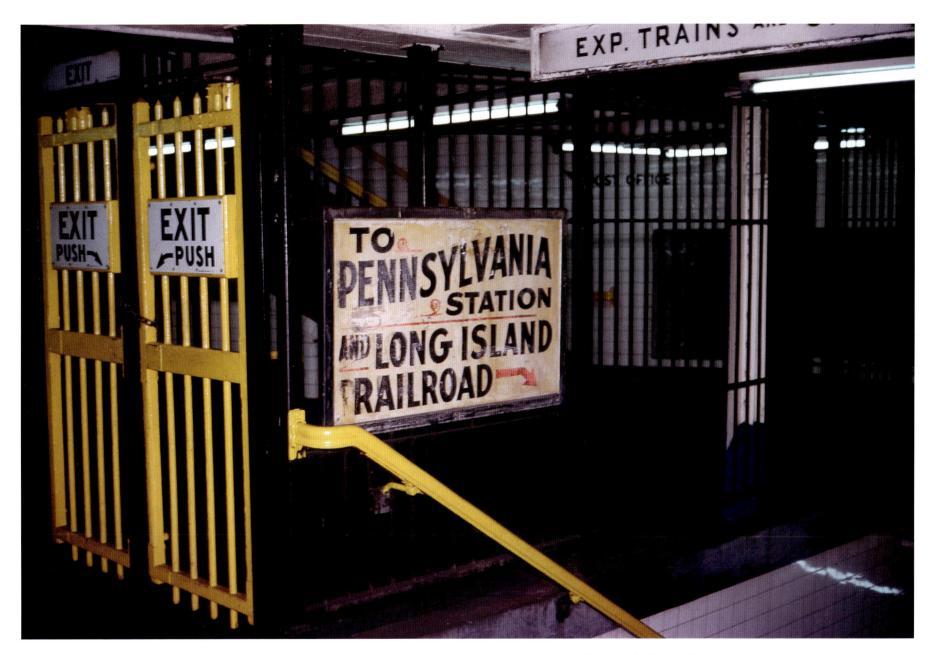

Hand-painted wood Penn Station and LIRR sign, IND, 34th St. Station, southbound platform, 8th Ave. Line, Manhattan, September 3, 1972

Chapter 4. Directional/Route Signs | 139

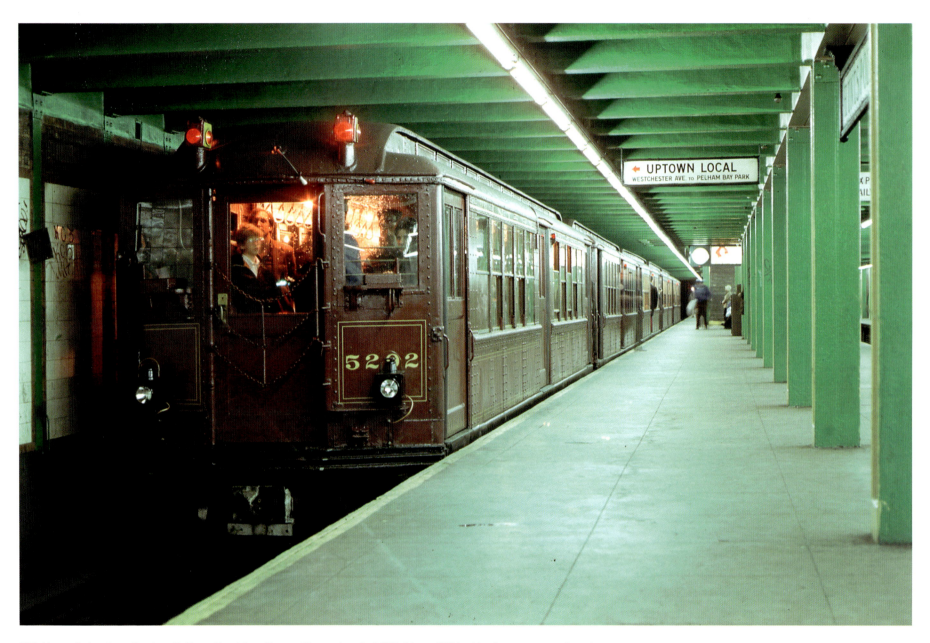

IRT, Hunts Point Ave. Station, Pelham Bay Line, Bronx, November 3, 1979. Note: IRT Lo-V subway cars on fan trip.

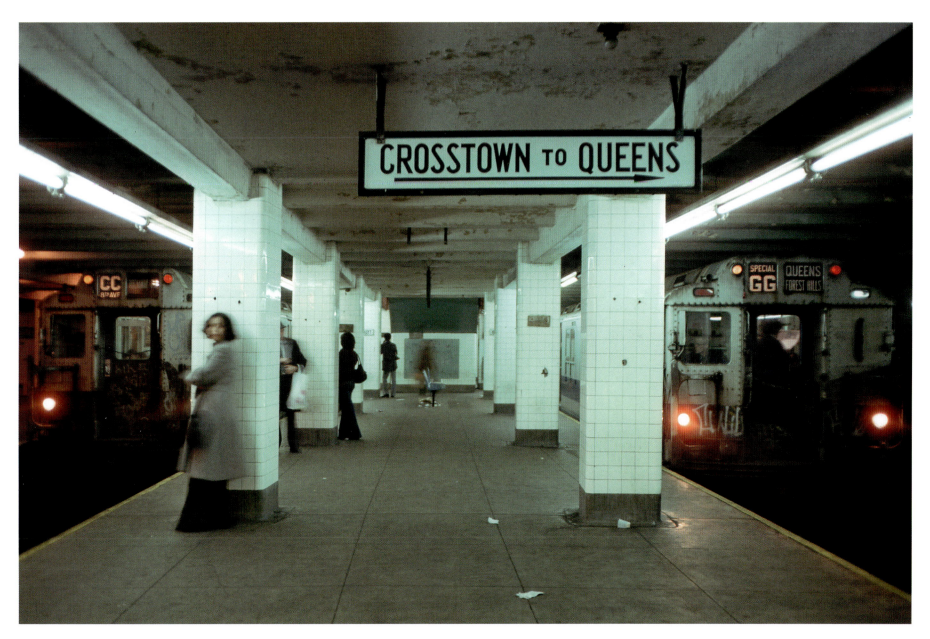

Porcelain sign, Crosstown to Queens, IND, Hoyt-Schermerhorn Sts. Station, Brooklyn, November 14, 1977. Note: R-10 subway cars on southbound "CC" 8th Ave. Local and Queens-bound "GG" Brooklyn–Queens Local.

Chapter 4. Directional/Route Signs

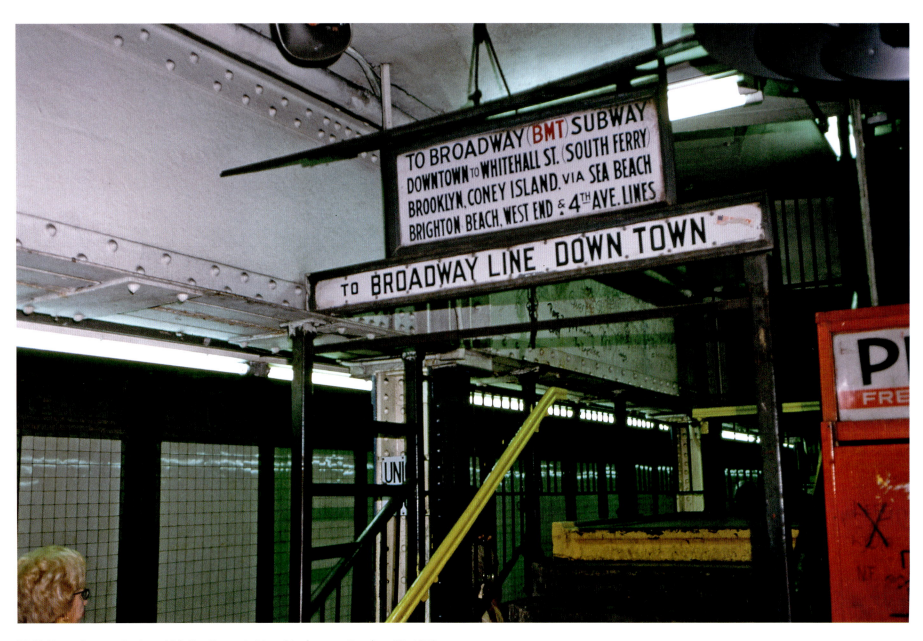

BMT, Union Square Station, 14th St.–Canarsie Line, Manhattan, October 15, 1972

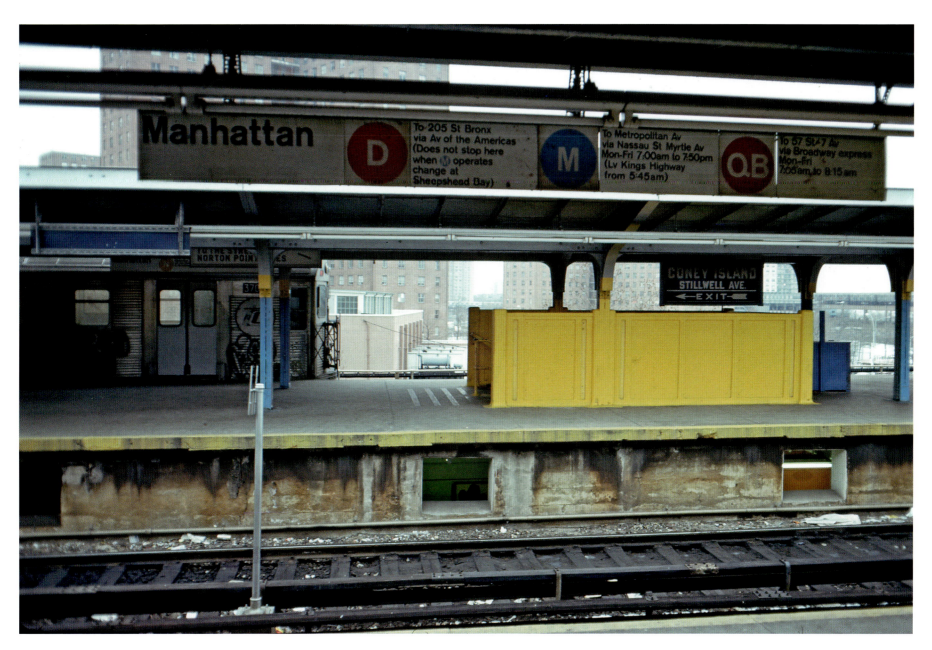

Newer-style route sign, IND/BMT, Coney Island–Stillwell Ave. Station, track #3, Brooklyn, January 25, 1976

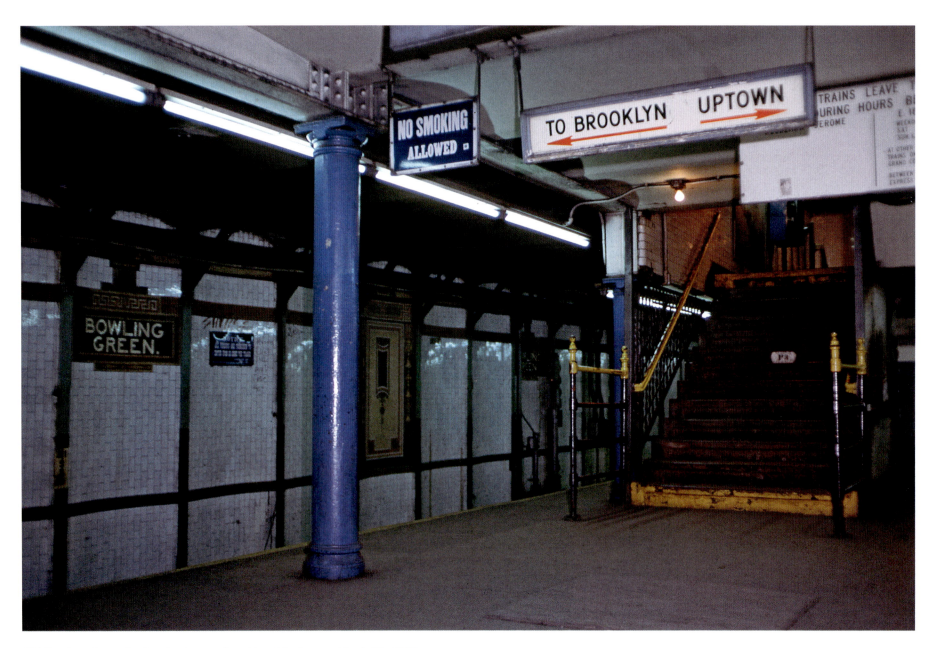

IRT, Bowling Green Station, Lexington Ave. Line, Manhattan, March 25, 1973

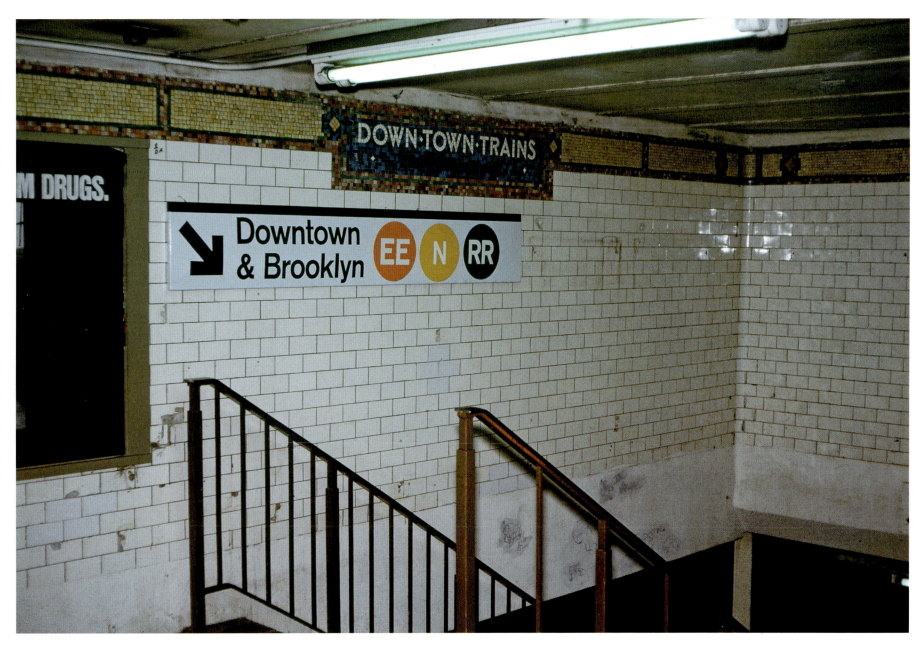

Newer-style route sign with older-style mosaic, BMT, 34th St. Station, southbound side, Broadway Subway, Manhattan, August 8, 1972

Chapter 4. Directional/Route Signs | 145

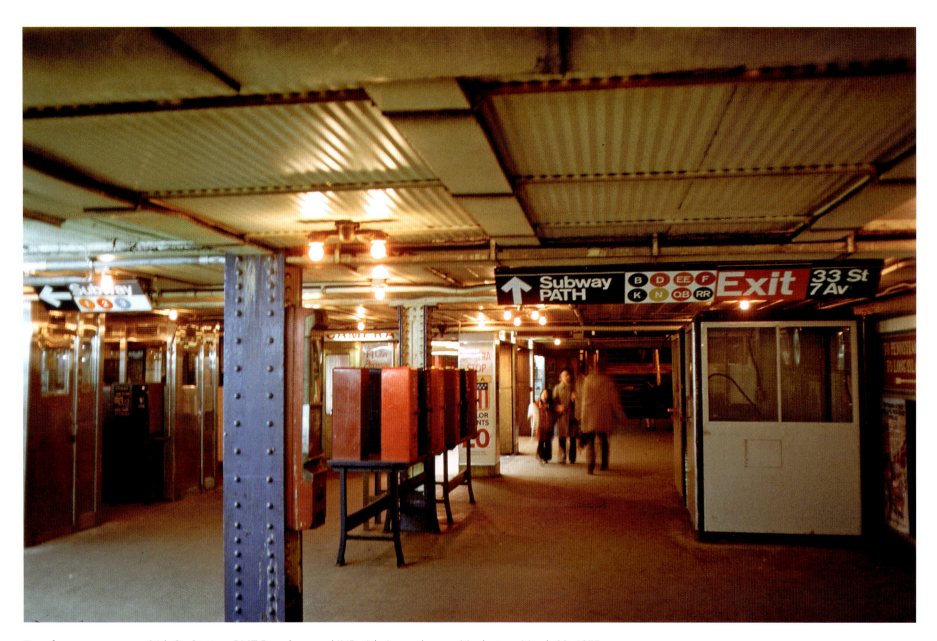

Transfer passageway to 34th St. Station, BMT Broadway and IND. 6th Ave. subways, Manhattan, March 22, 1975

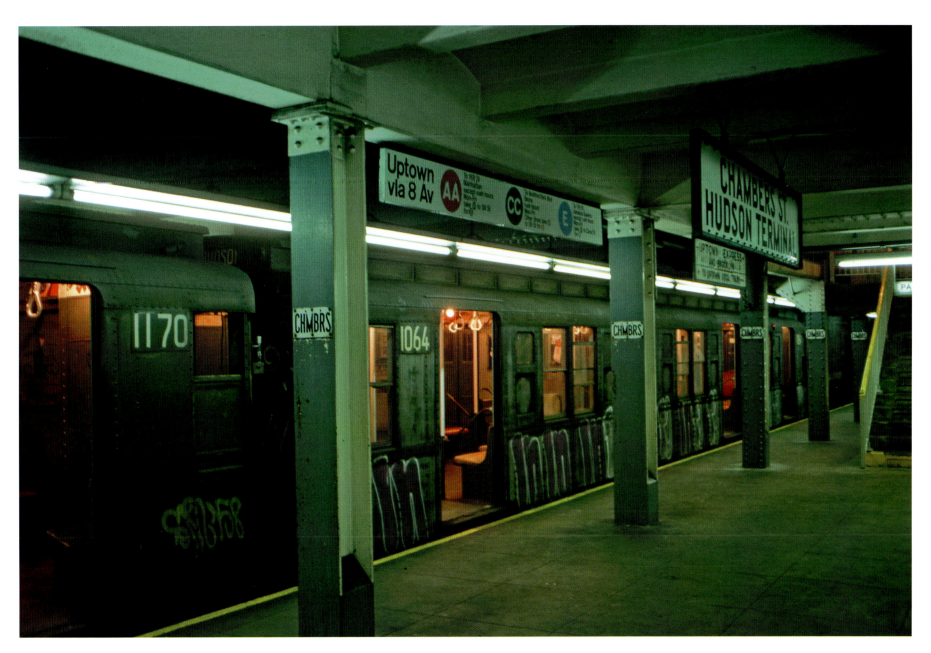

IND, Chambers St.–Hudson Terminal Station, 8th Ave. Line, Manhattan, October 24, 1975. Note: R-6 subway cars #1170 & 1064 on "CC" 8th Ave. Local.

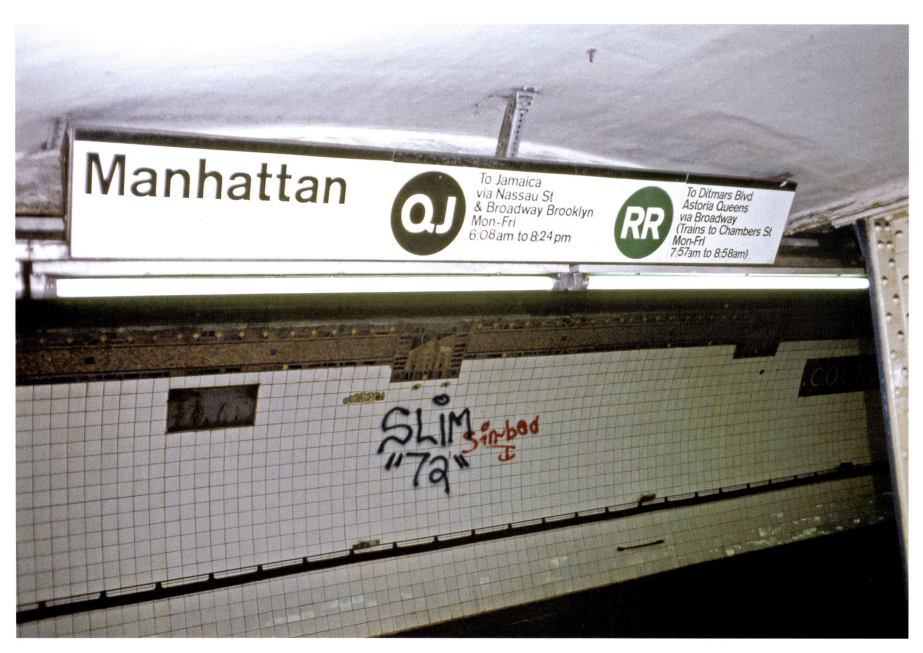

Newer-style route sign, BMT, Court St.–Borough Hall Station, northbound side, Brooklyn, August 26, 1972

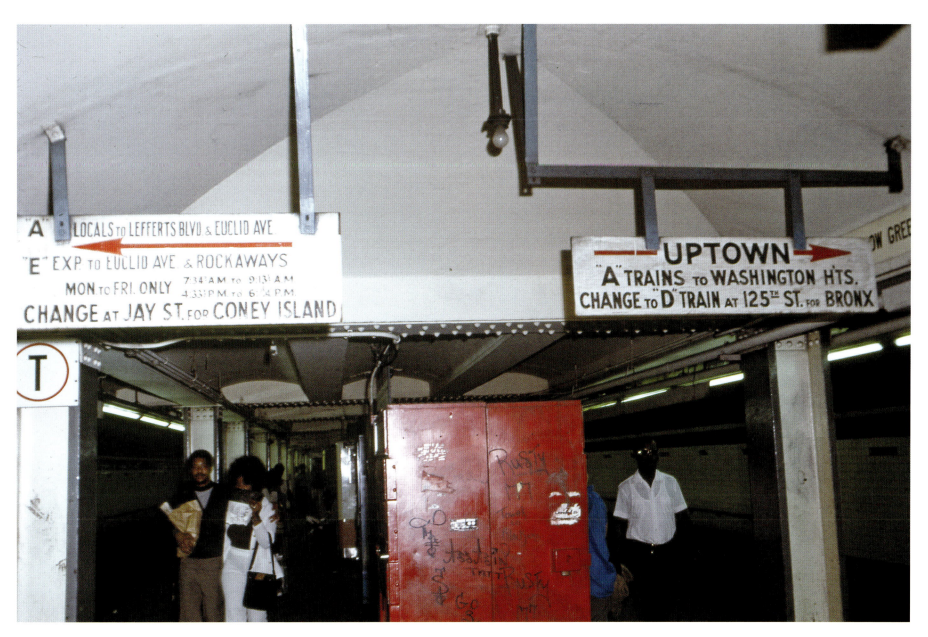

Hand-painted wood signs, IND, Broadway–Nassau St. Station, 8th Ave. Line, Manhattan, September 2, 1972

Chapter 4. Directional/Route Signs | 149

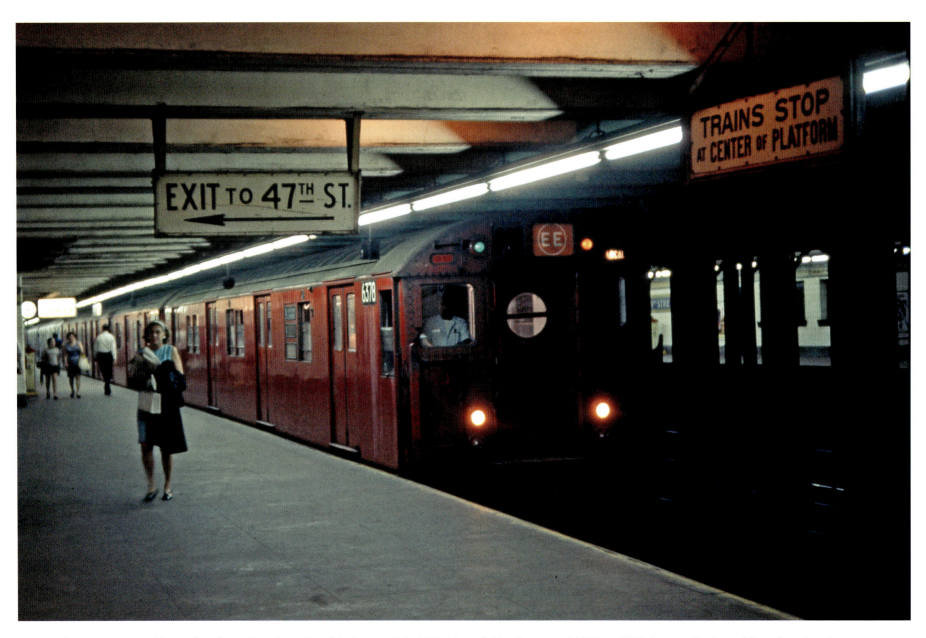

BMT, 49th St. Station, southbound platform, Broadway Line, Manhattan, July 1970. Note: R-16 subway car #6378 on "EE" Queens Boulevard–Broadway Local.

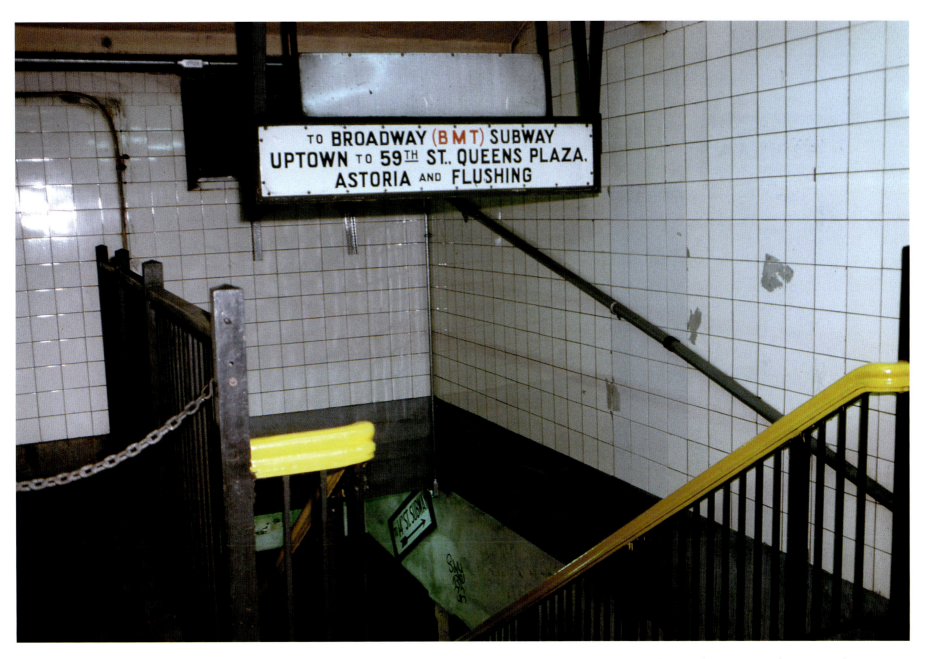

Porcelain sign at BMT 14th St.–Union Square Station, uptown side, Broadway Line, Manhattan, October 15, 1972

Chapter 4. Directional/Route Signs | 151

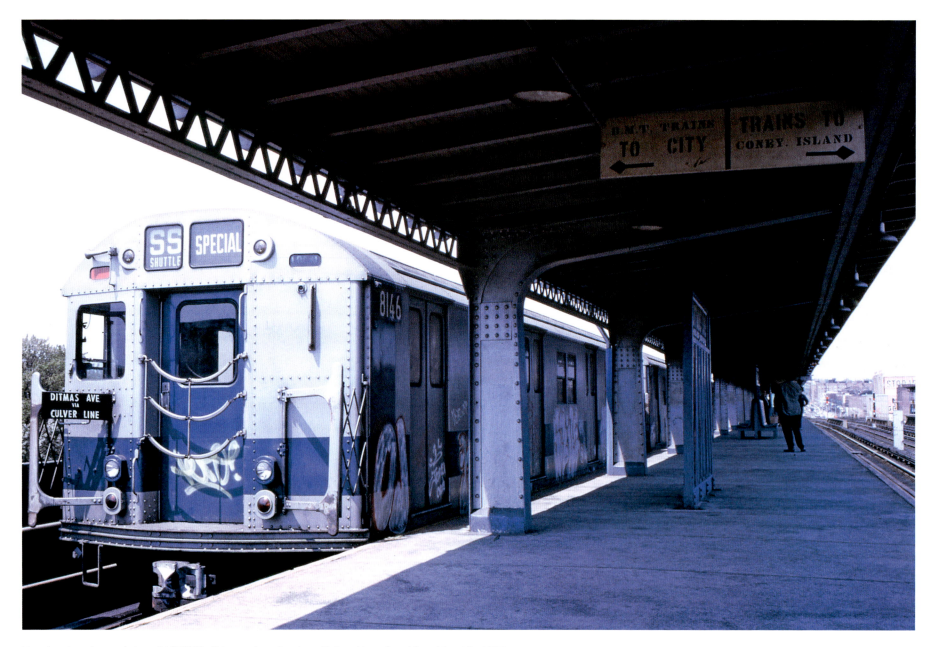

Hand-painted wood sign, BMT/IND, Ditmas Ave. Station, Culver Line, Brooklyn, May 10, 1975.
Note: R-27 subway car #8146 on Culver Shuttle, last full day of service.

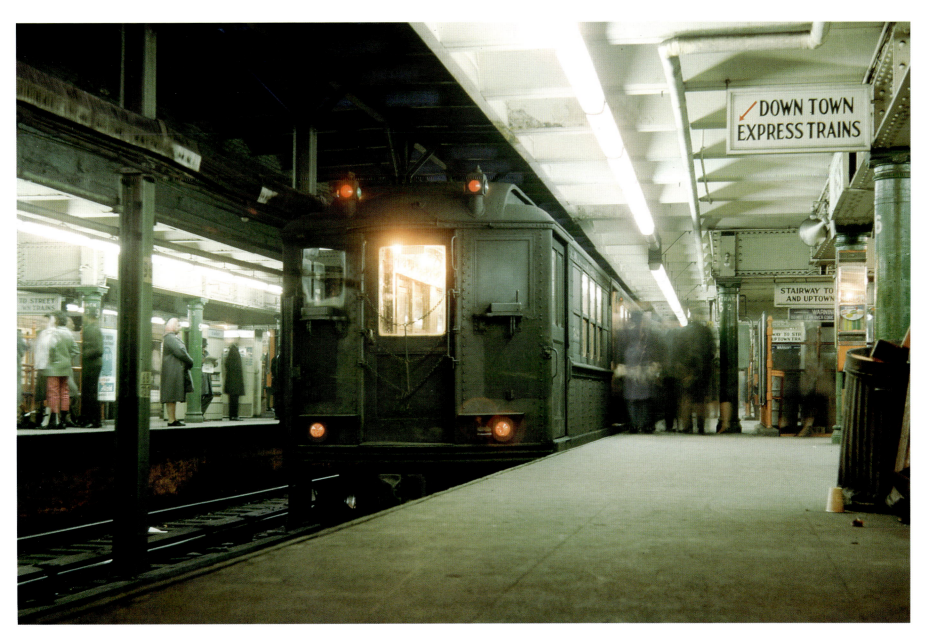

IRT, 96th St. Station, Broadway–7th Ave. Line, downtown platform, Manhattan, 1964. Note: Lo-V subway car, built 1925.

Chapter 4. Directional/Route Signs | 153

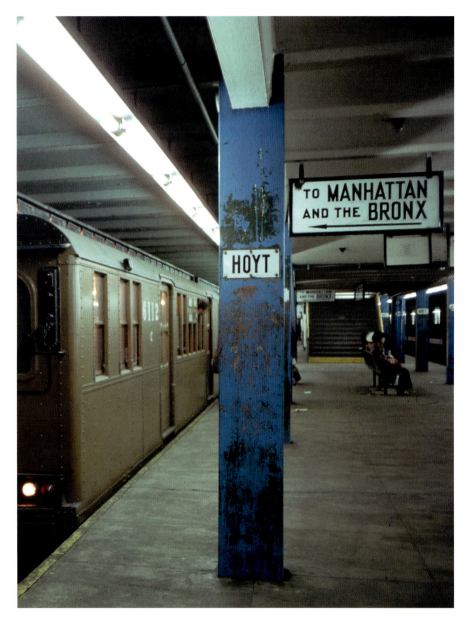

IND, Hoyt-Schermerhorn Sts. Station, Brooklyn, December 5, 1976

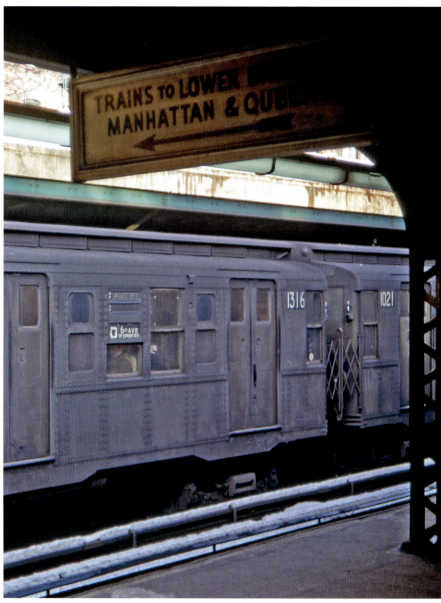

Hand-painted wooden sign, IND/BMT, Prospect Park Station, Brooklyn, February 13, 1969

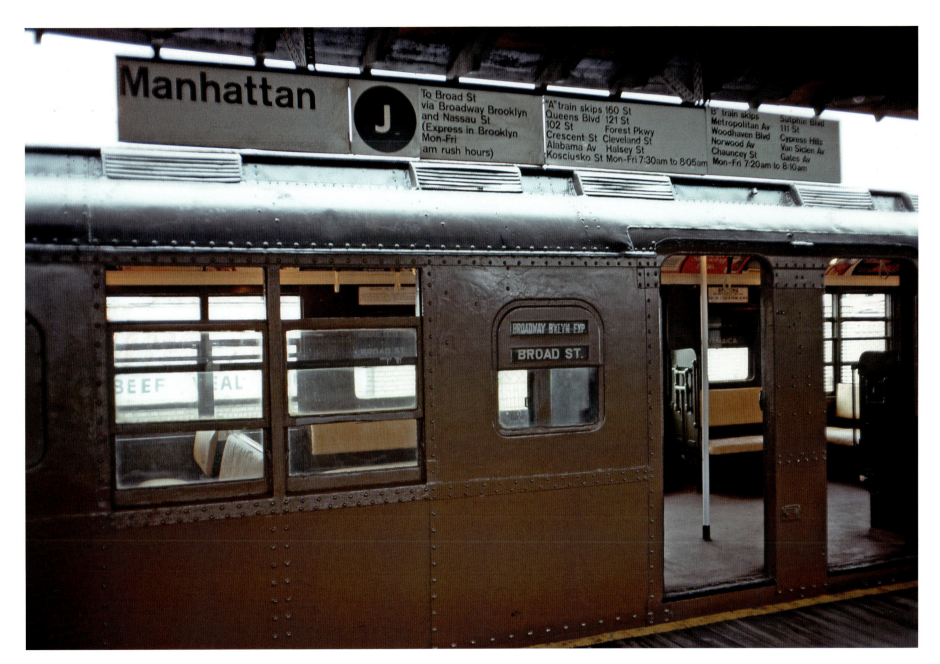

BMT, 168th St. Station, Jamaica Line, Queens, September 10, 1977. Note: restored B type, built 1917.

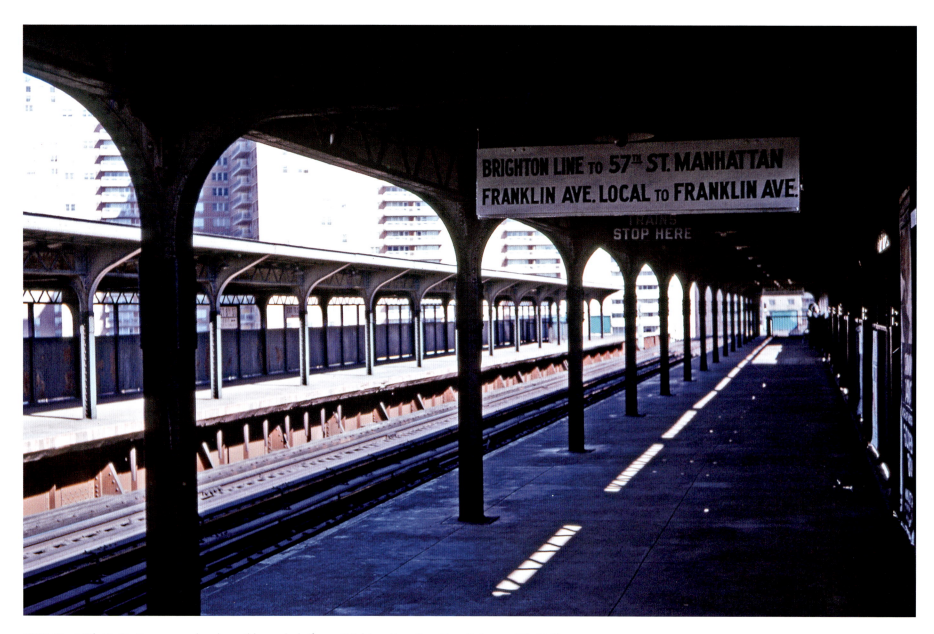

BMT, West 8th St. Station, upper level, northbound platform, Brighton Line, Brooklyn, February 20, 1965

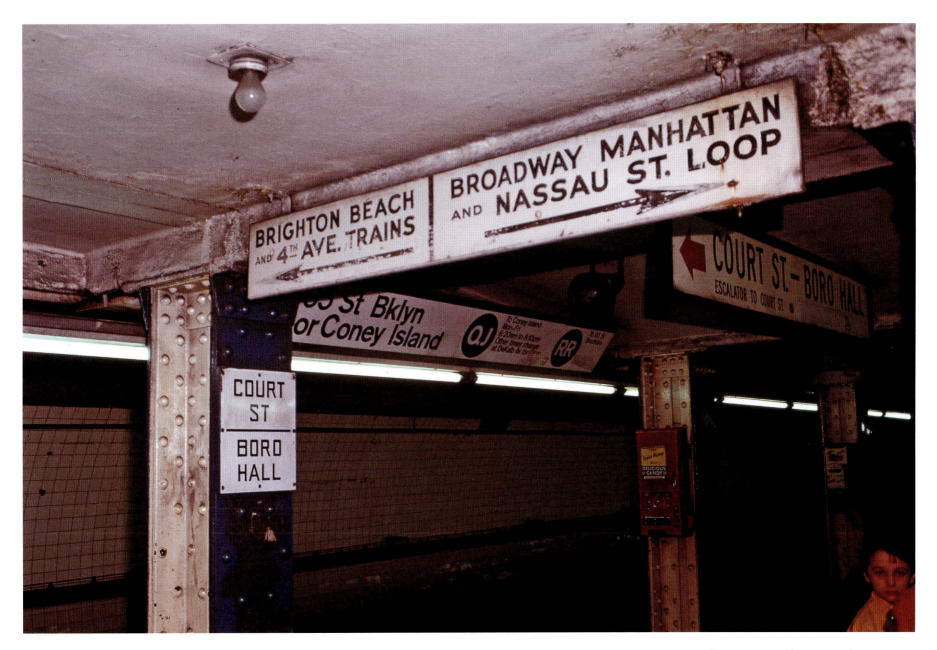

BMT, Court St.–Boro Hall Station, Brooklyn, November 19, 1972

Chapter 4. Directional/Route Signs | 157

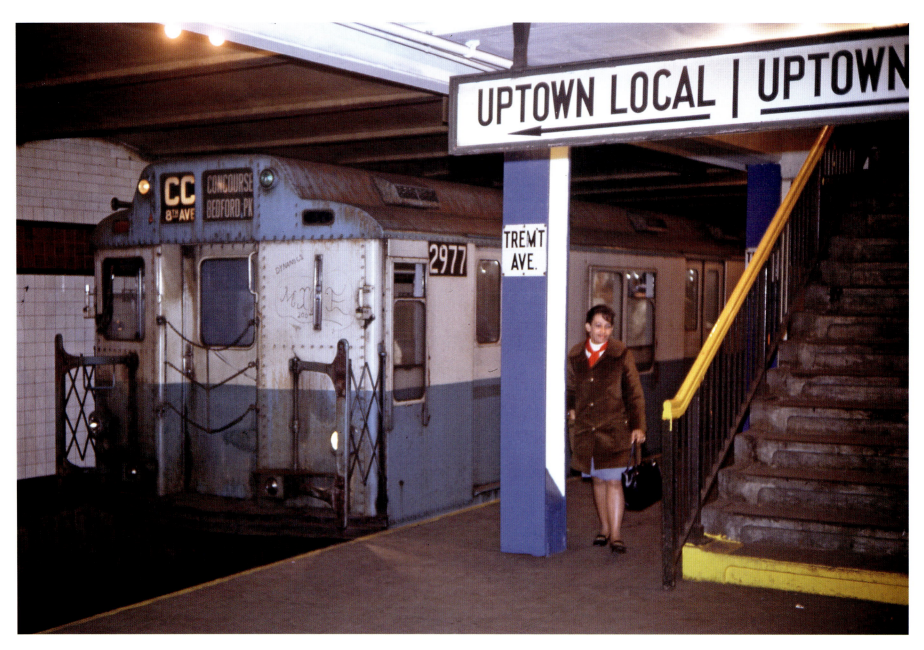

IND, Tremont Ave. Station, northbound platform, Concourse Line, Bronx, November 11, 1970. Note: R-10 subway car #2977 on "CC"–8th Ave. Local.

158 | Vintage New York City Subway Signs | 1920s-1980s

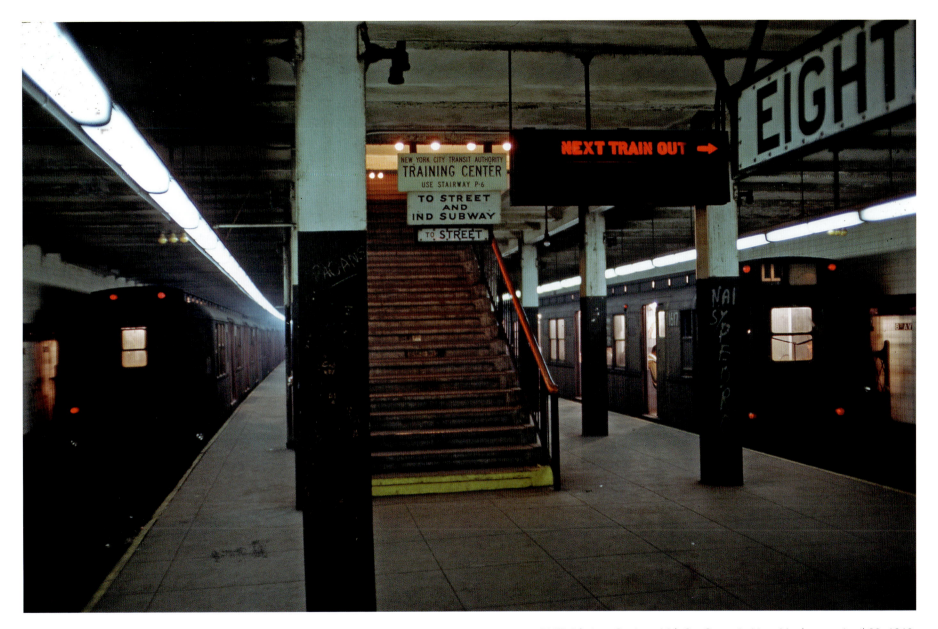

BMT, 8th Ave. Station, 14th St.–Canarsie Line, Manhattan, April 28, 1969.
Note: BMT B-type subway car #2752 (*at left*), and former IND R-7A subway car #1617 (*at right*).

Chapter 4. Directional/Route Signs | 159

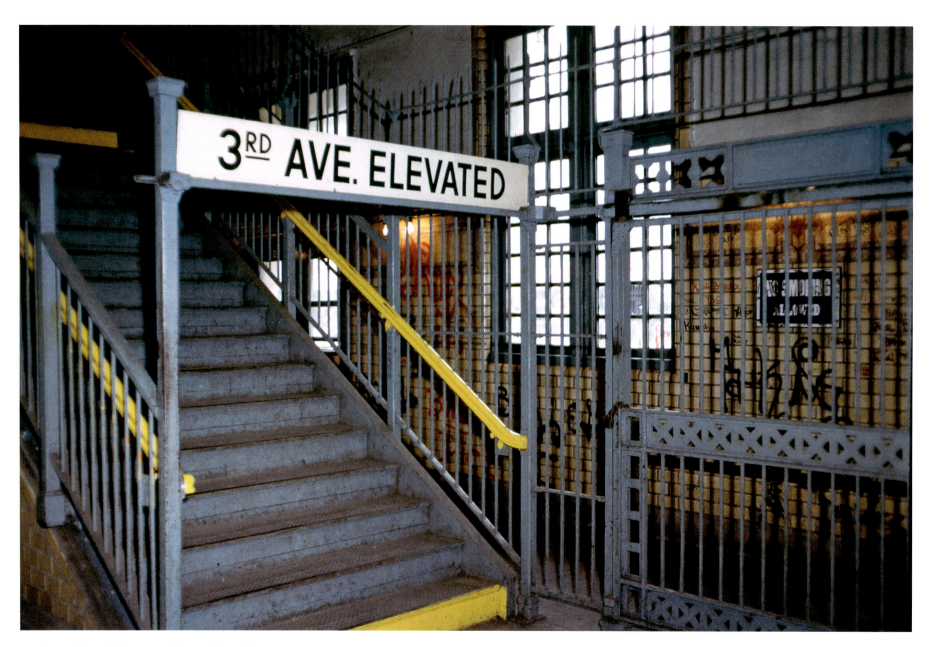

IRT, Gun Hill Road Station, 3rd Ave. Elevated Line, Bronx, 1973

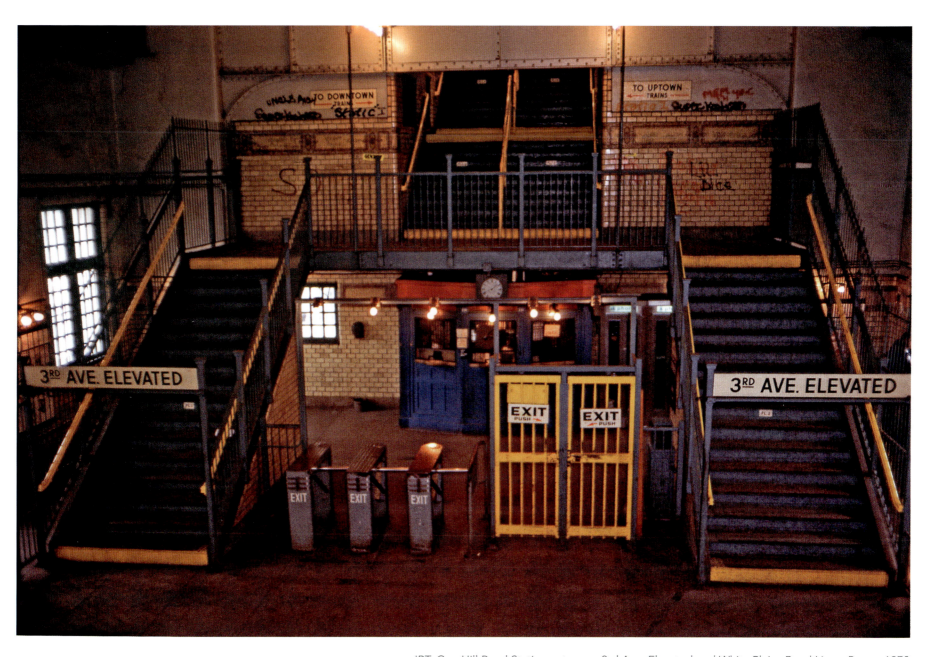

IRT, Gun Hill Road Station entrance, 3rd Ave. Elevated and White Plains Road Lines, Bronx, 1973

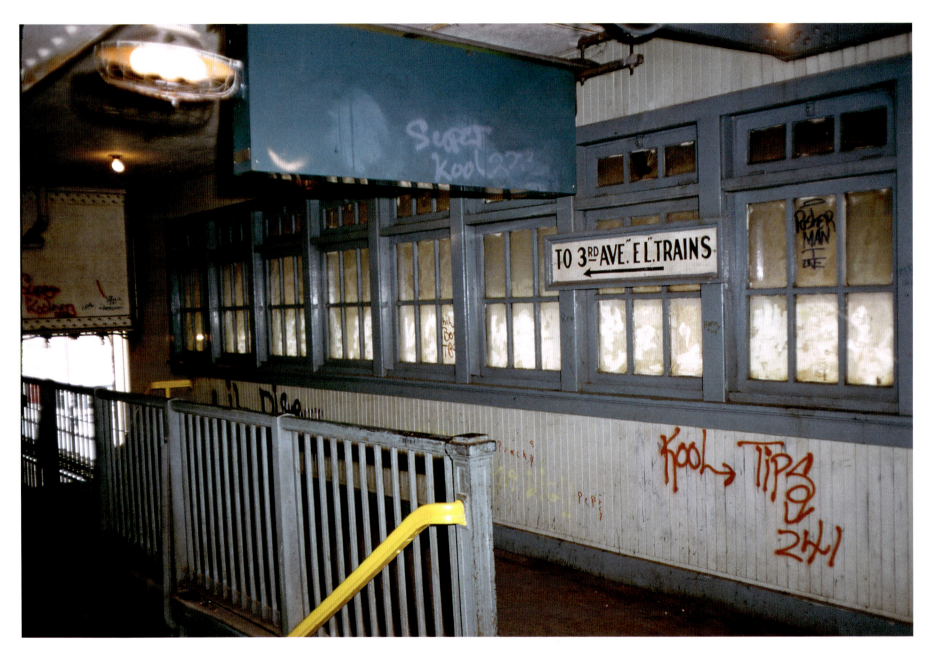
IRT, Gun Hill Road Station, passageway to 3rd Ave. Elevated, lower level, Bronx, March 25, 1973

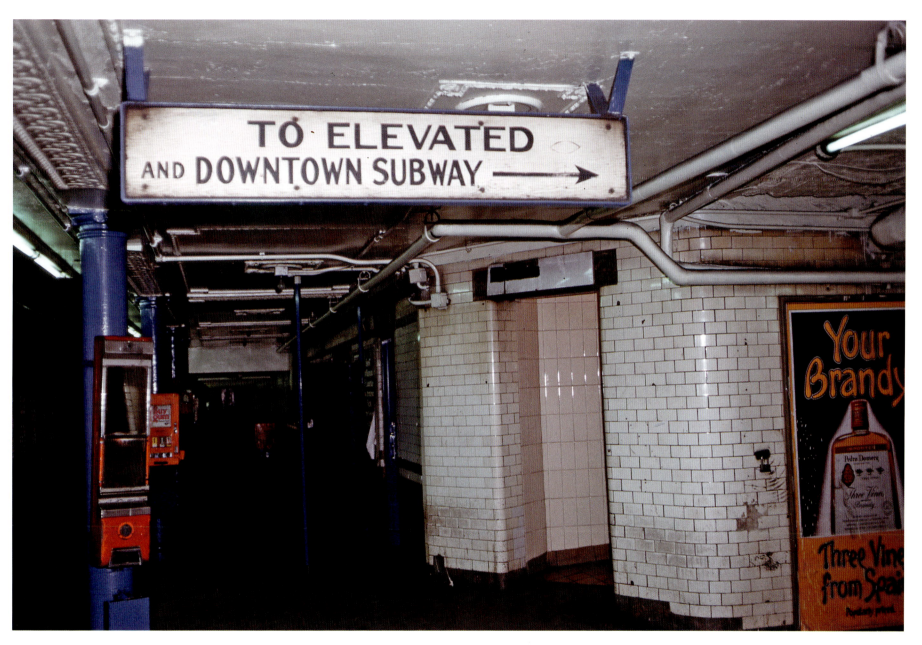

IRT, 149th St.–3rd Ave. subway station, northbound platform, Bronx, April 22, 1973

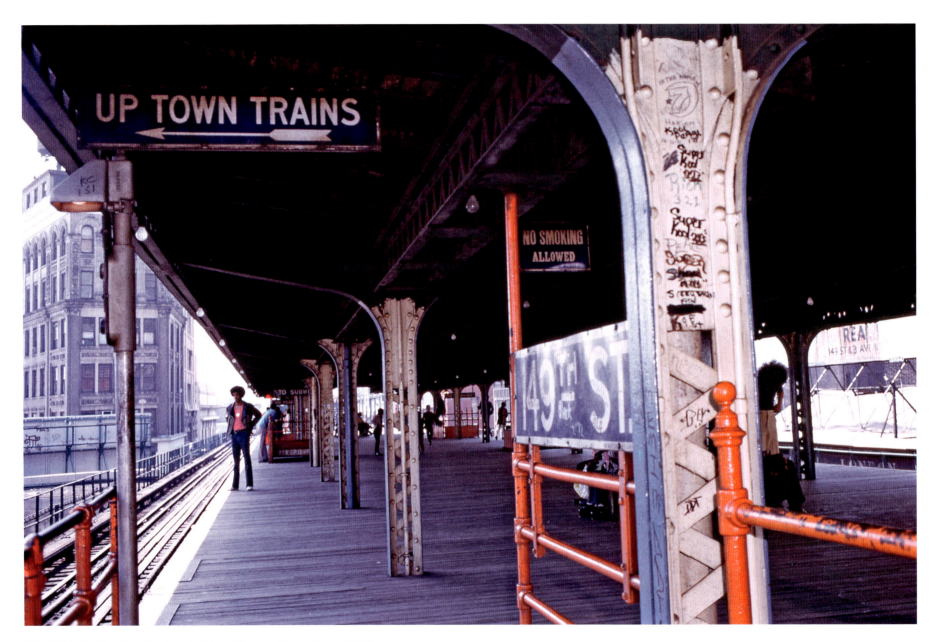

IRT, 149th St.–3rd Ave. Station, 3rd Ave. Elevated Line, Bronx, 1973

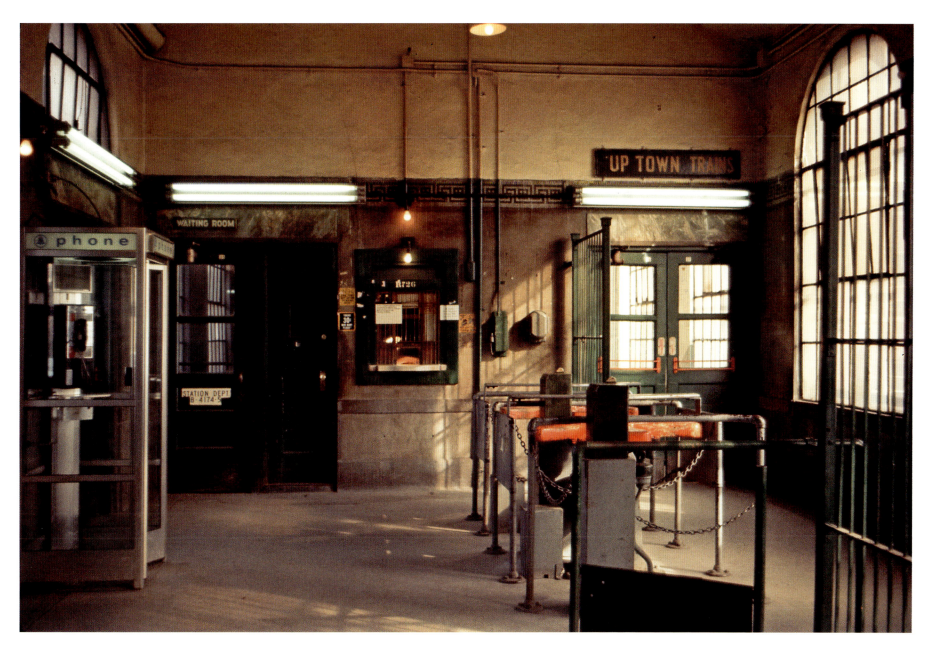

IRT, Morris Park Station Entrance, Dyre Ave. Line, Bronx, April 1970

Subway passageway, 1988

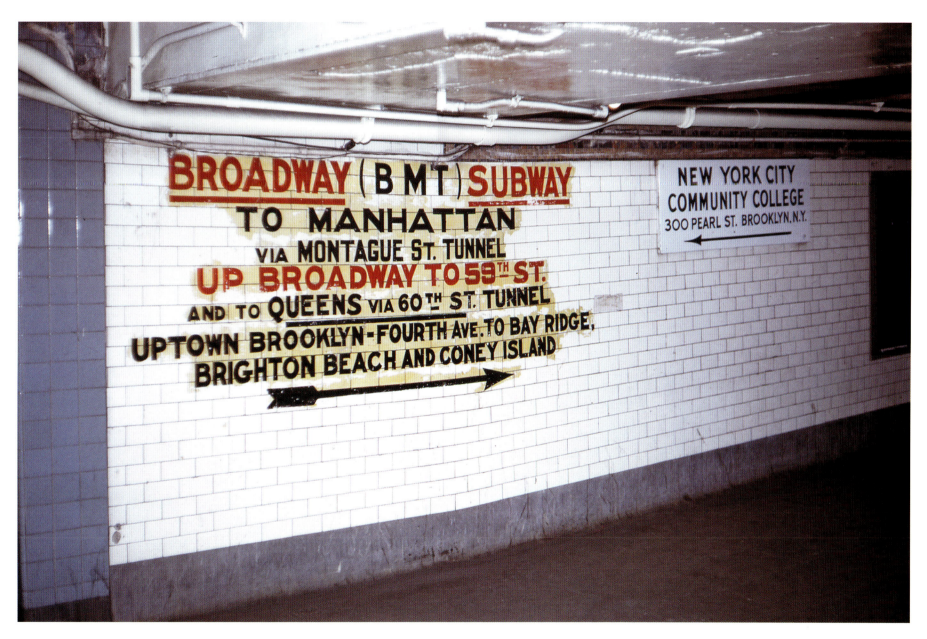

Painted tile sign, transfer passageway between IRT & BMT at Court St.–Boro Hall Station, Brooklyn, August 26, 1972

Chapter 4. Directional/Route Signs | 167

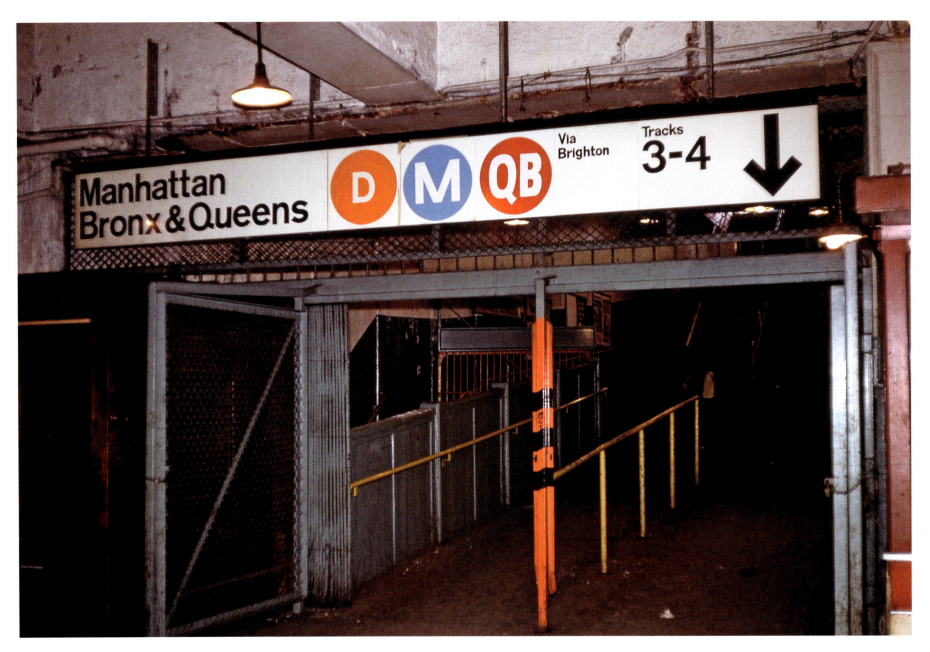

Stillwell Ave.–Coney Island Station, downstairs mezzanine, IND/BMT, Brighton Line, Brooklyn, March 18, 1973

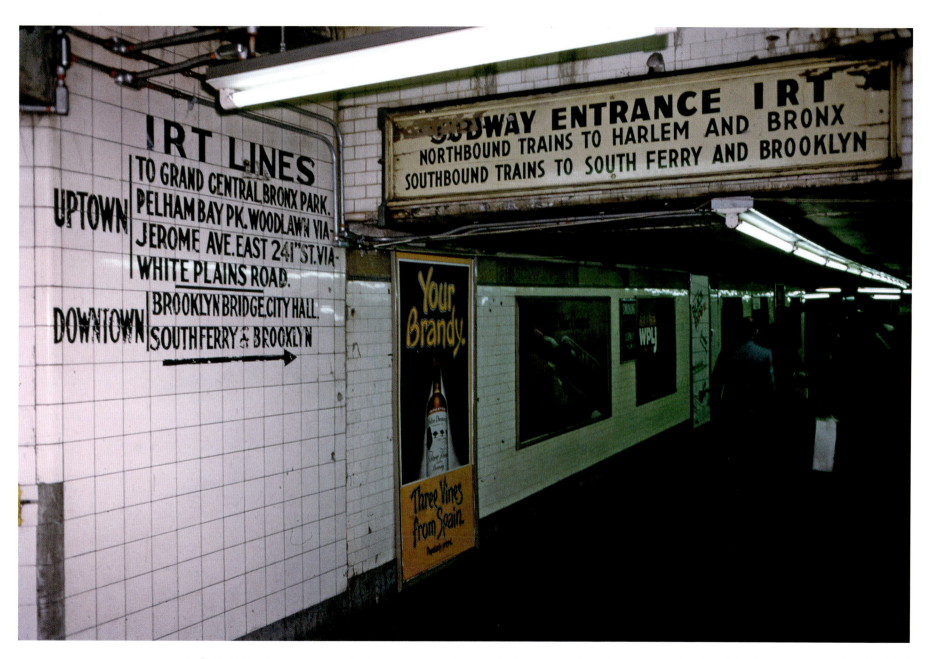

14th St.–Union Square subway station, passageway between IRT Lexington Ave. Line and BMT Broadway Line, Manhattan, October 15, 1972

Chapter 4. Directional/Route Signs | 169

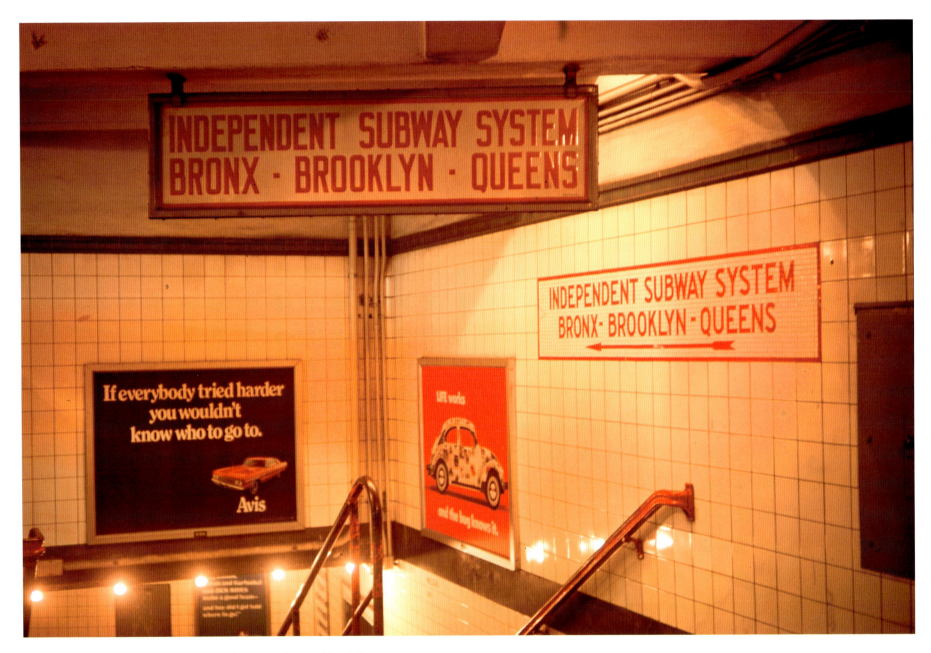

IND, 34th St. Station, 6th Ave. Line, Manhattan, February 22, 1969

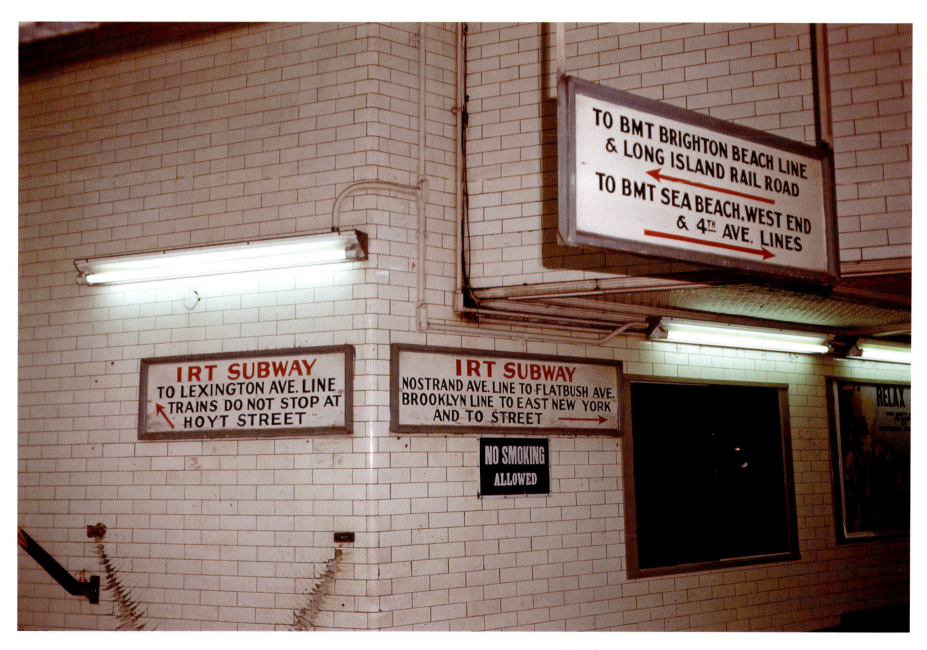

IRT, Atlantic Ave. Station, mezzanine, Brooklyn, November 19, 1972

Chapter 4. Directional/Route Signs | 171

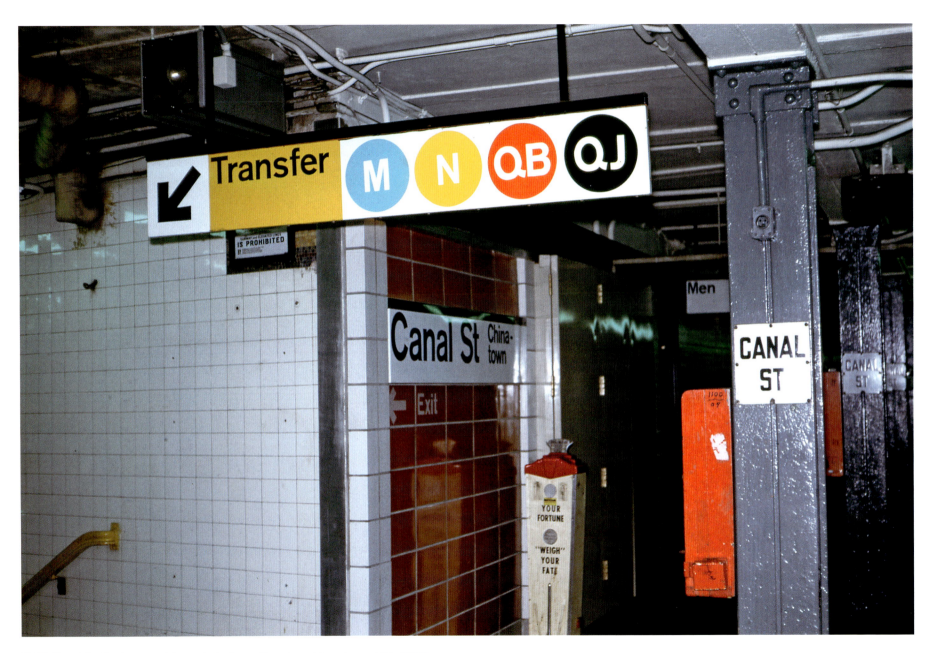

BMT, Canal St. Station, southbound platform, Broadway Line, August 26, 1972

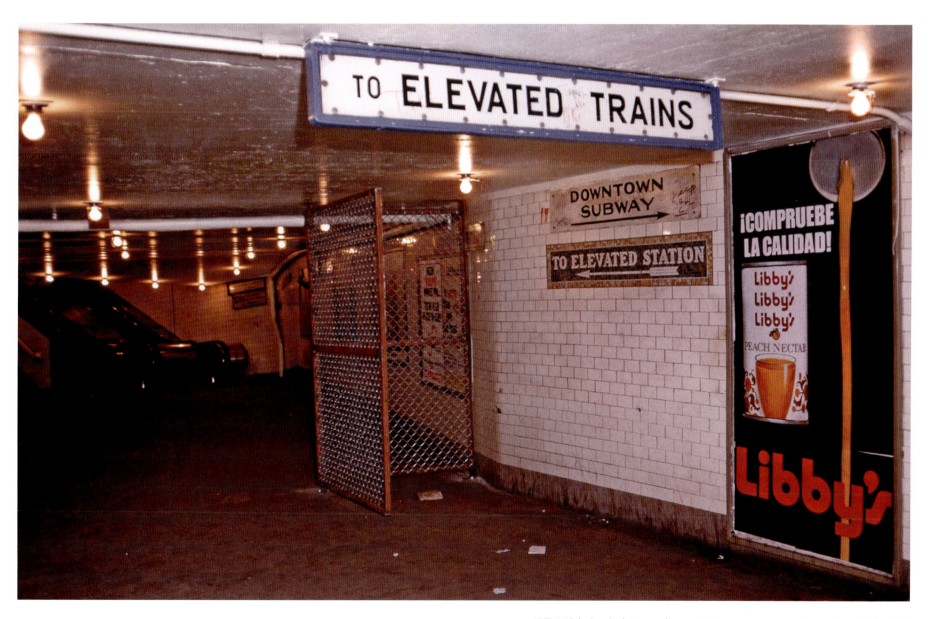

IRT, 149th St.–3rd Ave. subway station passageway, Bronx, April 13, 1973

Chapter 4. Directional/Route Signs | 173

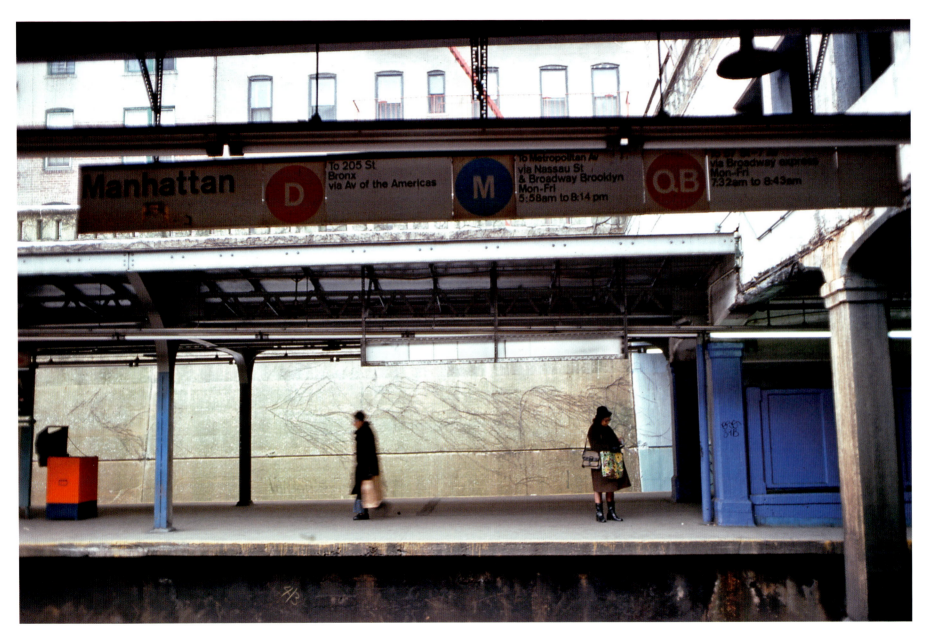

BMT/IND, Prospect Park Station, Brighton Line, Brooklyn, January 24, 1976

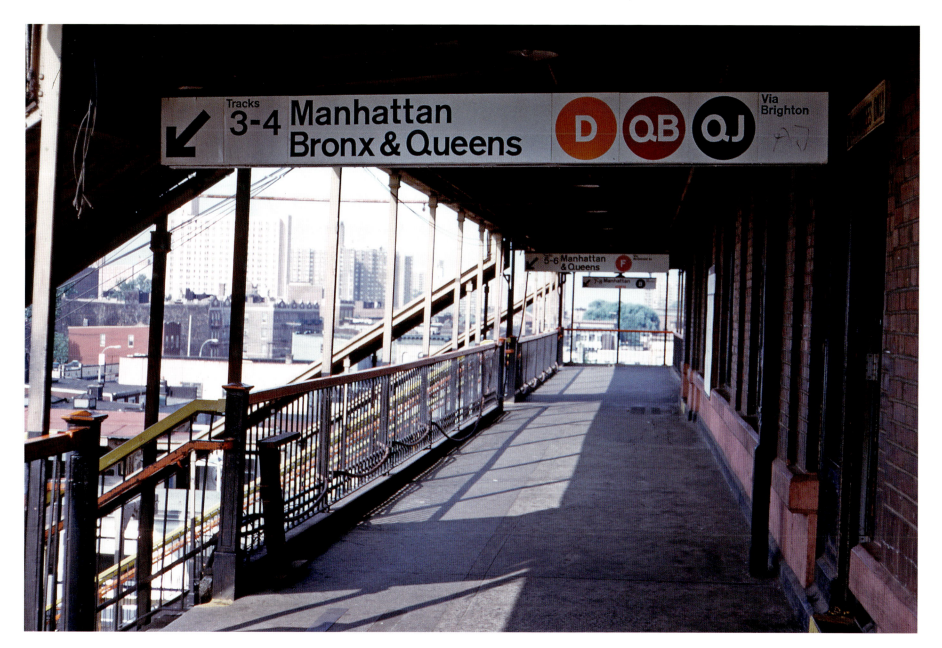

BMT/IND, Stillwell Ave.–Coney Island Station overpass, Brooklyn, August 27, 1972

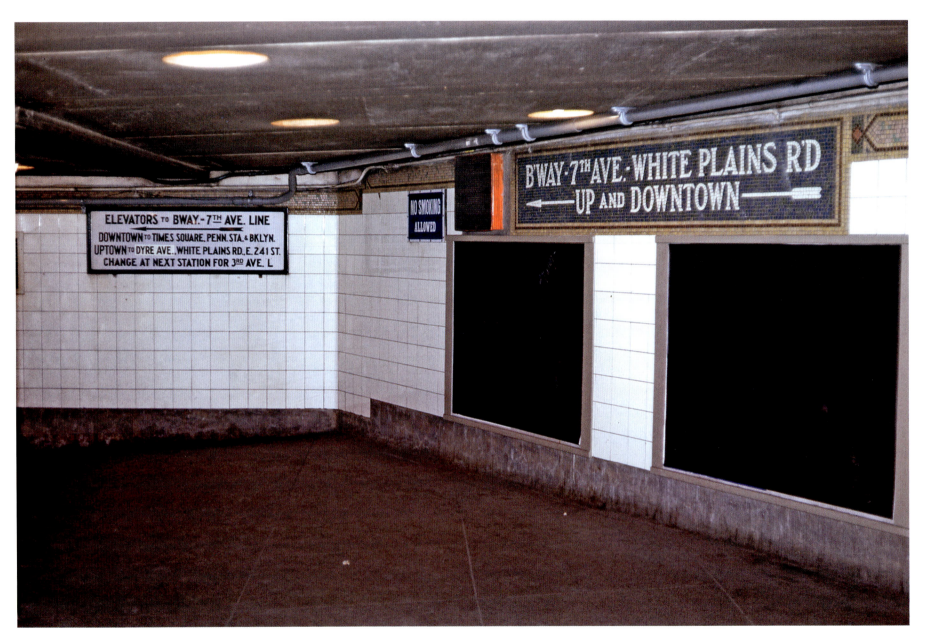

IRT, 149th St.–Concourse Station mezzanine, Bronx, May 9, 1970

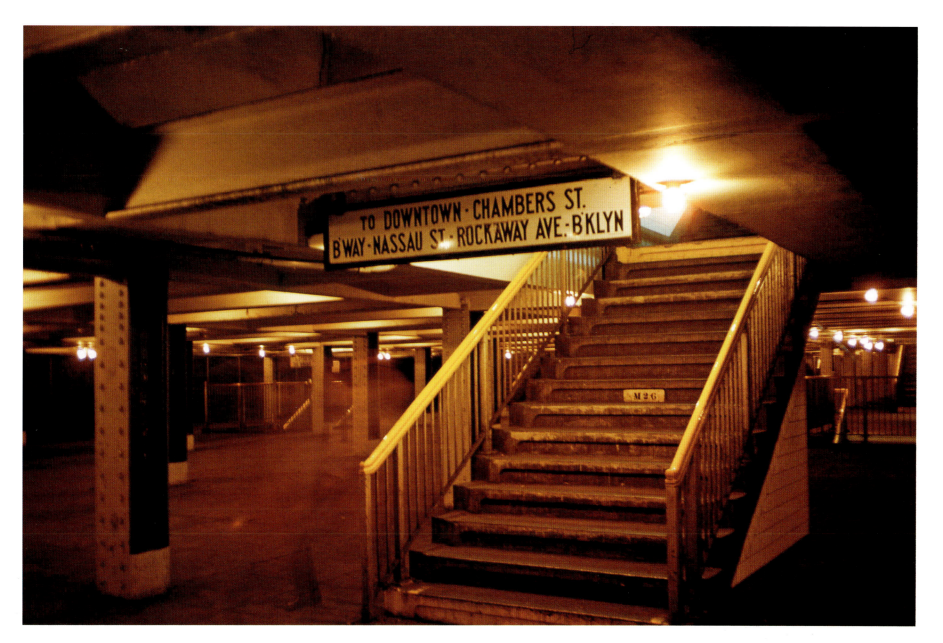

IND, West 4th St. Station mezzanine, Manhattan, December 27, 1974

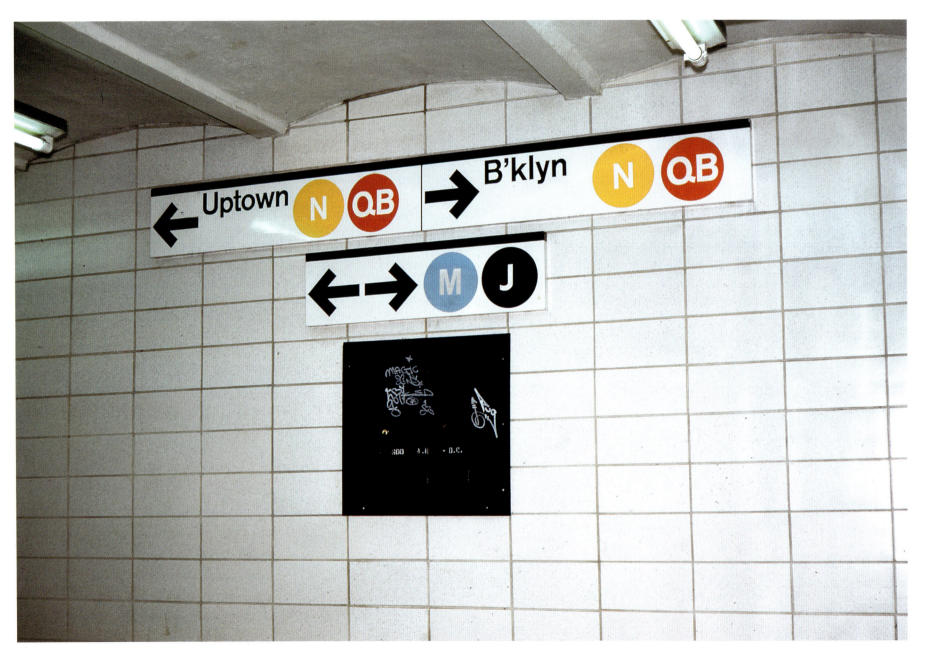

BMT, Canal St. Station passageway, Broadway Line, Manhattan, December 23, 1972

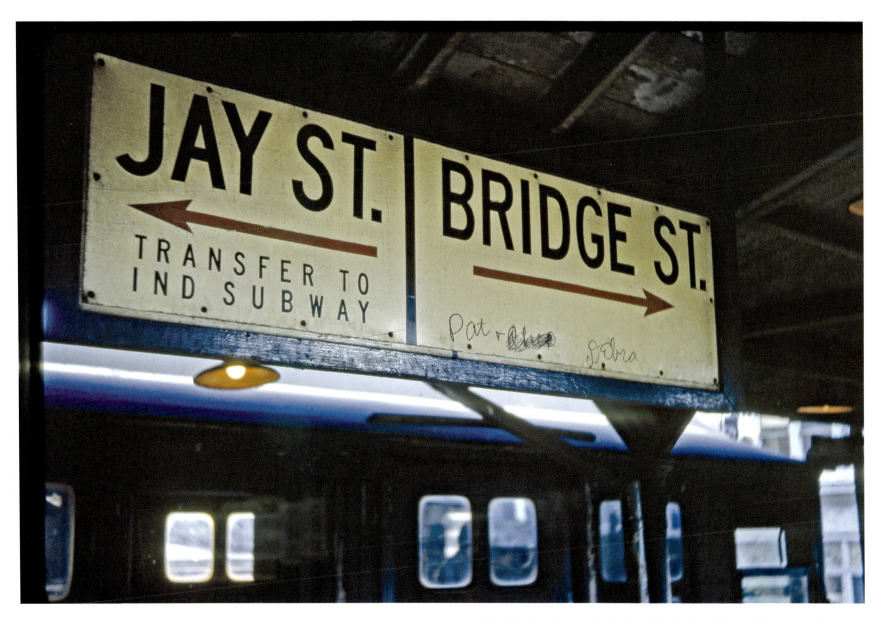

BMT, Bridge St.–Jay St. Station, Myrtle Ave. Elevated Line, Brooklyn, 1969

CHAPTER 5.
"NO SPITTING," "NO SMOKING," AND "WARNING" SIGNS

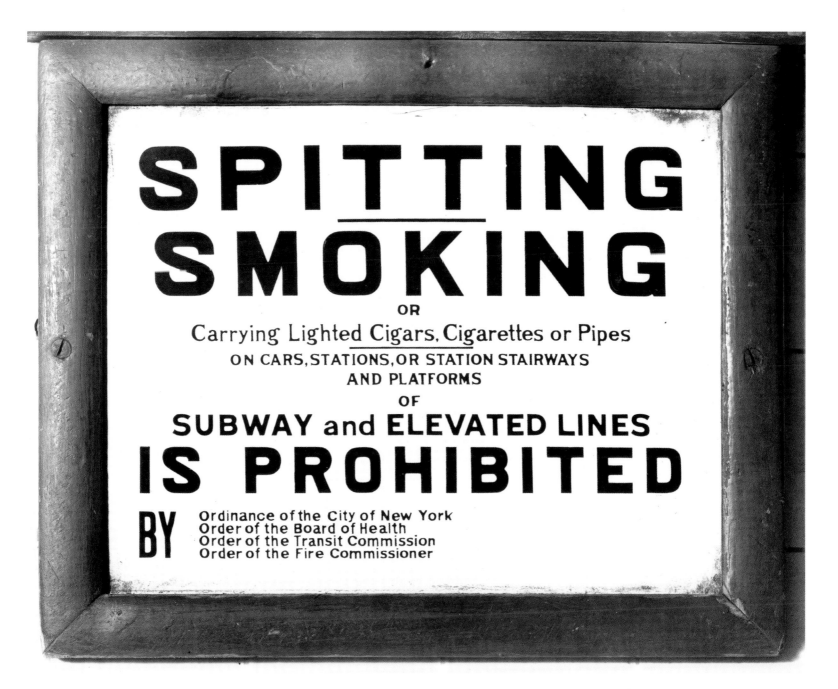

Porcelain sign with original frame, 1920s

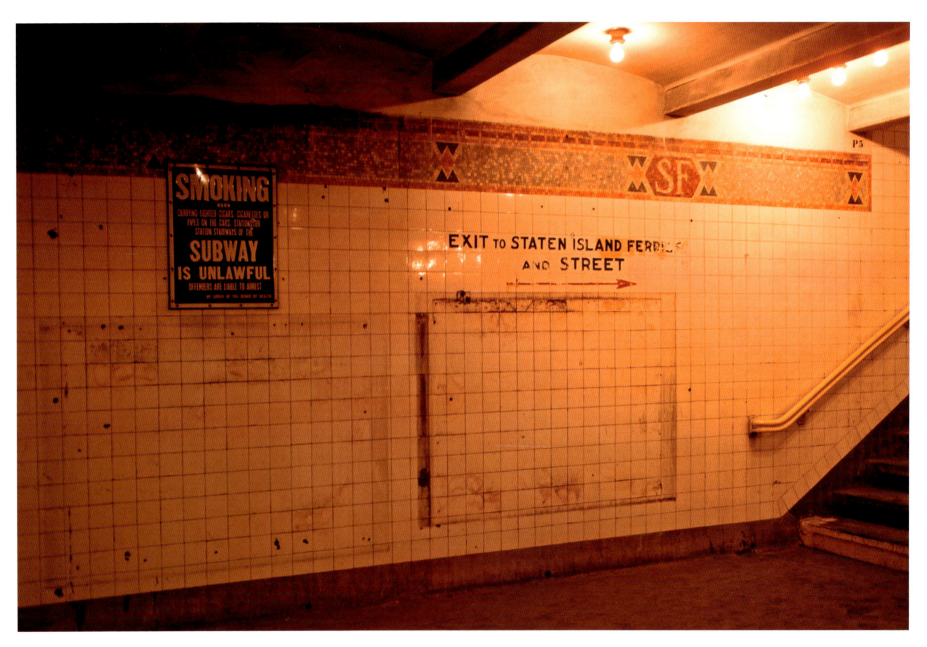

IRT, South Ferry Station, inner loop, Manhattan, February 11, 1977

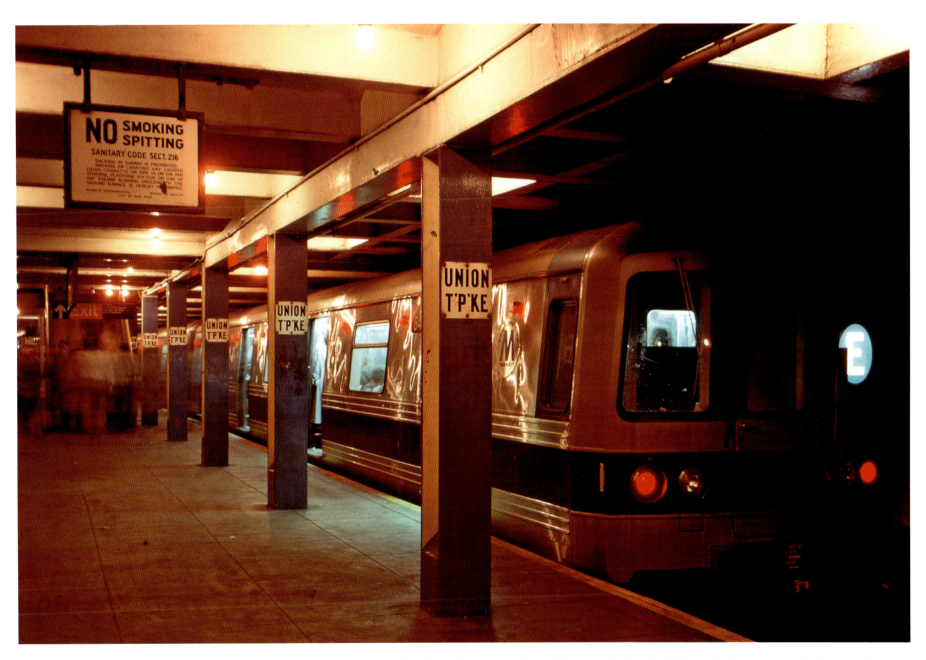
IND, Union Turnpike–Kew Gardens Station, Jamaica-bound platform, Queens Boulevard Line, October 26, 1977. Note: R-46 subway car #846 on "E" Express.

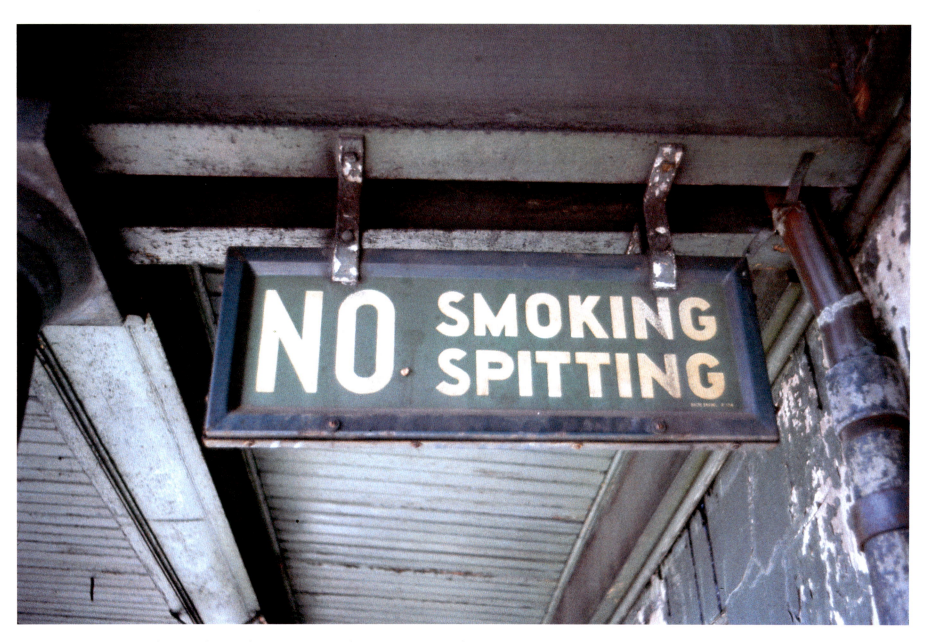

IRT, Dyre Ave. Line, original New York, Westchester & Boston Railway sign, Bronx, April 1970

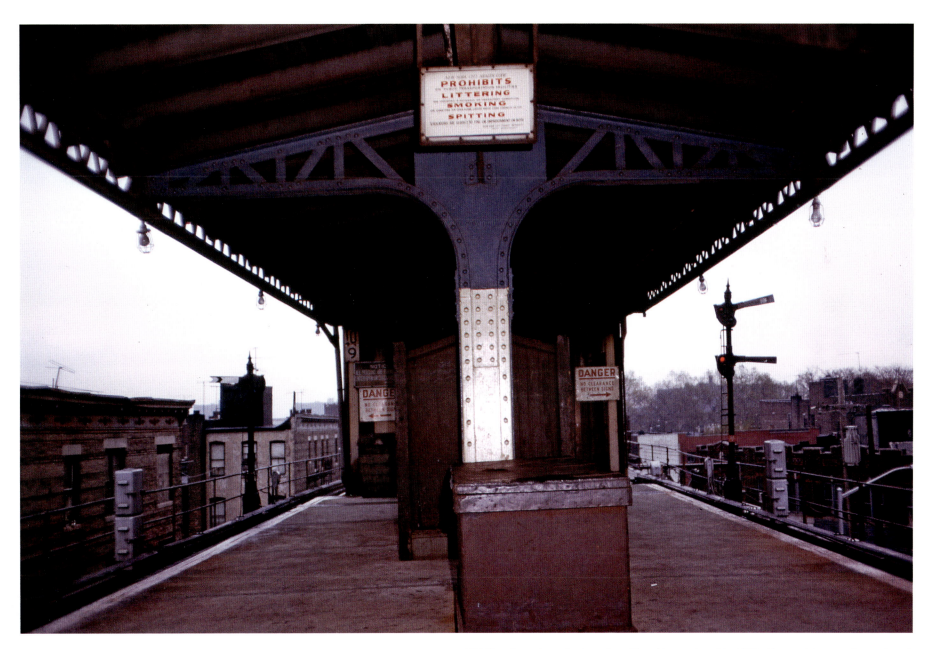

IRT, New Lots Ave. Station, Brooklyn, November 11, 1972. Note: old semaphore signal.

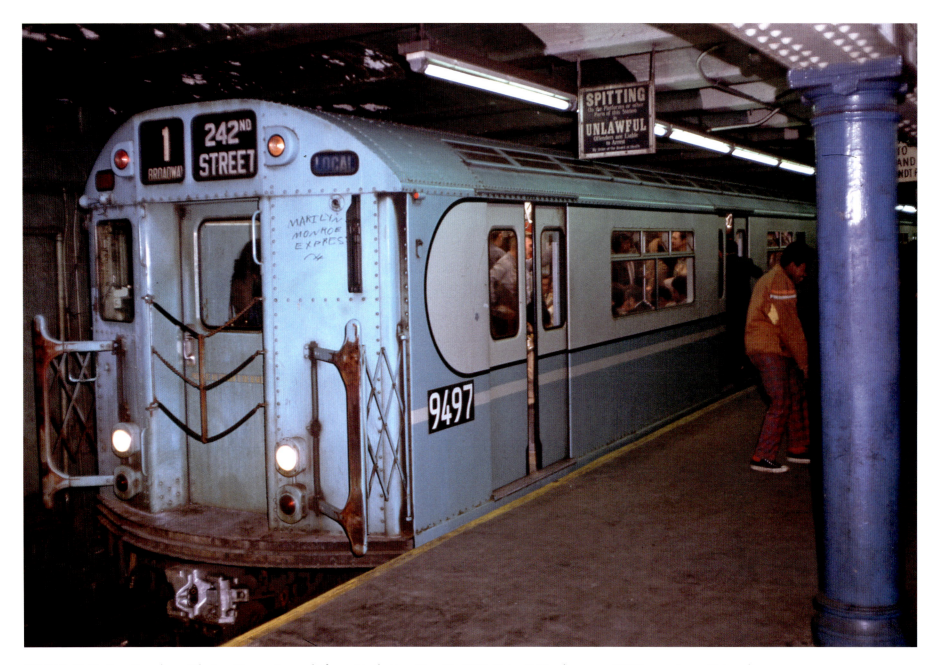

IRT, 96th St. Station, Broadway–7th Ave. Line, uptown platform, Manhattan, May 17, 1972. Note: R-36 subway car #9497 on uptown #1 Local.

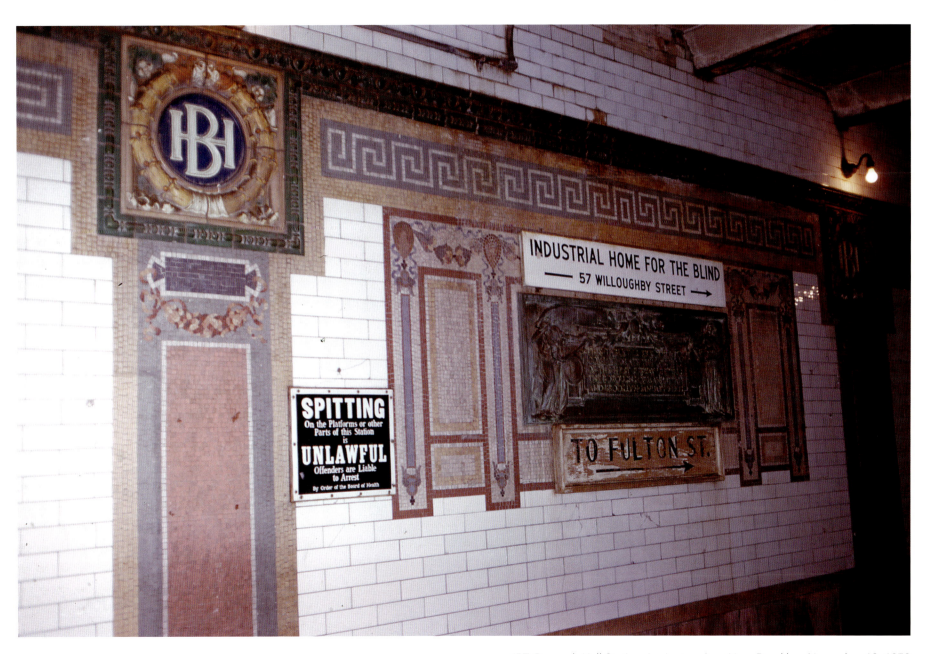

IRT, Borough Hall Station, Lexington Ave. Line, Brooklyn, November 19, 1972

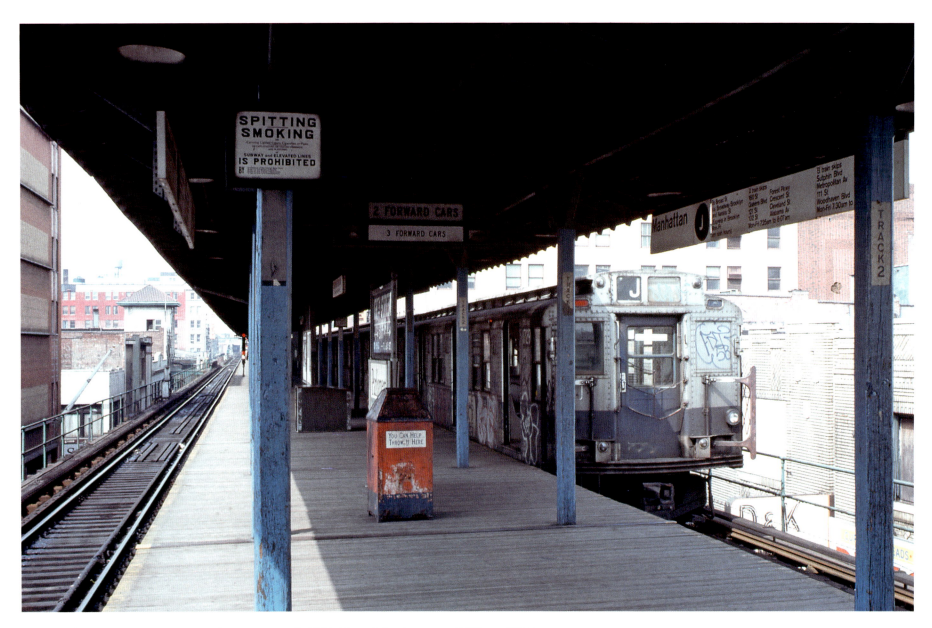

BMT, 168th St. Station, Jamaica Line, Queens, May 15, 1976. Note: R-9 subway car #1729 on "J" Line.

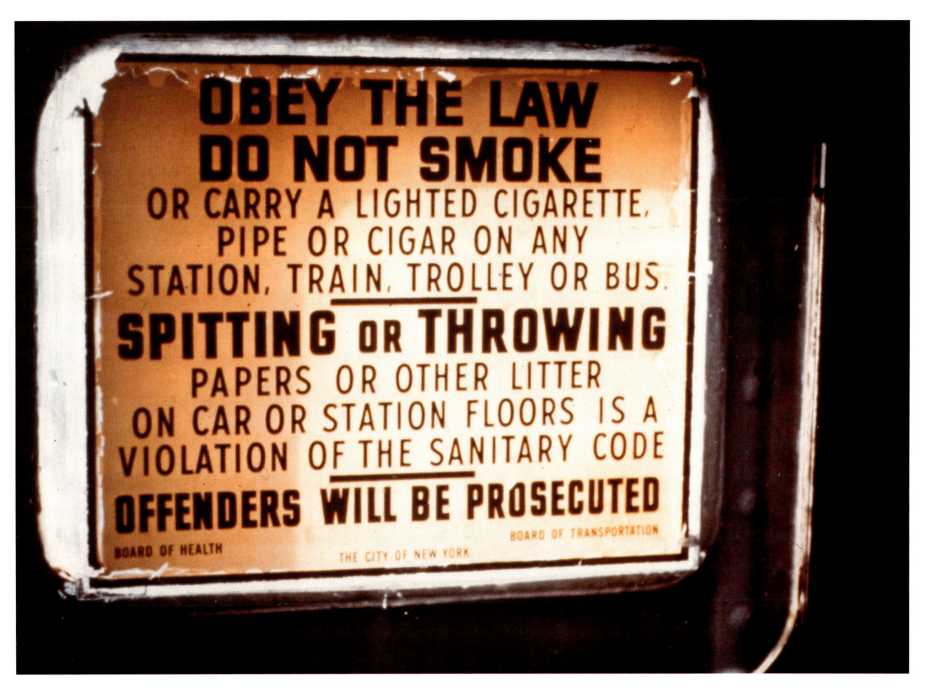

Sticker on subway car window, 1940s

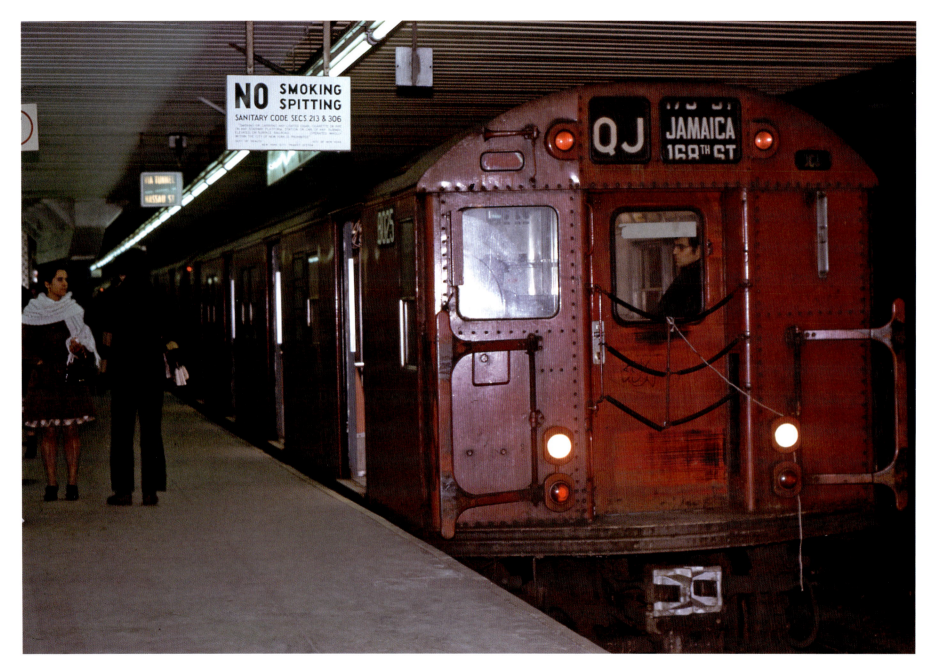

BMT, DeKalb Ave. Station, northbound platform, Brooklyn, February 10, 1971.
Note: R-27 subway car #8025 on Queens-bound "QJ" Brighton–Nassau St.–Jamaica Local.

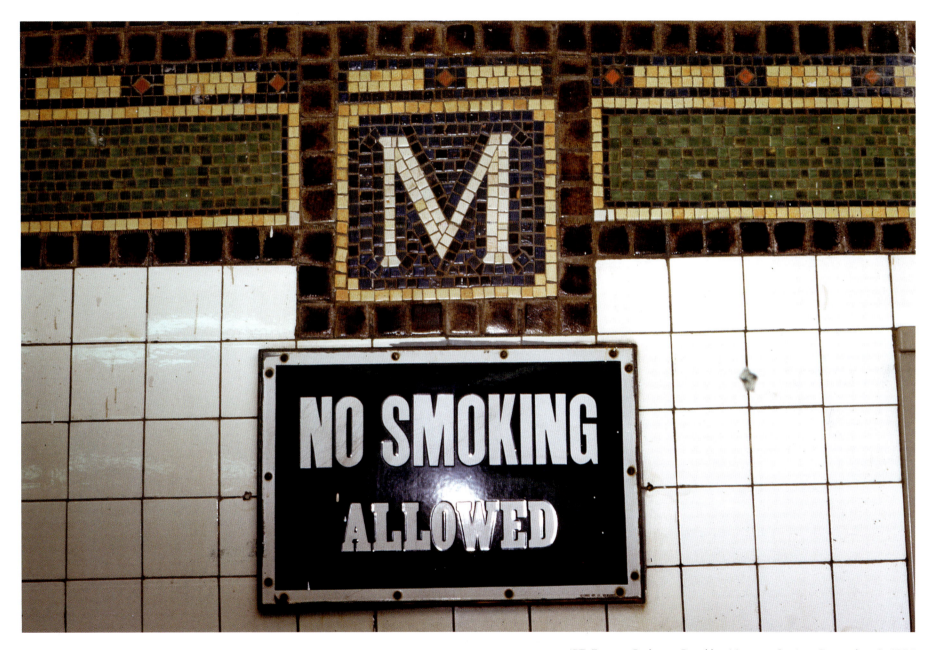

IRT, Eastern Parkway–Brooklyn Museum Station, December 9, 1974

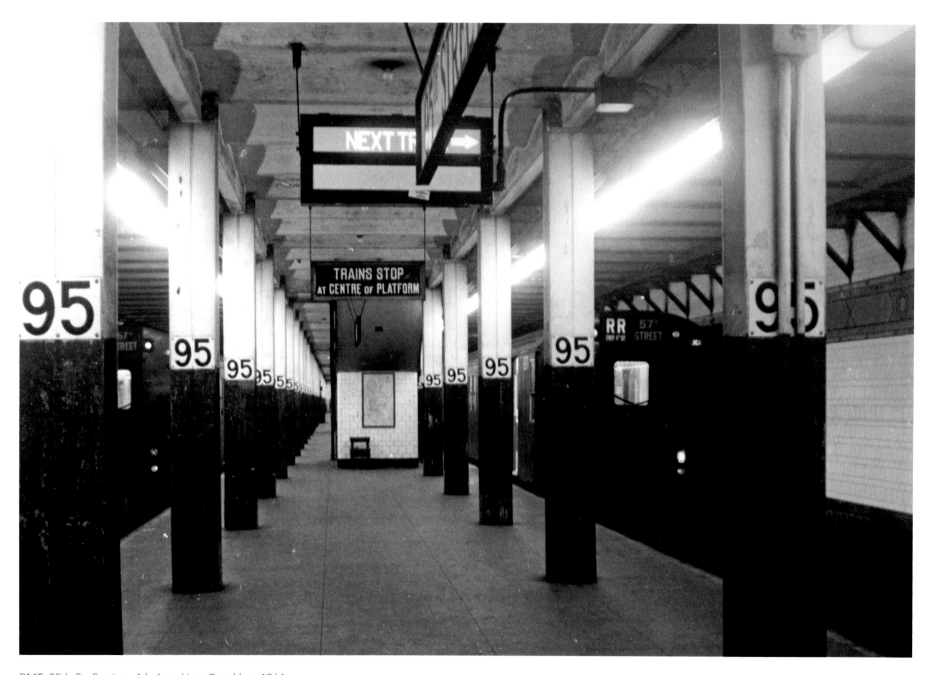
BMT, 95th St. Station, 4th Ave. Line, Brooklyn, 1961

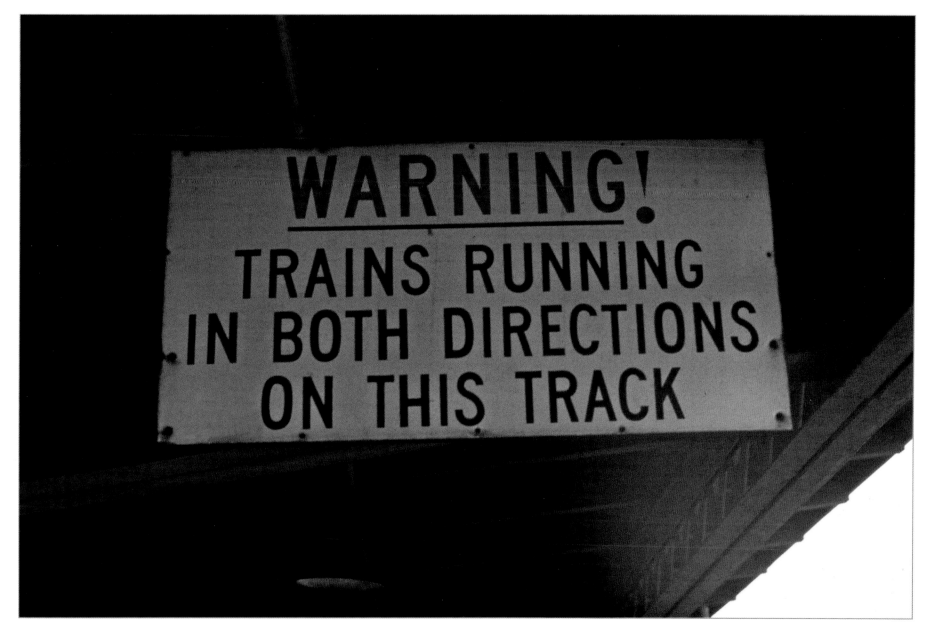

Warning sign, BMT, Culver Shuttle Line, Brooklyn, 1975

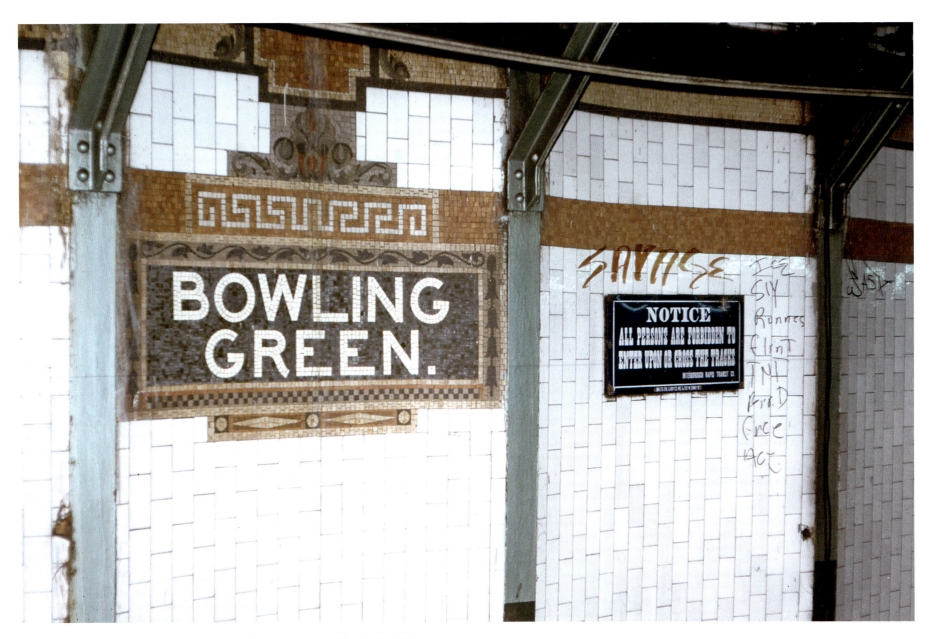

IRT, Bowling Green Station, Lexington Ave. Line, Manhattan, March 25, 1973

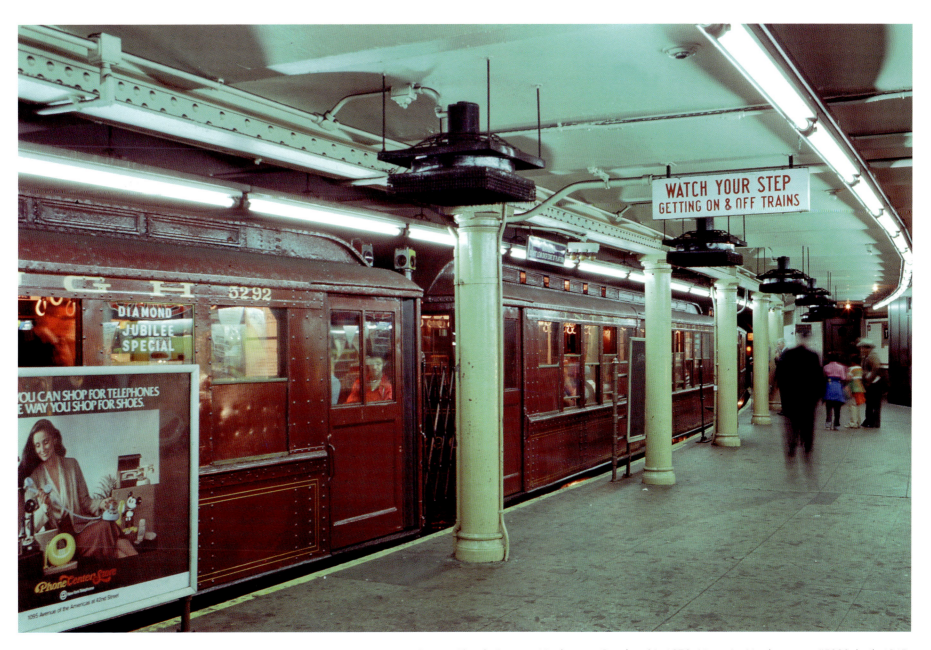

IRT, Times Square Shuttle Station, Manhattan, October 21, 1979. Note: Lo-V subway car #5292, built 1917.

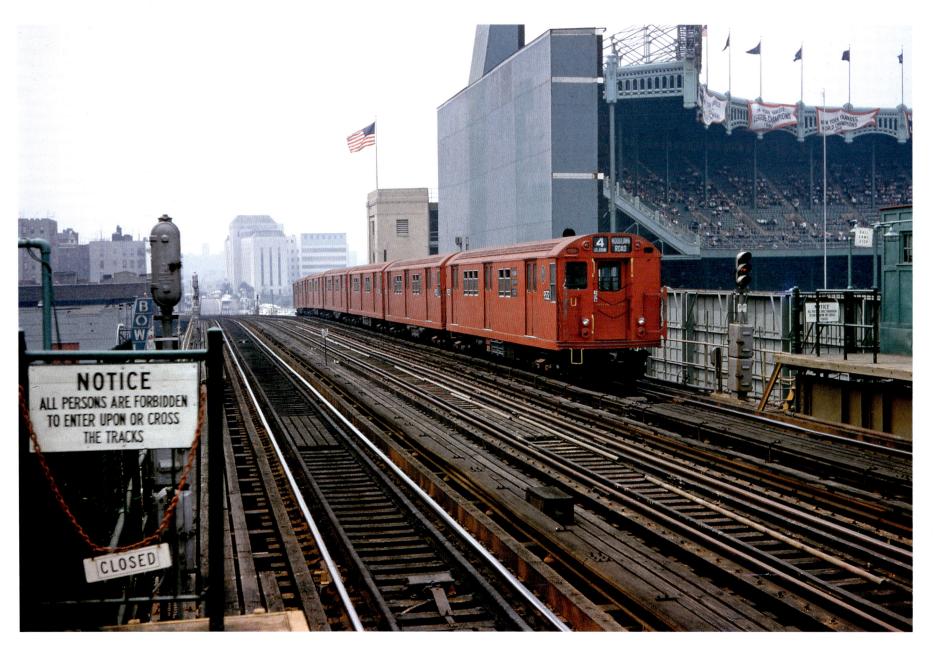

IRT, 161st St. Station., Jerome Ave. Line, Bronx, August 8, 1964. Note: R-36 subway car #9532 on Brooklyn-bound #4–Lexington Ave. Express, passing original Yankee Stadium.

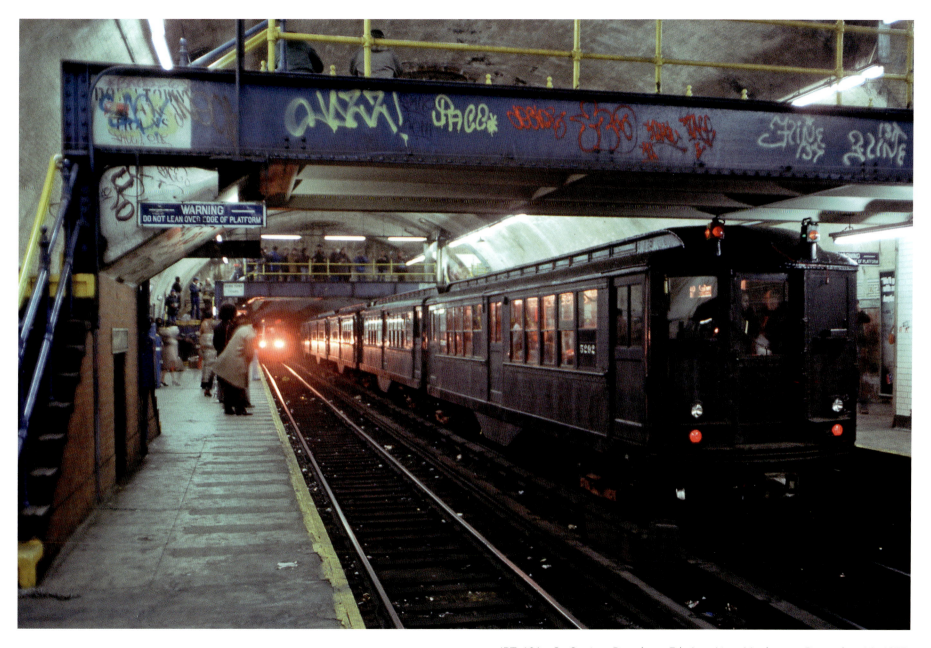

IRT, 181st St. Station, Broadway–7th Ave. Line, Manhattan, December 11, 1977.
Note: Lo-V subway car #5292, built 1917.

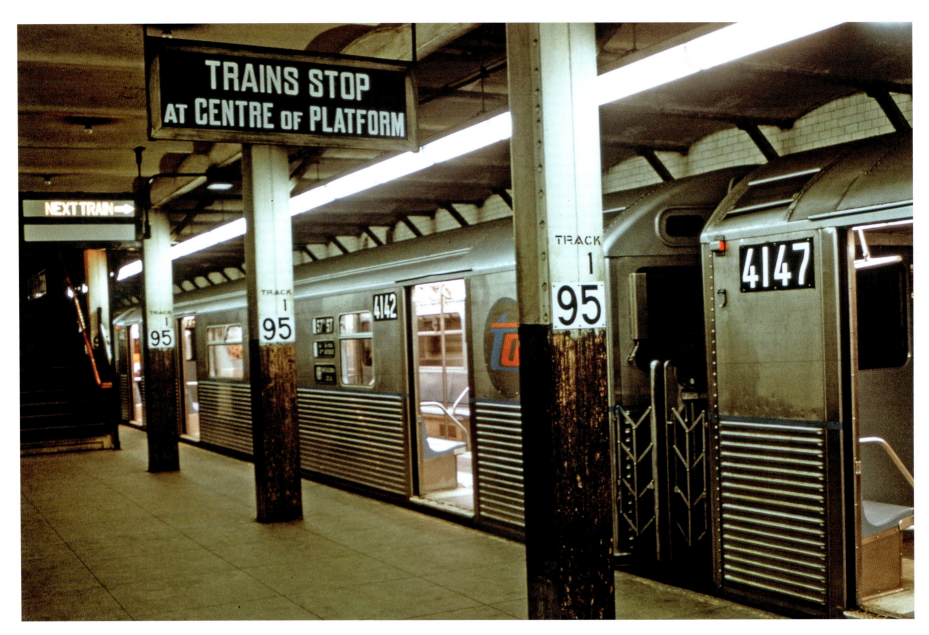

BMT, 95th St. Station, 4th Ave. Line, Brooklyn, September 1967.
Note: R-38 air-conditioned subway car #4142 and 4147 on "RR" Broadway–4th Ave. Local.

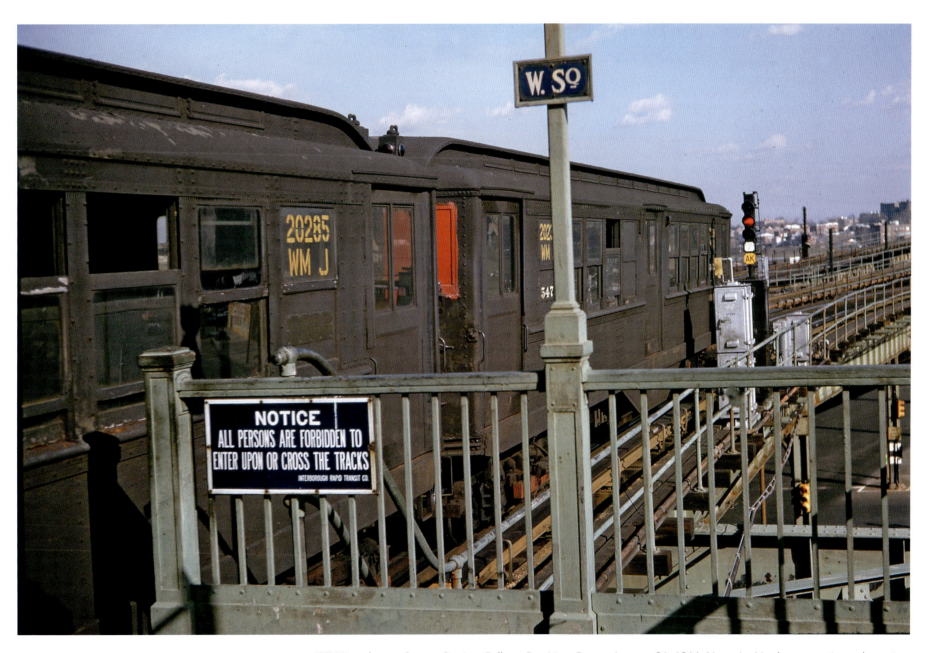

IRT, Westchester Square Station, Pelham Bay Line, Bronx, January 26, 1964. Note: Lo-V subway cars in work service.

IRT, Gun Hill Road Station, Dyre Ave. Line, original New York, Westchester & Boston Railway signs, Bronx, April 1970

IRT, 129th St. Station, 3rd Ave. Elevated Line, warning sign, Manhattan, 1950s

CHAPTER 6.
KIOSKS

PUBLIC NOTICE

At 7 A. M. Monday, November 8, 1948, the new 22nd Street entrances to the 23d Street IRT Station will be opened and

THIS STATION will be CLOSED.

The 22nd Street entrances will be open from 7 A. M. to 7 P. M. on weekdays and closed on Sundays and Holidays.

Board of Transportation
The City of New York

IRT, subway, 18th St. Station, Lexington Ave. Line, Manhattan, 1948

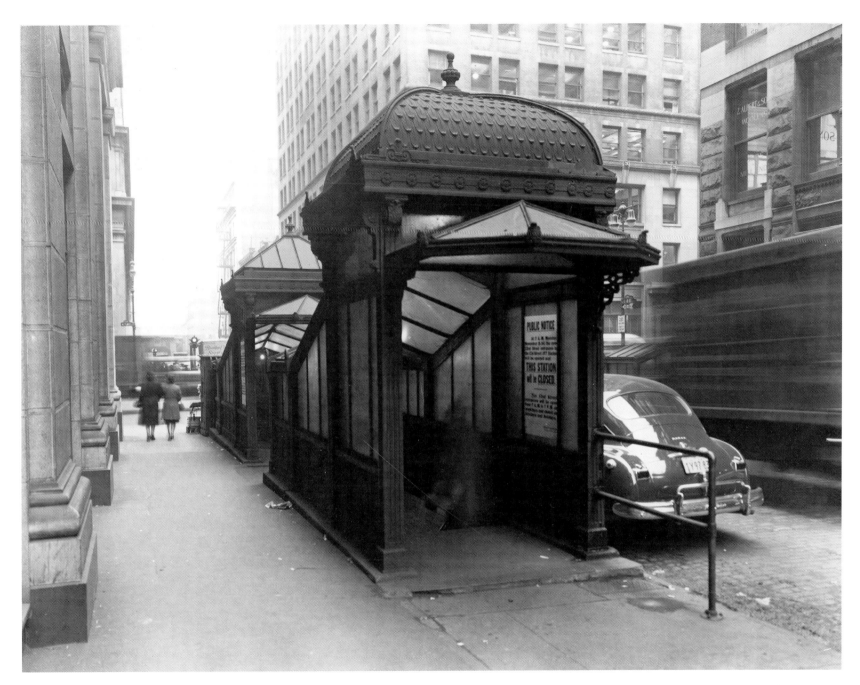

IRT, subway kiosk, 18th St. Station, Lexington Ave. Line, Manhattan, 1948

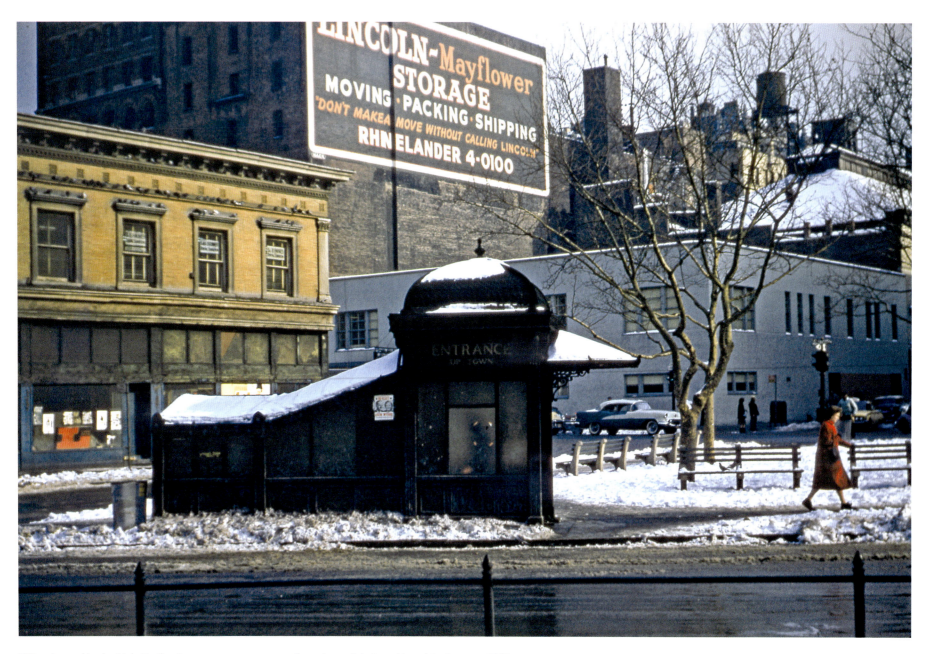

IRT, subway kiosk, 66th St. Station, uptown entrance, Broadway–7th Ave. Line, Manhattan, 1959

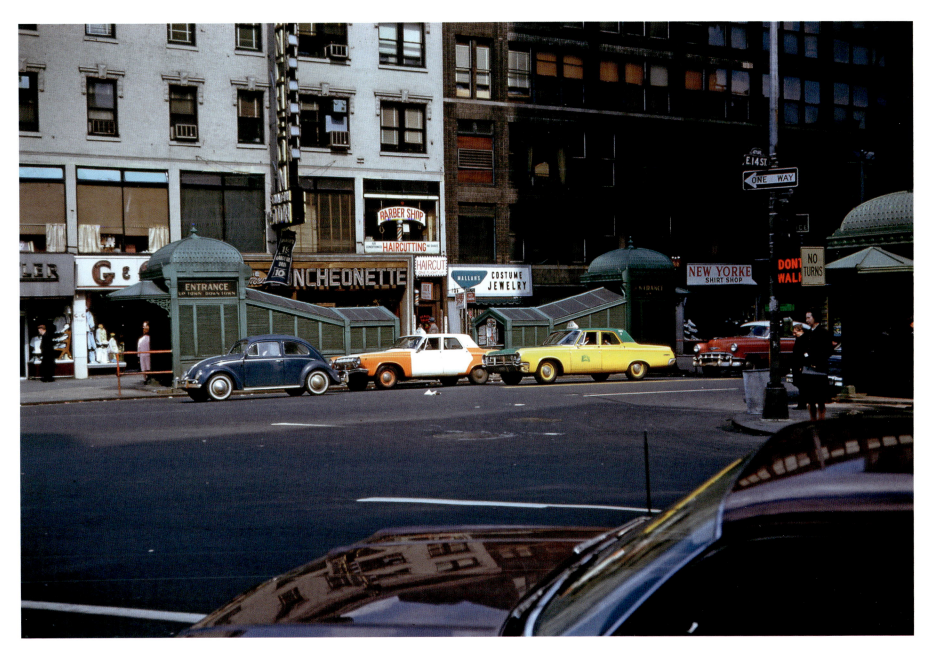

IRT, subway kiosks, 14th St.–Union Square Station, Lexington Ave. Line, Manhattan, March 29, 1964

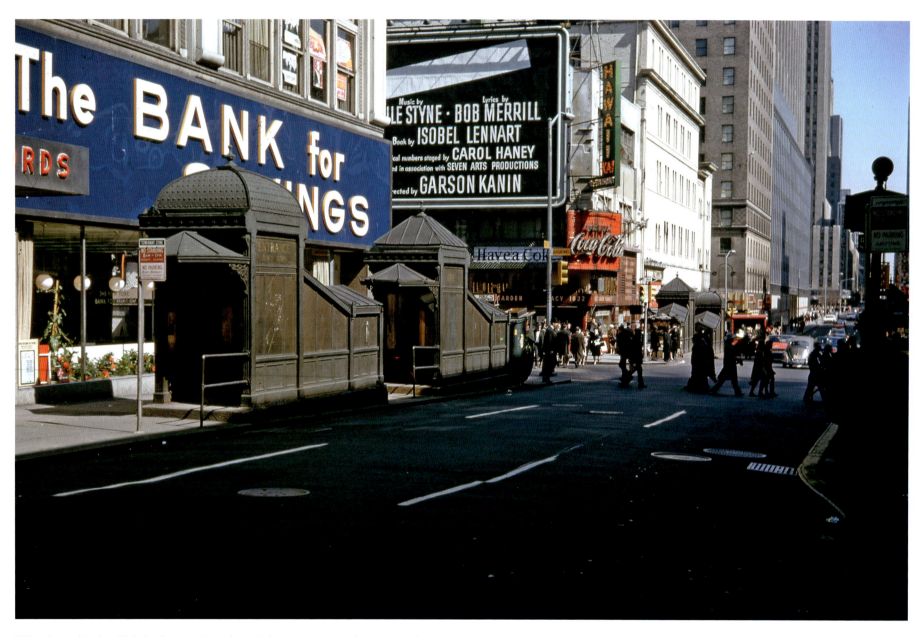

IRT, subway kiosks, 50th St. Station, Broadway–7th Ave. Line, Manhattan, April 4, 1964

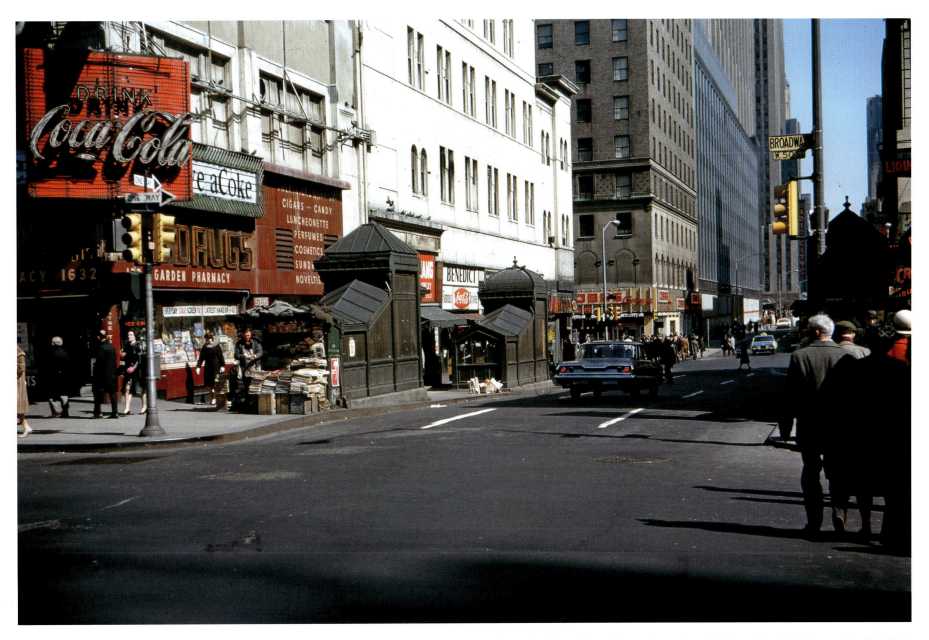

IRT, subway kiosks, 50th St. Station, Broadway–7th Ave. Line, Manhattan, April 4, 1964

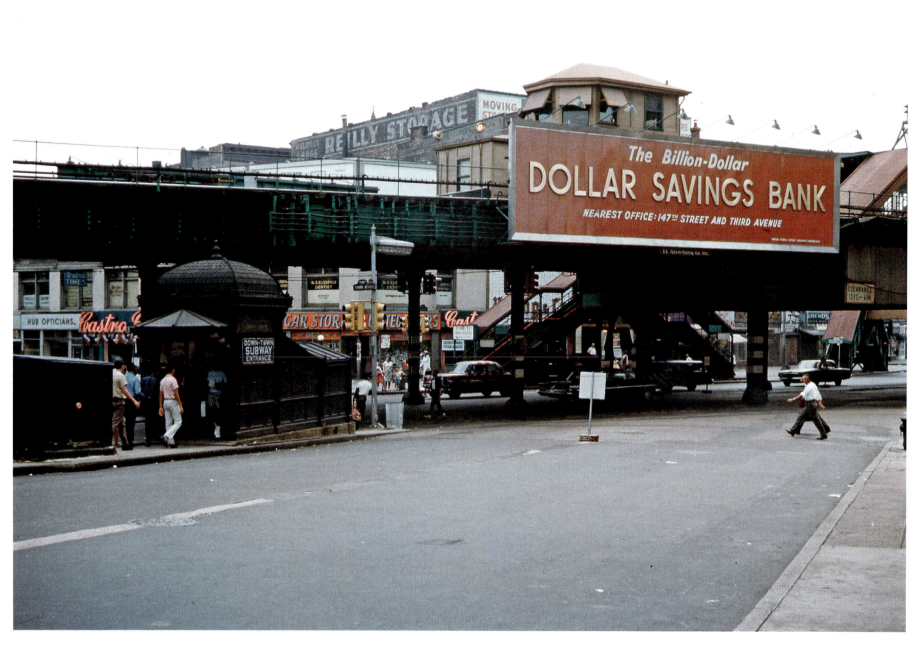

IRT, subway kiosk, 149th St.–3rd Ave. Station, Bronx, June 21, 1964. Note: 3rd Ave. Elevated Station.

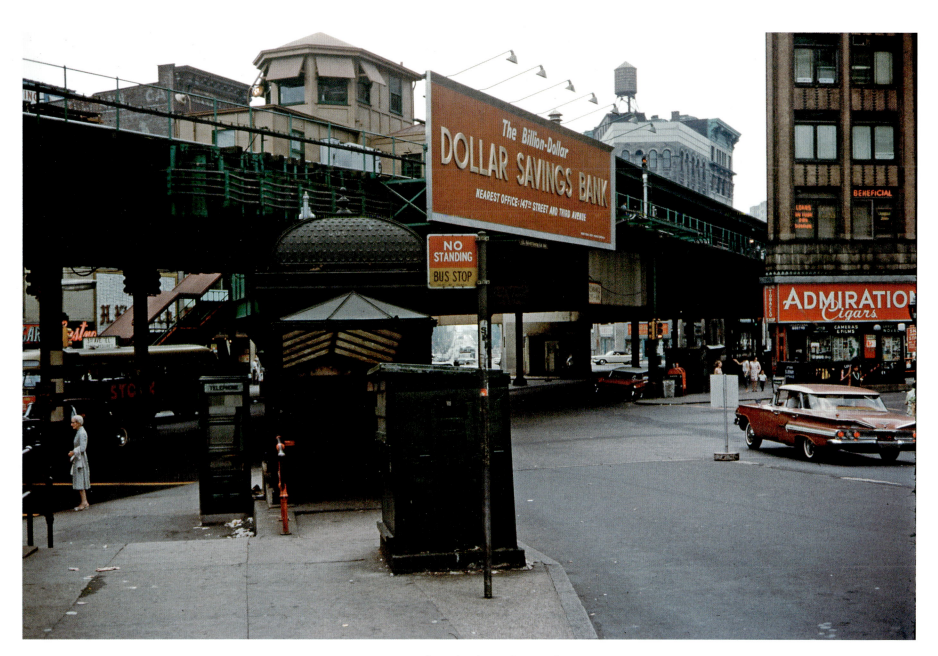

IRT, subway kiosk, 149th St.–3rd Ave. Station, Bronx, June 21, 1964. Note: porcelain sign inside kiosk.

Chapter 6. Kiosks | 209

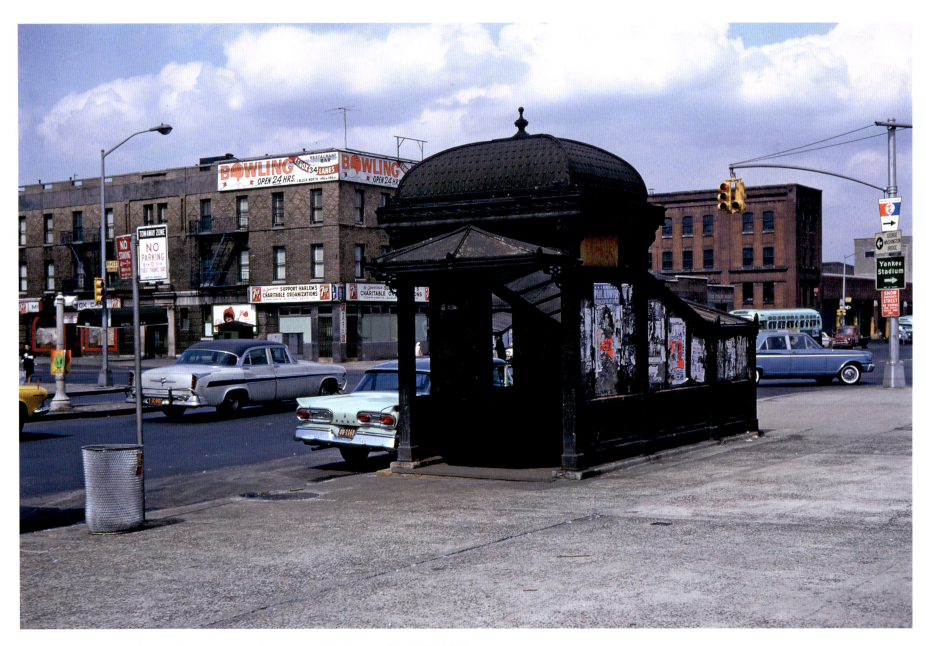

IRT, subway kiosk, 145th St. and Lenox Ave., 7th Ave. Line, Manhattan, March 29, 1964

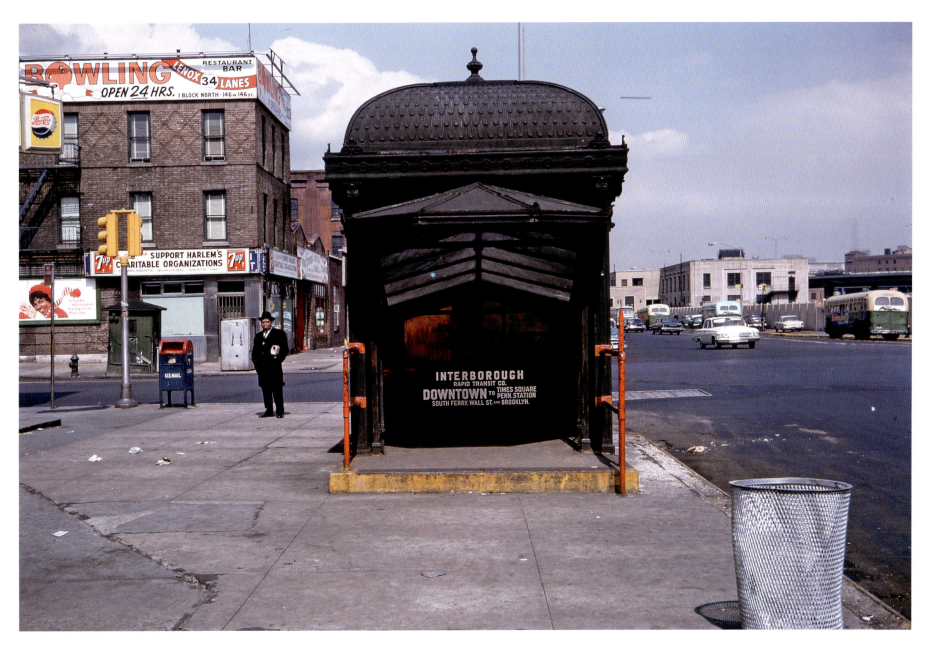

IRT, subway kiosk, 145th St. and Lenox Ave., 7th Ave. Line, Manhattan, March 29, 1964

Chapter 6. Kiosks | 211

CHAPTER 7. GLOBES

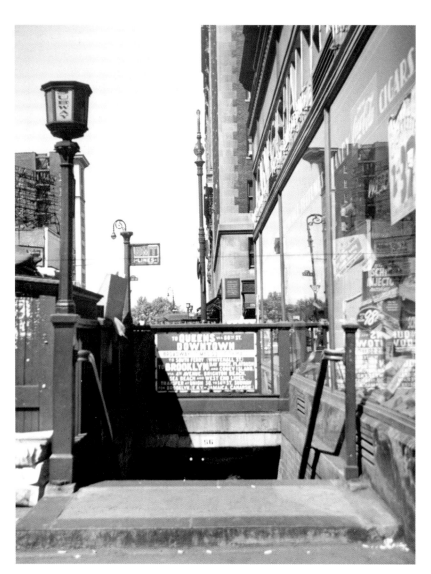

BMT, 57th St. Station, Broadway Line, Manhattan

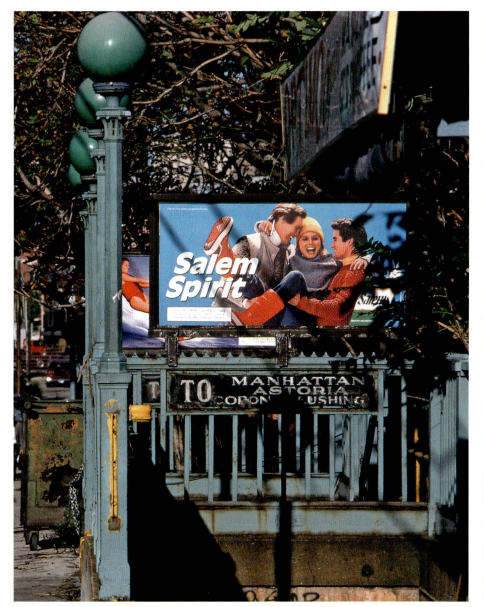

IRT, Vernon Ave.–Jackson Ave. Station, Flushing Line, Queens, 1986

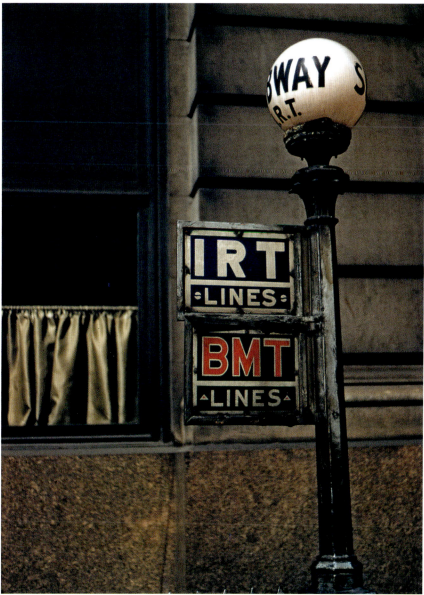

Round IRT glass globe and IRT/BMT flag signs, 1956

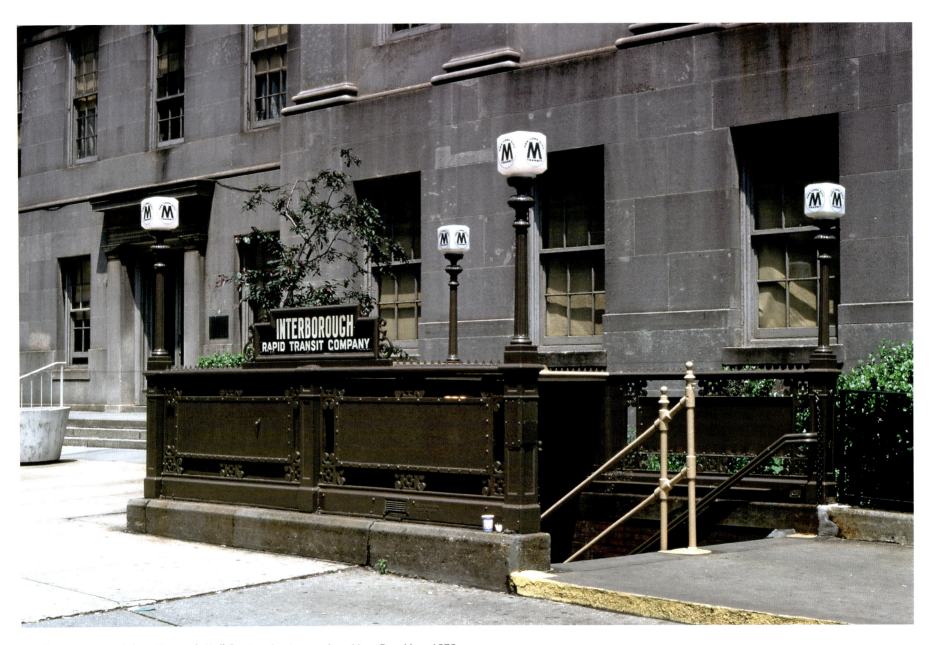

IRT, four entrance globes, Borough Hall Station, Lexington Ave. Line, Brooklyn, 1979

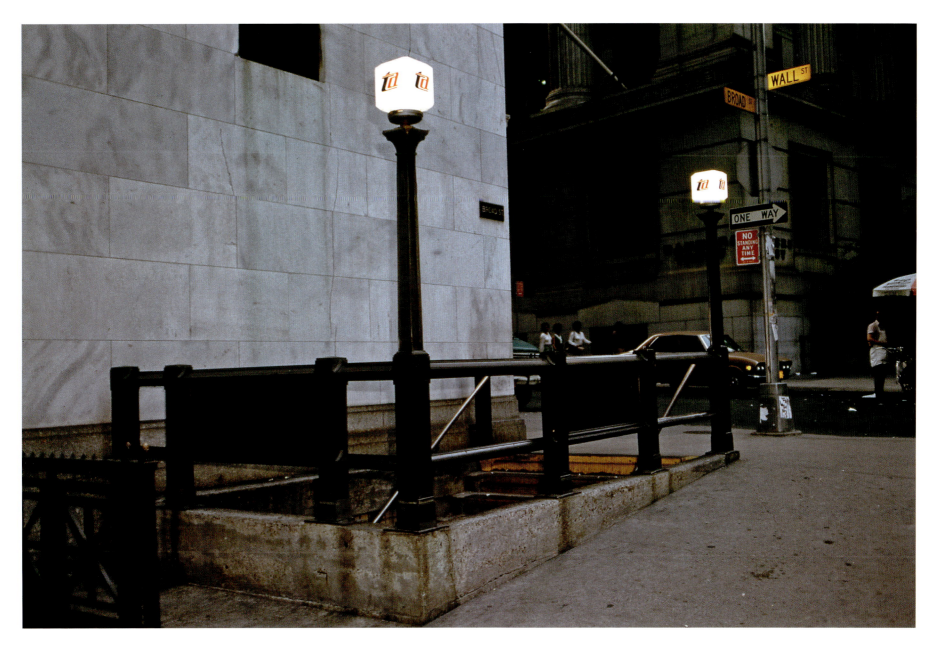

BMT, Broad St. Station, Nassau St. Line, Manhattan, July 3, 1974

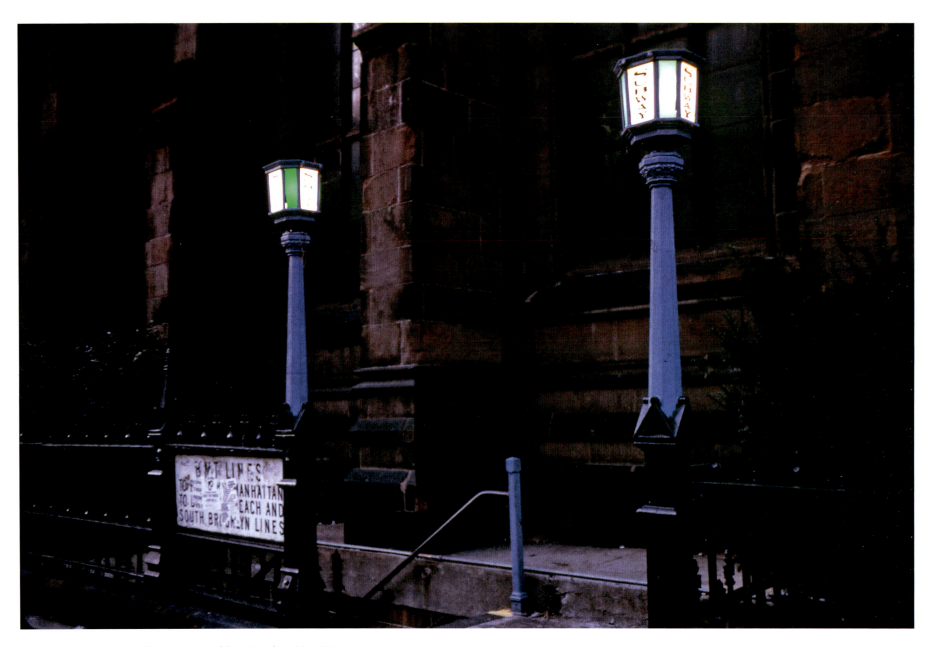
BMT, Court St.–Boro Hall Station, Brooklyn, October 21, 1974

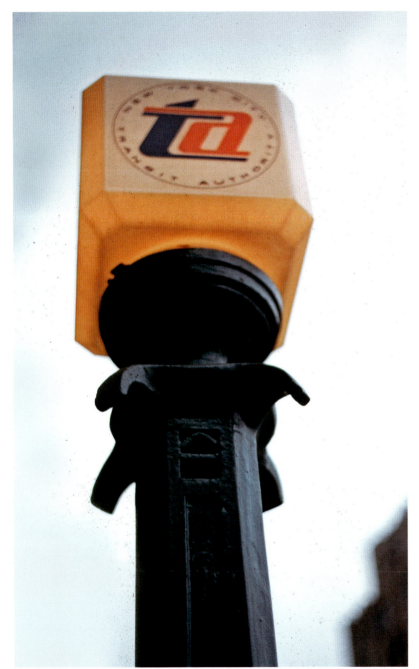
Square TA subway entrance globe, 1969

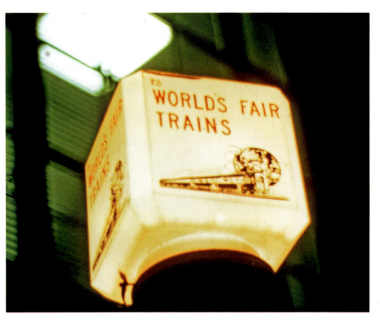
1964 New York World's Fair subway entrance globe

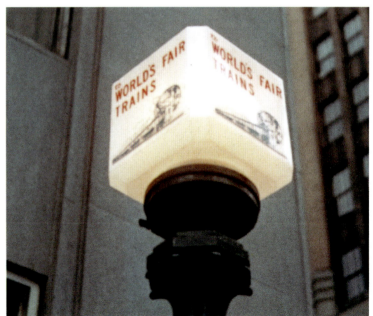
1964 New York World's Fair subway entrance globe

Chapter 7. Globes | 217

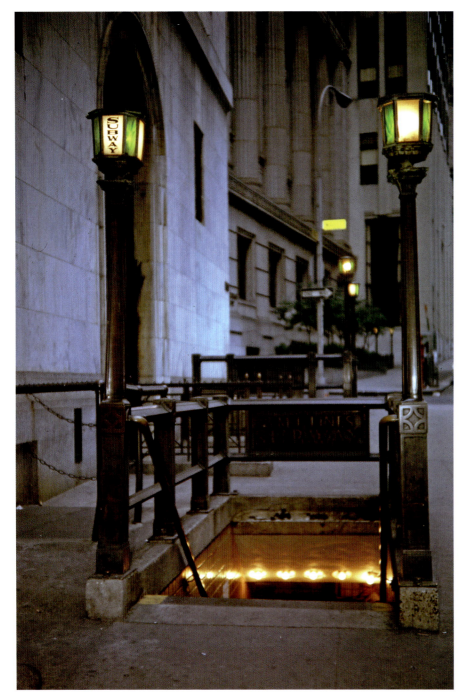
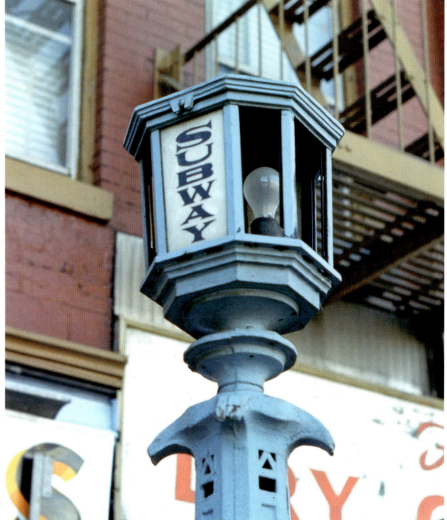

Left: BMT, Broad St. Station, Nassau St. Line, Manhattan, July 19, 1970

Right: BMT globe, 1977. By the 1970s, missing glass or broken inserts were common to see.

Left: Replacement subway insert for the BMT octagonal globe, made of plastic

Right: Glass subway insert for the BMT octagonal globe; original glass inserts were etched.

CHAPTER 8.
MOSAICS

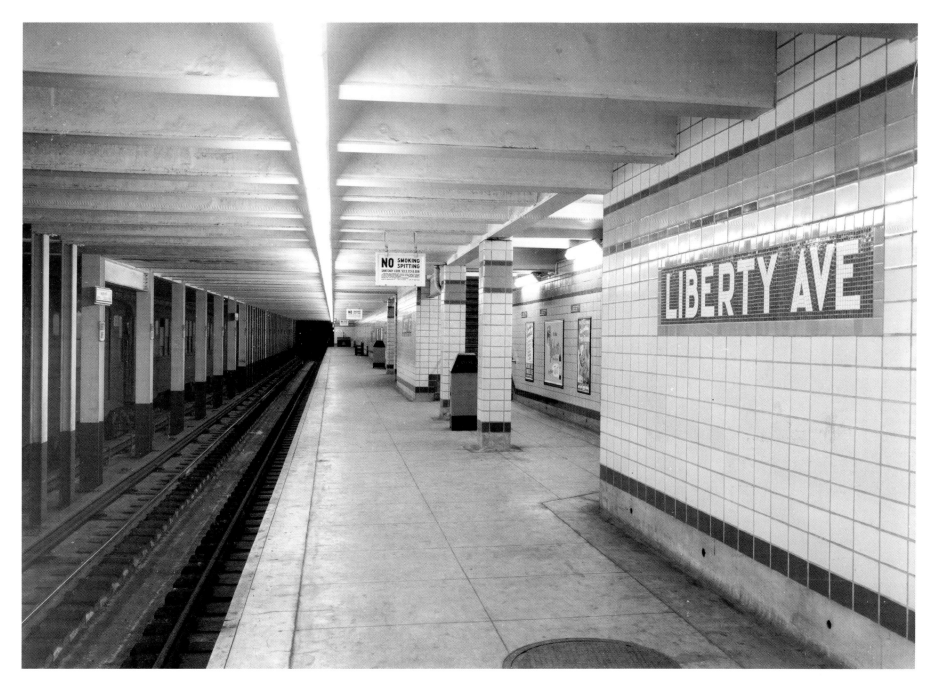

IND, Liberty Ave. Station, Fulton St. Line, Brooklyn, late 1940s

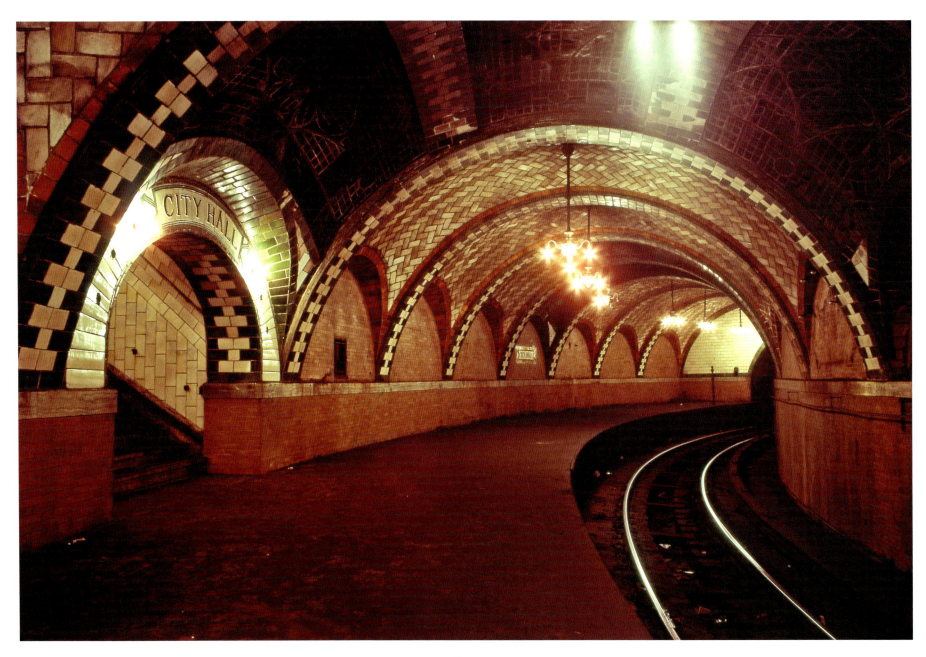

IRT, City Hall Station, Lexington Ave. Line, Manhattan, September 25, 1979. Note: officially closed to passenger service, December 31, 1945.

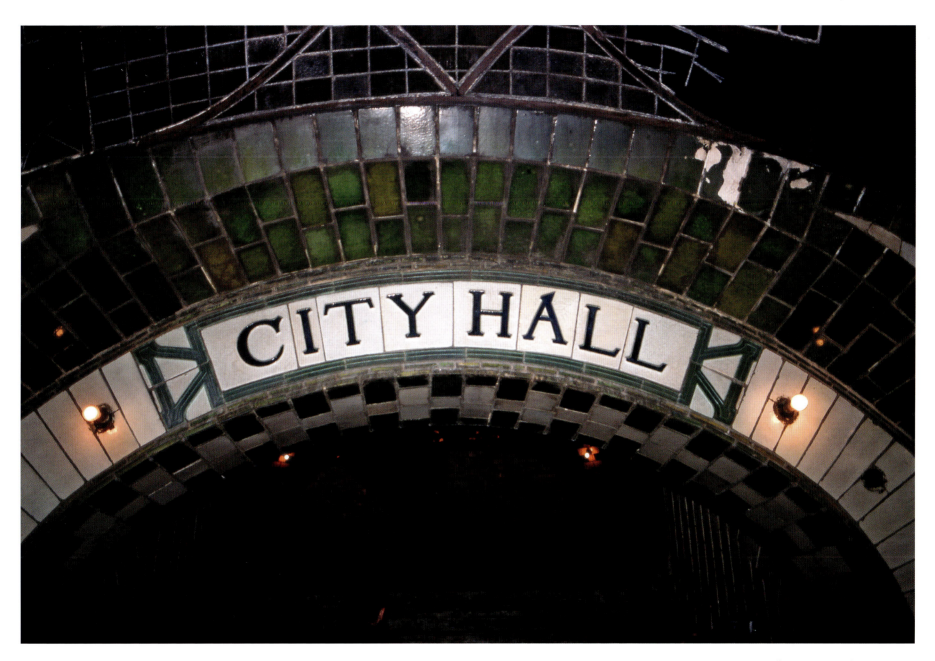

IRT, City Hall Station, Manhattan, 1979

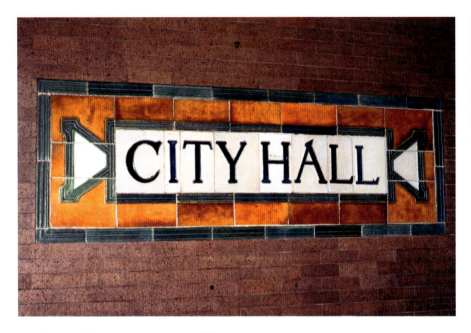

IRT, City Hall Station, Manhattan, 1979

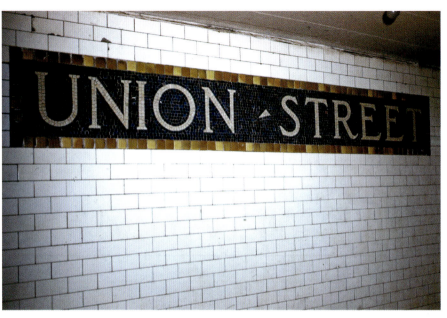

BMT, Union St. Station, 4th Ave. Line, Brooklyn, December 25, 1969

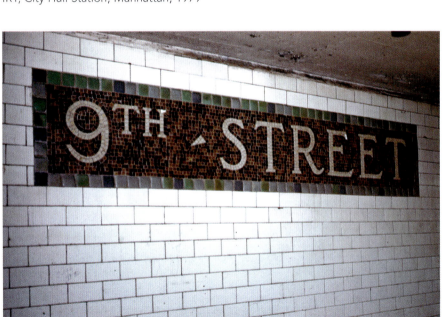

BMT, 9th St. Station, 4th Ave. Line, Brooklyn, December 25, 1969

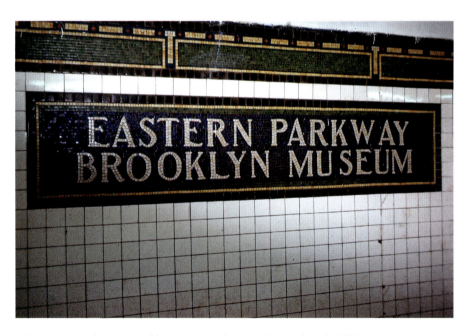

IRT, Eastern Parkway–Brooklyn Museum Station, December 9, 1974

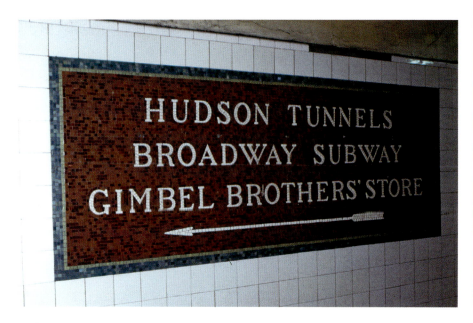

34th St. passageway between IRT and BMT, Manhattan, November 18, 1972

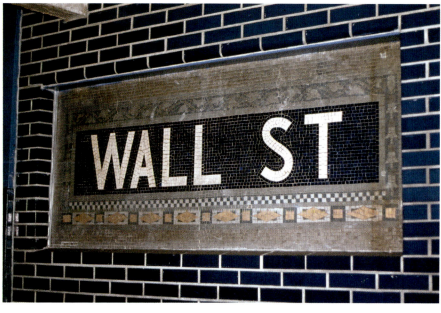

IRT, Wall St. Station, Lexington Ave. Line, Manhattan, 1982

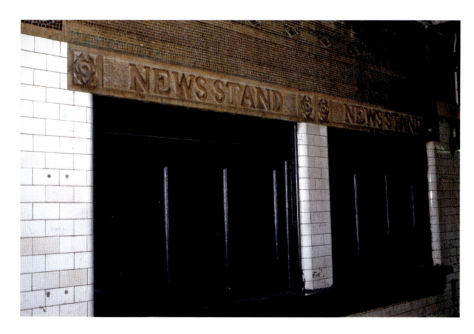

News Stand, BMT, 25th St. Station, 4th Ave. Line, Brooklyn, January 11, 1970

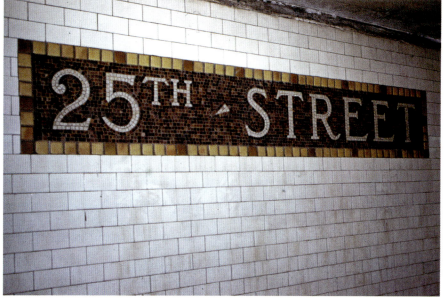

BMT, 25th St. Station, 4th Ave. Line, Brooklyn, January 11, 1970

Chapter 8. Mosaics | 225

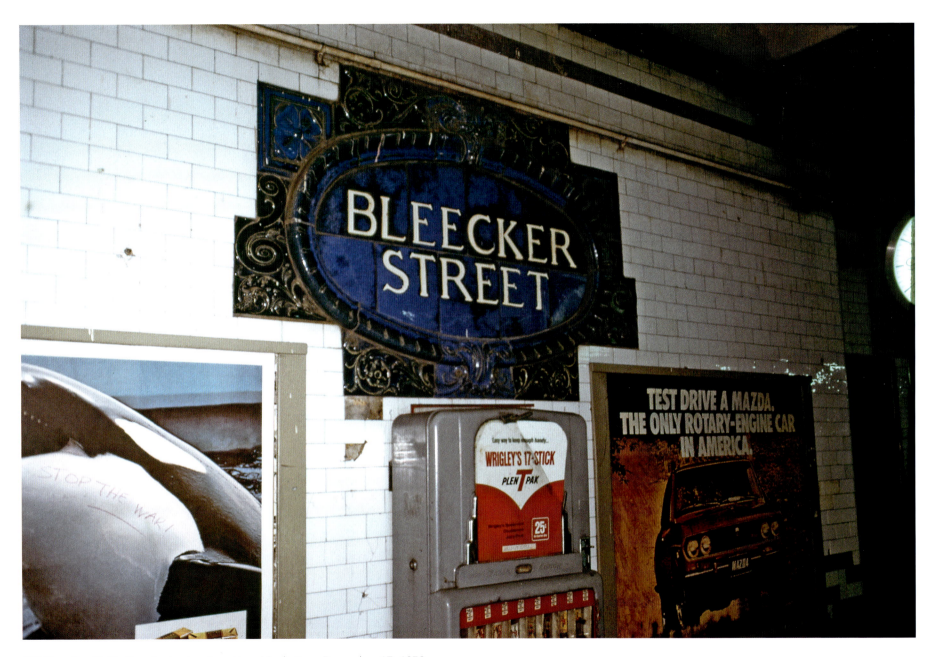

IRT, Bleecker St. Station, Lexington Ave. Line, Manhattan, December 17, 1972

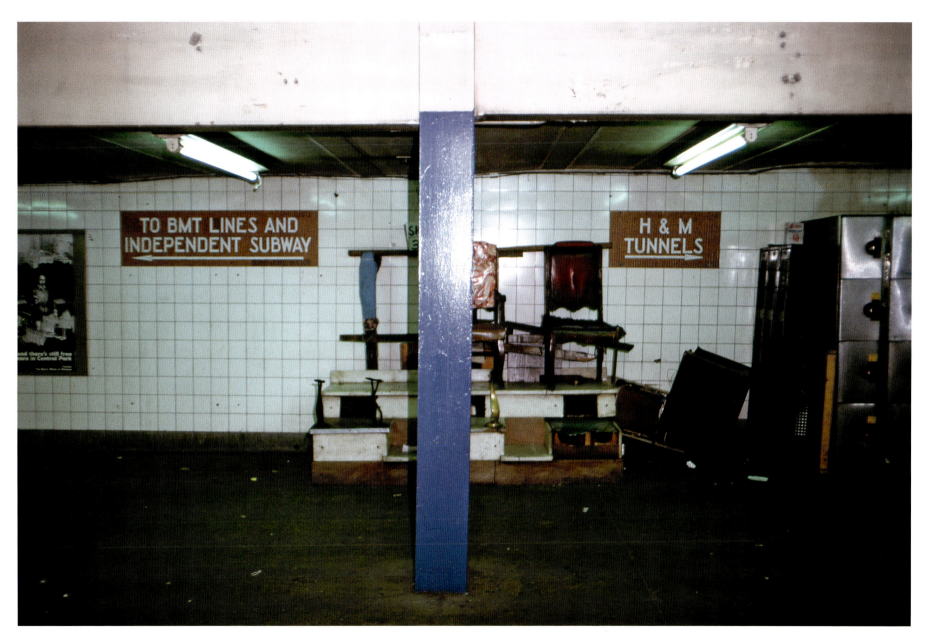

Passageway between IND/BMT and H&M Tunnels (PATH), 34th–33rd Sts., Manhattan, July 20, 1974

Chapter 8. Mosaics | 227

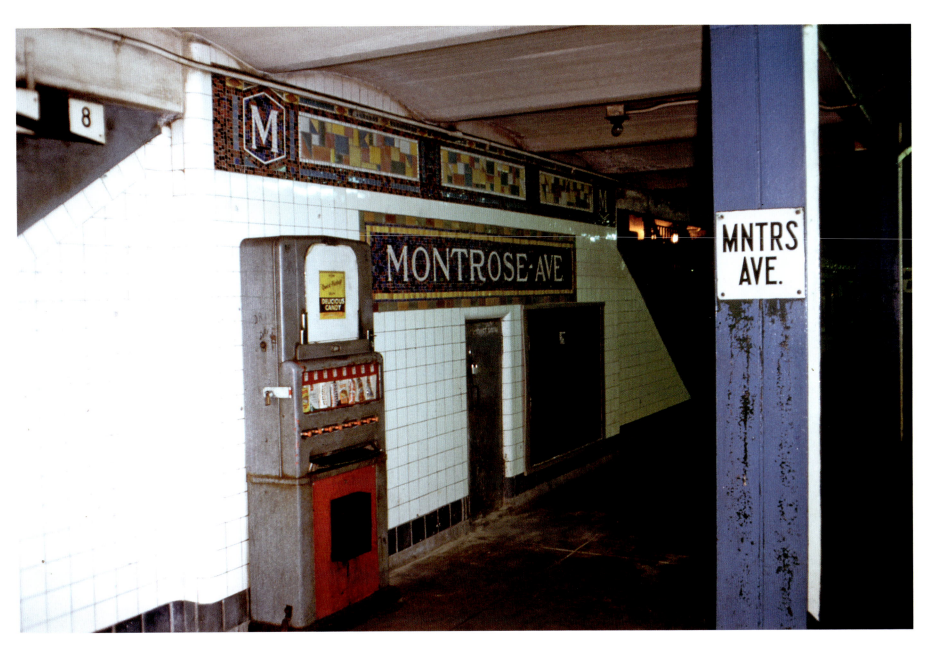

BMT, Montrose Ave. Station, 14th St.–Canarsie Line, Brooklyn, March 11, 1973

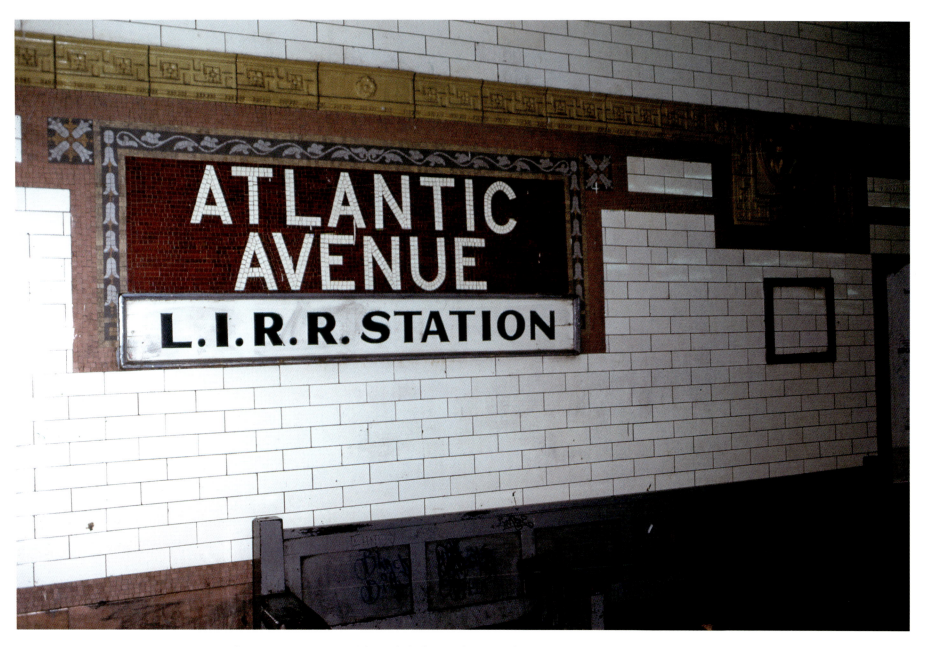

IRT, Atlantic Ave. Station, southbound platform, 7th Ave. and Lexington Ave. Lines, Brooklyn, November 19, 1972. Note: LIRR wood sign.

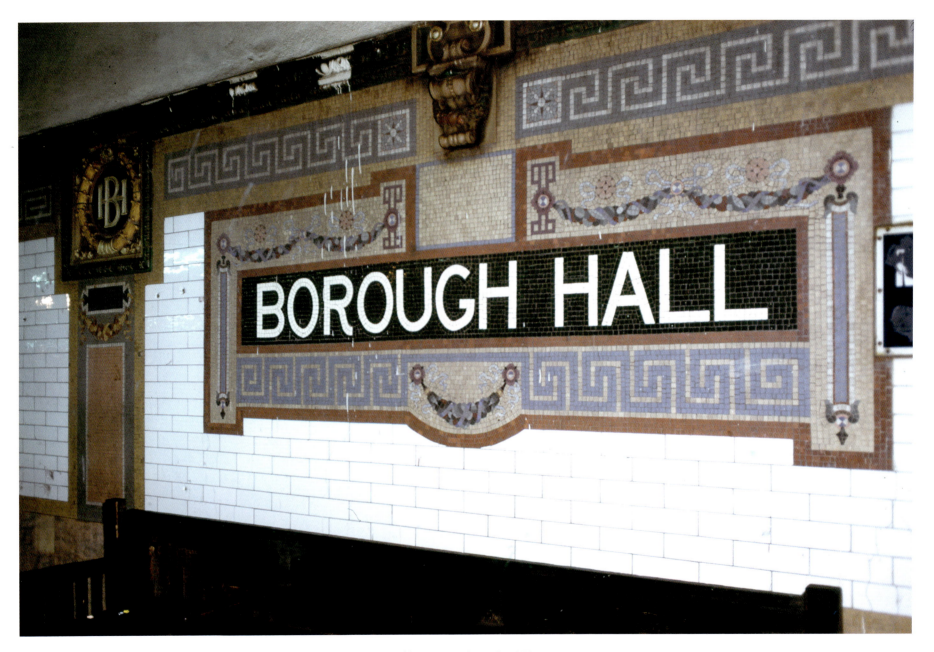

IRT, Borough Hall Station, southbound platform, Lexington Ave. Line, Brooklyn, November 19, 1972

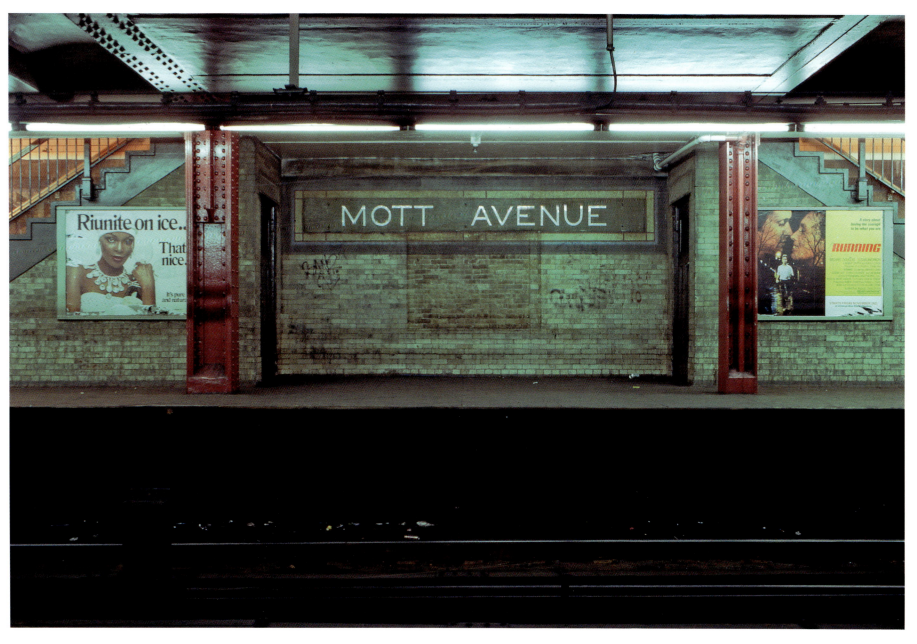

IRT, 149th St.–Grand Concourse Station, lower level, 7th Ave. and Lexington Ave. Lines, Bronx, November 22, 1979. Originally named Mott Avenue.

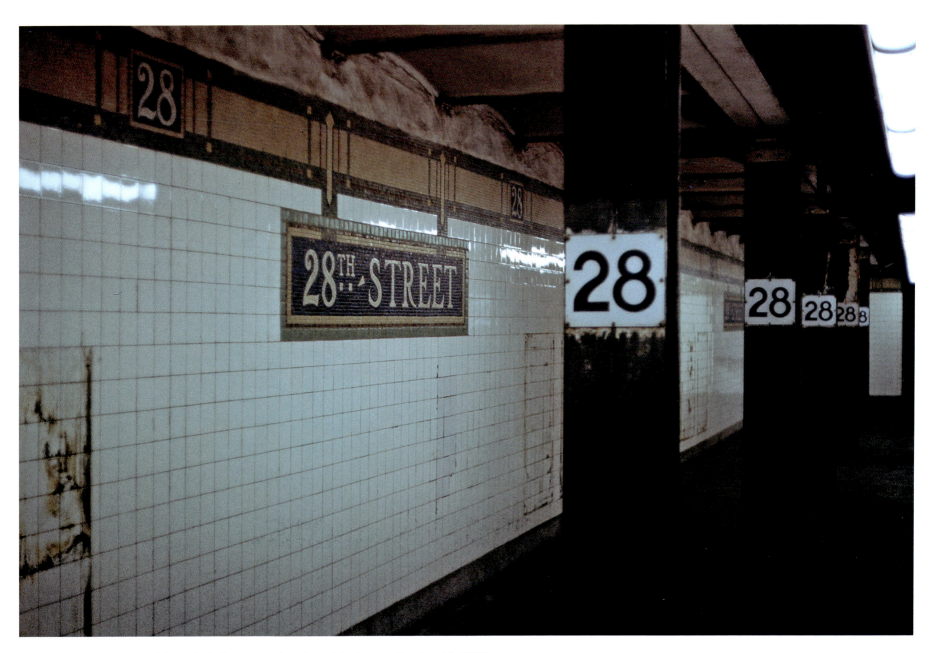

BMT, 28th St. Station, southbound platform, Broadway Line, Manhattan, October 19, 1969

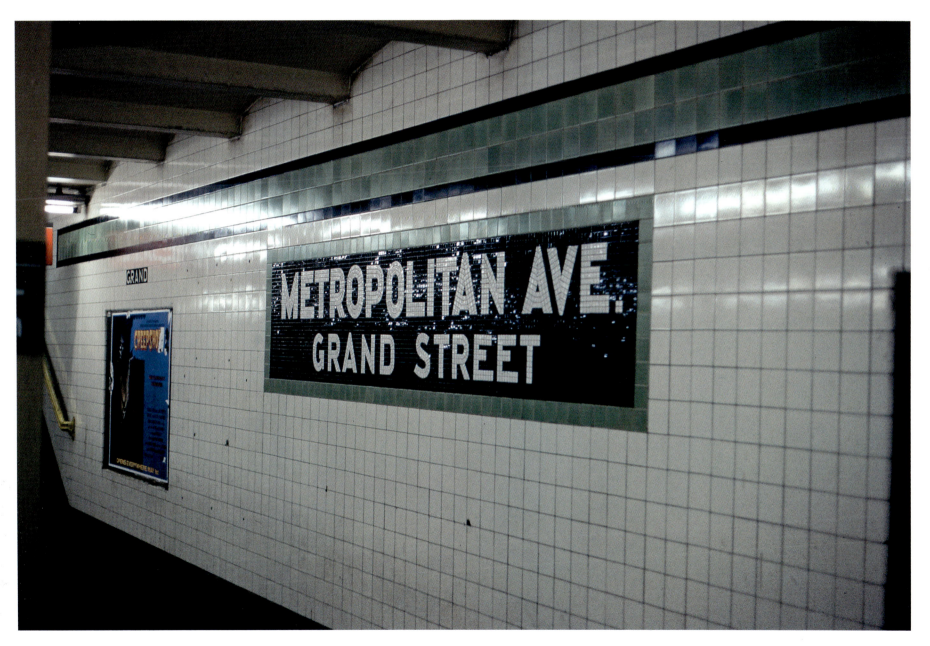

IND, Metropolitan Ave.–Grand St. Station, Crosstown Line, Brooklyn, May 5, 1987

Chapter 8 Mosaics | 233

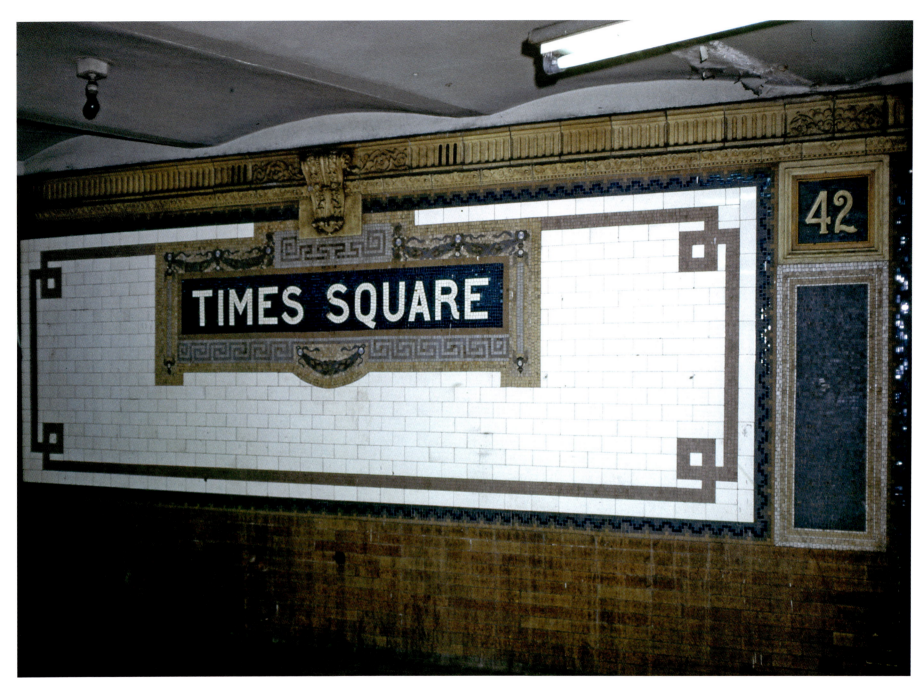

IRT, Times Square Shuttle Station, track #1, Manhattan, January 24, 1971

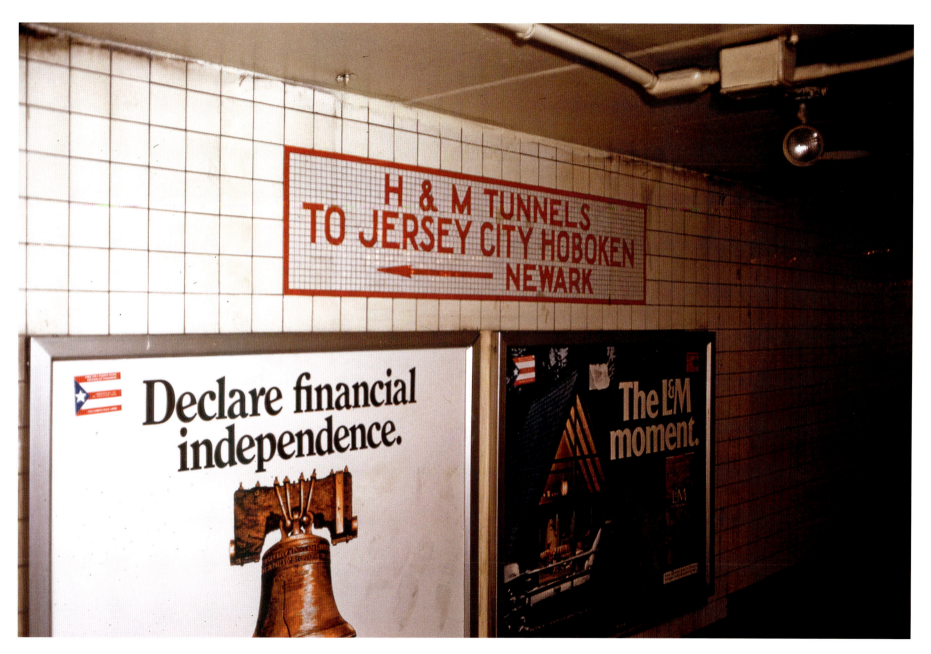

14th St.–6th Ave. Station passageway, Manhattan, October 27, 1975

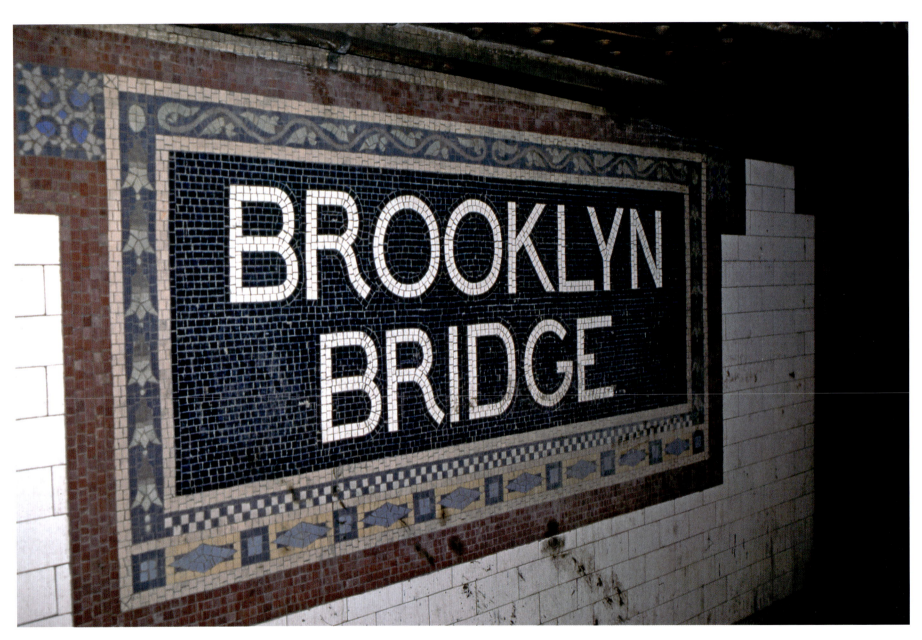

IRT, Brooklyn Bridge Station, Lexington Ave. Line, Manhattan, October 27, 1985

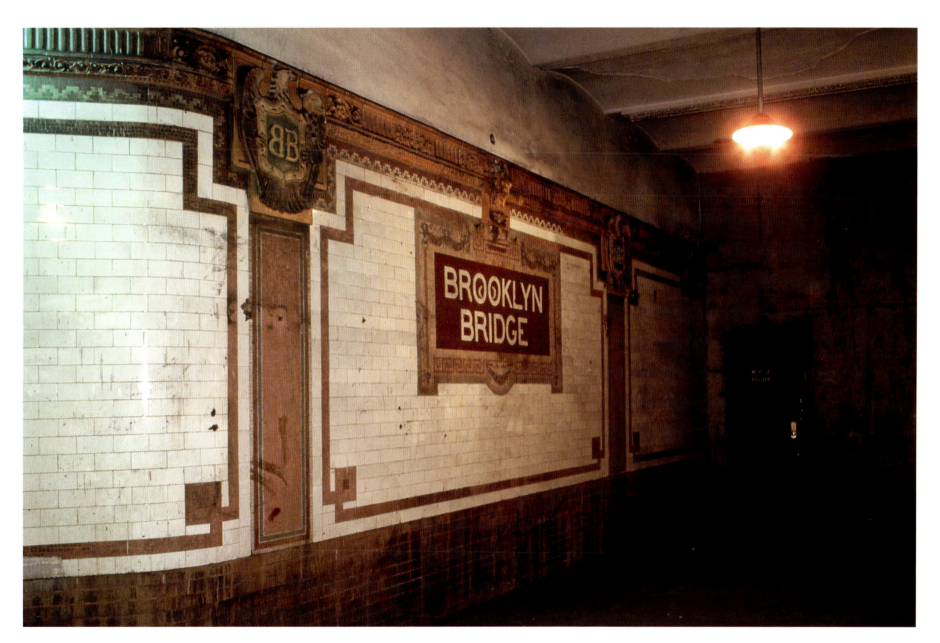

IRT, Brooklyn Bridge Station, Lexington Ave. Line, Manhattan, October 27, 1985

Chapter 8. Mosaics | 237

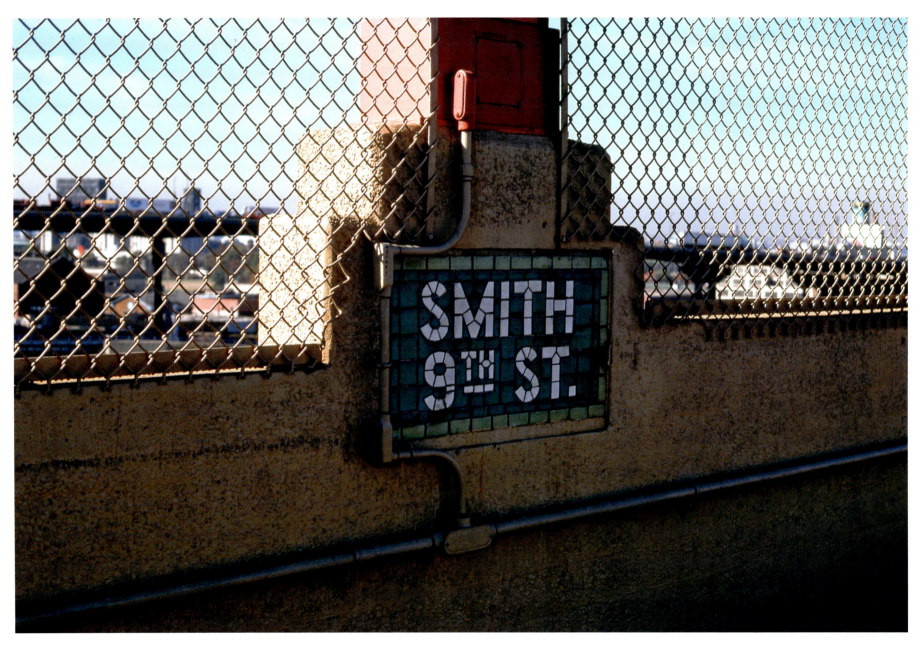

IND, Smith St.–9th St. Station, southbound platform, "F" and "G" Lines, Brooklyn, 1985

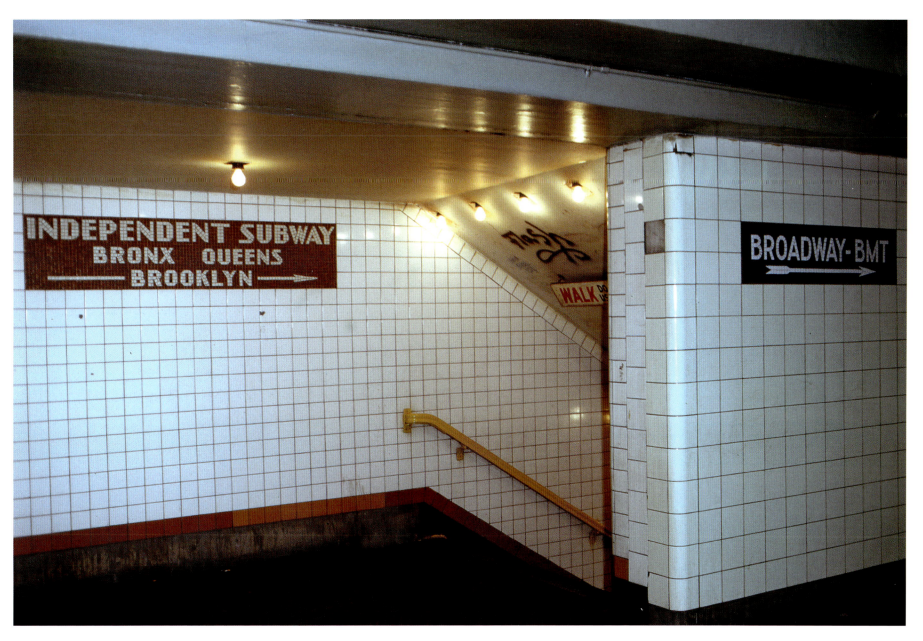

34th St. passageway from IRT Broadway–7th Ave. Line to BMT Broadway Line, IND 6th Ave. Line and PATH, Manhattan, November 18, 1972

Chapter 8. Mosaics | 239

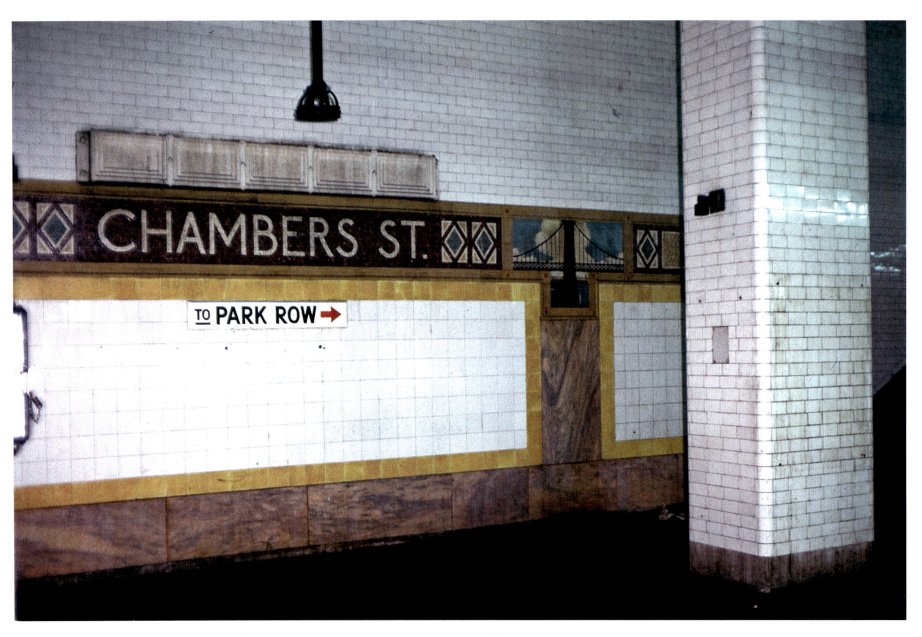

BMT, Chambers St. Station, northbound platform, Nassau St. Line, Manhattan, February 9, 1972

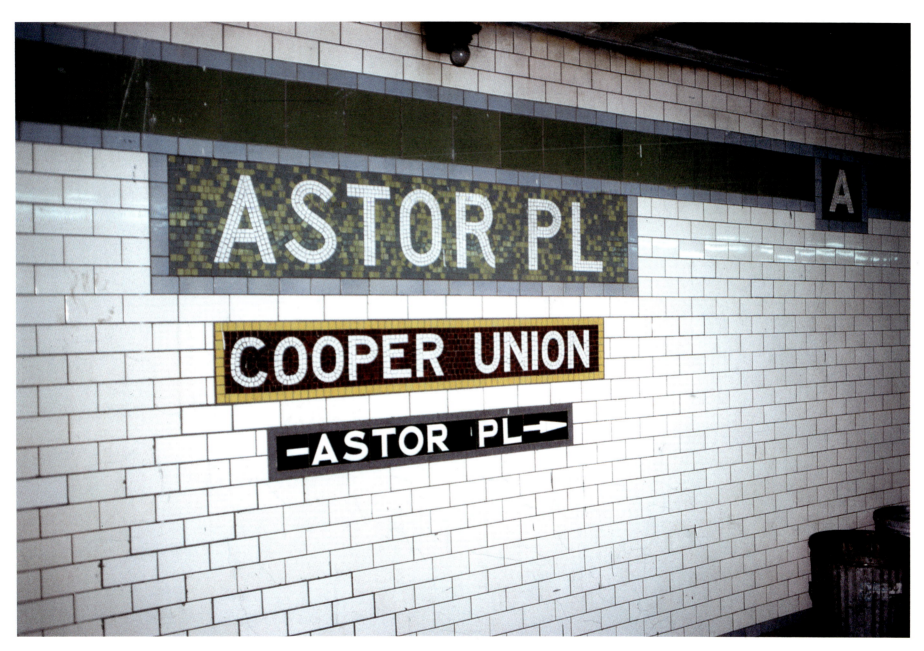

IRT, Astor Place Station, southbound platform, Lexington Ave. Line, Manhattan, December 17, 1972

Chapter 8. Mosaics | 241

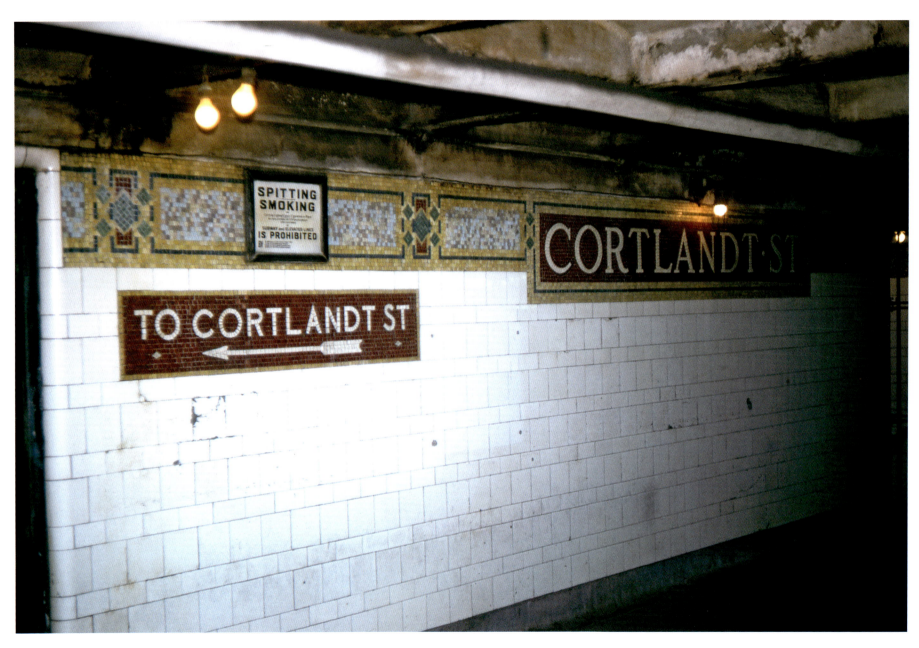

BMT, Cortlandt St. Station, southbound platform, Broadway Line, Manhattan, June 14, 1969

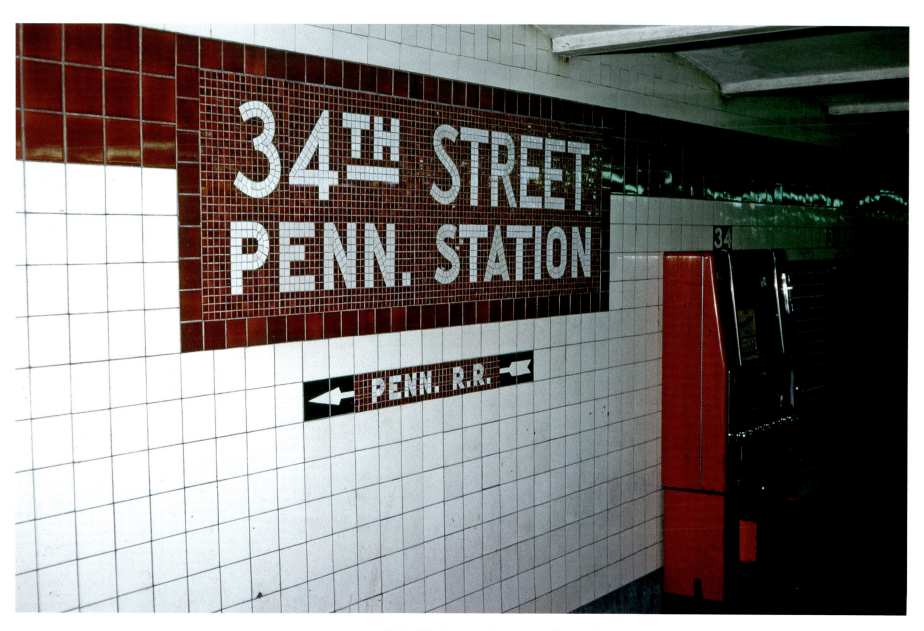

IND, 34th St.–Penn Station, southbound local platform, 8th Ave. Line, Manhattan, September 3, 1972

Chapter 8. Mosaics | 243

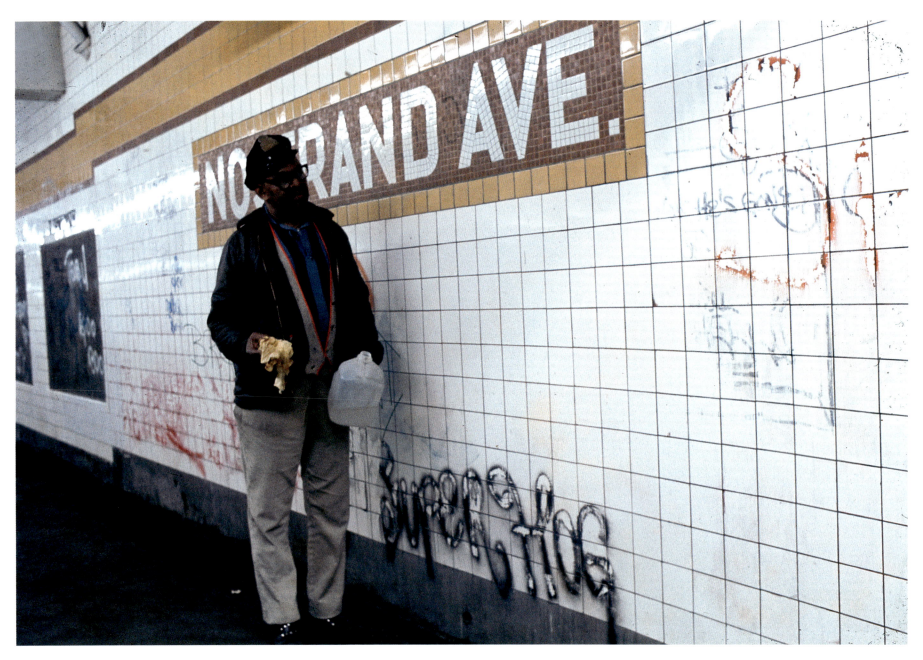

IND, Nostrand Ave. Station, Fulton St. Line, Brooklyn, 1973. Note: transit cleaner removing early graffiti.

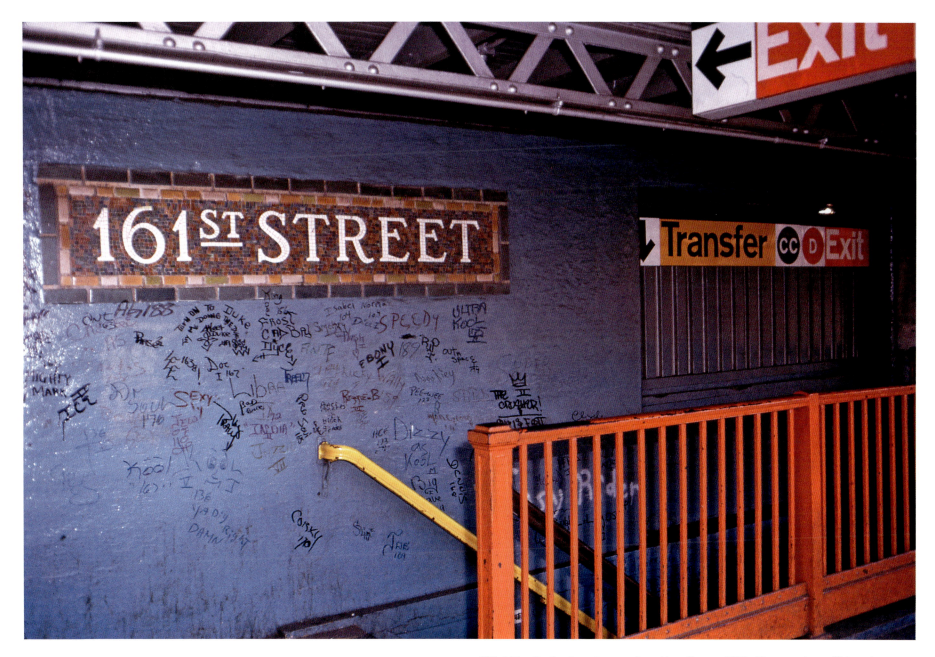

IRT, 161st St. Station, Jerome Ave. Line, Bronx, 1973. Note: early graffiti marker tags.

CHAPTER 9.
MISCELLANEOUS SIGNAGE AND ANCILLARY ITEMS

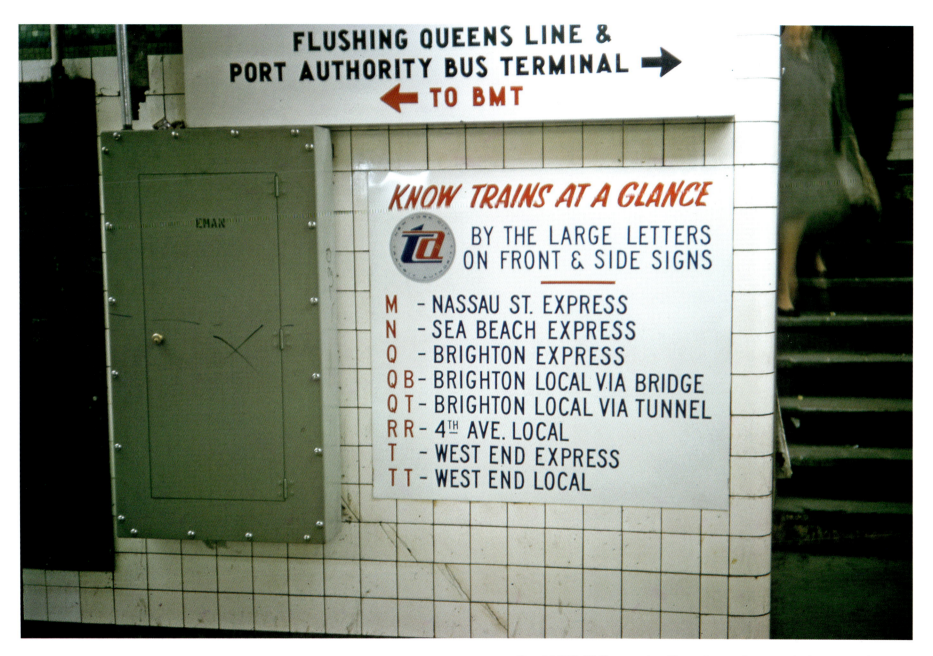

New NYCTA BMT route sign, Times Square Station, Manhattan, April 3, 1965

Chapter 9. Miscellaneous Signage and Ancillary Items | 247

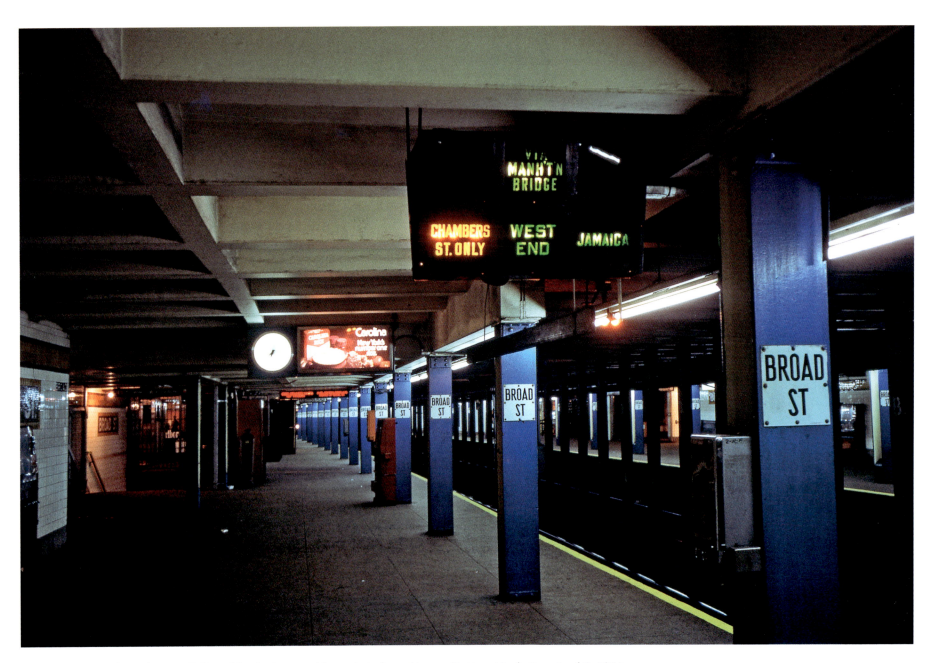

Electric illuminated sign box, BMT, Broad St. Station, northbound platform, Nassau St. Line, Manhattan, April 7, 1974.
Note: Manhattan Bridge service to and from Broad St. Station ended November 22, 1967.

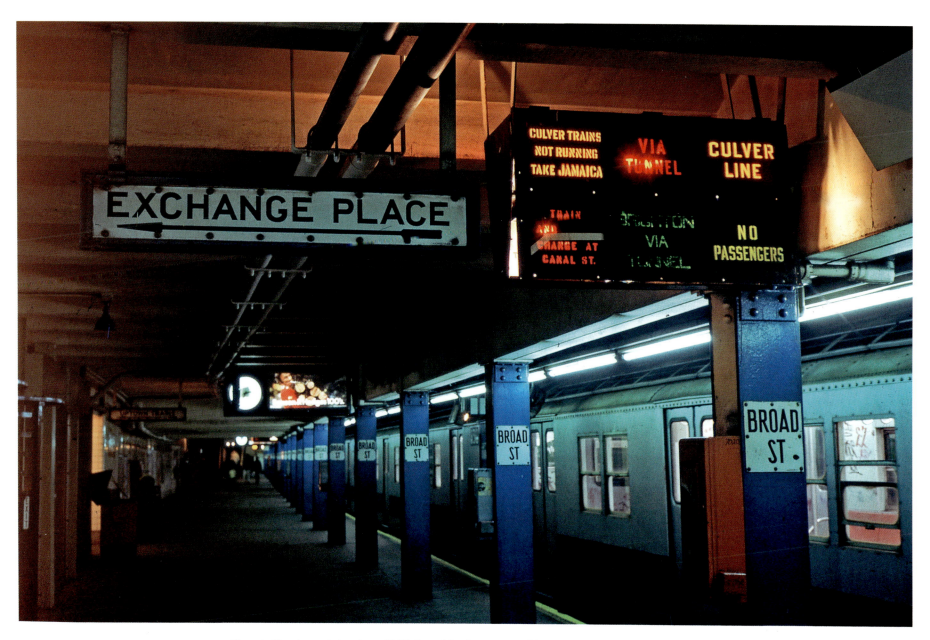

Electric illuminated sign box, BMT, Broad St. Station, southbound platform, Nassau St. Line (R-27/30 cars on "J" Line), April 7, 1974. Note: Culver Line service here ended as of May 28, 1959. Brighton line service here ended April 25, 1986.

Chapter 9. Miscellaneous Signage and Ancillary Items | 249

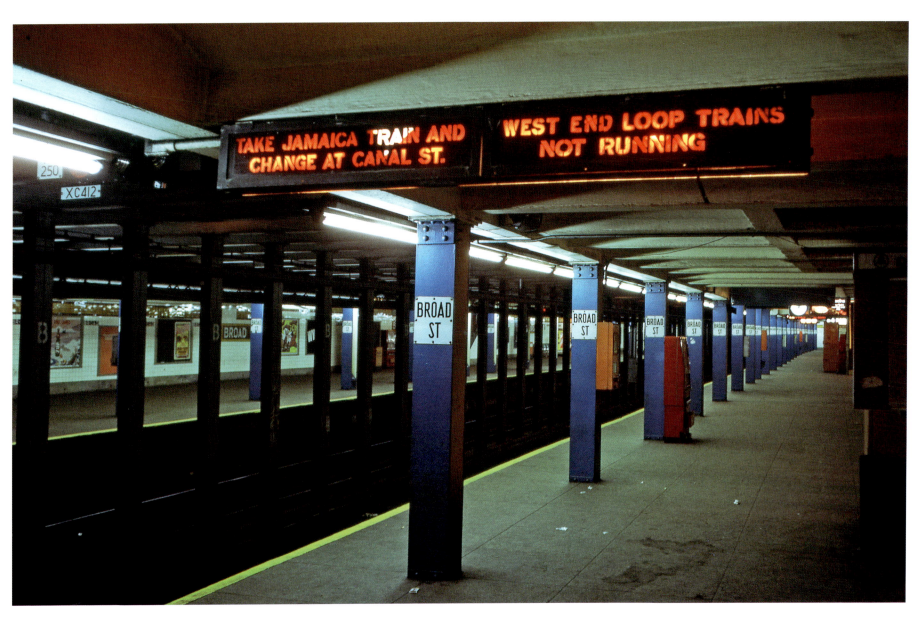

Electric illuminated sign box, BMT Broad St. Station, northbound platform, Nassau St. Line, Manhattan, April 7, 1974.
Note: West End Loop service from this platform ended May 28, 1959.

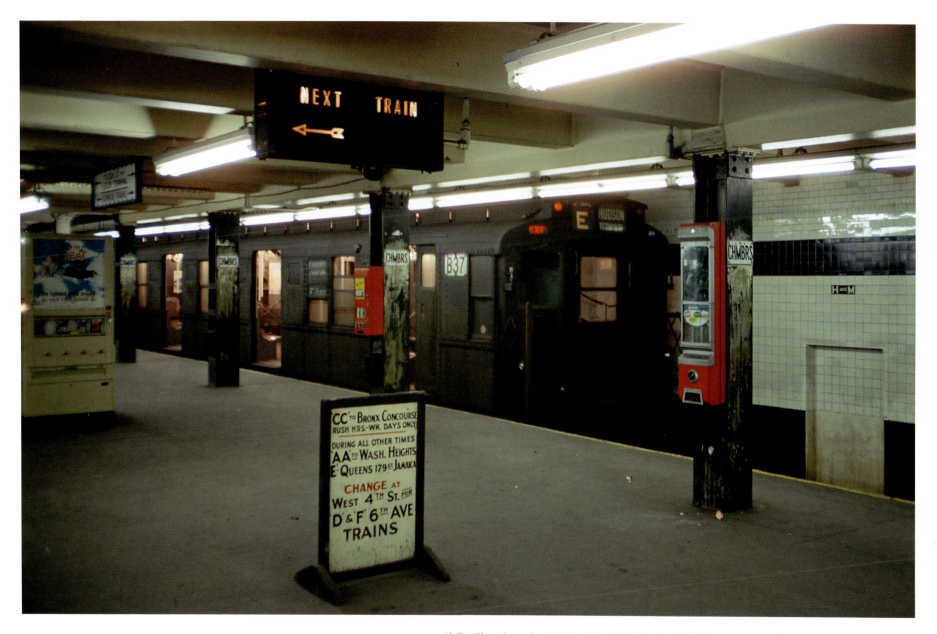

IND, Chambers St.–Hudson Terminal Station, 8th Ave. Line, Manhattan, December 1, 1968.
Note: R-9 #B37 (ex-#1733) on "E" 8th Ave. Local–Queens Boulevard Express.

Chapter 9. Miscellaneous Signage and Ancillary Items | 251

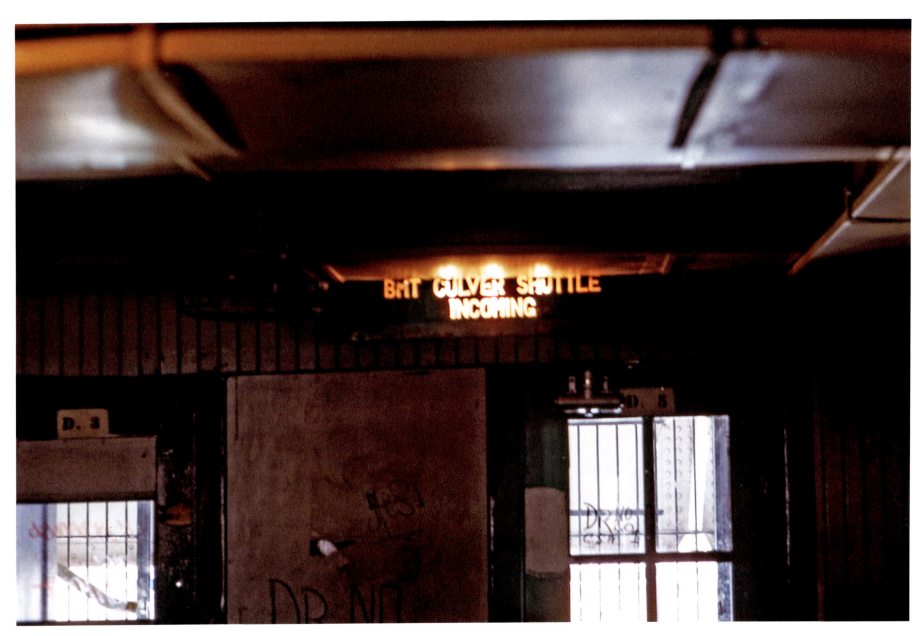

Passenger notification buzzer, BMT, Ditmas Ave. Station, Culver Shuttle Line, Brooklyn, May 4, 1975

Billboard at IRT Kingsbridge Road Station, Jerome Ave. Line, Bronx, May 28, 1961

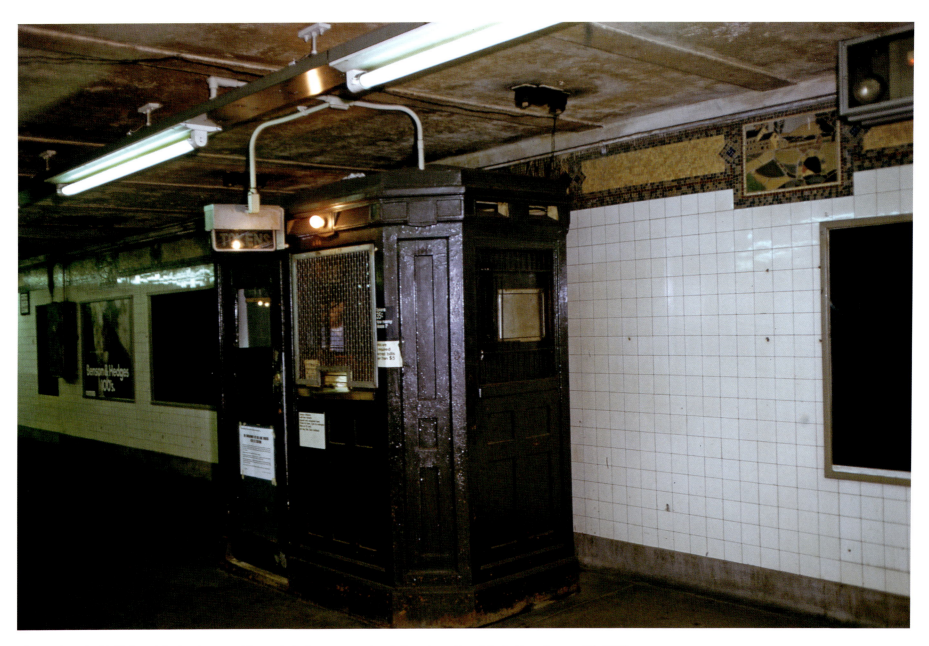

Change booth, BMT, Canal St. Station, southbound platform, upper level, Broadway Line, Manhattan, August 22, 1973

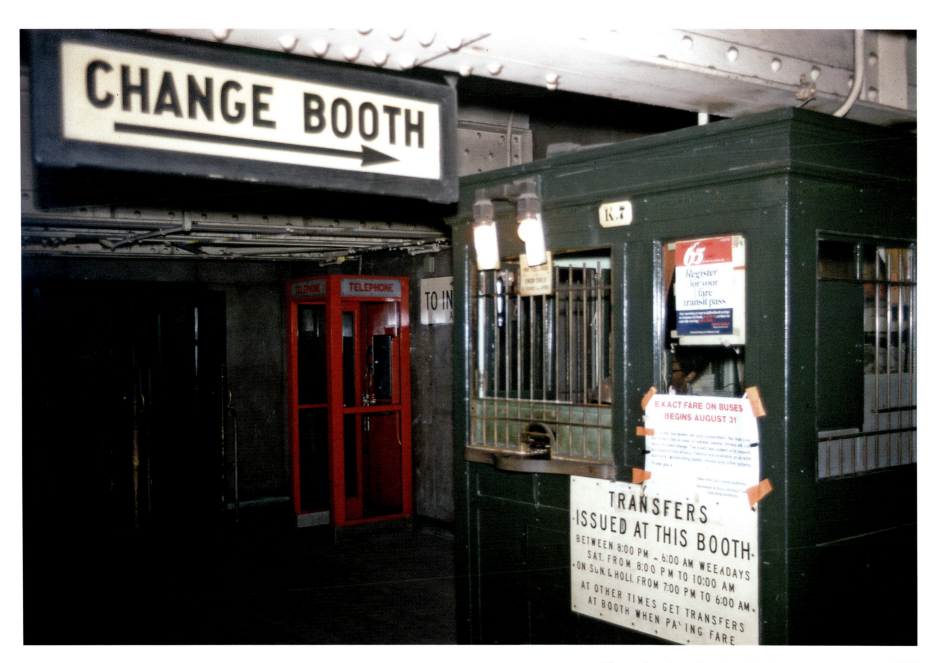

Change booth and iconic red subway telephone booth, 1969

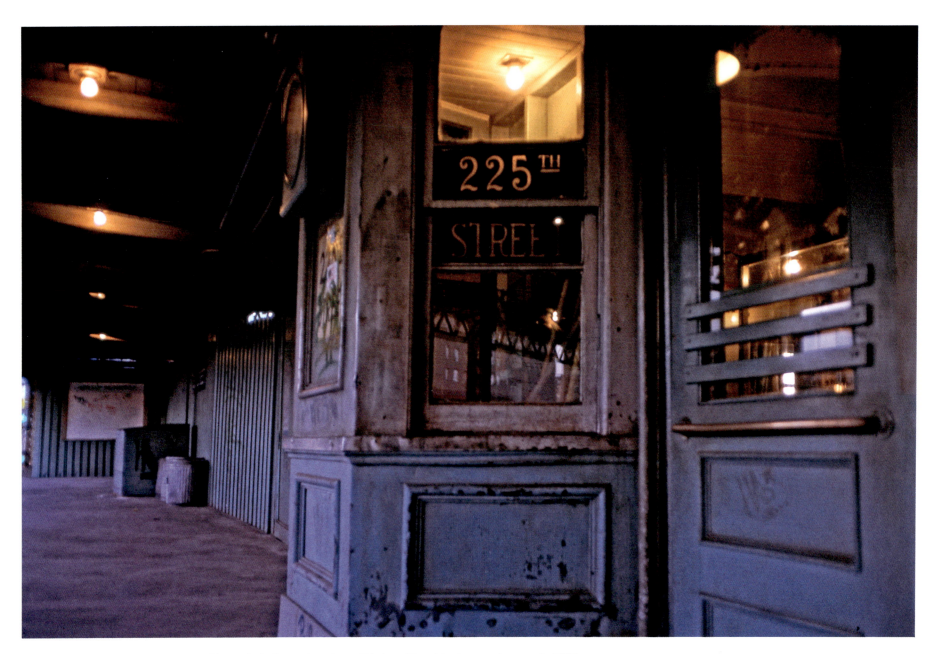

IRT, 225th St. glass station sign, southbound platform, Broadway–7th Ave. Line, Manhattan, January 5, 1975

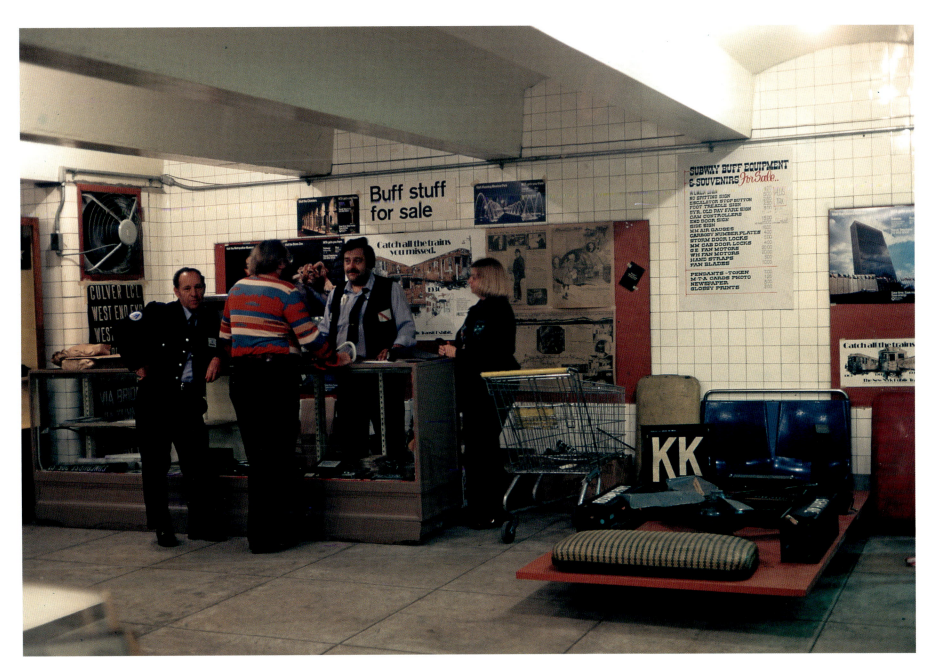

Transit relics for sale, New York City Transit Exhibition, Brooklyn (today's New York Transit Museum), 1976

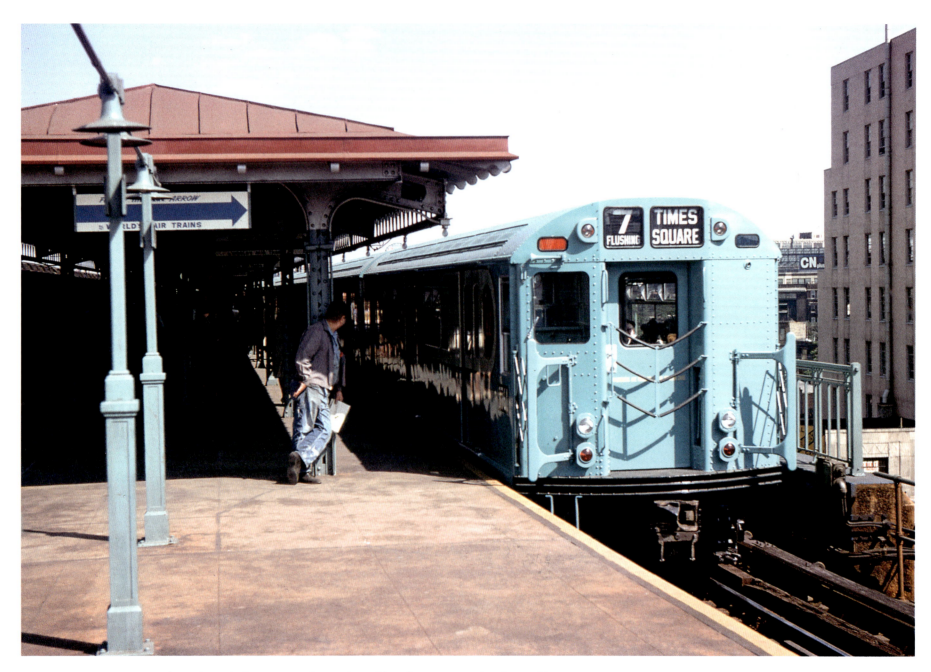

IRT, new R-36 #9761 on eastbound #7–Flushing Line at Queensboro Plaza Station, upper level, May 29, 1964.
Note: 6-foot "Follow The Blue Arrow To World's Fair Trains" sign.

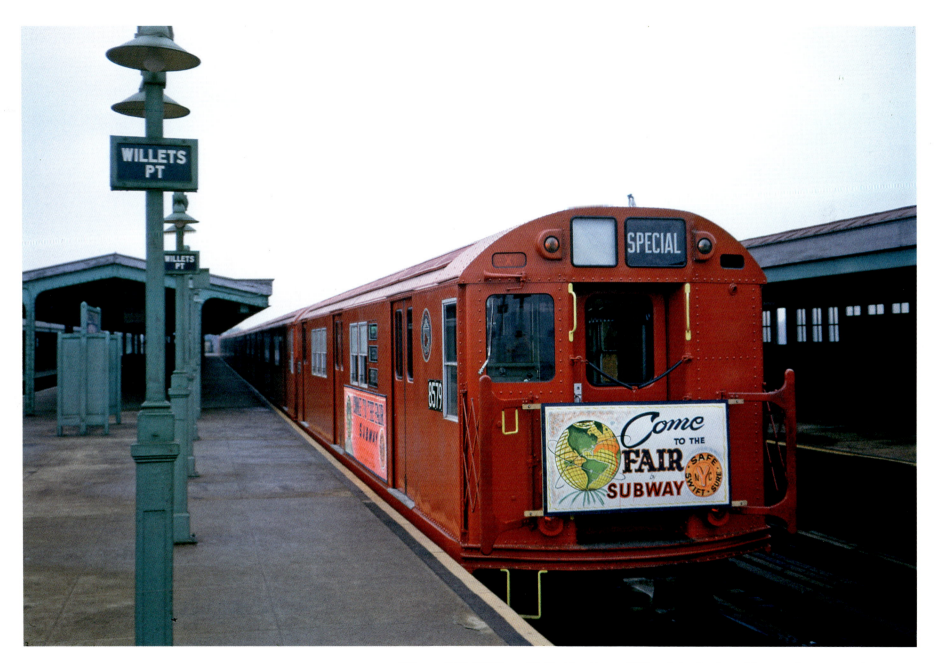

IRT, new R-29 #8579, on #7–Flushing Line at Willets Point Boulevard Station, Queens, April 30, 1962. Note: early promotional sign for the 1964 New York World's Fair.

Chapter 9. Miscellaneous Signage and Ancillary Items | 259

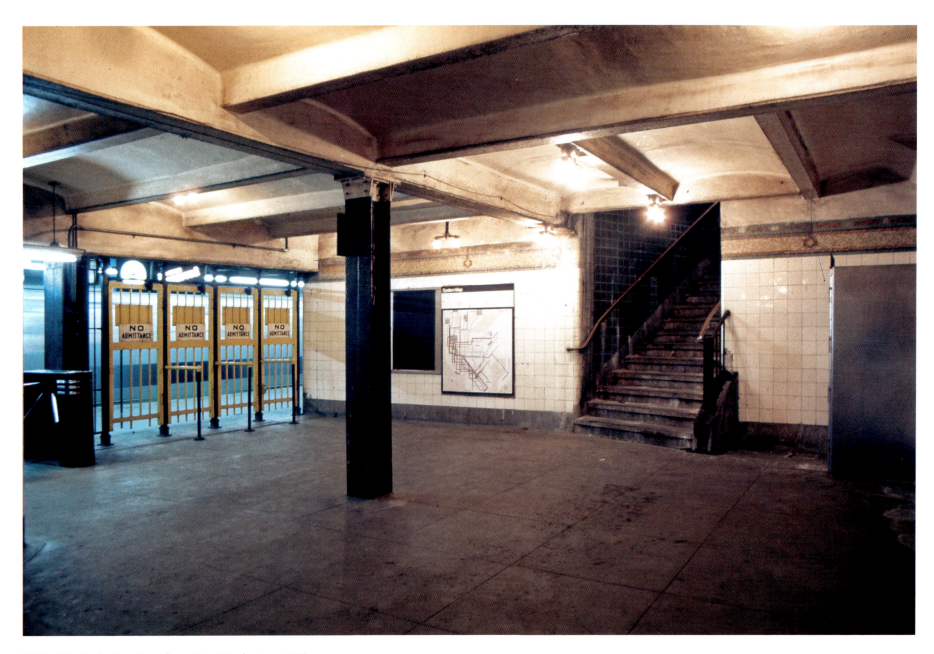
BMT, 49th St. Station, Broadway Line, Manhattan, 1973

1930s New Jersey Public Service porcelain "Bus Stop" sign, 1972

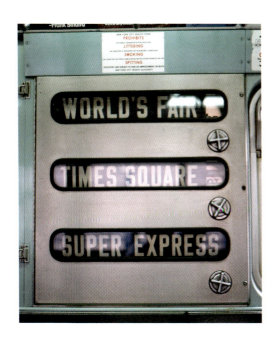

IRT, R-33/36, sign box, #7 Flushing Line, 1977

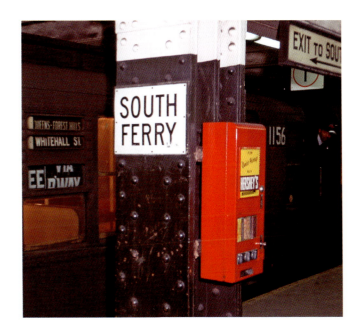

Hershey's candy machine, BMT Whitehall St.–South Ferry Station, Manhattan, December 24, 1968

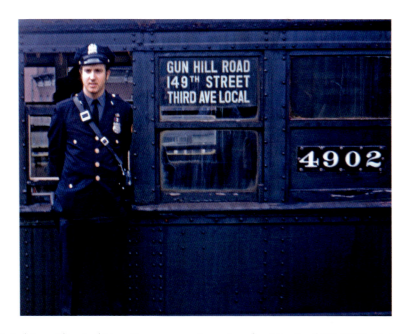

IRT, 3rd Ave. Elevated Line, Bronx, one-piece sign, fan trip, April 29, 1973. Note: transit policeman James Dell'Oglio.

Chapter 9. Miscellaneous Signage and Ancillary Items | 261

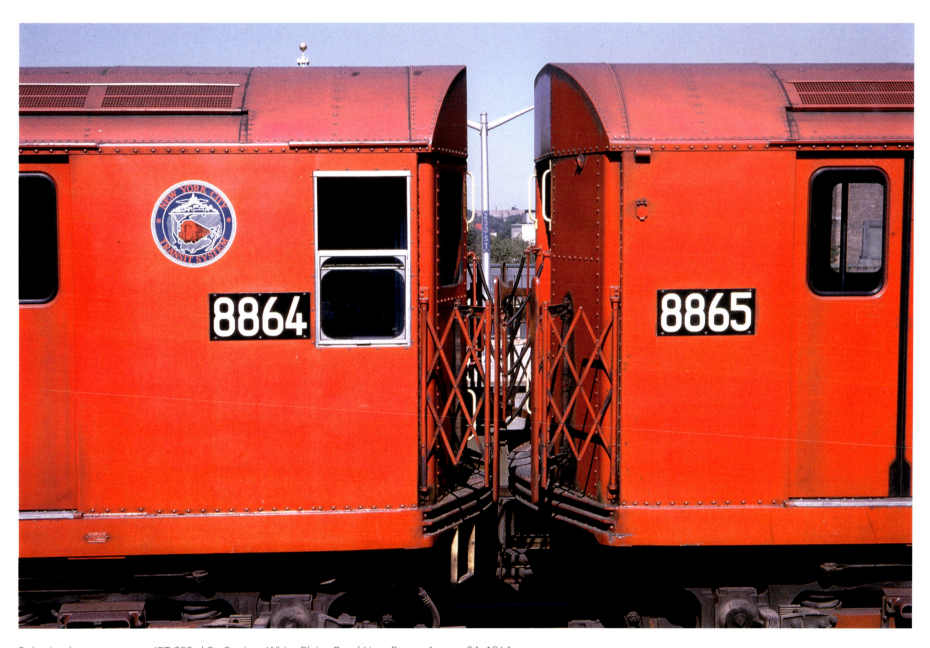

Pole sign between cars at IRT 233rd St. Station, White Plains Road Line, Bronx, August 24, 1964.
Note: R-33 subway cars with "New York City Transit System" logo sticker.

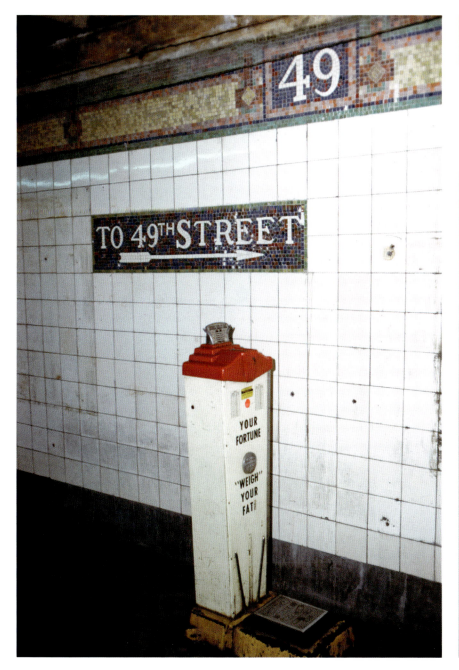

Fortune and weight scale, BMT, 49th St. Station, Broadway Line, Manhattan, March 18, 1973

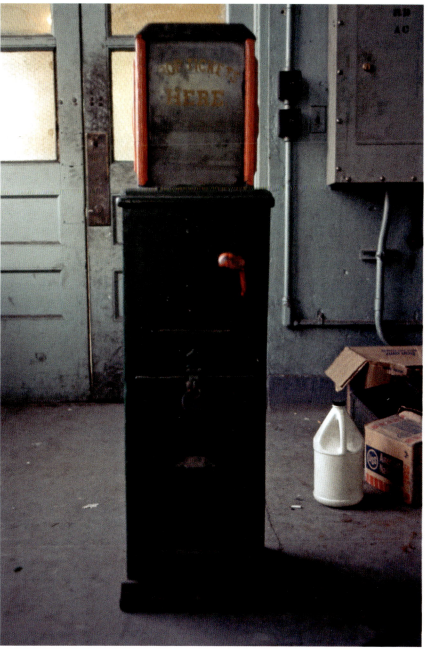

IRT ticket chopper. Under the green paint would have been beautiful oak wood, 1970. Note: Ticket choppers were removed in the early 1920s.

Chapter 9. Miscellaneous Signage and Ancillary Items | 263

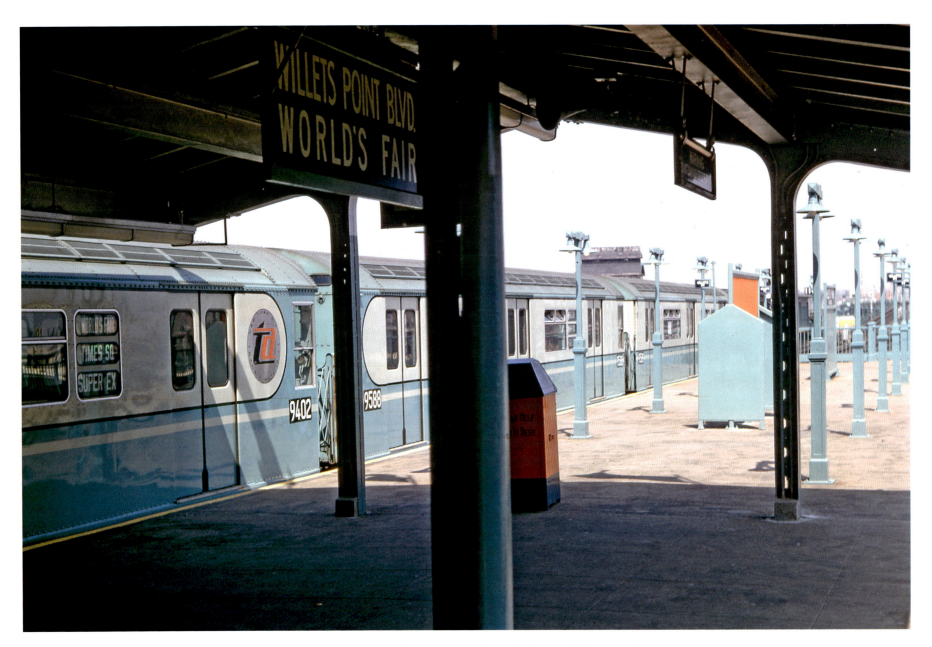

IRT, Willets Point Blvd.–World's Fair Station, Flushing Line, Queens, April 26, 1964. Note: R-36 #9402 and 9588-89 on #7 Super Express.

"Bus Stop" sign, IRT, 200th St. Station, 3rd Ave. Elevated Line, Bronx, April 22, 1973

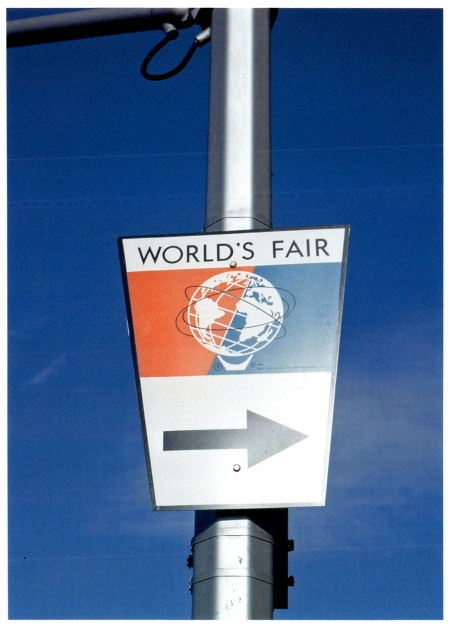
1964 New York World's Fair street/highway directional sign

Chapter 9. Miscellaneous Signage and Ancillary Items | 265

CHAPTER 10.
SURVIVORS
COLLECTION OF TOD LANGE, PAST AND PRESENT

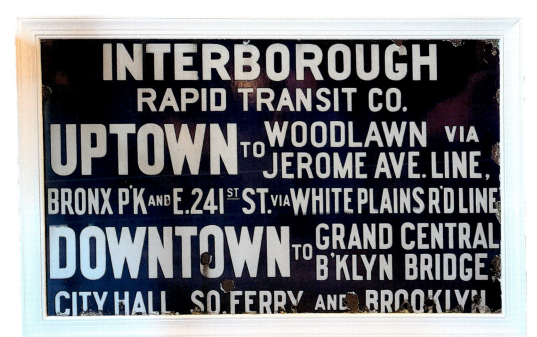

Porcelain IRT subway entrance sign, 1920s

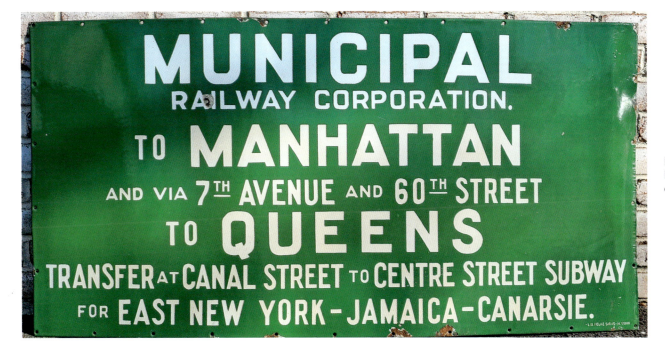

Porcelain Municipal Railway Corporation entrance sign, 1920s

Chapter 10. Survivors Collection of Tod Lange, Past and Present | 267

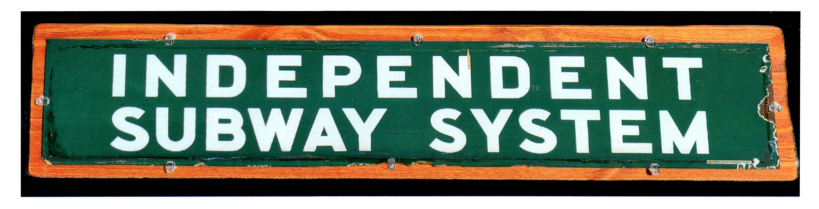

Porcelain Independent Subway System entrance sign, 1930s

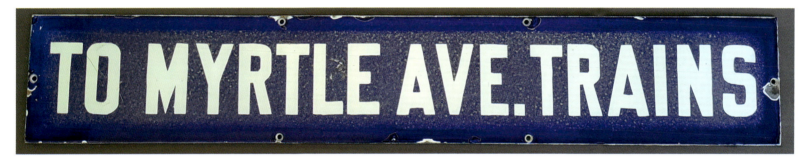

Porcelain directional sign, 1920s

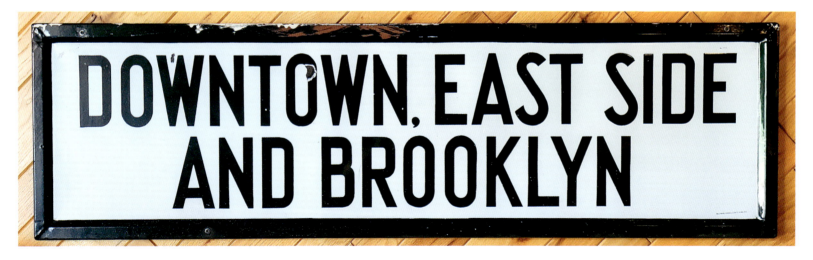

Porcelain directional sign from IND, 1930s

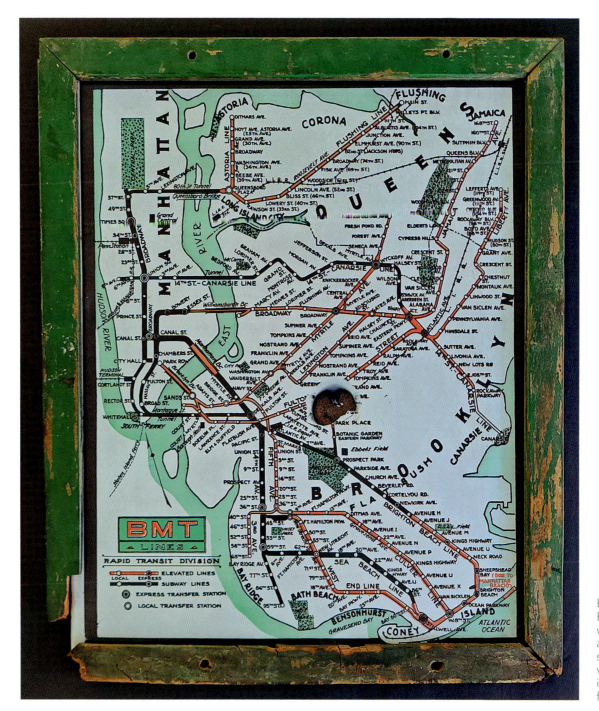

Extremely rare and scarce BMT porcelain map. These were mounted at eye level alongside change booths in select BMT stations. This version is from 1933, measuring 12 × 14⅝ inches, with frame 13¼ × 15⅞ inches.

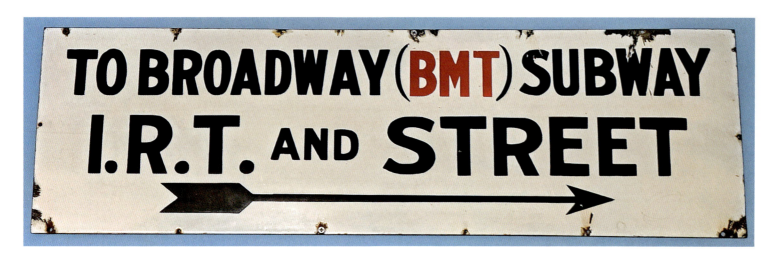

Porcelain BMT and IRT directional sign, 1930s

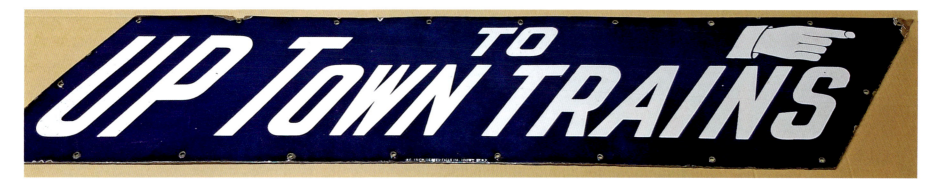

Porcelain IRT directional sign, 1920s

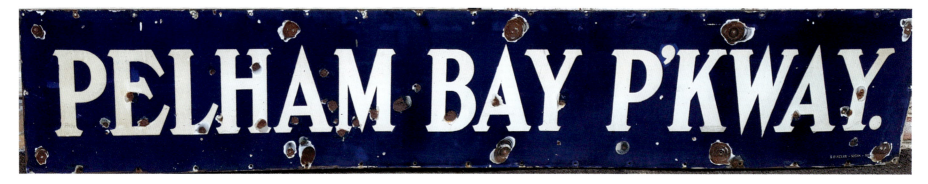

Porcelain IRT station sign, 1920s

270 | Vintage New York City Subway Signs | 1920s–1980s

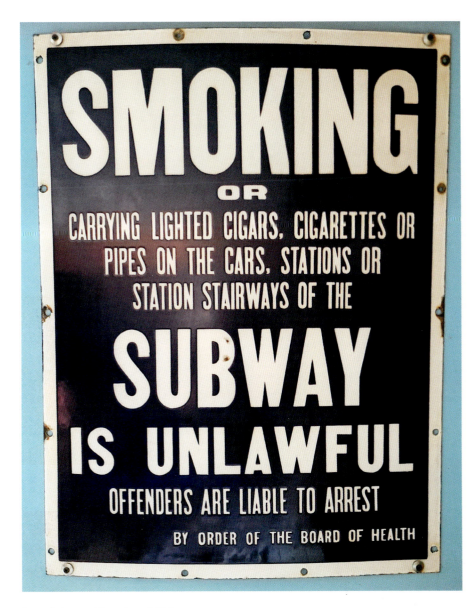

Porcelain smoking sign, 1930s

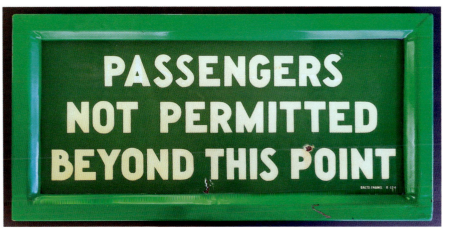

Porcelain sign from IRT, Dyre Ave. Line, former New York, Westchester & Boston Railway

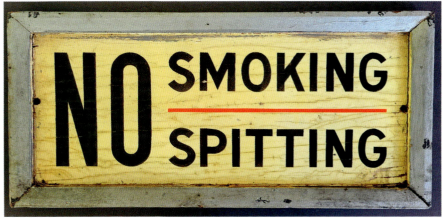

Wooden "No Smoking/Spitting" sign

Chapter 10. Survivors Collection of Tod Lange, Past and Present | 271

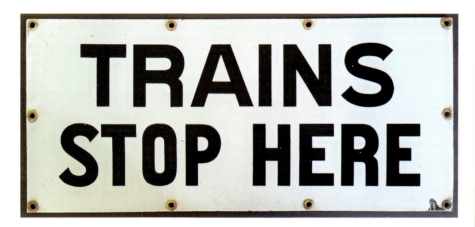
Porcelain sign, 1930s

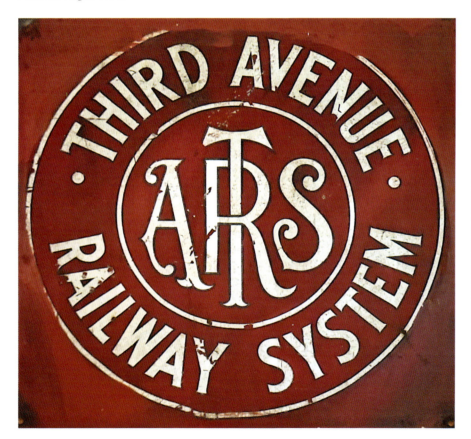
Early metal Third Avenue Railway System trolley sign

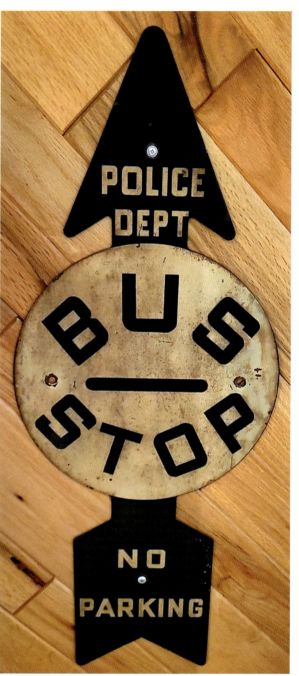
Metal "Bus Stop" sign, 1940s

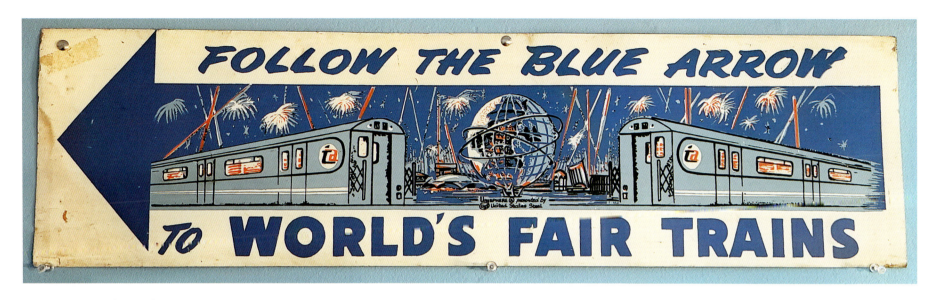

Tin 1964 New York World's Fair subway sign

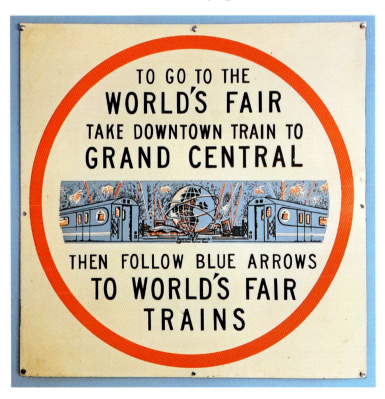
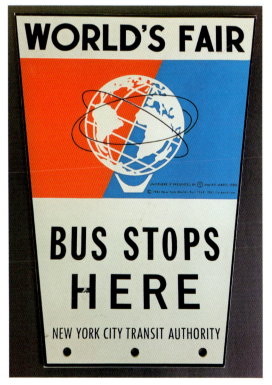

Left: Tin 1964 New York World's Fair subway sign

Right: Metal 1964 New York World's Fair "Bus Stop" sign

Chapter 10. Survivors Collection of Tod Lange, Past and Present | 273

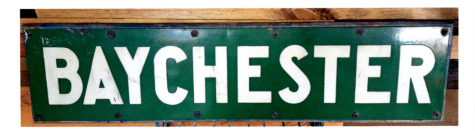

Porcelain-on-wood Baychester sign, IRT Dyre Ave. Line, former New York, Westchester & Boston Railway

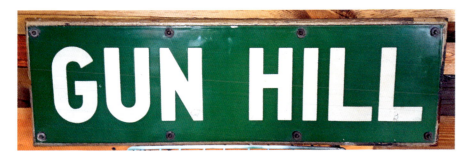

Porcelain-on-wood Gun Hill sign, IRT Dyre Ave. Line, former New York, Westchester & Boston Railway

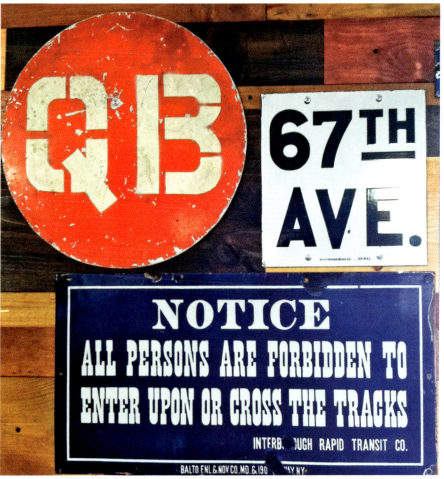

BMT 1967 metal "QB" route sign, IND 67th Ave. column sign, IRT notice sign, early 1900s

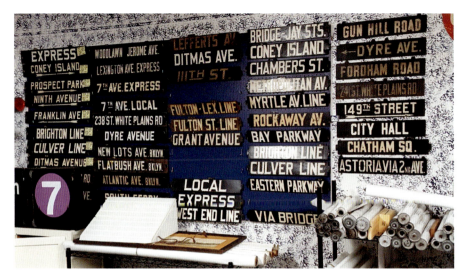

Various IRT and BMT subway / elevated route and destination metal plate signs

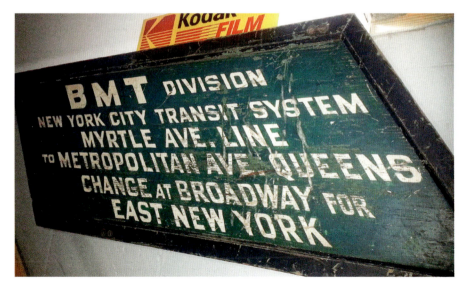

Wooden angle-cut staircase sign with original frame, BMT Myrtle Ave. Line, 1940s

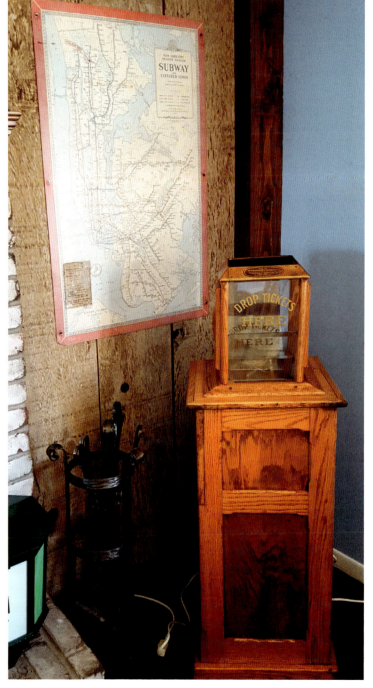

Ticket chopper, late 1800s, NYCTS 1947 subway map on Masonite

Chapter 10. Survivors Collection of Tod Lange, Past and Present | 275

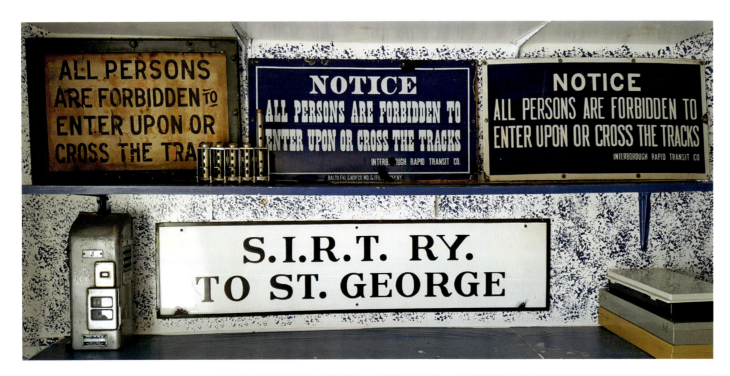

Various notice signs, "Staten Island Rapid Transit Ry" porcelain sign, 1920s

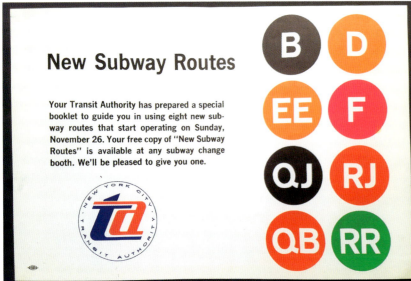

1967 poster advertising new BMT and IND subway routes

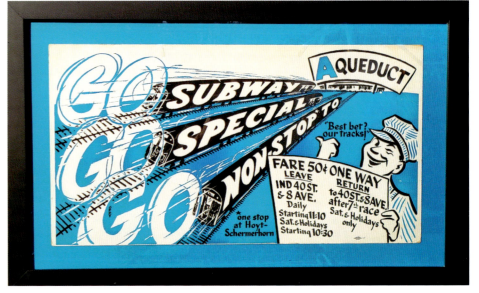

Oppy-designed subway advertisement poster, 1956

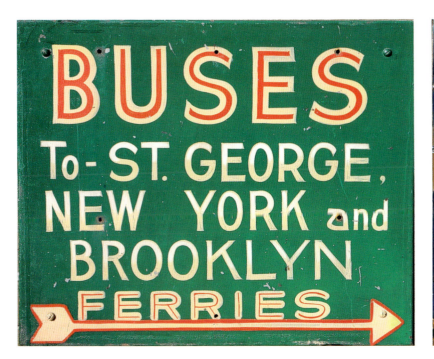
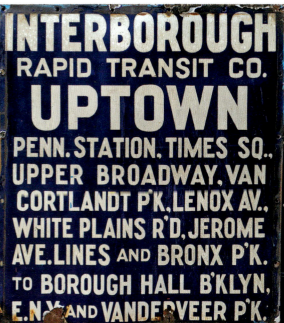

Left: Shop-made metal sign, 1940s/1950s

Right: Porcelain IRT subway entrance sign, 1920s

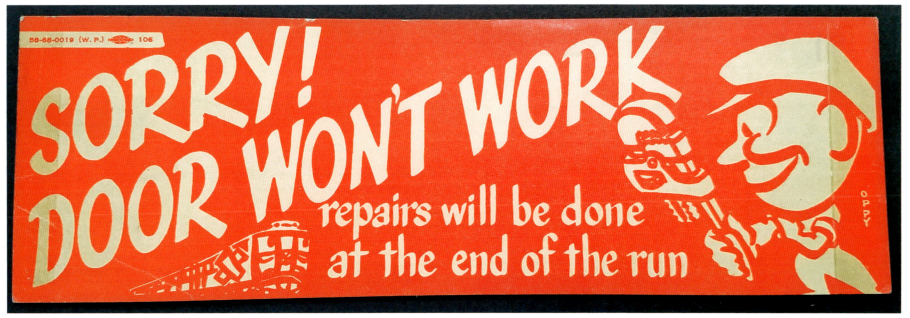

Oppy-designed subway door repair poster

Chapter 10. Survivors Collection of Tod Lange, Past and Present | 277

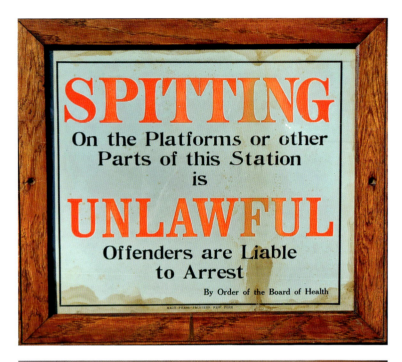

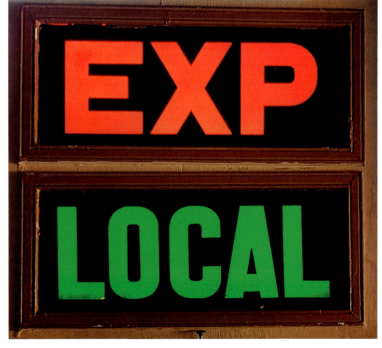

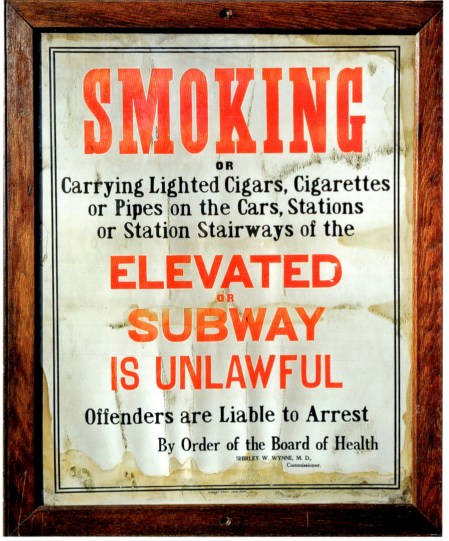

Top left: Early cardboard "Spitting" sign with original glass and wood frame, late 1920s

Bottom left: EXP and LOCAL glass subway car front signs displayed on left and right sides, 1950s. Note: homemade frame.

Above: Early cardboard "Smoking" sign with original glass and wood frame, late 1920s

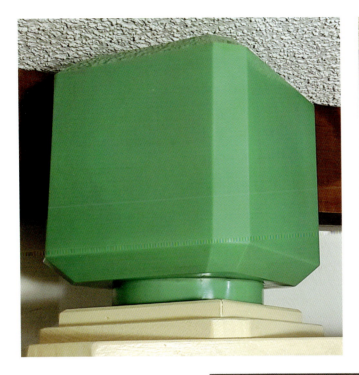
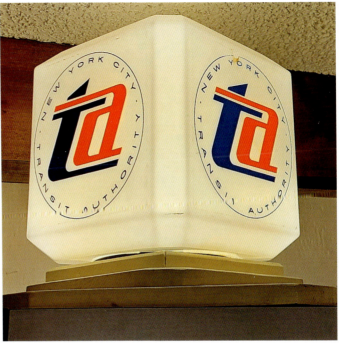
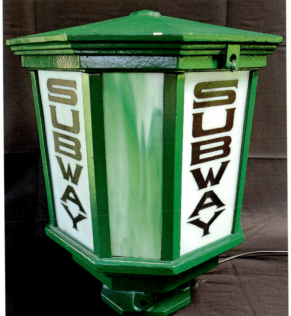

Top left: Square subway entrance globe, green lights—the entrance and token booth are open twenty-four hours a day, 1960s

Top right: Square milk-glass subway entrance globe, "TA" (lowercase) logo, 1960s

Bottom: BMT octagonal subway entrance globe, cast iron with eight glass panels, 1920s

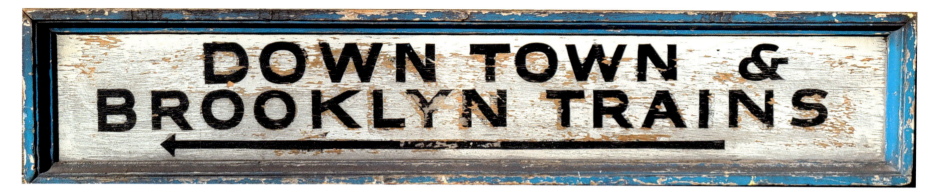

Wood directional sign with original frame, 1920s

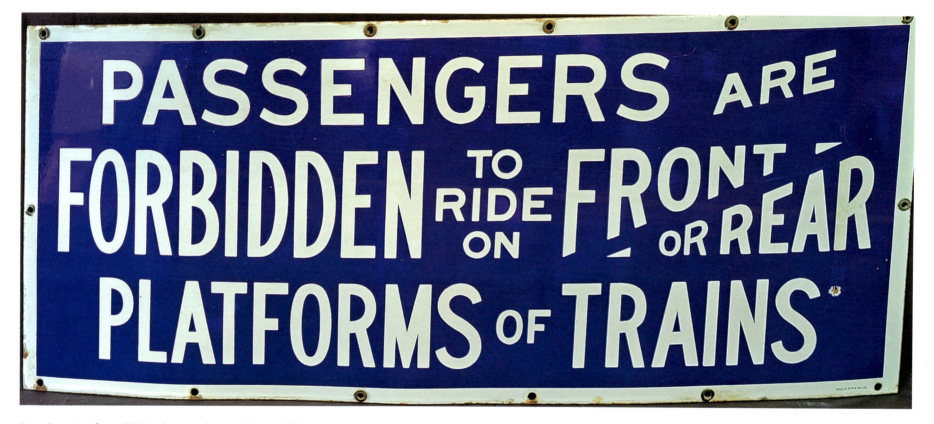

Porcelain sign from IRT Manhattan elevated lines, 1920s

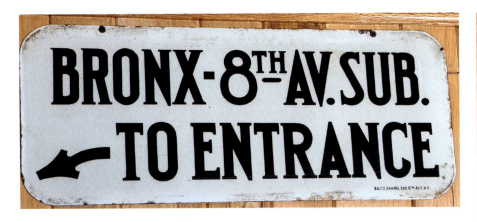

Porcelain street pole directional sign, 1930s

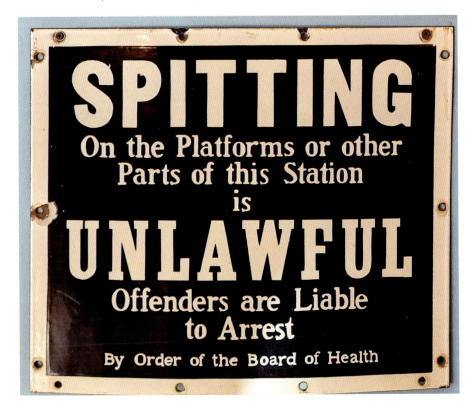

Porcelain "Spitting" sign, darker version, 1930s

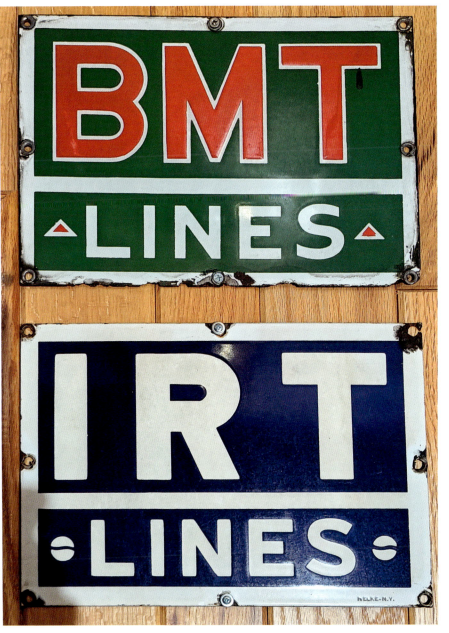

Porcelain BMT and IRT flag signs, mounted at subway station entrances, measuring 9 × 12½ inches, 1920s

Chapter 10. Survivors Collection of Tod Lange, Past and Present | 281

COLLECTION OF BRIAN MERLIS

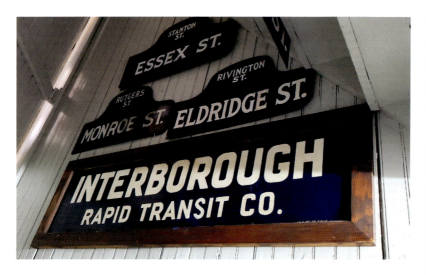

Various porcelain street signs, IRT porcelain subway station entrance sign, 1920s

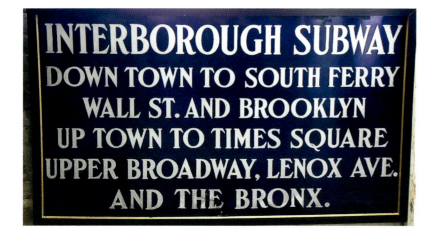

IRT porcelain subway station entrance sign, 7th Ave. Line, Manhattan, 1920s

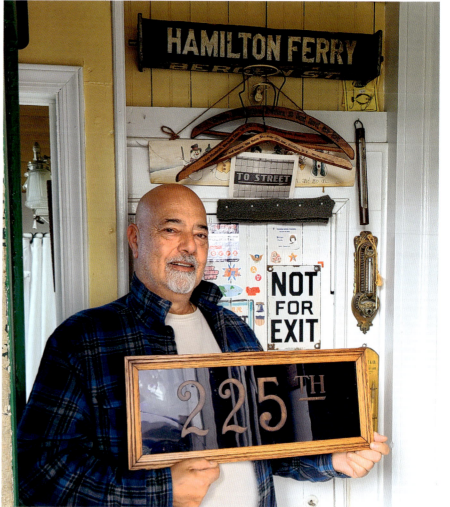

Brian Merlis, author and Brooklyn historian

COLLECTION OF JAMES GRELLER, AUTHOR

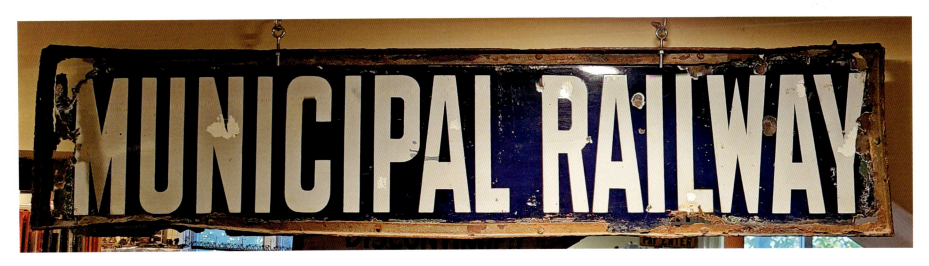

Porcelain Municipal Railway station entrance sign, 1910s/1920s

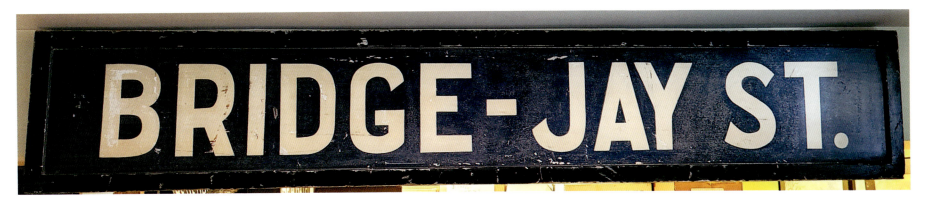

BMT double-sided wooden station sign, Bridge St.–Jay St., 1940s

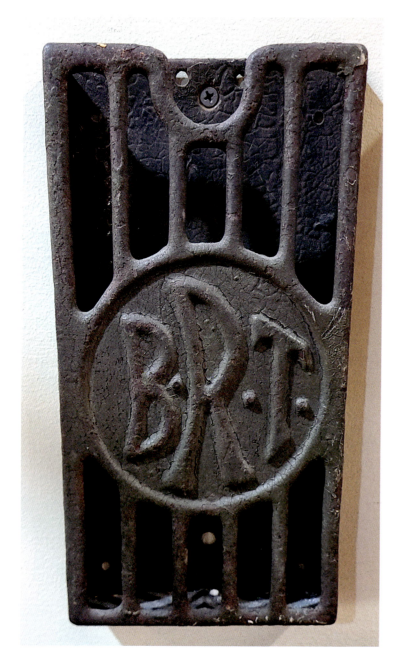
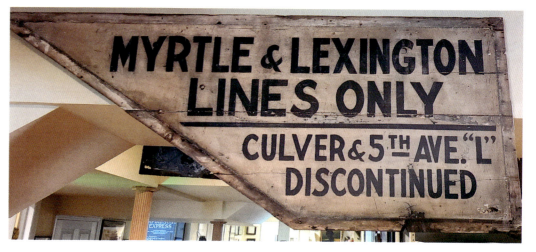
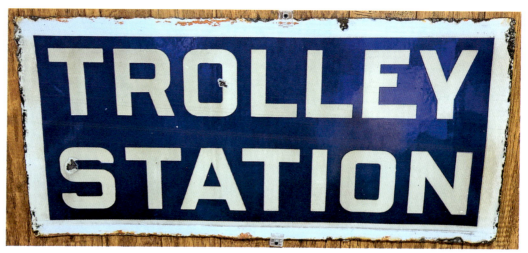

Left: BRT trolley map and information holder, late 1800s

Top: BMT angle-cut wood staircase sign, 1940s

Above: Porcelain Brooklyn & Queens Transit trolley sign, 1920s

COLLECTION OF GREGORY GIL

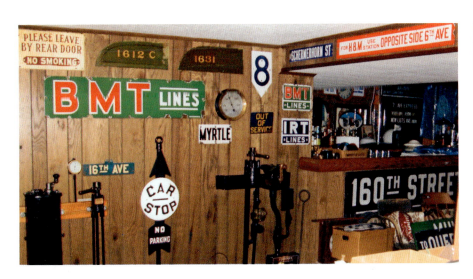
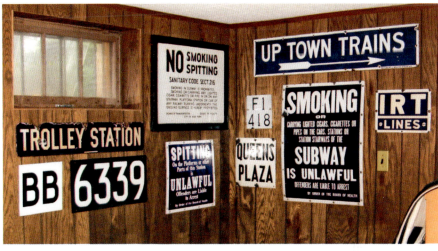
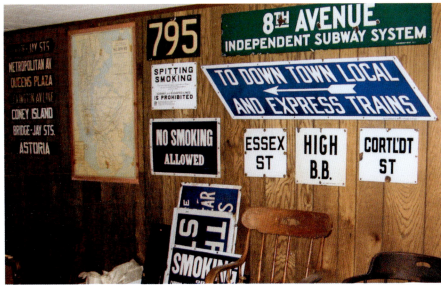
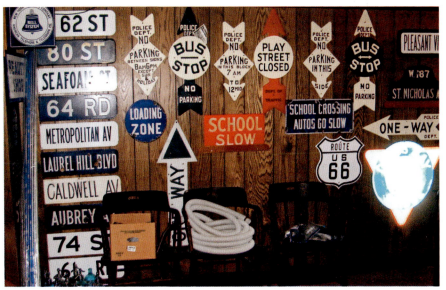

COLLECTION OF TOMMY HOLIDAY

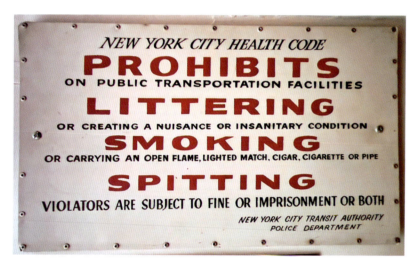

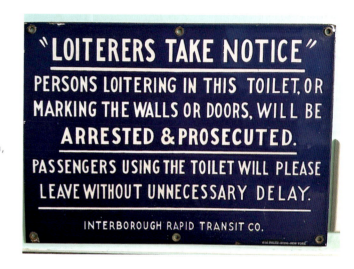

Left: Tin sign, 1950s

Right: Porcelain IRT "Loiterers Take Notice" sign, 1920s/1930s

Left: Porcelain "Warning" sign, 1930s/1940s

Right: Porcelain "Warning" sign, 1950s

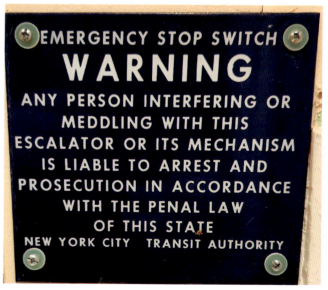

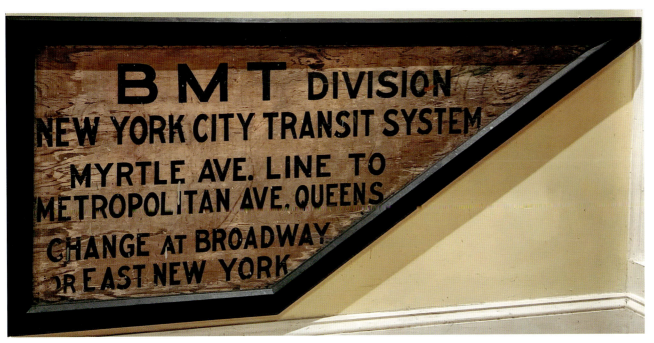
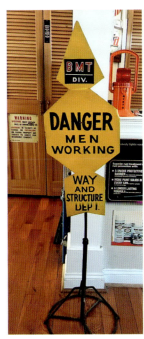

Left: Wooden angle-cut staircase sign, BMT Myrtle Ave. Line, 1940s

Right: Metal BMT "Danger" sign, 1940s

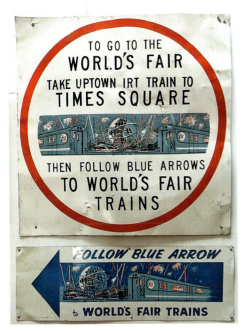
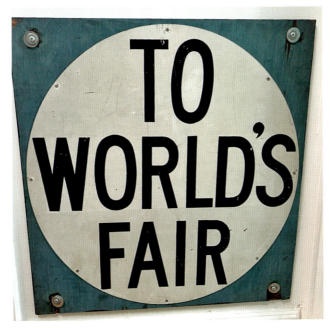
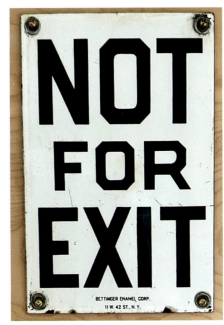

Left: Tin 1964 New York World's Fair subway signs

Middle: Tin-on-wood 1964 New York World's Fair subway sign

Right: Porcelain "Not for Exit" subway sign

Collection of Tommy Holiday | 287

COLLECTION OF THOMAS COLASANTO

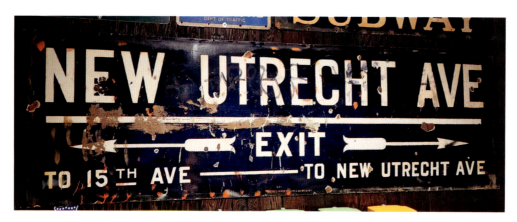

Porcelain New Utrecht Ave. subway station sign, Sea Beach Line, Brooklyn, 1920s

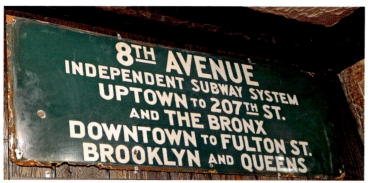
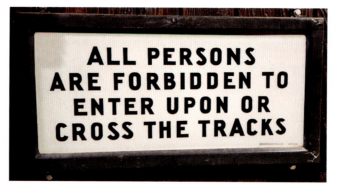

Left: Porcelain IND subway station entrance sign, 1930s

Right: Porcelain warning sign

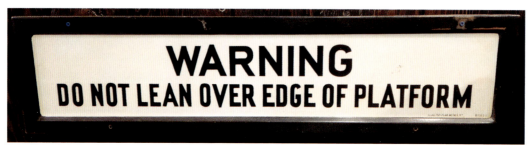

Porcelain warning sign

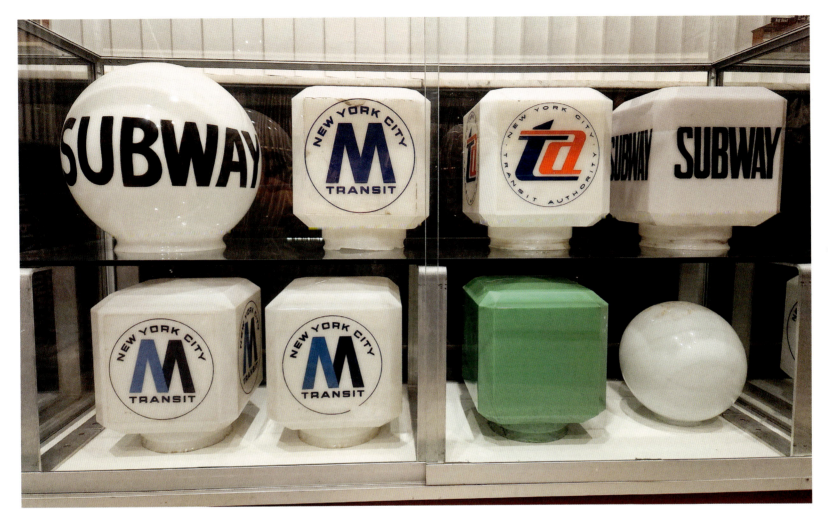

Various subway entrance globes

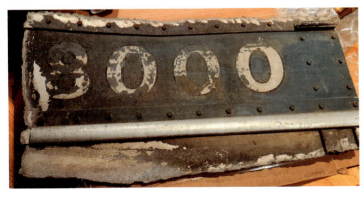

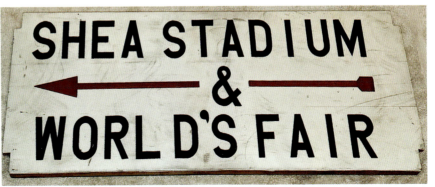

Left: Subway car #8000, BMT "Bluebird," built 1938

Right: 1964 New York World's Fair wooden subway sign

Collection of Thomas Colasanto | 289

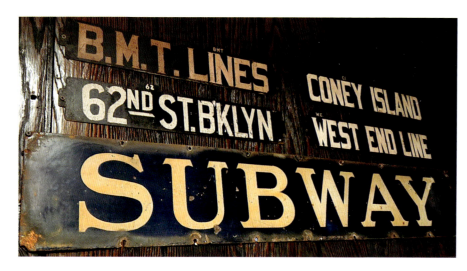

BMT plate signs, IRT porcelain subway entrance sign

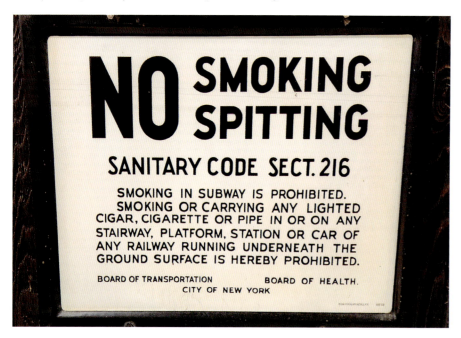

Porcelain "No Smoking & Spitting" subway sign, 1930s/1940s

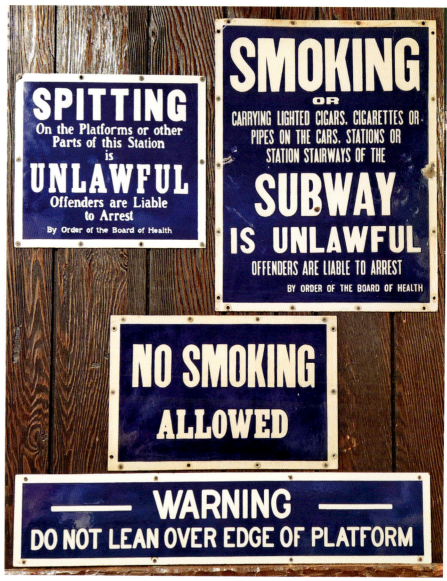

Various porcelain prohibitory subway signs

GLOSSARY

THE FOLLOWING IS A COLLECTION OF TERMS AND THEIR DEFINITIONS:

BMT: Brooklyn-Manhattan Transit Corp. A holding company created in 1923, succeeding the BRT (Brooklyn Rapid Transit Co.).

Board of Transportation of the City of N.Y.: Created on July 1, 1924. Was responsible for the management, operation, and maintenance of the New York City Transit System.

BRT: Brooklyn Rapid Transit Co. A public transit holding company formed in 1896 to acquire and consolidate railway lines in Brooklyn and Queens.

ceramic: Made from clay and similar materials.

flag signs: 9-by-12½-inch porcelain BMT and IRT station entrance signs.

H&M: Hudson & Manhattan Railroad Co. Rapid transit service between New Jersey and Manhattan, began February 25, 1908.

IND: Independent City-Owned Subway (its first official name), also called "Independent Subway System," the first segment of which opened on September 10, 1932. Operated by the Board of Transportation of the City of New York.

IRT: Interborough Rapid Transit Co., formed in April 1902 for the purpose of construction and operation of municipally-owned rapid-transit railroad lines.

kiosk: Covered subway entrance/exit, made of cast iron and glass.

mosaic: Picture or decoration made of small, usually colored, pieces of inlaid stone, glass, etc.

NYCTA: New York City Transit Authority, created March 25, 1953. On June 15, 1953, took over operation of the transit facilities owned by the City of New York, succeeding the Board of Transportation.

NYM: New York Municipal Railway Corporation. A BRT (Brooklyn Rapid Transit Co.) subsidiary, formed September 27, 1912, for entering into a contract with the City of New York to operate new rapid-transit railroads.

New York Rapid Transit Corp.: Formed on June 7, 1923, as a new subsidiary of the BMT (Brooklyn-Manhattan Transit Corp.) to operate its rapid-transit lines through consolidation of the New York Municipal Railway Corp. and the New York Consolidated Railroad Co.

New York, Westchester & Boston Railway Company: An electrified passenger railway, operated in Bronx and Westchester Counties, May 29, 1912–December 31, 1937, part of which exists today as the Dyre Avenue subway line, Bronx.

OPPY (Amelia Opdyke Jones): Commercial artist for the *Subway Sun*, 1946–1966, designed campaign posters for New York City Transit System.

PATH: Port Authority Trans Hudson. A rapid-transit service between New Jersey and Manhattan, operated by H&M prior to September 1, 1962.

porcelain sign: Graphics on thin metal sheets bonded with durable glass coating at high temperatures, further coated with enamel for protection.

ticket chopper: A tall piece of wooden furniture equipped with a shredding mechanism, located inside subway/elevated stations, into which nickel-fare paper tickets were deposited and shredded. Used 1870s/1880s–early 1920s.

ABOUT THE AUTHOR

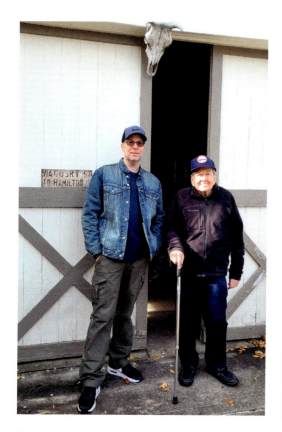

Tod Lange and Doug Grotjahn, 2023

Douglas Grotjahn contributed many images and his knowledge on the subject. I could not have completed this book without him. I have never met anyone with a stronger work ethic and meticulous attention to detail. Thank you, my friend; appreciate you very much.

Tod Lange was born in Lawrence, Massachusetts; lived in New Hampshire, New Jersey; and was raised in Queens, New York. He resides in Pennsylvania with his family and works in the antique and collectibles market. Tod has assembled the largest private collection of historic subway-related images. As a photo archivist he has worked closely with New York City photographers for decades. This is Tod's fourth book on the New York City subway system.

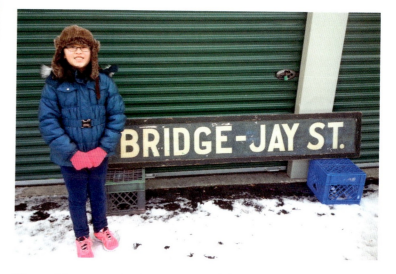

We would go out, rain, sleet, or snow. Collecting is all about being in the right place at the right time. It's hard to find good stuff nowadays, but you can get lucky. I still think the best pieces are waiting to be found. This is a photo of my daughter Madison posing with a wood Bridge St.–Jay St. Station sign from my hometown Myrtle Ave. Line.

For preliminary estimates on your sign collection, 35 mm slides, negatives, and historical-related subway items, contact:

Tod Lange | 484-241-7243 | kodachromeclassics@yahoo.com

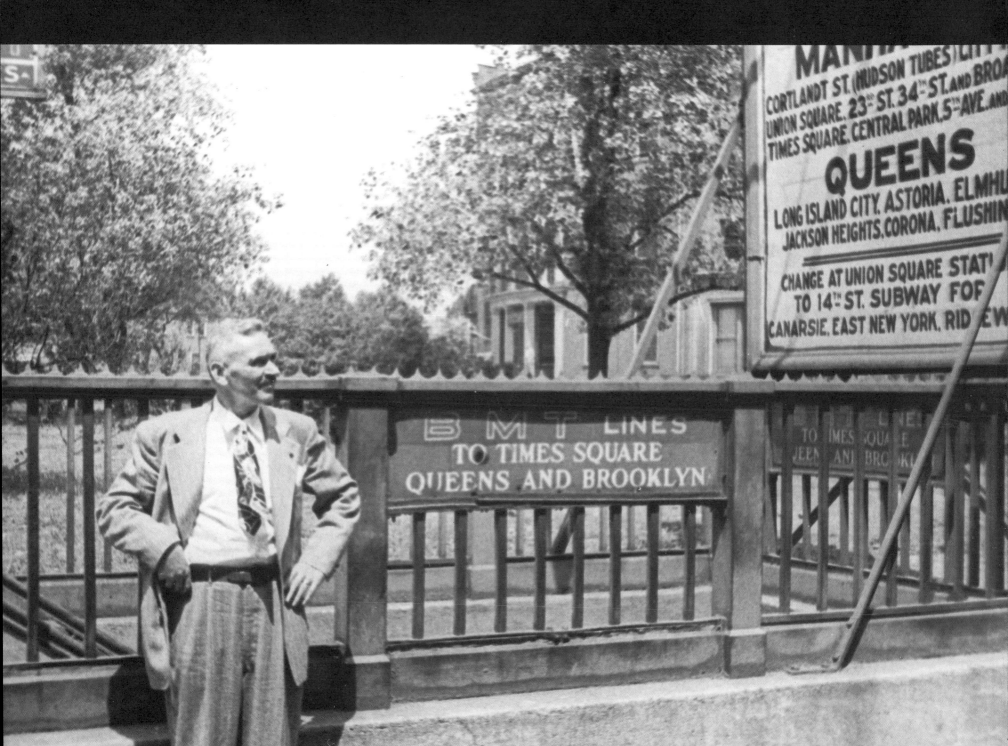